THE EAST
IMAGINED, EXPERIENCED, REMEMBERED

Orientalist Nineteenth Century Painting

THE EAST

IMAGINED, EXPERIENCED, REMEMBERED

Orientalist Nineteenth Century Painting

JAMES THOMPSON
with an essay by David Scott

THE NATIONAL GALLERY OF IRELAND
NATIONAL MUSEUMS & GALLERIES ON MERSEYSIDE
1988

For Luke

Ó níl aon teora leis an bhfear a shiubhluíonn

Muiris Ó Súileabháin, *Fiche Blian ag Fás*

British Library Cataloguing in Publication Data
Thompson, James
 The East: imagined, experienced,
 remembered: orientalist nineteenth century
 paintings.
 1. European paintings, 1800-1900.
 Orientalism — Catalogues
 I. Title II. Scott, David
 759.05

 ISBN 0-903162-45-8

First published, 1988, by the National Gallery of Ireland, Dublin 2, and the National
Museums and Galleries on Merseyside on the occasion of an exhibition at the Walker Art
Gallery, Liverpool and the National Gallery of Ireland.

Edited by Fionnuala Croke
Design, origination and print production by Printset & Design Ltd., Dublin.
Printed in Ireland by McBrinn & Ryan Ltd.

COVER: detail of *Falcon Hunt: Algeria Remembered* by Eugène Fromentin (National Gallery of
Ireland, cat. no. 4231).

Contents

Foreword

HOMAN POTTERTON

Director, The National Gallery of Ireland

Within the past decade there have been several studies and exhibitions which have focussed attention on the subject of Oriental themes in nineteenth-century European painting. The subject is open to different interpretations; and in *The East: Imagined, Experienced, Remembered,* James Thompson, formerly a lecturer in the History of Art at Trinity College, Dublin has selected an exhibition from collections in Britain and Ireland to demonstrate his own ideas as to what Orientalism meant to nineteenth century European painters. Dr. David Scott, also of Trinity College, Dublin, has contributed a valuable essay to the Catalogue on the literary background. Dr. Thompson is a recognised authority on the work of Fromentin, who is represented in the Exhibition by a number of largely unknown works from private collections; and by three capital oils from the collection of the National Gallery of Ireland. These paintings too are little known in our own time, although, for example, *The Falcon Hunt* (no. 34) is one of the artist's masterpieces. The pictures by Fromentin are among some twenty-five paintings from the National Gallery of Ireland that are included in the Exhibition; and it was the existence of so many fairly unknown Orientalist paintings in the Dublin Collection, together with Dr. Thompson's geographically accessible expertise, that prompted the idea of the exhibition in the first place. For the most part the Dublin pictures came to the National Gallery of Ireland as the gift of Sir Alfred Chester Beatty, a gift that was originally made to the Irish Nation in 1950 but transferred to the National Gallery of Ireland in 1978. Chester Beatty's magnificent gift of almost one hundred nineteenth century paintings included of course many paintings that are not Orientalist in subject matter: works by Boudin, Corot, Couture, Harpignies, Jongkind, Millet and Tissot to name but a few.

At the last moment the scale of the Exhibition for its Dublin showing has had to be curtailed (for financial reasons). It is all the more welcome, therefore, that the Exhibition will be seen at the Walker Art Gallery in Liverpool and I am grateful to the Acting Keeper, Edward Morris for his co-operation. At the National Gallery of Ireland the arrangements for the exhibition has been undertaken in the main by the Assistant Director, Raymond Keaveney. Several of the pictures have been cleaned in time for the Exhibition by Sergio Benedetti who has also supervised the transport arrangements. The Catalogue has been greatly enhanced by Fionnuala Croke's careful and diligent editing of the text; and Prof. Barbara Wright's assistance was also greatly appreciated. To all of these, and of course to James Thompson, I am grateful. I feel sure that the Exhibition will serve to widen public interest in Orientalist painting and at the same time draw attention to a lesser-known aspect of the Collection in the National Gallery of Ireland.

Preface

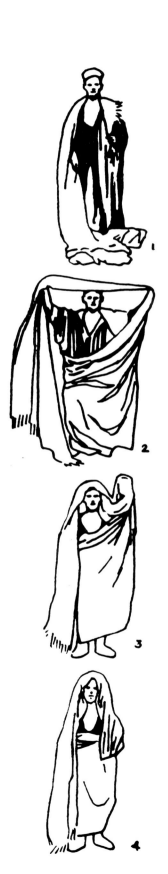

L'Invitation au Voyage

In the spring of 1975 I was watching my favourite Sunday night television show, an educational hour called NOVA. That evening's programme concerned a tribe of Arab warriors called the Tuaregs. Formerly they had lived as nomadic feudal lords, with serfs to tend their lands while they roamed the desert. Now, with slavery outlawed and drought widespread, they were reduced to extreme poverty. A young man, descendant of desert nobility, was engaged on screen in the lowest of labour: stooped over, knee-deep in water, he was cleaning out an irrigation ditch. His shaved head was uncovered; he wore a simple tunic pulled up between his legs so that it would not drag in the water. An Arab who once might have ruled the shifting sands atop a camel was now weeding his back-breaking way through the murky meanders of a modern agricultural project.

When his day's work was done, the young man prepared to return home by assuming the traditional robes of his tribe. In so doing he provided one of those rare moments of solid gold amidst the tinsel dross of media mediocrity. After loosing the hem of his tunic from his legs, he slowly but fluidly began to wrap round himself the long continuous cloth of his haïk. The effect was much like that of mild-mannered reporter Clark Kent hastily entering the phone booth to discard blue business suit and hornrimmed glasses only to exit an instant later, bulging biceps threatening to burst the indestructible red-yellow-and -blue of his skintight Superman suit. With each new fold the Tuareg youth seemed to gain a few inches in height, and at the end he looked at least a foot taller. But not just taller: indescribably grand, graceful, romantic. No sham Hollywood sheik, but an authentic desert lord. Decimated by drought and economic 'development', the dying remnant of a glorious manifestation of humankind's fighting spirit sent out a beam of hot sunlight that shot through the fog of my 'civilized' life:

> La splendeur orientale,
> Tout y parlerait
> A l'âme en secret
> Sa douce langue natale…

That was almost thirteen years ago. Since then the Tuaregs have done some television watching of their own. An ecologist friend informed me once that the annual Tuareg migration, an event which goes back hundreds if not thousands of years, had to be postponed in order that the tribe, squatting sagely in the sun outside the door of a small dark hut, might catch the last episode of 'Dallas'. The enquiry into the nature of Western perceptions of the East which formed the basis of a course I pursued for three years with my Trinity students taught me that my own reaction to the television transformation was yet another Western attempt to 'mythologize' the East rather than to see it for what it actually is (whatever that is). Was I wrong to turn that young Tuareg into an archetype? Insofar as my reaction was one of surprise, appreciation, visual and cultural excitement, I think not; insofar as my reaction simplified, structured or otherwise limited him or my ability to perceive him or others more profoundly, I certainly was.

I would wish this show and this catalogue to excite a reflective wonder which does not delimit but which expands an awareness of the Arab world, so different from our Western countries and yet so much a part of our common planet. As befits pictures representing the countries which gave us pepper, coffee, and all manner of things to smoke, the reactions these works provoke should be varied: piquant, stimulating, soothing. Neither the author nor viewers and catalogue readers can afford to congratulate themselves on how much eccentricity they can accommodate in their

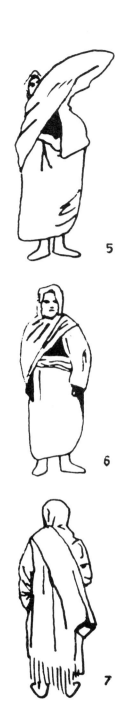

benign Western tolerance and wisdom, but should seriously question the comfortable rigidity of the received structures of our daily lives, in order to explore the wider shores and the deeper deserts of self as well as others. In the world there are aspects of several systems or codes, mainly moral ones, which in relation to a particular environment suggest, allow or promote worthy and widespread human values and dignity; there are also systems, or parts of systems, mainly economic ones, that restrict, forbid or even exterminate human values and dignity. In an increasingly monocultural world, capitalist and socialist, the problem is not to enforce unity but to allow, to encourage, to cherish diversity.

I would like to thank Homan Potterton, the Director, for inviting me to organize this exhibition for the National Gallery of Ireland; my former colleague David Scott of Trinity College for helping me sustain the idea of an Orientalist exhibition through the years and for contributing an enlightening essay to the catalogue; Kim-Mai Mooney, Exhibitions Officer, for coordinating the exhibition; Katherine Swift, for her help in organizing the book loans; Frances Gillespie, for looking after photographs; my former students Stephen Campbell, Jacqueline Clarke and Veronika Montag, for their substantial help in writing some of the catalogue entries, also the staff of the National Gallery of Ireland, particularly Fionnuala Croke, Paula Hicks, Adrian Le Harivel and Elizabeth Mayes. For other extra assistance I would like to thank Peter Butler, Patrick Connor, Brendan Dempsey, James Gorry, Lynn Jenkins, Michael Kenny, Richard Keresey, Briony Llewellyn, John Poxton, Lynne Thornton, Gretchen Wold, Barbara Wright and all the lending institutions and their curatorial staff.

A Note on the Catalogue Entries

While I have tried to provide as much essential information about the artists' lives as possible, I have also attempted to make the *vitae* and entries on the works interpretative and somewhat analytical, as well as descriptive, in hopes of piquing the viewer's interest, disagreement, or assent. The offensive '*q.v.'s*' which litter the text are there to make an important point: that these painters lived at the same time, personally and artistically interacting, even though they are often rigidly confined by historians to different national schools. Following that same argument, I apologize for the inconsistent isolation of the 'Irish Orientalists', which was intended to draw special attention to artists and pictures that are almost unknown in studies of similar painters. I hope that in the next survey of this type of subject matter they will be rightfully integrated amongst their fellow artists of Eastern scenes.

Figs. 1-7:
'How to wear the haïk', author's drawings
after Edmond Doutte's photographs
for his book *Marrakech* (Paris:
Comité du Maroc 1905), fig. 56.

The Literary Orient

DAVID SCOTT

1. Introduction

> Ce que j'aime [...] dans l'Orient, c'est cette grandeur qui s'ignore, et cette harmonie des choses disparates. Je me rappelle un baigneur qui avait au bras gauche un bracelet d'argent, et à l'autre un vésicatoire (Flaubert).[1]

> (What I like [...] about the Orient, is its unconscious grandeur, its harmony of disparate objects. I remember a bather with a silver bracelet on one arm, and a blister on the other.)

Just as evocations of the East were to become a significant part of nineteenth-century English and French 'history' painting, Orientalism was to establish itself in both countries as an important literary genre. In England, Byron was the first to exploit the glamour and topicality of Orientalist themes, the first two cantos of *Childe Harold's Pilgrimage* being published in 1812. Byron is himself represented as the image of Romantic exoticism in his portrait in Turkish costume — based on sketches made in 1813 and 1814 — by Thomas Phillips (Fig. 8). But, as in France, it was above all the prose writers who were to gain a literary reputation as Orientalists. Edward William Lane was one of the first to make his name with his *Account of the Manners and Customs of the Modern Egyptians* of 1836. Lane's scholarly and scientific approach contrasts both with that of Byron and that of his contemporary Alexander Kinglake, whose colourful adventures in Asia Minor are vividly recorded in *Eothen* (1844). In his *Personal Narrative of a Pilgrimage to Al Madinah and Meccah* of 1856, Sir Richard Burton combined adventure and documentation in an enthralling mixture, some of the ruggedness of his approach perhaps being reflected in Seddon's portrait, presumed to be of him (Fig. 9). In France, Chateaubriand's *Itinéraire de Paris à Jérusalem* (1811)

1. Letter to Louise Collet, 27 March 1853 cited from *Extraits de la Correspondance ou Préface à la vie d'écrivain,* ed. G. Bollème' (Paris 1963), p. 105.

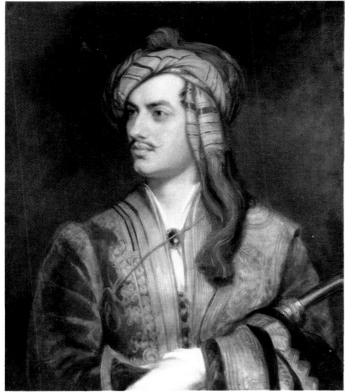

Fig. 8 Thomas Phillips, *Portrait of Lord Byron*, oil on canvas (National Portrait Gallery, London).

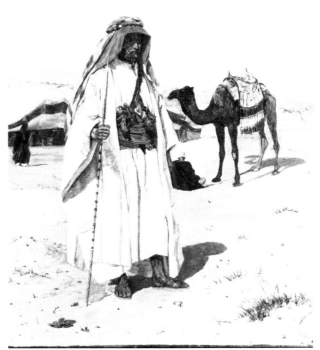

Fig. 9 Thomas Seddon, *'Arab Shaykh' (probably Richard Burton)* 1854, oil on canvas (Private collection).

3

launched the vogue of the Orientalist travelogue, a genre which was adopted by many important French writers in following decades — Lamartine: *Voyage en Orient* (1835); Gautier: *Voyage en Espagne* (1843), *Voyage pittoresque en Algérie* (1853) and *L'Orient* (published posthumously in 1877); Fromentin: *Un Eté dans le Sahara* (1857) and *Une Année dans le Sahel* (1859); Flaubert: *Voyage en Orient* (based on his travels of 1849-51 but not published until after his death). Although, then, European Orientalist literature was to be dominated by the travelogue, poetry and fiction were also to draw on the new experience of the East, submitting it to various degrees of imaginative recreation, as in Hugo's *Les Orientales* (1829), Nerval's *Les Chimères* (1853) and Flaubert's *Salammbô* (1862) and *La Tentation de Saint Antoine* (1874).[2]

Nineteenth-century writers' motivations for exploring the Near or Middle East (which included Spain, Greece and North Africa as well as Egypt, Arabia, the Holy Land, Syria and Turkey) were multiple and complex. Like the painters, poets and novelists turned to the Orient as an exotically different world which became a real alternative to their own at precisely the moment it was being opened up to them by European political and commercial expansion. The East was thus to be explored by the West with an urgency and excitement prompted both by an obscure awareness of the possibility that the mystique of the Orient might not long outlast European colonization and by a need to replenish the cultural resources of Western civilization which, for two thousand years, had been dominated by Christian or classical Greek and Roman myths and archetypes. Writers were fascinated in particular by the Arab world as it had been presented to them, first in translations of *The Arabian Nights*, and slightly later in the accounts of European travellers at the end of the eighteenth century. This Orient represented an alluring Other to Western eyes: a land of fantasy in which the repressed desires of European consciousness could find expression. Writers were also, like the painters, searching for new aesthetic principles: an exotic picturesque to replace conventional neoclassical models, local colour and vivid imagery to supersede the sombre palette they had inherited from their seventeenth- and eighteenth-century predecessors. Sometimes it was Orientalist painting as much as Oriental reality which provided the initial inspiration: Marilhat's picture of the *Place de l'Esbekieh au Cairo*, for example, prompted Gautier to visit Egypt and many Orientalist writers (especially the French: Gautier, Flaubert, Fromentin, Loti) were as much concerned with *aesthetic* issues — the analysis of oriental light, shade and colour — as with accurate documentation.

European painters and writers were nevertheless also anxious to explore in the East the historical and ideological roots of classical and Christian civilization in their Hebrew and Egyptian origins, to rediscover and renew the elements of Oriental culture which the West had over the centuries absorbed into its own. Both Chateaubriand and Burton looked upon their Oriental voyages — whether to Jerusalem or Mecca

2. The best account to date of French Orientalist literature is Hassan el Nouty's *Le Proche-Orient dans la littérature française de Nerval à Barrès* (Paris 1958); for a comprehensive and provocative introduction to the political and ideological issues raised by European interest in the Middle East, see Edward W. Said's *Orientalism* (London 1978), though this book is not very comprehensive in its treatment of literature.

Fig. 10 Holman Hunt, *The Scapegoat*, 1854, oil on canvas (Lady Lever Art Gallery, Port Sunlight).

Fig. 12 Gustave Guillaumet, *Le Désert* 1867, oil on canvas (Musée d'Orsay, Paris).

Fig. 11 Léon Belly, *Pèlerins allant à la Mecque*, 1861, oil on canvas (Musée d'Orsay, Paris).

— as pilgrimages. The Biblical past, it was discovered, could be experienced in the present by travellers to the Holy Land or Egypt, much of the seemingly changeless landscape of these countries being impregnated with archetypal imagery. Thus the arid wilderness of the Dead Sea as viewed by Chateaubriand in his *Itinéraire* is still blighted by God's immemorial wrath, the Godforsaken desolation of the same area being evoked as a backdrop in Holman Hunt's famous painting *The Scapegoat* (1854) (Fig. 10). Similarly, the terror and excitement of the timeless desert crossing by caravan is recreated as vividly by Burton in his *Personal Narrative* as in such paintings as Belly's *Pelèrins allant à la Mecque* (1861) (Fig. 11) or in Guillaumet's *Le Désert* (1867) (Fig. 12). Anglo-Saxon writers, in particular, were successful in immersing themselves in the traditions and customs of the foreign environment. Like their Orientalist compatriots in the topographical watercolourist tradition (Roberts, Lewis, Lear), their eye for geological or architectural detail, their meticulous observation of customs and costumes, enabled them to produce texts which became major sources for later Orientalist writers. Lane's *Modern Egyptians*, in particular, was heavily plundered for local colour and picturesque detail by subsequent writers, above all, by Nerval.

But the response to the Orient of writers was different from that of the painters in that, ultimately, it was more complex and wide-ranging. Whereas nineteenth-century painters concentrated on capturing the exotic, picturesque, colourful or erotic aspects of Oriental life and scenery and, in doing so, tended towards a high degree of selectivity and idealization, writers were much more various and comprehensive in their approach. Linda Nochlin has shown how the 'telltale presence of western man' (but not western consciousness) was systematically excluded form Orientalist painting in favour of 'a plethora of details which authenticate[d] the total visual field as a simple, artless reflection of a supposed Oriental reality'[3]. The nature of this 'Oriental reality' had always been much more problematic to nineteenth-century Orientalist writers who were, for the most part, far more searching in their investigation of Oriental life. Whereas poverty, dirt and disease were either ignored or glamorized by the painters — the painterly genre of the 'dirty picturesque' is ironically referred to by Richard Burton in his evocation of the grotesque scenes of the Caravanserai[4] — the clashes of Eastern and Western moral and cultural values are far more steadfastly confronted by the writers.[5] Language's greater scope for expressing irony, humour and opposition was obviously a factor here, as were literature's (by the nineteenth century) much more flexible conventions in relation to the mixing of genres. Paradox and striking juxtaposition become, in fact, some of the features most characteristic of the more original Orientalist writing. Flaubert, for example, will not hesitate to record the fact of 'la bêtise moderne' — even in Egypt, where the base of Pompey's column was covered in graffiti, the work of one 'Thompson of Sunderland' who had written his name

3. 'The Imaginary Orient', *Art in America*, 71 (1983), pp. 123, 125.
4. *Personal Narrative of a Pilgrimage to Al-Madinah and Meccah* (ed. I. Burton, 2 vols., London 1883), vol. I, p. 42.
5. One of the most perspicacious and least prejudiced of these was Eugène Fromentin who was also, of course, an important Orientalist painter.

5

in letters three feet high.[6] Similarly Flaubert will note the grotesque incongruity of the decor of the Hotel du Nil in Cairo where

> Le corridor du premier étage est tapissé des lithographies de Gavarni arrachées au *Charivari*. Quand les sheiks du Sinai viennent pour traiter avec les voyageurs, le vêtement du désert frôle sur le mur tout ce que la civilisation envoie ici de plus quintessentiél comme parisianisme [...]; les lorettes, étudiants du quartier latin, et bourgeois de Daumier restent immobiles devant le négre qui va vider les pots de chambre[7].

> (The corridor of the first floor was decorated with Gavarni lithographs torn out of *Le Charivari*. When Sheiks from Sinai come to negotiate with Western travellers, desert robes brush against walls on which hang all that is most quintessentially Parisian in civilization [...]; lorettes and students from the Latin Quarter and bourgeois out of Daumier, stare unblinkingly at the negro who empties the chamber pots.)

And although Flaubert was as seduced as any other nineteenth-century writer by the mystery and eroticism of the Orient, he will still remark on the absurdity of the Westerner's obligation to 'faire l'amour par interprète'.[8]

The aim of this essay will be, in exploring nineteenth-century writers' reactions to the East, to suggest that the three interpenetrating and ultimately inseparable processes of *imagining*, *experiencing* and *remembering* — the central themes of this exhibition and fundamental principles of creative activity, whether literary or artistic — find particularly rich and exemplary expression in Orientalist literature. In this way, I hope to show how the work of Orientalist writers, informed, as it often was, as much by irony as by desire, as much by observation as imagination, — clarified, complemented and extended the work of their painter contemporaries.

2. The East Imagined

> L'Orient, c'est [...] la scène primitive du rêve, l'hiéroglyphe majeur de notre inconscient. Et c'est aussi le grand fantasme projectif de la culture occidentale, qui feint d'y retrouver, dans une fascination horrifiée, tout ce qu'elle refoule (Michel Thévoz).[9]

> (The Orient constitutes the primeval theatre of dream, the major hieroglyph of our unconscious. It also represents the great collective fantasm of Western culture which pretends to discover in it, with horrified fascination, all that it has itself repressed.)

Like most phenomena the existence of which is as much a result of imaginative recreation as a matter of fact, the Orient was, for many nineteenth-century western writers, essentially a work of *fiction*. It was an exotic book, a hermeneutic, the decoding of which was attempted using the instruments of literary analysis. For Théophile Gautier, exploring Moorish cities in his *Voyage en Espagne*, the western tourist was primarily a *reader*, a 'grand [...] lecteur [...] d'enseignes, s'il en fut'[10]. The three mysterious and sacramental words *Juego de villar*, for example, whose decoratively interlaced lettering added to the difficulty of their deciphering, held a fascination for the uninitiated reader akin to that of an obscure text (on translation the words are discovered to mean: Billiard Room). Likewise, Gérard de Nerval's life in Cairo is experienced as a *story* which unfolds according to the laws and conventions of the fictional genre: Nerval's experience is coloured by the phenomenon of intertextuality: memories of other writers' adventures or imaginings colour and shape his own just as elements derived from *The Arabian Nights* or plagiarized from contemporary Orientalist texts, motivate both thematic and structural developments in his *Voyage en Orient*. Meanwhile, Victor Hugo, being primarily a *poet*, applied the forms and habits of thought of the *verse-writer* when coming to grips with his imaginary Orient. 'A quoi rime l'Orient?' he enquires in the preface to *Les Orientales* and, in the poems of this collection, will consistently attempt to capture the paradoxes and contrasts of the East, as perceived by western eyes, in terms of formal antithesis and rhyme-based juxtaposition.

The aim of this section will be briefly to introduce the concept of the Imaginary

6. *Voyage en Orient: Egypte* in *Oeuvres* (ed. B. Masson, 2 vols.; Paris 1964), vol. II, p. 558. 'On est irrité par la quantité de noms imbéciles écrits partout' Flaubert adds later in the same work (p. 563).
7. *Ibid.*, p. 560.
8. *Ibid.*, p. 561.
9. *L'Académisme et ses fantasmes* (Paris 1980), p. 74.
10. *Voyage en Espagne* (ed. J.-F. Revel; Paris 1964), p. 135.

East as it was explored in literary terms by looking at two texts — the first part of Nerval's *Voyage en Orient*, called 'Vers l'Orient'[11] and Hugo's *Les Orientales* — both of which explore an Orient that had not yet been experienced at first hand by either author.

The itinerary Nerval adopted in his *Voyage en Orient* was partly imaginary: he never visited the island of Cythera and the passages on Switzerland, South Germany and Austria in 'Vers l'Orient', which form a preamble to the departure for Egypt, derive from earlier and quite separate trips. These extraneous elements form, however, a vital part of Nerval's literary strategy. On the one hand, they bear witness to the complex preparatory and anticipatory experiences of the traveller, so lucidly analyzed by Gautier in his review of Nerval's *Voyage*:

> Le pays ne lui [Nerval] apparaît pas avec une nouveauté absolue; il lui revient comme un souvenir d'existence antérieure, comme un de ces rêves oubliés que ravive la rencontre inattendue de l'objet dans la réalité. Les récits des historiens et des voyageurs, les tableaux, les gravures composent au fond de l'âme une sorte de géographie chimérique que contrarie souvent la véritable, et c'est là un des désenchantements du touriste. Il voit crouler, une à une, devant lui des villes merveilleuses qu'il s'était créées avec la libre et riche architecture de l'imagination. Mais ici, ce n'est pas le cas; il n'y a pas de déception; la fantastique perspective existe et satisfait à toutes les exigences du mirage...[12].

> (The country does not appear to him [Nerval] as a complete novelty; it comes back to him like a memory of a previous existence, like one of those forgotten dreams rekindled by the chance discovery of an object in reality. The accounts of historians and travellers, pictures and engravings, compose in the depths of the mind a kind of chimerical geography which often contradicts reality, and this is one of the great disappointments of the tourist to see crumbling one by one before his very eyes the wonderful cities he had created with the rich and unshackled architecture of the imagination. But this is not the case here; there is no disenchantment; the fantastic perspective really exists and satisfies all the demands of a mirage...)

On the other, they underline the fact that for the inspired Orientalist, the East already informs the more exotic parts of the country or continent from which the writer sets out. Thus from the point of view of Parisian Nerval, the town of Mâcon is already perceived as being half Swiss, Bourg's church as Byzantine and Geneva itself as the beginning of the Orient. The Rhône as it leaves Lake Geneva is as blue as Alexander's Néwa, the lake itself giving a foretaste of the Gulf of Naples. Constance, as its name confirms, is a little Constantinople, Munich a German Florence with Greek overtones, and, finally, Austria is perceived as the China of Europe, and a vast synthesis of Eastern and Western racial and cultural types[13].

The notion of synthesis was central both to Nerval's concept of the Orient and to his understanding of the function of literature. The attraction of Cairo, Beirut and Constantinople was that, like their European counterparts, Vienna, Constance and Geneva, they unified a plenitude of contrasts and differences inherent in the national or continental hinterlands surrounding them. Literature was conceived by Nerval to operate in a similar way to the great Oriental city: its aim was an ideal synthesis of the multiple and heterogeneous elements which constitute a given culture, one uniting personal and subjective experience with that recorded by other writers, named or anonymous, from the point of view of history, religion, myth or fantasy. 'Je te parle ici un peu déjà par mon expérience et beaucoup par celles des autres' Nerval candidly admits[14], underlining the fact that, for him, plagiarism was not a moral issue. As a traveller, Nerval also even finds out from others *after the event* what he had missed: this phenomenon, what one might call the paradox of retrospective anticipation, colours much nineteenth century Orientalist writing and is, as we shall see, evident in Gautier and Kinglake as well as in Nerval. Because of this, no synthesis — whether actual (that is, place related) or literary — is ever definitive: cultures, like subjectivities, are inherently mobile, constantly tending towards transcendence of themselves. As Nerval says:

11. pp. 55-146 in vol. I of Michel Jeanneret's edition of Nerval's *Voyage en Orient* (2 vols., Paris 1980).
12. 'A propos du Voyage en Orient de Nerval', *La Revue Nationale* (25 December 1860), cited in *L'Orient* (2 vols., Paris 1877), vol. I, pp. 180-81.
13. Nerval's 'géographie chimérique' has been well investigated by Jean-Pierre Richard in the chapter 'Géographie magique de Nerval' in *Poésie et profondeur* (Paris 1955), pp. 15-89.
14. *Voyage en Orient*, vol. I, p. 92.

En Afrique, on rêve l'Inde comme en Europe on rêve l'Afrique; l'idéal rayonne toujours au-delà de notre horizon actuel.[15]

(In Africa we dream of India as in Europe we dream of Africa; the ideal always shines beyond our present horizon.)

The moral of this for Orientalist literature — as also for Orientalist painting — becomes clear: the aim should not be the impossible one of complete documentation or of exhaustive description but the creation of a suggestive synthesis, one in which the manner of the telling or the style of presentation become as significant — and evident — a part of the experience as the object itself. Authentic Orientalist art — whether literature or painting — is thus not that which tries to create an illusion of objective reality (like that of Gérôme's paintings, rightly taken to task by Linda Nochlin) but that which invents a *suggestive equivalent* in which the medium and forms used by the writer or artist become part of the truth of the experience communicated.

This is particularly true of poetry and in no case more so than that of Hugo who, as we saw, in *Les Orientales* set out, literally, to see what *rhymed* with the Orient. Rhymes, like puns, are often an indication of irrational or unconscious activity, the tip of the iceberg of fantasm. It is thus no accident that in attempting to conjure up an imaginary Orient, Hugo should use rhyme as his point of departure and as the structural principle of his verse. We find therefore in his erotic reveries of the Orient, which centre round the Western fantasy archetypes of the abducted female, the harem and violent death, that rhyme personifies and re-enacts the events of the fantasy drama. In his 'Chanson de pirates', for example, a rhythmic sea-shanty recounting the abduction of a nun by Turkish pirates, the masculine rhymes (based on the image of the rowers or *rameurs*, repeated as a refrain at the end of each stanza) *capture* and *embrace* the feminine rhymes, the latter relating directly or metonymically to the image of the abducted woman. Thus the Oriental 'fils de Satan' and 'capitan' kidnap the prioress, take her to 'Catane' in their 'tartane' where from Christian she becomes 'mahométane' and ultimately 'sultane'. The reader of the poem is as easily seduced by these rhyme transformations as the nun by the sailors.

In 'La Captive', a kind of sequel to 'Chanson de pirates', Hugo exploits the potential of rhyme with similar skill, in this case to express the gradual seduction of the captive Westerner by the charms of Oriental landscape and custom. Hugo's strategy here is to evoke the wearing down of the captive woman's resistance to her new environment, as before, by playing off masculine against feminine rhymes, in this case not only by allowing the feminine rhymes (which express the beauties of Eastern life) to outnumber the masculine ones but also by incorporating masculine echoes of the feminine rhymes in the main or internal rhyme scheme. Thus in the following three stanzas (the 3rd, 7th and 8th in the poem), the dominant motifs of greeness, whiteness and roundness are carried not only by the triply repeated feminine rhymes but also by the masculine adjectives expressing these colours or shapes:

> Pourtant j'aime une rive
> Où jamais des hivers
> Le souffle froid n'arrive
> Par les vitraux ouverts.
> L'été, la pluie est chaude;
> L'insecte vert qui rôde,
> Luit, vivante émeraude,
> Sous les brins d'herbe verts.

> J'aime de ces contrées
> Les doux parfums brûlants;
> Sur les vitres dorées
> Les feuillages tremblants;
> L'eau que la source épanche
> Sous le palmier qui penche,
> Et la cigogne blanche
> Sur les minarets blancs.

15. *Ibid.*, vol. I, p. 262.

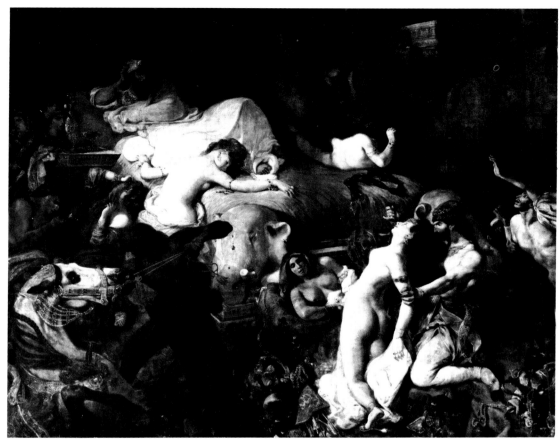

Fig. 13 Eugène Delacroix, *La Mort de Sardanapale*, 1827, oil on canvas (Musée du Louvre, Paris).

> J'aime en un lit de mousses
> Dire un air espagnol,
> Quand mes compagnes douces,
> Du pied rasant le sol,
> Légion vagabonde
> Où le sourire abonde,
> Font tournoyer leur ronde
> Sous un rond parasol.

The visual or painterly potential of Hugo's use of rhyme here is readily apparent. Like the Romantic colourist in painting, Hugo established the aesthetic unity (or 'beauty') of his poem by repeating or harmonizing similar or complementary words or images, building up in this way a unified impression which was as important to the significance of the poem as its content or meaning. His procedure in some poems is indeed very like that of Delacroix. In 'La Sultane favorite', for example, the violent clash of eroticism and death is expressed as harmoniously and aesthetically as the lavish slaughter depicted in *La Mort de Sardanapale* (Fig. 13). Just as Delacroix shows the icy blade of a dagger penetrating the gorgeous neck of a naked female beauty in the foreground of the picture, so in the first stanza of his poem Hugo rhymes axe-stroke with beautiful Jewess (*belle juive/coup de hache suive*), and, in subsequent verses, rose bush with steel (*acier/rosier*), ointment with dagger (*nard/poignard*), the final juxtaposition being heightened with the observation, evident also in Delacroix's painting of instruments of Death, that the phallic, masculine rapier is decorated with the most feminine of jewels: the pearl:

> Ne songe plus qu'aux frais platanes,
> Au bain mêlé d'ambre et de nard,
> Au golfe où glissent les tartanes...
> Il faut au sultan des sultanes;
> Il faut des perles au poignard!

3. The East Experienced

Comment ferez-vous pour parler de l'Espagne quand vous y serez allé? (Heine to Gautier) [16]

(How will you manage to talk about Spain when you have been there?)

The point behind the wittily malicious question posed by Heine in this section's epigraph is easy to see: if Hugo could reconstruct an Eastern world as dazzling as that of *Les Orientales* without so much as setting foot in Asia Minor or North Africa, what was the point of suffering the dangers and discomforts of weeks of travel over sea and desert to see the real thing if there was no guarantee of the authentic experience being more vivid — and more susceptible to vivid expression — than the imaginary? The 'désenchantements du touriste [qui] voit crouler une à une, devant lui les villes merveilleuses qu'il s'était créées avec la libre et riche architecture de l'imagination', as Gautier pointed out, was also a risk the Orientalist, like the modern tourist, was obliged to run. But risk was — and is — of course part of the very essence and point of travel: on the one hand the stimulus and excitement of adventure, on the other the desire to measure oneself and the power of fantasy when confronted with reality. And such experience did in fact succeed in stimulating some of the finest passages of Orientalist writing. The following examples are from two of the greatest Orientalist travellers of the nineteenth century, Burton and Chateaubriand:

> We journeyed on till near sunset through the wilderness [of the Sinai Desert] without ennui. It is strange how the mind can be amused by scenery that presents so few objects to occupy it. But in such a country every slight modification of form and colour rivets observation: the senses are sharpened, and the perceptive faculties, prone to sleep over a confused mass of natural objects, act vigorously when excited by the capability of embracing every detail. Moreover, Desert views are eminently suggestive; they appeal to the Future, not to the Past: they arouse because they are by no means memorial. To the solitary wayfarer there is an interest in the Wilderness unknown to the Cape seas and the Alpine glaciers, and even to the rolling Prairie, — the effect of continued excitement on the mind, stimulating its powers to their pitch. Above, through a sky terrible in its stainless beauty, and the splendour of a pitiless blinding glare, the Samun carresses you like a lion with flaming breath.
>
> Around lie drifted sand-heaps, upon which each puff of wind leaves its trace in solid waves, flayed rocks, the very skeletons of mountains, and hard unbroken plains, over which he who rides is spurred by the idea that the bursting of a waterskin, or the pricking of a camel's hoof, would be a certain death of torture, — a haggard land infested with wild beasts and wilder men — a region whose very fountains murmur the warning words "Drink and away!" What can be more exciting? What more sublime? Man's heart bounds in his breast at the thought of measuring his puny force with Nature's might, and of emerging triumphant from the trial. This explains the Arab's proverb, "Voyaging is victory". In the Desert, even more than upon the ocean, there is present death: hardship is there, and piracies, and shipwreck, solitary, not in crowds, where, as the Persians say, "Death is a festival"; — and this sense of danger, never absent, invests the scene of travel with an interest not its own.[17]

Burton's vivid evocation of the tension and excitement of desert travel is parallelled by that of Chateaubriand in the following passage in which the same dissipation of ennui, the same uplifting and concentrating of the mind, the same possibility of human grandeur are reaffirmed. Whereas, however, the Arabist Burton views the Sinai Desert as an essentially abstract landscape, a blank page on which the mind is at liberty to inscribe its own future, for the Christian Chateaubriand, the desert of Judea is read as a text heavily imbued with a Biblical past:

> Quand on voyage dans la Judée, d'abord un grand ennui saisit le coeur; mais lorsque, passant de solitude en solitude, l'espace s'étend sans borne devant vous, peu à peu l'ennui se dissipe, on éprouve une terreur secrète, qui, loin d'abaisser

16. *Voyage en Espagne*, p. 41.
17. *Personal Narrative of a Pilgrimage to Al-Madinah and Meccah*, vol. I, pp. 148-49.

l'âme, donne du courage, et élève le génie. Des aspects extraordinaires décèlent de toutes parts une terre travaillée par des miracles: le soleil brûlant, l'aigle impétueux, le figuier stérile, toute la poésie, tous les tableaux de l'Ecriture sont là. Chaque nom renferme un mystère: chaque grotte déclare l'avenir; chaque sommet retentit des accents d'un prophète. Dieu même a parlé sur ces bords: les torrents déssechés, les rochers fendus, les tombeaux entrouverts attestent le prodige; le désert paraît encore muet de terreur, et l'on dirait qu'il n'a osé rompre le silence depuis qu'il a entendu la voix de l'Eternel.[18]

(When you travel in Judea, a great boredom seizes your soul; but when, moving from solitude to solitude, space extends limitlessly before you, little by little your boredom disappears and you feel a secret terror which, far from depressing your spirits, raises them up and gives courage. Extraordinary features on every side confirm that this is a landscape that has witnessed miracles: the burning sun, the impetuous eagle, the sterile figtree, all the poetry, all the scenes of the Bible are here. Each name contains a mystery; each grotto declares the future; each summit echoes with the voice of a prophet. God himself has spoken on these banks: the dried up riverbeds, the split rocks, the half-opened tombs attest prodigious acts; the desert seems mute with terror still, and you would say that it has not dared to break the silence since it heard the sound of the Eternal's voice.)

But Chateaubriand's *Itinéraire* was also vivid in its recording of the frustrations and disappointments of Oriental travel: the difficulties of interpretation, the shifting of geographical landmarks, the changing of place names. Chateaubriand's eventual discovery of the ruins of Sparta during the Greek part of his trip becomes a saga in itself: first, confusion about the ancient city's location causes him to look for Sparta in the modern town of Misitra:

Qu'on juge de mon embarras, lorsque, du haut du château de Misitra, je m'obstinais à vouloir reconnaître la cité de Lycurgue dans une ville absolument moderne, dont l'architecture ne m'offrait qu'un mélange confus du genre oriental, et du style gothique, grec et italien: pas une pauvre petite ruine antique pour se consoler au milieu de tout cela.[19]

(Imagine my confusion when, from high up on the castle at Misitra, I persisted in seeing Lycurgus's city in an absolutely modern town whose architecture offered only a confused mixture of Oriental, Gothic, Greek and Italian styles: not one little ancient ruin to console myself with in all that.)

Second, a comic misunderstanding with his guides and cicerones, none of whom spoke the same language:

Mon cicerone savait à peine quelques mots d'italien et d'anglais. Pour me faire mieux entendre de lui, j'essayais de méchantes phrases de grec moderne; je barbouillais au crayon quelques mots de grec ancien; je parlais italien et anglais, je mêlais du français à tout cela. Joseph voulait nous mettre d'accord, et il ne faisait qu'accroître la confusion; le janissaire et le guide (espèce de Juif demi-nègre) donnaient leur avis en turc, et augmentait le mal. Nous parlions tous à la fois, nous criions, nous gesticulions; avec nos habits différents, nos langages et nos visages divers, nous avions l'air d'une assemblée de démons perchés au coucher du soleil sur la pointe de ces ruines.[20]

(My guide barely knew a few words of Italian and English. To make myself better understood by him, I tried a few clumsy phrases in modern Greek; I scrawled in pencil a few words of ancient Greek; I spoke Italian and English mixing in some French. Joseph wanted to help us understand each other but only added to the mix-up; the janissary and the guide (a sort of half-negro Jew) gave their view in Turkish and increased the confusion. We all spoke at the same time, shouting and gesticulating; with our different clothes, languages and facial features, we must have seemed like a gang of demons perching in the sunset above the ruins.)

18. *Itinéraire de Paris à Jérusalem* (ed. J. Mourot; Paris 1968), pp. 254-55.
19. *Ibid.*, pp. 93-94.
20. *Ibid.*, p. 94.

Eventually, the original site of Sparta is found but it is discovered to be a desolate spectacle:

> Comme j'arrivais à son sommet, le soleil se levait derrière les monts Ménélaïons. Quel beau spectacle! Mais qu'il était triste! L'Eurotas coulant solitaire sous les débris du pont Babyx; des ruines de toutes parts, et pas un homme parmi ces ruines! Je restai immobile, dans une espèce de stupeur, à contempler cette scène. Un mélange d'admiration et de douleur arrêtait mes pas et ma pensée; le silence était profond autour de moi: je voulus du moins faire parler l'écho dans des lieux où la voix humaine ne faisait plus entendre, et je criai de toute ma force: Léonidas! Aucune ruine ne répéta ce grand nom, et Sparte même sembla l'avoir oublié.[21]

> (When I arrived at the summit, the sun was rising behind the Menelaian Mountains. What a fine spectacle! but how sad! The Eurotas ran its solitary way beneath the debris of Babyx Bridge; ruins on every side, and not one man amongst them! I stood still, in a kind of stupor, contemplating the scene. A mixture of admiration and sadness stilled my step and my thought; everything around me was silent; I wanted at least to make echo speak in this place where no human voice was anymore to be heard, so I shouted Leonidas! at the top of my voice. Not one ruin reechoed with the sound of this great name and Sparta itself seemed to have forgotten it.)

Nerval's dream of the Orient as an ideal synthesis is thus experienced by Chateaubriand as the nightmare of a cultural Babel, an incomprehensible and heterogeneous mixture of languages, races and architectural styles in which the true and authentic lie abandoned and unidentified as ruins. No wonder Chateaubriand a few days later dreams of founding a university on the ruins of Athens which would restore the monuments of ancient Greece, teach ancient and modern languages and generally restore to culture the unity and purpose it so patently lacked.

Gautier's expectations in Spain were less often disappointed than those of Chateaubriand in Greece. This was due not only to the fact that he was exploring a country less affected by the ravages of history but also because his concerns were primarily aesthetic rather than religious, historical or archeological. Like Nerval in Eastern Europe, Gautier in Spain had already programmed himself to discover the Orient, painting in particular having indelibly coloured his expectations in relation to landscape, architecture and costume. Thus already in Castille

> Un village, un ancien couvent bâti en forteresse, variaient ces sites d'une simplicité orientale, qui rappelaient les lointains du *Joseph vendu par ses frères*, de Decamps.
> Dueñas, situé sur une colline, a l'air d'un cimetière turc; les caves, creusées dans le roc vif, reçoivent l'air par de petites tourelles évasées en turban, qui ont un faux air de minaret très singulier. Une église de tournure mauresque complète l'illusion.[22]

> (A village and a fortified convent lent an Oriental simplicity to the site, which reminded me of the background in Decamps's *Joseph sold by his brothers*.
> Dueñas, situated on a hill, looks like a Turkish cemetery; its cellars, carved out of solid rock, are ventilated by little turban-like towers which have a strange air of false minarets. A Moorish-looking church completes the illusion.)

In Venta de Trigueros, Gautier's carriage is drawn by a *pink* horse, which, Gautier says, 'justifiait pleinement le cheval tant critique du *Triomphe de Trajan* d'Eugéne Delacroix'. In proceeding to remark that

> Le génie a toujours raison; ce qu'il invente existe, et la nature l'imite presque dans ses plus excentriques fantaisies[23]

> (Genius is always right; what it invents exists and Nature will imitate it even in its most excentric fantasies.)

Gautier is, of course, reasserting the Romantic belief in the power of the imagination to half create the reality it perceives: by the same token, an exotic Orient, like

21. *Ibid.*, p. 99.
22. *Voyage en Espagne*, pp. 88-89.
23. *Ibid.*, p. 89.

Delacroix's pink horse, *must* exist because it is so deeply desired by Western consciousness.

But although Gautier was particularly atuned to experiencing Spain in aesthetic terms, he was also alert to the unexpected or disconcerting and acute in his analysis of its impact on the voyager. Thus the thrill of the dangers of travel is as effectively captured by Gautier as by Burton and Chateaubriand:

> cette crainte ajoute beaucoup au plaisir, elle vous tient en éveil et vous préserve de l'ennui: vous faites une action héroïque, vous déployez une valeur surhumaine; l'air inquiet et effrayé de ceux qui restent vous rehausse à vos propres yeux. Une course en diligence, la chose la plus vulgaire qui soit au monde, devient une aventure, une expédition; vous partez, il est vrai, mais vous n'êtes pas sûr d'arriver ou de revenir. C'est quelque chose dans une civilisation si avancée que celle des temps modernes, en cette prosaïque et malencontreuse annee 1840.[24]

> (this fear adds a lot to pleasure, it keeps you on your mettle, fends off boredom: your action is a heroic one, involving superhuman effort; the disturbed or frightened look of those who remain behind, raises you in your own estimation. A coach-ride, the most banal of actions, becomes an adventure, an expedition; you are setting out, it is true, but your return is not guaranteed. That is already something in a civilization as advanced as that of modern times, in this prosaic and unfortunate year of 1840.)

And Gautier's account of his visit to Toledo, one of the climaxes of his Spanish tour, constitutes a remarkable analysis of the almost existential crisis experienced by the western traveller on arriving in the exotic city of his dreams:

> Accoudé à l'embrasure d'un créneau et regardant à vol d'hirondelle cette ville où je ne connaissais personne, où mon nom était parfaitement inconnu, j'étais tombé dans une méditation profonde. Devant tous ces objets, toutes ces formes, que je voyais et que je ne devais probablement plus revoir, il me prenait des doutes sur ma propre identité, je me sentais si absent de moi-même, transporté si loin de ma sphère, que tout cela me paraissait une hallucination, un rêve étrange dont j'allais me réveiller en sursaut au son aigre et chevrotant de quelque musique de vaudeville sur le rebord d'une loge de théâtre. Par un de ces sauts d'idées si fréquents dans la rêverie, je pensai à ce que pouvaient faire mes amis à cette heure; je me demandai s'ils s'apercevaient de mon absence, et si, par hasard, en ce moment même où j'étais penché sur ce créneau dans l'Alcazar de Tolède, mon nom voltigeait à Paris sur quelque bouche aimée et fidèle. Apparemment la réponse intérieure ne fut pas affirmative; car, malgré la magnificence du spectacle, je me sentis l'àme envahie par une tristesse incommensurable, et pourtant j'accomplissais le rêve de toute ma vie, je touchais du doigt un de mes désirs le plus ardemment caressés...[25]

> (Leaning on the battlements with a swallow's-eye view of the town where I knew nobody and where my name was perfectly unknown, I fell into deep meditation. Confronted with all these objects and forms which I saw but which I would probably never see again, I began to have doubts about my own identity; I felt so distant from myself, transported so far from my usual sphere, that it all seemed like an hallucination, a strange dream from which I would suddenly awake at the sound of some shrill and quavering vaudeville tune in a box at the theatre. In one of those leaps of the imagination so frequent in reverie, I thought of what my friends must be doing at this time; I wondered if they noticed my absence and whether, by any chance, at the very moment when I was leaning over the parapet of the Alcazar in Toledo, my name was being murmured in Paris by any beloved or faithful mouth. Apparently the reply from within me was negative; for, in spite of the magnificence of the spectacle before me, I felt overcome with an immeasurable sadness; and yet I had fulfilled a lifetime's dream, I had touched with my finger one of my most cherished desires...)

24. *Ibid.*, pp. 170-71.
25. *Ibid.*, pp. 178-79.

But let us conclude this section by citing Eugène Fromentin who, uniting the painter's infinitely subtle analysis of light and colour and the writer's acute observation of psychological or symbolic detail, was able to express the complicated sensations of the Orientalist, confronting Africa or Arabia for the first time, with exemplary freshness and vitality. In the following passage from *Un Eté dans le Sahara*, he not only creates a vivid picture of the North African landscape as it unfolds before him but also succeeds in moving into and inhabiting it, experiencing its moral and symbolic as well as its aesthetic dimensions:

> Les palmiers, les premiers que je voyais; ce petit village couleur d'or, enfoui dans des feuillages verts déjà chargés des fleurs blanches du printemps; une jeune fille qui venait à nous, en compagnie d'un vieillard, avec le splendide costume rouge et les riches colliers du désert, portant une amphore de grès sur sa hanche nue; cette première fille à la peau blonde, belle et forte, d'une jeunesse précoce, encore enfant et déjà femme; ce vieillard abattu, mais non défiguré, par une vieillesse hâtive; tout le désert m'apparaissant ainsi sous toutes ses formes, dans toutes ses beautés et dans tous ses emblèmes, c'était, pour la première, une étonnante vision. Ce qu'il y avait surtout d'incomparable, c'était le ciel: le soleil allait se coucher, et dorait, empourprait, émaillait de feu une multitude de petits nuages détachés du grand rideau noir étendu sur nos têtes, et rangés comme une frange d'écume au bord d'une mer troublée. Au delà commençait l'azur, et alors, à des profondeurs qui n'avaient pas de limites, à travers des limpidités inconnues, on apercevait le pays céleste du bleu. Des brises chaudes montaient, avec je ne sais quelles odeurs confuses et quelle musique aérienne, du fond de ce village en fleur; les dattiers, agités doucement, ondoyaient avec des rayons d'or dans leurs palmes, et l'on entendait courir, sous la forêt paisible, des bruits d'eau mêlés aux froissements légers du feuillage, à des chants d'oiseaux, à des sons de flûte. En même temps un *Muezzin*, qu'on ne voyait pas, se mit à chanter la prière du soir, la répétant quatre fois aux quatre points de l'horizon, et sur un mode si passionné, avec de tels accents, que tout semblat se taire pour l'écouter.[26]

> (Palm trees, the first I had seen; the little village, all golden, nestling in the leafy greenery already blossoming with white Spring flowers; a young girl coming towards us in the company of an old man, wearing the splendid red desert costume and necklaces, carrying a stoneware waterjug on her bare hip; the first of these fine, bronzed young women whose youth had come early and who, though still a child, was already a woman; and the old man, worn but not disfigured by premature old age; the whole desert thus appeared to me in all its forms, in all its beauties, in all its emblems — for a first vision, it was an astonishing one. What was above all incomparable about it was the sky: the sun was setting and gilding, reddening and enamelling with fire a multitude of little clouds which had detached themselves from the great black curtain spread above our heads and which were gathering like the foaming fringe at the edge of a stormy sea. Beyond, all was azure and from limitless depths and across distances of matchless limpidity, the celestial blue country appeared. Warm breezes were blowing, wafting strange fragrances and aerial music from the depths of the blossoming village; the date palms swayed softly, with golden rays flickering in their fronds and you could hear in the peaceful wood the sound of water mingling with the rustling of the leaves, the twittering of the birds and the sound of a flute. At the same time, an invisible *Muezzin* began to chant the evening prayer, repeating it at each of the four corners of the horizon, and with such a passionate tone of voice that it seemed that all became silent to hear it.)

Here the golden light of the setting sun penetrates every recess of the landscape — the village, the skin of the girl with her water jar, the clouds, the swaying fronds of the date palms — heightening and unifying the colours — green, white, red, crimson, black, azure — which enliven the scene. The evocation of sounds is equally subtle, the murmur of forest and water mingling with birdsong and the notes of the flute while the piercing accents of the *Muezzin* fill the sky. Fromentin thus succeeds in creating a *simultaneity* of vision and sound moving in an ascending order of quality

26. *Un Eté dans le Sahara* (ed. M. Revon; Paris 1938), pp. 7-8.

from elemental, vegetable, animal, human (and artistic: flute-playing) to religious (the *Muezzin's* prayer). This simultaneity is paralleled by the *synchronism* of the imagery, such as that of the young girl 'd'une jeunesse précoce, encore enfant et déjà femme' juxtaposed with the old man 'abattu, mais non défiguré, par une vieillesse rapide'; the simultaneous awareness of the four points of the horizon, echoing with the *Muezzin's* prayer; and, in the passage directly following the one cited above, the simultaneity of weathers and seasons experienced:

> Derrière, descendaient lugubrement les traînées grises d'un vaste déluge; puis, tout à fait au fond, une montagne éloignée montrait sa tête couverte de légers frimas. Il pleuvait à torrents dans la vallée du Metlili, et quinze lieues plus loin il neigeait. L'éternel printemps souriait sur nos têtes.[27]

> (Behind were the dreary grey diagonal lines of heavy rainfall; then far away, a distant mountain raised its frosty head. Torrential rain was falling in the valley of the Metlili, and fifteen miles beyond it was snowing. An eternal Spring smiled down on our heads.)

Fromentin is thus able, in his North African travels, to glimpse that ideal synthesis, that symbolic unity which Nerval had seen the Orient as essentially embodying, 'une étonnante vision', as Fromentin says, in which the object simultaneously appears 'sous toutes ses formes, dans toutes ses beautés et dans tous ses emblèmes'.

4. The East Remembered

> Tout voyage se passe après, en esprit, il vaut, par recherche ou comparaison, quand on est de retour. (Mallarmé)

> (Every voyage is lived through again afterwards in the mind and is assessed through research or comparison after the return.)

It was in the writing up of the voyage that the reality of the Orient ultimately became fixed: after the kaleidoscope of experience, with its excitements and misapprehensions, its climaxes and disappointments, the writer had, retrospectively, to make sense of the varied and heterogeneous material he had collected on his expeditions. It was the time for unpacking souvenirs, for sorting through the paraphernalia of travel — maps, documents, tickets, mementos, for re-reading the source books, for comparing notes with other Orientalist travellers. In a sense, every writer faces with hope and dread the fellow adventurer who, as Nerval says, having made a similar trip, exclaims: 'Mais vous avez passé trop vite! mais vous n'avez rien vu.'[28] The necessity of lengthy preparation or retrospective research is commonly accepted by the travel writer but how is it to be reconciled with the spontaneity and open-mindedness which so much enliven travel, allowing the unexpected to happen or at least creating, in the writing process, the illusion of surprise and discovery? The point is vividly made by Chateaubriand early in his travels when on leaving Greece for Turkey he crosses an insignificant little stream which he would not have given a second glance had someone not shouted that it was the Granicus, a name sufficient to unfold the glorious heroic exploits of Alexander the Great:

> Quelle est donc la magie de la gloire? Un voyageur va traverser un fleuve qui n'a rien de remarquable: on lui dit que ce fleuve se nomme Sousonghirli; il passe et continue sa route; mais si quelqu'un lui crie: C'est le Granique! il recule, ouvre des yeux étonnés, demeure les regards attachés sur le cours de l'eau, comme si cette eau avait un pouvoir magique, ou comme si quelque voix extraordinaire se faisait entendre sur la rive. Et c'est un seul homme qui immortalise ainsi un s'élève un empire encore plus grand; l'océan Indien entend la chute du trône qui s'écroule près des mers de la Propontide; le Gange voit accourir le Léopard aux quatre ailes, qui triomphe au bord du Granique; Babylone que le roi bâtit dans l'éclat de sa puissasnce, ouvre ses portes pour recevoir un nouveau maître; Tyr, reine des vaisseaux, s'abaisse, et sa rivale sort des sables d'Alexandrie.[29]

> (Such is the magic of Fame! A traveller, about to cross an unremarkable river, is told that it is called the Sousonghirli. He crosses and continues on his way.

27. *Ibid.*, p. 8.
28. *Voyage en Orient*, p. 72.
29. *Itinéraire de Paris à Jérusalem*, p. 200.

15

But if someone shouts: it's the Granicus! — he steps back, opens his eyes wide with astonishment, fixing his attention on the water's course as though it had some magic power or as if some supernatural voice were calling from the further bank. And it is one man alone who makes this desert stream immortal. Here a vast empire falls; here an even greater empire rises; the Indian Ocean reechoes with the collapse of a throne which tumbles by the Propontic Seas; the Ganges sees the coming of the four-winged leopard which triumphs on the Granicus's banks; Babylon, built by a king at the height of his powers, opens its doors to welcome its new master; Tyr, queen of vessels, falls and her rival emerges from the sands of Alexandria.)

The idealizing tendencies of anticipation and memory are also vividly investigated by Kinglake in *Eothen*, again in the context of an apparently insignificant stream which later turns out to be none other than the divine Scamander:

> Away from our people and our horses, Methley and I went loitering along, by the willowy banks of a stream that crept in quietness through the low, even plain...
> Softly and sadly the poor, dumb, patient stream went winding, and winding along, through its shifting pathway; in some places its waters were parted, and then again, lower down, they would meet once more. I could see that the stream from year to year was finding itself new channels, and flowed no longer in its ancient track, but I knew that the springs which fed it were high on Ida — the springs of Simois and Scamander!
> It was coldly, and thanklessly, and with vacant unsatisified eyes that I watched the slow coming, and the gliding away of the waters. I tell myself now, as a profane fact, that I did indeed stand by that river (Methley gathered some seeds from the bushes that grew there), but, since that I am away from his banks, 'divine Scamander' has recovered the proper mystery belonging to him as an unseen deity; a kind of indistinctness, like that which belongs to far antiquity, has spread itself over my memory of the winding stream that I saw with these very eyes. One's mind regains in absence that domination over earthly things which has been shaken by the rude contact; you force yourself hardily into the material presence of a mountain or a river, whose name belongs to poetry and ancient religion, rather than to the external world; your feelings, wound up and kept ready for some half-expected rapture, are chilled and borne down for the time under all this load of real earth and water, but, let these once pass out of sight, and then again the old fanciful notions are restored, and the mere realities which you have just been looking at are thrown back so far into distance, that the very event of your intrusion upon such scenes begins to look dim and uncertain as though it belonged to mythology.[30]

Here the actual experience, as Nerval and Gautier often feared, and Heine maliciously predicted, was a banal and anticlimactic event: the meandering stream could as well have been seen in the Thames valley as in exotic Asia Minor. But the power to recuperate without falsifying the significance of apparently banal objects is literature's greatest strength: it is able to present a series of relative truths — subjectively experienced, objectively observed, mythologically or historically transformed — and then to synthesize them, creating a composite truth in which the demands of science and imagination are satisfied. It is one of the peculiar charms of Chateaubriand's *Itinéraire* that he is prepared to reveal so much of these complicated processes at work, both during the event and after. It is therefore appropriate to close this short essay with a last quotation from his great pioneering Orientalist text in which, exploring the phenomenon of memory in the context of the souvenir, he concludes by citing from the *Arabian Nights*:

> Je pris, en descendant de la citadelle, un morceau de marbre du Parthénon; j'avais aussi recueilli un fragment de la pierre du tombeau d'Agamemnon; et depuis j'ai toujours dérobé quelque chose aux monuments sur lesquels j'ai passé. Ce ne sont pas d'aussi beau, souvenirs de mes voyages que ceux qu'ont emportés M. de Choiseul et Lord Elgin; mais ils me suffisent. Je conserve

30. *Eothen* (Oxford 1982), pp. 45-46.

aussi soigneusement de petites marques d'amitié que j'ai reçues de mes hôtes, entre autres un étui d'os que me donna le père Munoz à Jaffa. Quand je revois ces bagatelles, je me retrace sur-le-champ mes courses et mes aventures; je me dis: ''J'étais la, telle chose m'advint.'' Ulysse retourna chez lui avec de grands coffres pleins des riches dons que lui avaient faits les Phéaciens; je suis rentré dans mes foyers avec une douzaine de pierres de Sparte, d'Athènes, d'Argos, de Corinthe; trois ou quatre petites têtes en terre cuite que je tiens de M. Fauvel, des chapelets, une bouteille d'eau du Jourdain, une autre de la mer Morte, quelques roseaux du Nil, un marbre de Carthage et un platre moulé de l'Alhambra. J'ai dépensé cinquante mille francs sur ma route, et laissé en présent mon linge et mes armes. Pour peu que mon voyage se fût prolongé, je serais revenu à pied, avec un bâton blanc. Malheureusement, je n'aurais pas trouvé en arrivant un bon frére qui m'eût dit, comme le vieillard des Mille et Une Nuits: '''Mon frère, voilà mille séquins, achetez des chameaux et ne voyagez plus.''[31]

(On descending from the citadel, I picked up a bit of marble from the Parthenon; I had already collected a fragment of stone from Agamemnon's tomb; and since then I have always taken something from the monuments I have visited. These souvenirs are not as fine as those collected by M. de Choiseul or Lord Elgin; but they are enough for me. I also carefully preserve the small marks of friendship received from my hosts, including a small box carved in bone given to me by Father Munoz in Jaffa. When I look at these trifles, I immediately relive my travels and adventures; I say to myself: I was there, this happened to me. Ulysses returned with his coffers full of booty presented by the Pheacians; I came home with a dozen rocks from Sparta, Athens, Argos and Corinth; three or four clay heads from M. Favel, rosaries, bottles of water from the Jordan or the Dead Sea, reeds from the Nile, a marble from Carthage and a plaster moulding from the Alhambra. I spent 50,000 francs on my way and left my linen and arms as presents. If my voyage had been longer, I would have returned on foot with a white stick. Unfortunately, I would not have found on coming home a good brother who would have said to me, like the old man in *The Arabian Nights*: "Brother, here are a thousand sequins, buy some camels and travel no more.")

DAVID SCOTT

31. *Itinéraire de Paris à Jérusalem*, p. 147.

Mapping the Mind
The Quest for Eastern Metaphors and Meaning

JAMES THOMPSON

C'est l'Orient toujours
Gustave Flaubert, 25 January, 1841[1]

We are talking about a major nineteenth-century European preoccupation. A fair few good painters — as, it is hoped, this exhibition demonstrates — and a large number of the best writers occupied at least part of their time with the East, via journeys of the imagination, actual visits or recollected memories. The richness, variety, and complexity (or, equally, the shallowness, superficiality, and prejudices), which can characterize all three forms of travel, reflect and even affect comparable qualities in the individual. Enjoying and exploring the 'otherness' of the East was and is an act of self-definition; in the words of a recent writer, the exotic is less an *elsewhere* than a *within*.[2] Like the earlier pursuit of the Holy Grail, an evocative and elusive object whose shape defined a void, the travellers' Eastern experience was in part crafted into an ornate vessel wherein they could concoct an image of themselves.

Which is not to say that they observed, appreciated or understood nothing, only that such acts can never be neutral, and involved the cultural and personal notions the travellers took along. Before the nineteenth century, most artists and writers had made the trip in their mind. The Orient of paintings and literature was pre-eminently 'imagined'. One reason for this was practical: before the colonial conquests and steamships and railways of the nineteenth century, travel was much more difficult. But on another level it is almost as if the West did not yet *want* an 'accurate' East. The artistic skills had been there for some time; in the late fifteenth century Gentile Bellini saw and depicted the Turkish court admirably with the sophistication of late *quattrocento* perspective and early Venetian oil colours. In the seventeenth century as impressive expedition of artists and naturalists, working for Count Johan Maurits of Nassau-Siegen, demonstrated that in the greatest age of pictorial naturalism, even the totally new wonders of Brazil were not beyond the sophisticated skills of the painter.[3] And in the eighteenth century, Jean-Etienne Liotard portrayed the intricate glories of Eastern dress (albeit often filled by an actual or armchair Western traveller) with a precision that Gérôme himself might have envied. So there is little sense in suggesting that the flood of nineteenth century artists were the first ones capable of correctly portraying the East; rather it seems that such a depiction had previously held little interest for anyone.

Among nineteenth-century writers there was a fairly clear and consistent sense of the shift from an 'imagined' East to an 'experienced' one. Gerard de Nerval, whose time in Turkey and Egypt resulted in a key Orientalist text, lamented in a letter to his friend Théophile Gautier the unhappy effect that an actual visit to the East upon the enchanted image he had held before going:

> I have already lost Kingdom after Kingdom, province after province, the more beautiful half of the universe, and soon I will know of no place in which I can find a refuge for my dreams; but it is Egypt that I most regret having driven out of my imagination, now I have sadly placed it in my memory.[4]

Again writing to Gautier he had assessed what he had brought back from the Orient and found that there was nothing not originally contained in his imaginative conception prior to his journey:

> What is left to me? An image as confused as that of a dream: the best part of what one finds there, I already knew in my heart.[5]

At about the same time, the Englishman Thackeray discussed the way in which extended contact with the Orient diminished the conception — or preconception — of the artist, coming down, as usual somewhat facetiously, in favour of the imagined Orient:

1. Gustave Flaubert, *Souvenirs, notes et pensées intimes* (Paris 1965) 'L'Orient' is one of those French 'false friends' which does not mean quite the same thing in English, translating best into English not as 'The Orient' but as 'The East'. The English 'Orient' thus becomes 'l'Extrême — Orient' or the 'Far East'. The French 'Orient' comprised Greece and Turkey, the Middle-East, Egypt, North Africa and was sometimes extended to parts of conquered Spain and Eastern Europe under the Ottoman Empire (until the end of the seventeenth century). In the rest of this essay and the catalogue, 'Orient' will be employed in the French sense, and used interchangeably with 'East'.
2. Michael Gilsenan, *Imagined Cities of the East* (Oxford 1986), p. 11.
3. See 'The Treasures at Grussau', *New Scientist*, (22 April 1982).
4. Gerard de Nerval, *Oeuvres*, ed. Albert Beguin and Jean Richet, vol. 1 (Paris 1960), p. 933.
5. Gérard de Nerval, *Voyage en Orient*, introduction by François Herbault, vol. I (Paris 1964), p. 13.

After that (the first day in the East) there is nothing. The wonder is gone and the thrill of that delightful shock, which so seldom touches the nerves of plain men of the world, though they seek for it everywhere...A person who wishes to understand France or the East should come in a yacht to Calais or Smyrna, land for two hours and never afterwards go back again.[6]

Writing at a time when air travel made his ideas even more eccentric, Paul Valéry would not even allow Thackeray's two hours:

The 'Orient' is one of those words I treasure most. Here I make a critical point. For this word to have its total impact on one it is absolutely essential *that he never have been* in the country vaguely being described. He must know it only as an image, via travel books, general reading, and a few curios of the most non-specific sort. Thus one can compose for oneself fine material for a dream. There must be an intermingling of space and time, of timelessness and uncertainty, of intimate details and endlessly vast panoramas. This is the Orient of the mind.[7]

Yet if Nerval sounded somewhat childlike, Thackeray flippant, and Valéry perverse, their shared stress on an essentially imaginative component of Eastern perceptions, a 'geography of the imagination' (to borrow the title of a recent book)[8], clearly came because they feared the growing frequency of first hand experience might eradicate it altogether. But even as the increasing vogue for an art including elements of anthropology, archaeology and topography came to dominate the more fanciful East, that component did not disappear. In the work of many of the richest Orientalist painters, such as Delacroix, it became part of a three-stage development, where the artist first imagined the East, then travelled there to experience it, and afterward mixed the memory of his visit with elements of earlier fantasy.

The anthropologist Claude Lévi-Strauss, though obviously committed to the firsthand experience of travel, saw himself as caught between two unsatisfactory alternatives in terms of how he might cope with the alien reality before him:

I have only two possibilities: either I can be like some traveller of the olden days, who was faced with a stupendous spectacle, all or almost all of which eluded him, or worse still, filled him with scorn and disgust; or I can be a modern traveller, chasing after the vestiges of a vanished reality.[9]

The 'old-fashioned' traveller was insensitive to the quality of primitive life, the 'modern' traveller ignores its present reality and hastens its eradication even as he examines its relics. Travel books, both product of and inspiration to voyagers, exist, said Lévi-Strauss, mainly to sustain among the powers that push an all-embracing and irrevocable 'monoculture' the illusion that nothing is being destroyed, that regional cultures are not being swallowed up.

In many ways what Lévi-Strauss said about travel books parallels the situation with reference to paintings of that homegrown exotic type, the French peasant, which, as Robert Herbert has pointed out,[10] were bought up by those industrialists most committed to stamping out the rural way of life. The peasant who was being represented himself indirectly stood for things such as the new urban industrialization: he was a sort of rotating two-way mirror, on the one hand reflecting back the attitudes of its maker and owner, on the other revealing (through a glass darkly) a different world. In a similar fashion Orientalist paintings, while embodying the cultural stereotypes of the Western artists and their patrons, while itemizing the cultural evidence of a civilization they were committed to dominate and exploit, still do contain insights into a foreign culture which were captured best, as Nerval, Thackeray, and Valéry suggested, by the equivocal complexities of the artists' imaginations. Even Edward Said, who has little time for *any* Western perceptions of the East, acknowledges that works of what he calls 'personal utterance' have been less infected with cultural, political and racial prejudice than the 'science' of supposedly unbiased scholars.[11] And when Lévi-Strauss came to resolve the conflict between the traveller and his foreign environment, he quoted from the most self-absorbed of all imaginative writers about the East, Chateaubriand; and Lévi-Strauss' method of achieving perspective upon his experience was the same as that of Fromentin and others: by filtering it through his memory. So that the artistic tools of imagination and reflection have

6. W.M. Thackeray, *Cornhill to Grand Cairo* (first published 1845), edition integral with *Paris Sketchbook* and *Irish Sketchbook* (London 1900), p. 628.
7. Preface to Roger Bezombes, *L'Exotisme dans l'art et la pensée* (Paris 1953), p. VII.
8. Guy Davenport, *The Geography of the Imagination; forty Essays* (San Francisco 1981).
9. Claude Lévi-Strauss, *Tristes Tropigues* (Paris 1955). English translation (London 1973), p. 51.
10. Robert Herbert, 'City vs. County: The Rural Image in French Painting from Millet to Gauguin', *Art Forum* (8 February 1970), p. 44.
11. Edward Said, *Orientalism* (New York 1978), p. 176.

been and continue to be as essential in understanding other peoples, other environments, as they are in the perception of oneself, which, finally, is only another aspect of the same thing.

The Napoleonic campaign in Egypt inaugurated a new phase of European Orientalism just before the nineteenth century began. The most important document of that expedition, the *Description de l'Egypte* (1808-22, XIII vols.), compiled by what one has little hesitation in dubbing an 'army' of *savants*, remains a remarkable compendium of information. Its frontispiece, drawn by 'Cécile,'[12] is certainly an extraordinary visual document, presenting an extensive assemblage of many great Egyptian monuments (Fig. 14). Its frame, in the shape of an Egyptian doorway, contains elaborate stylized representations of the laurels and plunder of Napoleonic victories, with the hero himself in the chariot at the top, looking like Alexander the Great. Fresh off the boat from his triumphant Italian campaign, he drives back, with a single spear, an entire Eastern army, past the reclining river god Nile. The central landscape provides a telescopic view of the great river, from the delta all the way to the cataracts. Framed by Pompey's Pillar on the right and Cleopatra's Needle on the left, the foreground is littered with artefacts; at their feet are precious objects like the planisphere of Dendura, the Rosetta Stone, a papyrus, a date palm capital, and one

12. 'Cécile' is apparently a pseudonym. Peter Clayton, in *The Rediscovery of Ancient Egypt* (London 1982), attributes the drawing to Vivant Denon, without giving grounds for so doing. It is a Denon sort of conception, yet providing a frontispiece for an enterprise in which he did not take part would be a bit eccentric for a man used to being in charge.

Fig. 14 'Cécile', frontispiece for the *Description of l'Egypte*, 1809, engraved by Louis Sellier and Abraham Girardet (British Museum, London).

of the Sphinxes of Thebes. On the right side (the West bank) of the river, the stepped, sloping corner of the Great Pyramid precedes the Great Sphinx, followed by Dendura, The Ramesseum (the tomb of Ozymandias), the Colossi of Memnon, Medinet Habou, Esneh, Armant and Edfu. In the distance can be seen the Island of Elephantine and, to the left, the Island of Philae, flanked by granite mountains. Returning to the foreground on the left (the East bank) are Kom Ombo, the grottos of Elethyia, Luxor with its two obelisks, Karnak and vestiges of Thebes, Heliopolis, and other sites.

This composite image is rich in several senses: not only did it associate the Napoleonic conquest with Eastern history (as did the French General himself when he invoked for his French troops the attending spectres from the glorious Egyptian past just before they began the Battle of the Pyramids), but also it visually packaged Egypt as one big museum. The monuments have been edited and controlled in the composition by Western perspective (and in reality by Western military organization), the objects in the foreground ready for crating and shipping back to Europe on a Man-of-War anchored in the Mediterranean just outside the picture. With such a precedent, it is hardly surprising to find André Malraux over a century later beginning his extraordinary career as a Cambodian tomb-robber years before evolving his influential theory about the dislocating ruptures of the *Musée Imaginaire*. 'Cécile' has condensed all Egypt into one artistic fun-fair, with the gift shop in the foreground.

The *Description de l'Egypte* may have provided the ultimate scholarly word on that country, but in the blockbuster, super-sized publication stakes, it had been beaten to the punch by Vivant Denon's single-handed achievement, *Voyage dans la Basse et la Haute Egypte*, which was brought out in a similarly grand format seven years before the first volume of the *Description* appeared, with a prestigious list of subscribers to help defray the cost of printing and ensure its success. It was reissued in several less-imposing editions, and immediately translated into English.

Except for their similar size and lavish presentation, Denon's volumes provide an almost total contrast to the *Description*. Where the later work was relentlessly pedagogical, offering its endless erudition with scholarly 'detachment', as if unconnected with a systematic colonial conquest, Denon's chatty, informal account was frank about the author's involvement in the French military effort, and sceptical about many of its means and ends. Yet he was also learned, and, what is particularly interesting for an exhibition of this sort, tremendously varied in his visual and written approaches to the East (though in the latter the author's ever-present *persona* provides a consistent unity). Examining the plates of his splendid volumes, or, even better, admiring the remarkable drawings Denon did for them collected in the British Museum (which someday must be exhibited in their entirety, with a full scholarly catalogue), one could easily hazard the incorrect guess that Denon or Napoleon had employed a whole team of draughtsmen as his illustrators, rather than the single multitalented author himself. In many ways Denon the artist-writer defined, *avant la lettre*, a whole set of Orientalist tropes and compositions that were to be endlessly repeated in the subsequent century. And in so doing, he comfortably alternated completely different styles, in an imaginative attempt to throw as many nets around this new experience as possible.

Regarding his beautiful map of the Battle of Aboukir, (Fig. 15), where, on 27 July, 1799, Napoleon won a decisive victory, Denon wrote:

> From that moment, no more enemy; never was a battle more absolutely necessary, never was a victory more complete; it was just what Bonaparte had promised his brave men in leading them from Syria; it was the final triumph that he would take from Egypt. In embracing him, Kléber said, flushed with enthusiasm, 'General, you are great, like the world, and it is not great enough for you.'[13]

Of the opposing force of Mameluke Turks, twenty thousand strong, six thousand were taken prisoner, four thousand left dead or wounded on the battlefield, and no less than ten thousand terrified Turks driven into the sea, where they drowned. That last slaughtered group appear in Denon's delicately-coloured delineation as little flattened commas, ruffling the surface of the sea (the pointed, wave-like shapes on shore, sometimes topped by a tiny sickle moon, are Turkish tents). The diagrammatic abstraction of such massive bloodshed was the closest Denon came to the *savants*

Fig. 15 Vivant Denon, Plan of the Battle of Aboukir, 27 July 1799, drawing for plate LXXXIX of *Voyage dans le Basse et la Haute Egypte*, pen and ink and watercolour (British Museum, London).

13. Vivant Denon, *Voyage dans la Basse et la Haute Egypte*, vol. I (Paris 1802), p. 260.

Fig. 17 Vivant Denon, *How Egyptians Make Macaroni*, drawing for plate LXXXV of *Voyage dans le Basse et la Haute Egypte*, pen and sepia wash over graphite (British Museum, London).

Fig. 16 Vivant Denon, *Battle of the Pyramids*, drawing for plate XII of *Voyage dans le Basse et la Haute Egypte*, pen and sepia wash over graphite (British Museum, London).

of the *Description*, but even his map is too active to freeze the event aesthetically, with its nervous calligraphy, colours, tones and shapes. Denon presented a more involved view of war in his largest study for the series, a spectacular horizontal panorama of the Battle of the Pyramids (Fig. 16). According to Denon:

> I have tried to capture the image of a Mameluke cavalry charge, which I witnessed several times, and whose rapidity, abandon, devotion and chivalric bravery always struck me.[14]

Artistically the execution related to the flamboyant draughtsmanship of the eighteenth century (Fragonard comes to mind), but its epic scale and involved clash of men and horses looked forward to the later battle scenes of Gros, who might well have been inspired by it.[15] Thus in this one drawing at least, Denon stands at the head of those massive Napoleonic Eastern battle scenes, which inspired a whole generation of nineteenth-century Orientalists, not least Delacroix.

Quite a different drawing is *How Egyptians Make Macaroni* (Fig. 17), where Denon seems to have gone back to Rembrandt in search of an appropriate draughtsman's approach to Oriental genre. Rembrandt was a touchstone for Orientalist painters, and his name was repeatedly invoked on the Eastern visits of Wilkie[16] and others, in wonderment that the Dutchman had managed to represent the Orient so well without ever leaving Holland, a triumph of the artistic imagination over lack of actual travel experience.

Perhaps the most prophetic of Denon's compositions shows an unveiled Egyptian woman (Fig. 18), with whom he became friendly. Denon's account of her remains as touching and wistfully lovely as the drawing itself, and set an early precedent for the widespread nineteenth-century picture of the Oriental woman as a creature of strong sensuality. According to Denon, she was:

> a female native married to a Frank.[17] She spoke Italian and was sweet and beautiful. She loved her husband, but he was not so charming that she could love only him. Jealous, he often provoked heated arguments; submissive, she always renounced the object of his jealousy. But on the following day, there would be a new complaint. She wept again and repented; but her husband still had some reason for scolding her. Her windows faced mine; as the street was narrow, I very naturally became the lady's confidant and the witness of her chagrins. Plague broke out in the city; my neighbour was so communicative that she could not fail to catch and spread it. Accordingly she got it from her final lover, bestowed it faithfully on her husband, and the entire romantic triangle died. I regretted her loss: her singular goodness, the *naïveté* of her waywardness, the sincerity of her regrets, had intrigued me, more particularly since, as a mere confidant, I could not quarrel with her either as a husband or a lover, and since, happily, I was no longer at Rosetta when the plague devastated that area.[18]

14. *Ibid*, vol. II, pp. iii, iv.
15. Gros never actually went to the East, though he painted several episodes of Napoleon's campaign there.
16. Alan Cunningham, *The Life of Sir David Wilkie*, vol. III (London 1843), pp. 325-26.
17. 'Frank' was the all-purpose designation Orientals employed for Europeans.
18. Vivant Denon, *op. cit.*, vol. I, p. 64.

Fig. 18 Vivant Denon, *Egyptian Woman in the Harem,* drawing for plate LXXIV, no. 1 of *Voyage dans le Basse et la Haute Egypte,* graphite (British Museum, London).

Fig. 19 Hugues Picart, Title page for *Historie Generale de la Religion des Turcs,* published 1625 (British Library, London).

Denon's drawing looked forward to the work of Wilkie or even Delacroix, more than three decades later, and his description helped establish an artistic view that would consider Eastern women almost exclusively as images of sexuality.

It was an attitude that went back far. A significant French book published in 1625, *Histoire générale de la religion des Turcs* by Michel Baudier was decorated with a remarkable frontispiece etched by Hugues Picart, where Christianity was contrasted with Mohammedanism in a three stage opposition (Fig. 19). The Latin inscription beginning at the bottom, explained that while the Christians followed the certain light of Salvation, represented by the sun, the Turks took their inspiration from the fickle, changeable light of the moon (the crescent having been identified by the West from the beginning of the sixteenth century as a symbol or the Ottoman Turks and Islam[19]); secondly the Christians cleansed themselves 'properly', that was, in a spiritual sense and only at birth; while heathen Eastern males, in sharing public baths, were defiled by indecent washing. Finally and most important was the climactic upper contrast of the afterlife, where Christians worship the Trinity, Mary and assorted angels in celestial spiritual glory; the Easterner's heaven, on the other hand, is well provided with the pleasures of the body, delicious pears on trees and a table as easily accessible as (and graphically identical to) the bare breasts of beautiful *houris.* Mohammedanism was thus damned, perversely by modern standards, for its daring suggestion that heaven might be more desirable if it offered limitless sex and food rather than enforced kneeling as a final reward. Thomas Moore's mockery of the Eastern belief:

19. The symbol predates the Ottoman Turks and probably derives from the paired ram's horns which were placed on the top of flagstaffs and tentpoles of Central Asian Turkish tribal chiefs.

23

A Persian's heaven is eas'ly made
'Tis but black eyes and lemonade.[20]

perhaps also contained an element of envy.

Psychological insight has since taught us that those who most vociferously denounce something are those most obsessed or frightened by aspects of it within themselves. But in the nineteenth century the West quite unashamedly regarded and represented Eastern women almost solely in terms of sex. For his late great imaginative compilation of Eastern eroticism, *The Turkish Bath* (Louvre, Paris), Ingres borrowed from widely disparate sources, happily integrating two clothed figures (Fig. 20b) from sixteenth-century engraving amidst his timeless nudes. He also found inspiration in the eighteenth-century writing of Lady Wortley-Montague, whose own devout wish when admiring a bath filled with Turkish female nudity was to have the Irish painter Charles Jervas (Fig. 20a) observing invisibly at her side,[21] and in a sense it is the fantasy of invisibility that Ingres' picture fulfils. Lady Wortley's description, however, specifically stated that accompanying the women's nakedness was 'not the least wanton smile or immodest gesture among them'. And she took issue with an earlier male writer on Turkey for his lack of understanding with regard to the sorts of restrictions placed upon Turkish women, 'who are perhaps freer than any ladies in the universe.'[22]

Ingres' bath scene is circular; and though its round shape may have come from his lifelong emulation of Raphael, the circle acted as the ideal receptacle for the round

20. The lines are in Moore's poem 'From Abdallah, in London, to Mohassan in Ispahan', *The Twopenny Post-Bag, or, Intercepted Letters* (London 1813).
21. Lady Mary Wortley-Montague. *Letters* (London 1906), p. 105. The remarkable Lady Wortley Montague was responsible for, among other things, bringing the smallpox innoculation to England.
22. *Ibid*, p. 167.

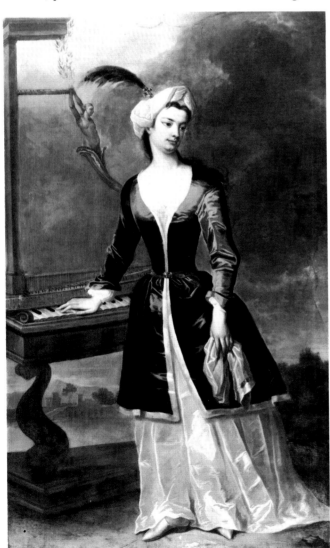

Fig. 20a A. Charles Jervas, *Lady Wortley-Montague in Turkish Dress with a Clavicytherium*, oil on canvas (National Gallery of Ireland, Dublin).

Fig. 20b Master L.D., *Turc allant au Bain*, originally published in 1568. This version printed in 1650 (Trinity College Library, Dublin).

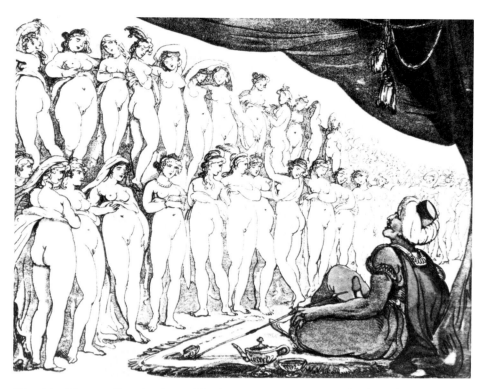

Fig. 21 Thomas Rowlandson, *The Harem*, c.1810, pen and ink and watercolour (Private collection).

breasts and bottoms that fill the composition. It is also circular like a peephole, or the perceiver's own eye, emphasizing the implicit spectator of the voluptuous vision. A spectator who was partly the artist himself, as evidenced by the testimony of one of his young female models:

> If you knew what cries of admiration he utters when I work for him...they make me quite ashamed...And when I am leaving, he goes to the door with me and says 'Goodbye, my lovely child', and kisses my hand.[23]

The complex sophistication of Ingres' compositional structure functioned similarly to the artist's faithful marital morality in restraining his deep sensuality. The abstract painter Barnett Newman responded to the eccentric nature of Ingres' eroticism when he viewed the artist's Paris retrospective in 1967:

> He's sort of sensuous, but his sensuousness is weird. Maybe he used to pride himself on how long he could hold back an orgasm. Passion, yes, but passion held.[24]

Perhaps the unseen spectator of Ingres' composition was the wealthy collector Khalil Bey, to whom the artist sold his painting in 1865.[25] A sometime Turkish diplomat who enjoyed Eastern (and Western) erotica as much as gambling, Khalil Bey was often portrayed in Parisian circles as a lusty Oriental prince. But the most obvious implicit viewer for Ingres scene had been drawn decades earlier by Thomas Rowlandson, a master of comic reflection on the business of seeing, particularly voyeurism. Rowlandson's scandalous harem scene (Fig. 21) includes a sultan and spectator; explicit in every sense, despite its linear economy, Rowlandson's drawing clearly delineates sexual detail, from the wives' pubic stubble to the sultan's arousal. Gert Schiff compared the sexual excess of this drawing to William Beckford's *Vathek*, where the eponymous Caliph complained he could not taste more than thirty-two of the three hundred dishes placed before him, and typed the drawing's approach as 'characteristic of the imaginative technique of the masturbation fantasist.'[26] But in a way that is typical of much 'low art' Rowlandson made obvious one suggestive aspect of the more indirect approach of Ingres' later, layered work the regard of an unseen Sultan.

23. Henry Lapauze, *Ingres, sa vie et son oeuvre* (Paris 1911).
24. Pierre Schneider, *Louvre Dialogues* (New York 1971), p. 219.
25. Francis Haskell, 'A Turk and his Pictures in nineteenth-century Paris', *Oxford Art Journal*, vol. 5, no. 1, pp. 40-47.
26. Gert Schiff, *The Amorous Illustrations of Thomas Rowlandson* (New York 1969), p. xxxii.

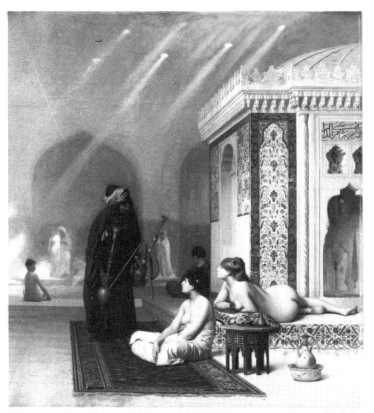

Fig. 22a Jean Léon Gérôme, *Turkish Women at the Bath,* Salon of 1876, oil on canvas (Hermitage Museum, Leningrad).

Fig. 22b Artist unknown. Belle of Nelson Advert, 1882, (Library of Congress, Washington).

27. For more information on Paul Mary Gray, see Chris Bailey, *Irish Illustrators in the Nineteenth Century,* M.A. thesis, Trinity College, Dublin, 1983.

28. The complete poem reads:
THE NEW MAHOMET
BY A PARTY FROM ALL-JEERS
DARK Folks! MAHOMET's come to the mountain!
On my manoeuvres there's no countin'!
I found these Arabs a queerish nation,
So I've come down here for their education.
 (Walks round.)
I'm the novel MAHOMET, oh!
I'm the latest MAHOMET, out!
I'm the last new MAHOMET — *me voilà*!
I'm LOUIS MAHOMET, oh!
 (Strikes an attitude)
Dark folks! am you a regardin' ob dis Arab?
I'm a Riddle — y card there's no denying —
It's hard to see at what I'm trying;
But as moonshine's my little game at present,
I'm throwing new light with the ancient crescent.
 (Walks round the Algerians.)
I'm the fated MAHOMET, oh!
The destined MAHOMET, oh!
I'm the new French MAHOMET — *me violà*! (sic)
I'm LOUIS MAHOMET, oh!
 (Strikes another attitude.)
Dark folks! am you a -realizing ob dis prophet?

A more accurate *hamman* or bath scene was rendered a decade later by Jean-Léon Gérôme, in a work (Fig. 22a) where languorous Circassian beauties are offered *hookahs* by a black servant. *Hamman* lights of bottle green glass send down eerie shafts of illumination, and Isnik tiles decorate the small structure in the centre. An amusing appropriation of Gérôme's painting for advertising purposes, employing abstinent Muslims to promote, of all things, bourbon whiskey (Fig. 22b), reveals how an American illustrator with no experience of the East attempted to ape Gérôme's carefully accurate transcriptions of Oriental ornament but instead produced patterns that went no further East than William Morris. The carpet, the cushion, the tiles, all lose their distinctive patterns under the uninformed and insensitive hand of the anonymous copyist. Most absurdly of all, the bottle of Belle of Nelson being imbibed on the *kursi* or damascus table turns the Circassians into undressed Southern belles, the negro servant into an ante-bellum darkie. Gérôme's portrayal of light looks magically subtle alongside the harsh simplifications of the advertisement, and particularly with the French artist's ghostly glowing figures in the distance is the spectator given space in which to exercise imaginative fantasy.

A more specific comic parallel between the East and the American South was provided in a satirical drawing by the Irish illustrator Paul Mary Gray (Fig. 23a).[27] A scant month and a half after the Surrender at Appomatox, which ended the Civil War and freed the Southern slaves, Gray's drawing appeared in *Fun,* a rival publication to the more popular *Punch,* with the young Irishman an opposite number to the talented Sir John Tenniel before the former's untimely death at age twenty-four. *Mahomet, Al-lah Français,* one of Gray's finest efforts, was accompanied by a poem where the French Emperor Napoleon III harangued the obeisant dark-skinned Arabs as if he were addressing uneducated American slaves.[28] On the one hand, the poem was written from the two-fold English moral superiority of having abolished slavery over thirty years earlier than the Americans and of holding insignificant North African colonial involvements in comparison to France. On the other hand, Gray's depiction of the ignorant Arabs wholeheartedly accepting Louis Napoleon as a quasi-divinity and his publication's happy ridicule of all things Eastern, from the country's name ('All-Jeers'), to its religion ('Al-lah Francais'), makes his drawing and its accompanying

MAHOMET, AL-LAH FRANCAISE.
OR, THE NEW KORAN.

Fig. 23a Paul Mary Gray, *Mahomet,
Al-Lah Française, or the New
Koran,* 27 May 1865
(National Library, Dublin).

Fig. 23b James Tissot, *Abdul Aziz,
Sultan of Turkey, Vanity
Fair,* 30 October 1869
(Trinity College Libary,
Dublin).

text an obvious example of Western insensitivity. The poem's association of Louis
Napoleon's misleading 'moonshine' and the 'ancient crescent' could almost be directly
derived from Baudier's derogatory frontispiece of two hundred and forty years before.

A satirical drawing of Abdul Aziz, Sultan of Turkey (Fig. 23b), done four years
later by James Tissot for the English publication *Vanity Fair* had a facing explanation
expressing the hope that the Sultan might be able to stand strong against Russian
and German interference, even though Europe had in the past done everything possible
to undermine his authority. The pro-Turkish tenor of the text was not particularly
reinforced by the image of the Sultan. Although handsome and thoughtful in his
full military garb, he is idly seated, Eastern-style. Clutching the phallic mouth piece
of a waterpipe, passively providing a divan for scantily-clad dual miniatures of his
dominions of Turkey (on the left) and Egypt (on the right), he is tranquilly unaware
that he is about to be engulfed by what appears to be a large cooking-pot, wielded
by a Russian or German officer.

Apart from the main (and mixed) political messages of the image, the subsidiary
characterization of the two Eastern countries as both female and passive is significant.
Edward Said has pointed out how often 'relations' between the West and East were
linguistically rendered in sexual terms, with the West taking a dominant-active-male
role and the East a submissive-passive-female one. As the images already examined
show, Eastern women were perceived as simultaneously wanton and submissive. This
widespread view, it hardly needs saying, was one formed by men; female visitors like
the aforementioned Lady Wortley Montague had more complex perceptions of, deeper
insight into their Eastern counterparts: her comment that Turkish women were freer
than females in the West was as tellingly perceptive about Western Society as it was
about the East.

Lady Lucy Duff Gordon, whose failing health sadly forced her to separate from
her husband and children, first in South Africa, then in Egypt, left in her *Letters from
Egypt* one of the most sensitive and sympathetic perceptions of Eastern life ever written
by a Westerner. An account she gave of an exchange between an Egyptian and an
Englishman showed the hypocrisy hidden behind Victorian 'morality' and the sense
of social responsibility and restraint operating in Islamic polygamy:

The English would be a little surprised at Arab judgements on them; they admire our veracity and honesty, and like us on the whole, but they blame the men for their conduct to women. They are shocked at the way Englishmen talk about hareem among themselves, and think the English hard and unkind to their wives, and to women in general. . . . There are a good many things about hareem here which I am barbarian enough to think extremely good and rational. An old Turk of Cairo, who had been in Europe, was talking to an Englishman a short time ago, who politely chaffed him about Mussulman licence. The venerable Muslim replied, 'pray how many women have you, who are quite young, seen (that is the Eastern phrase) in your whole life?' The Englishman could not count, of course not. 'Well, young man, I am old and was married at twelve, and I have seen in all my life seven women: four are dead, and three are happy and comfortable in my house. *Where are all yours?*'[29]

The principal inspiration for the Western view of Eastern women as boundlessly sensual was the *1001 Nights*. Although not until Burton's unbowdlerized translation late in the nineteenth century did the tales come into full licentious flower, the framing stimulus to the stories, in any version, was profoundly misogynic, establishing the 'fact' of Eastern women as creatures of such uncontrollable faithless lust that a cuckolded omnipotent Sultan decided on safe sex only with virgins whom he had slaughtered the morning after.[30] Rana Kabbani has recently tried to dismiss the *1001 Nights* as minor works whose significance was blown way out-of-proportion by the obsessional concerns of their translators and their subsequent Western celebrity.[31] Her attempt to invalidate the *Nights* as significant folk literature is less convincing than her perceptive analyses of the translators; the tales must be considered (and, on that level, indicted) as examples of an international misogyny that is manifested in many societies, regardless of religion. There are, of course, counteracting tales with more positive stereotypes, but these are few and far between in the *Nights*, and even the final triumph of Shahrazad in the framing story cannot erase the memory of the many massacred virgins who preceded her.

Louis Napoleon's Arab garb in Gray's cartoon also reflected a popular tendency among Western men to identify with a heroic image of the Arab. Just as women who wore parts of or entire Eastern female attire endeavoured to assume some of the heady sensuality attributed to Eastern women, so also did Western men who donned Arab robes often aspire to aspects of the fierce independence, pride, dignity, grace, power and a host of similar qualities that were felt to be embodied in the lord

29. Lucy Duff Gordon, *Letters from Egypt* (London 1969), pp. 3, 102-3.
30. A depressing modern parallel is provided by reports that well-to-do patrons of prostitutes turn to increasingly young victims, in order to lower the risks of contracting diseases, especially AIDS.
31. Rana Kabbani, *Europe's Myths of Orient: Devise and Rule* (London 1986). Kathy Acker, *Algeria: A Series of Invocations Because Nothing Else Works* (London 1984) has tried to explode Western sexual preconceptions in a far less clear and coherent, far more outrageous fashion.

Fig. 24a Théodore Chassériau, portrait of *Prosper Marilhat*, oil on canvas (Musée du Louvre, Paris).

Fig. 24b Henri (le Douanier) Rousseau, portrait of *Pierre Loti*, oil on panel (Kunsthaus, Zurich).

of the desert, even as they were perceived to be vanishng from the increasingly industrialized West. Artists and writers like Nerval, J.F. Lewis, Gleyre and Melville — in fact most of the painters whose work is displayed in this exhibition — all tried on Eastern dress while travelling, and some continued to sport it in the West. Critics frequently detected a spiritual kinship between Orientalist painters and writers with their subject, which was often seen to extend to their personal appearance.[32] Chassériau's portrait of Marilhat (Fig. 24a), while not depicting the Orientalist landscape painter in Eastern robes, clearly stressed an Arab aspect of his features: his dark eyes, long, graceful face, and solemn, dignified mien. In addition to his sketchbook on the table alongside can be seen an attic red-figure trefoil *oinchoe*, and what appears to be a contemporary small woven basket. Thus was the artist linked to the classical past and the ethnic present, even if attired in the tight-waisted Western fashions of the time. A work over half a century later by an altogether different sort of 'Orientalist' painter shows one of the most famous *fin - de - siècle* French writers on the East, Pierre Loti, attired in a fez and smoking a cigarette (Fig. 24b). Scholars disagree as to whether Loti or someone else was the subject of the picture; certainly likeness was a less central concern of Rousseau than it was of Chassériau. And even if Rousseau used a similar set of accompanying props, he achieved his Easternness or 'otherness' more through his strange and poetic imagination than through gentle alteration of features or inclusion of ethnographic attributes. Even the unnerving cat, whose stare is much more arresting than that of the musing writer, derives his visual power less from association with ancient Egypt than from his own strong horizontal banding and slightly irregular frontal symmetry.

Apart from their fantasy identification with the 'noble Arab', Westerners tended to wrench the living Muslim from his own culture to be cast as an all-purpose actor in nostalgic pictorial re-makes of the West's own history: as Primitive or 'Natural' man, as classical Greek or Roman, as Biblical Patriarch and as Medieval *Seigneur*. Fromentin, who made the Arab horseman his principal subject, noted, without actually classifying, all these associations in his writings on Algeria. The one that most commonly comes to mind with reference to his work is the medieval lord, whose delight in blood sports, with falcons or hunting dogs, found parallels in the occupations Fromentin frequently gave to his picture's protagonists. One of his most iconic depictions, *Arab Falconer* from the 1863 Salon (Fig. 25a), could almost be a hunting

32. Théophile Gautier was constantly evoking the image of a lost Arab past, not only for Orientalist painters but also for himself. In a letter to Gérard de Nerval, published in *La Presse* (25 July 1843), he wrote:
... I am a Turk, myself, not from Constantinople, but from Egypt. It seems to me that I've lived in the East, and when I disguise myself in the carnival with a caftan and a tarbounds I feel I am wearing my real clothes again, I have always been surprised not to understand Arabic fluently. I must have forgotten it.
 Much later, in his Salon of 1869, he described Fromentin as a descendant of Saracens who had stayed behind after the evacuation of Spain, concluding, 'he paints the Bedouin so well only because he is a Bedouin himself'.

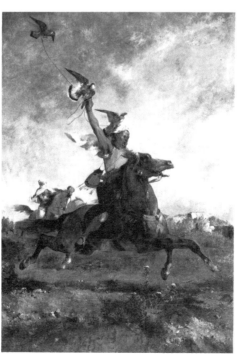

Fig. 25a Eugène Fromentin, *Arab Falconer*, Salon of 1863, oil on canvas (Chrysler Museum, Norfolk).

Fig. 25b Artist unknown, *Arabe, Larousse Classique Illustré*, 24th edition (Paris 1917).

Fig. 26a Eugène Fromentin, *Cavalier Arabs*, c.1857, oil on canvas (Musée des Beaux-Arts, La Rochelle).

Fig. 26b Dublin billboard, 1979 (photograph John Kellett).

baron from the Middle Ages. Fromentin wrote of the 'still feudal' side of Arab life, and a subtext of Arab chivalry which reflects flatteringly back on the French conquerors can certainly be read in his images. An illustration from a Larousse dictionary of 1917 (Fig. 25b), shows how Fromentin's type of representation persisted. Almost two decades into the twentieth century, the Arab was defined as a dark, aggressive, musket-wielding horseman in desert robes, galloping full tilt. Which is not to say that similarly armed and dressed Arabs had ceased to ride fast, nor to suggest that mastery of animals and weapons cannot be read positively; but as an all-embracing image of an incredibly diverse ethnic group of all ages, several countries, and both sexes, it was rather limited. Also worthy of note is the dictionary's final colloquial derogatory meaning of 'Arab', which, ironically, is comparable to the unfavourable usage of 'Jew' in English.

Another Fromentin painting *Arab Horsemen*, sometimes called *The Meeting* (Fig. 26a), can be paired with a more modern picture (Fig. 26b) in order to stress not just compositional affinities but also similar qualities as images of escape to an all-male world of dynamic adventure. While to relate the rectangular Marlboro crush-proof pack to the stabilizing shapes of distant Eastern architecture would be going too far, certainly the fantasy qualities of rugged desert independence were no further removed from the nineteenth-century Frenchman than are the rugged American cowboys from a modern Dublin pedestrian. The parallel between America's West and Europe's East is rich and interesting, since colonial North Africa did function in many ways as a European 'frontier', a land ripe for exploits and exploitation, a vast expanse where invaders could ride rough-shod over indigenous populations in quest of personal gain and national glory (still too often confused and seen as one and the same). Both American Indians and Arabs were admired and mythologized as 'natural men' even as they were being exterminated or ruthlessly subjugated. The thrilled reaction of Baudelaire, Delacroix and others to Catlin's touring troupe of American Indians in Paris and the overwhelming enthusiasm for Buffalo Bill's Wild West Show half a century later marked an excitement over American exotic types similar to that already manifested for the denizens of the East.

The archetypes of 'classical man' and 'Biblical man' commonly recur in the writings and paintings of Europeans who ventured to the East. Delacroix was perhaps the most eloquent of all artists who argued that the Arab was an ancient Greek or Roman reincarnated.[33] As he wrote to Pierret:

> Imagine, my friend, what it is to see lying in the sun, walking about the streets, cobbling shoes, figures like Roman consuls, like Cato or Brutus, not even lacking that disdainful look which those rulers of the world must have worn; these people possess only a single blanket, in which they must walk about, sleep or are buried, and they look as satisfied as Cicero must have been in his curule chair.[34]

And in his art the way in which he portrayed classical subjects was certainly informed by his experience of living Arabs. Fromentin too was struck by such parallels and his background education in classical literature made his Arab encounters a ready source of resonance with those texts. Reversing that association (but simultaneously

33. See Jonathan Mayne, 'Delacroix's Orient', *Apollo* (September 1963), pp. 203-07.
34. Letter ot 29 February, 1832. Fromentin wrote to his friend Gustave Moreau: 'I challenge anyone to show me an antique figure that is better draped, more finely proportioned and more scrupulously beautiful than a Bedouin, any Bedouin picked at random in the market, the café or the street'.

validating it) a modern historian Martin Bernal has strenuously argued an Afro-asiatic ancestry for Greek culture, stating that the 'Aryan model' of ancient history, which denied such a derivation, was only created in the 1840s and 1850s as a result of European racism (particularly anti-semitism).[35]

Sir David Wilkie also sought out ancient sites almost as avidly as Biblical ones. But his increasing aim as his Eastern voyage progressed was to produce the first truly 'accurate' image of the Bible, which he thought he had found, as did several other artists, in the contemporary Arab. Almost every artist who visited the East referred at least once to the 'Biblical' or 'patriarchal' quality of the modern Arab, but only a few pursued that principle of continuation with systematic thoroughness. Horace Vernet was the first conscientious seeker of the Christian past in the Eastern present, and he was obliged to defend before the French Academy his practice of using contemporary Arabs as Biblical characters. As the prize pupil of Vernet's son-in-law, Gérôme was almost directly connected to Vernet's painstaking finish and concretization of every imagined detail of sacred scenes. The very particularity of these depictions, an aspect of their careful craftsmanship, was, in fact their undoing. Gérôme's consummate skill in rendering specific natural light effects misfired when he attempted to embody a Holy Vision; the accuracy of his perceptions of the contemporary East fixed his Biblical dramas firmly in the present. As Fromentin argued in a thinly disguised attack on Vernet, a certain degree of generalization was necessary to represent the subjects of the Bible. Particularly with such epic and frequently depicted events, the painter either had to allow the viewer's own imagination room to manoeuvre or else approach the subject in an oblique, unusual fashion, as Gérôme and Tissot did with their different eccentric perspectives on the crucifixion. In both works, though, after the startling originality of approach has been comprehended, the precision of vision still reduces the viewer's ability to imagine. Both pictures look forward to the advent of film, where an ever increasing devotion to 'realism' in terms of special effects and spectacular sets has not increased the conviction or credibility of the artistic statement. Far more powerful efforts have been achieved in the earlier more poetic and stylized days of the cinema or in low-budget efforts like Pasolini's *Gospel According to Saint Matthew*, where the visual inspiration was not Salon or Royal Academy extravaganzas but Italian Renaissance art (which Pasolini studied with Roberto Longhi, one of this century's great art historians), as well as surviving vernacular architecture and culture.

If the Arab Horseman was the quintessential masculine image of the East, the desert background against which he was often so majestically set was the grandest and most central image of the Eastern environment. Its vastness and emptiness, which dwarfed or swallowed everything within, offered a mid-nineteenth century version of the sublime, which had been successfully sought earlier amidst the spectacular peaks and declivities of the Swiss Alps. But whereas the mountains provided limitless shapes, textures, and flora for articulation and scale, the desert was a nature so stripped and bare that it could not properly be accommodated by established landscape conventions. Artists sometimes employed part of an oasis as a Claudian coulisse, not only establishing a foreground and a scale for the sandy wastes beyond, but also setting up the strongest possible opposition between verdant lushness and barren drought. The ancient Egyptians had offered future landscapists some assistance, in leaving behind constructions of such scale that they interrupted parts of the limitless horizon near the Nile. Ancient Egyptian monuments frequently helped structure the desert views of painters such as Berchère. Another artistic approach was to focus on the caravan itself as it crossed the sands. Unquestionably the most emblematic and important constituent of the caravan was the one-humped camel or dromedary, whose triangular shape, sometimes accentuated by the tent-like *attatich* it carried on its back, became a kind of moving pyramid.

Although it slightly post-dates the period of this exhibition, the most popular desert image ever conceived, if frequency of reproduction is the determining criterion, is the design of the Camel cigarette packet. In this celebrated emblem, of which more than a hundred and sixty-five billion copies have been sold, a camel was employed both as a sinuous compositional diagonal and a central triangle, an undulating, mobile counterpart to the two receding Pyramids and the triangular triple group of date palms. Although originally brought back from America, tobacco was strongly associated

35. Martin Bernal, *Black Athena: The Afroasiatic roots of Classical Civilisation*, vol. I (London 1987).

Fig. 27a Artist unknown, The Camel:
Imagined, Experienced,
Remembered (photographs
courtesy R. J. Reynold's
Tobacco Company).

Fig. 27b Peter Charlesworth, photograph of the Sudan for *Africa in Crisis*
(Earthscan 1985).

with the East, particularly Turkey (from which it spread to Europe and back to
America). 'Camel' was only one of a sequence of Oriental names the R. J. Reynolds
Tobacco Company, initiating America's native cigarette industry, considered for their
product, after 'Osman', a name taken from two Turkish Sultans, had failed. Others
were 'Kismet', 'Nabob' and 'Rembrandt' (interesting in light of his position as
godfather of pictorial Orientalism). Rival companies had marketed products with the
names 'Murad', 'Fatima' and 'Mogul', while a northern brand called 'Red Kamel'
had already been tried. The three overlapping pictures illustrated here (Fig. 27a)
demonstrate the evolution of the world's most famous desert image. The landscape,
consisting simply of flat sand and a low horizon, was set from the start, with the
reduced scale of a giant pyramid, tall date palms, and a dramatically diminished distant
pyramid establishing the recession. The camel, drawn with the same sort of artistic
imagination, was instantly recognizable, but, with its strong sense of forward motion
and its caricatural head, hardly iconic. The arrival in Winston-Salem, home to the
R.J.Reynolds Tobacco Company, of the Barnum and Bailey Circus on 29th September,
1913, provided an authentic model in a dromedary named 'Old Joe'. The animal was
reluctant to stand still, but a slap on the nose from his trainer raised his tail, laid
back his ears, and narrowed his eyes in the pose caught by the cameraman and adapted
by the artist.[36] Thus one can lightly impose this exhibiton's title on the archetypal
Oriental beast — the camel: imagined, experienced, remembered (the third category
combining the first two) — to describe the evolution of the world's most famous
cigarette pack. What is interesting from a formal point of view is how the relatively
small composition encapsulates or distils the three most powerful signifiers (and
articulators) of the empty desert landscape: oasis palms, Egyptian monuments, and,
most importantly, the camel. Even in Guillaumet's original and radical attempt to
represent the sandy wastes (see David Scott essay, Fig. 12), a central camel carcass
was an essential visual signifier, just as it was a crucial literary one in Flaubert's written
desert descriptions.[37] An earlier lost attempt at the same subject by Fromentin[38] had
used a dead camel covered in vultures to establish its right foreground. Similarly in
a modern photograph used to illustrate a study of African famine (Fig. 27b), Peter
Charlesworth structured his picture of the Sudan with a foreground camel carcass
half-buried in sand, and broke up his horizon with the diminishing silhouettes of
a caravan.

The desert was easier to mythologize in words than in pictures. In the opening
lines of 'Childe Harold', Byron's:

O that the desert were my dwelling place

36. Early advertisements declaring 'the
Camels are coming' copied the
photographed Circus beast exactly, even
retaining his halter.
37. 'All along the route we came upon
the carcasses of camels that had died of
exhaustion', Francis Steegmuller, editor
and translator, *Flaubert in Egypt: A
Sensibility on Tour* (London 1972), p. 201
(see also p. 184).
38. Illustrated in James Thompson and
Barbara Wright, *La Vie et l'oeuvre,
d'Eugène Fromentin* (Paris 1987), p. 91.

Fig. 28 Jean-François Millet, *Hagar and Ishmael in the Desert,* oil on canvas (Mesdag Museum, The Hague).

39. Ces solitudes mornes
Ces déserts sont à Dieu . . .
Hugo, 'Le Feu du Ciel; section V, *Les Orientals,* no. I (Paris 1829).
40. 'La désert donne à l'homme un affranchissement . . .
L'espace ouvre l'esprit à l'immatériel.
Lamartine, 'Le Désert, ou l'Immatérialité de Dieu', section VII. The poem was begun in the Orient in 1832 but not completed until 1856.
41. Honoré de Balzac, *A Passion in the Desert* (Gloucester 1985), p. 15.
42. Ernest Renan, *La Vie de Jésus* (Paris 1974), p. 175 (originally published 1863). Renan's book was controversial and popular. Fromentin, for example, owned and signed a copy of the first edition.
43. The Gérôme, called *In the Desert* is in a private collection and is illustrated in Gerald Ackerman's *Jean-Léon Gérôme* (London 1986), no. 220, p. 232, and p. 90 (colour). The Rosa Bonheur is in this exhibition, no. 4.
44. Henry James, *Paris Herald Tribune,* (22 April 1876), reprinted in *Parisian Sketches* (New York 1937), p. 108.

sounded the Eastern traveller's rallying cry. Victor Hugo, who never got near the great stretches of sand, wrote in *Les Orientales*: 'Deserts belong to God',[39] a mystical strain also evident about the same time in the poetry of Lamartine:

> The Desert gives to man an emancipation . . .
> Space opens the mind to the immaterial[40]

and also in Balzac, who in his short story, 'A Passion in the Desert' wrote:

> In the desert there is everything and there is nothing ... it is God without men.[41]

The venture into the desert, a confrontation of its ultimate vastness and emptiness, threw the pilgrim back upon him/herself. It was a place to search not only for God but also for self-knowledge; it provided a rite of passage that tempered great men. As Renan wrote in 1863 of the desert sojourns of John the Baptist and Jesus:

> The retreat to the desert thus became the condition and the prelude of high destinies.[42]

It is not an endeavour or a metaphor whose resonance has been lost — as late as 1981, Cardinal Hume said on Thames Television:

> I understand the need to frequent the market place ... but I miss the chance of going into the desert.

In addition to stirring works by Fromentin and Guillaumet, the desert inspired two poignant images of Arab horsemen mourning their expiring steeds by Jean-Léon Gérôme and Rosa Bonheur,[43] but a true desert masterpiece was produced by a Frenchman who, like Hugo and Balzac, had never seen the Sahara. The peasant painter Jean-François Millet was commissioned by the 1848 Republican Government of France to paint a picture of *Hagar and Ishmael in the Desert* (Fig. 28). It was a work of strong ethnic significance, since, according to one theory, the desert tribes were 'Agareni', all descendents of Hagar (an alternate theory derived them from Sarah, hence the name 'Saracens'). Meeting a crisis that would affect other artists like Degas years later in attempts to revivify Biblical or history painting, Millet foundered and could not complete the work, perhaps sensing that the slick Salon finish and detailed fixed image commonly produced were too frozen and confining to leave any working room for the viewers' imagination. Henry James attacked just such a limiting effect, when he wrote of the high priest of minutiae:

> Gérôme was of the troupe that rifled the Oriental world of its uttermost vestiges of mystery.[44]

Yet although Millet abandoned his picture without finishing it, the surviving painting remains one of the most powerful desert images ever produced. His stark portrayal of essential human suffering, neither aestheticized nor particularized, his lack of focus on racial or sexual stereotypes, gave his image a strength, force and freedom from *cliché* that elaborate Salon works lacked. Similarly his hazy, expressive handling of the landscape, suggestive of uncertain shifting space and visual ambiguity, provided an effective painted simulacrum of the desert's vast infinity. Fromentin's two notable attempts twenty years later with *Land of Thirst*[45] were, in comparison, much more stagey and constructed.

In dealing with a completely new kind of experience offered by the East, the artistic approach that provided the most memorable images was the one where the creative personality of the artist was most openly acknowledged, where the imagination of the spectator was left with the most free play. A drawing like Delacroix's sketch for *Sardanapalus* (Fig. 29a), mixed the inspiration of Byron's energetic and dramatic fantasy Orient with Delacroix's own observation of the exotic objects in M. Auguste's collection to produce a composition that could rival any Frank Stella in forceful abstract rhythms and energy. An unfinished Chassériau sketch of a *Harem* (Fig. 29b) combined in a different way accurate visual notions of Eastern costume, pose and appearance with bravura, expressive handling of paint, and remains an image of expansive rather than delimited sensuality, 'fine material for a dream', whose renewed viewing provides, again to restate Valéry, 'an intermingling of space

Fig. 29a Eugène Delacroix, Study for the *Death of Sardanapalus* (*Cabinet des Dessins*, Louvre, Paris).

Fig. 30 Artist unknown, *Aldiborontiphoskyphorniostikos*, published 1824 (from Iona and Peter Opie, *A Nursery Companion* (Oxford 1980)).

45. Both versions are illustrated in Thompson and Wright, *op. cit.*, pp. 240-41.
46. From classical times to the nineteenth century, Arabs were often seen as acting the opposite of Westerners. Herodotus wrote: 'Concerning Egypt...the people also, in most of their manners and customs, exactly reverse the common practice of mankind', and in 1837 Prince Puckler Müskau, citing some of the same examples of opposite behaviour, wrote of Algeria, 'nearly everything is done in a manner precisely the reverse of ours'.

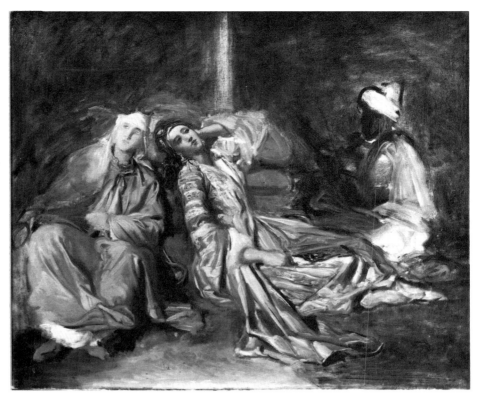

Fig. 29b Théodore Chassériau *Interieur de Harem,* oil on canvas (*Louvre,* Paris).

and time, of timelessness and uncertainty, of intimate details and endlessly vast panoramas'.

The verbal counterparts to such pictorial creativity with reference to the East occupy a complex area worth several books, but I would like to signal just one inventive type where literary and pictorial inspiration combined. Such a conjunction occurred when the 'otherness' or difference of the East provoked the writer-artist to produce verbal-visual works in which the Orient's opposition to Western 'reason'[46] was rendered by nonsense. Designed by the illustrator R. Stennett, the splendid *Aldiborontiphoskyphorniostikos* of 1824 (Fig. 30) was an alphabetical party game that challenged the ability of young and old to pronounce, read and remember testingly long, invented words, whose absurd extravagance was justified by connecting them to an 'Eastern' subject. Similarly, in words and pictures, rhyming 'Philae' with 'wily', Edward Lear could portray an 'Old Person' (possibly a Western artist or colonial, with his frock coat and clean shaven face) atop a palm — 'when the weather was calm' observing all the ruins on that magical Island.[47] Despite its simplicity, such wonderful whimsy does not limit the East intellectually, but opens it out imaginatively, like a dream.

Two final images from the early twentieth century can close out this hasty, heterodox survey of nineteenth-century approaches to the East. The first, a painting of 1904 by Osman Hamdy Bey, an artistic polymath who was one of the most distinguished figures of his native Turkey in the second half of the nineteenth century. In this work (no. 40) an Easterner has mastered and equalled the brilliant Western pictorial techniques he learned from his French teachers Gustave Boulanger and Jean-Léon Gérôme. The accuracy of the Arab text the young Emir studies, the wall of decoration, the costume he wears, the interior furnishings are beyond question. Something like a full turn of a circle has occurred; and just before Matisse began his magical transformation of North Africa into large areas of strong colour, an Easterner himself stuffed and mounted an understated *tableau vivant* of his own culture for Western consumption. As a feat of craftsmanship and adaptablity it is simultaneously extremely impressive and strangely unsettling. In a more modern work (Fig. 31) T.E. Lawrence has been portrayed, in front of an Orphist landscape that almost might have been reworked from the Camel pack. Grains of desert sand slip through his

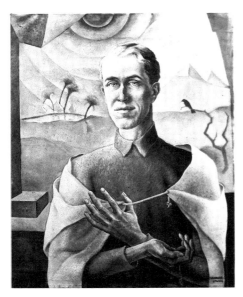

Fig. 31 Herbert Gurschner, *Lawrence of Arabia*, oil on canvas (National Gallery of Ireland, Dublin).

right hand, while his left, skeletally extended like that of a saint in a fifteenth-century Ferrarese altar, lightly fingers his simple pilgrim's cloak. Like Burton, Lawrence was one of those magical men who achieved in his life a startling, contradictory fusion of Eastern knowledge and Western fantasy, of indisputably heroic acts and fabricated myths. In a sense he was the last of the great nineteenth century Orientalists, with his extraordinary blend of imagination, experience and memory.

In our own time the ruthless 'realities' of politics and economic profit have reduced the Arab world to yet another market to be manipulated or feared, rather than understood. Such a situation hardly represents the sort of progress in which most of us would wish to believe. How can this condition change? Italo Calvino has offered the following injunction to appreciate, rather than to fear or damn, what is unusual:

> ... We must project ourselves into our own absence, the only certain thing before we came into this world or after death. Hence the pleasure of recognizing the infinite variety of what is other than us...[48]

In terms of both saving our abused planet and avoiding the staggering loss of human and natural resources from the pursuit of racial and national rivalries too often based upon childish incomprehension, Calvino's advice to forget ourselves and enjoy difference is excellent, if overly optimistic, granted the self-obsessed, self-serving nature of humankind. Yet an intense enthusiasm for what is 'other' is possible, as artists and writers (among the most self-involved of all people) have shown, without a suppression of self, indeed as part of the process of self-exploration. Much of the richness of Eastern encounters derives from a deeper perception of all the world around us, a humbling sense of complexity that Jonathan Raban saw embodied in the Arab language,[49] and others have found in Eastern social organization, religion, decoration or art. Such things should not be, as they have so often become, founts of fear and comparative rivalry, but, as they were for most of the nineteenth-century artists, (despite their Imperial fantasies and preconceptions of Western superiority), sources of visual and intellectual delight.

'Man is a prisoner of his metaphors', William Golding wrote after a visit to Egypt.[50] But the word 'metaphor', from the Greek for 'bearing across', describes an essential movement of ideas into images that Salman Rushdie has compared to the migration of people, including temporary travellers, from one country to another:

> Migrants — borne across humans — are metaphorical beings in that very essence, and migration, seen as metaphor, is everywhere around us. We all cross frontiers, in that sense we are all migrant peoples.

The quest for original and evocative Eastern metaphors does not imprison but expands the pilgrim consciousness, and an essential part of any Oriental journey is mapping one's own mind. As Maxime Rodinson, a most learned, self-critical and fair-minded scholar of the Arab peoples has written:

> There is no such thing as the East. In reality, there are simply large numbers of peoples, countries, regions, societies, and cultures that exist in our world. The perceptions held regarding a counterpart of another culture are less concerned with the reality than whether that counterpart appears to be a threat or a hope, whether it is somehow related to the observer's passions or interests or can reinforce or illustrate internal trends and currents in the observer society. Foreign peoples or cultural universes are loved or hated, not as the result of loose passions, but for reasons rooted in the observer's own society. The images held pass through the usual prism of ideological formation and evolution. This process represents a vast field of inquiry whose study has scarcely begun.[51]

47. Lear's complete limerick reads:
 There was an Old Person of Philae
 Whose conduct was dubious and wily;
 He rushed up a palm
 When the weather was calm
 And observed all the ruins of Philae.
48. 'Man, the Sky and the Elephant', preface to Pliny's *Natural History*, in *The Literature Machine* (London 1987), p. 325. Calvino's *Imaginary Cities* (London 1979), is a crucial text about travellers' perceptions of the unfamiliar. Witness the exchange between Marco Polo and the Chinese Khan after several of the Italians accounts of exotic towns, p. 69:
 'There is still one place of which you never speak',
 Marco Polo bowed his head
 'Venice', the Khan said.
 Marco smiled, 'What else do you believe I have been talking to you about?'
49. *Arabia through the Looking Glass* (London 1980), pp. 18-19. J. G. Hara's Arabic-English dictionary lists under the word 'Jawn' the meanings 'Black. White. Light red. Day Intensely black (horse)' (see John Julius Norwich, *A Taste for Travel* (London 1985), p. 20).
50. 'Egypt from my Outside', in *A Moving Target* (London 1982), pp. 82.
51. Maxime Rodinson, *Europe and the Mystique of Islam* (Seattle 1987), pp. 117, 129. Originally published as *La Fascination de l'Islam* (Paris 1980).

Narcisse Berchère

1819, Etampes (Seine et Oise) — 1891, Asnières.

When Eugène Fromentin (q.v.) wrote to Narcisse Berchère, then on his first visit to Egypt early in 1849, he agreed with his friend that Marilhat (q.v.) was 'an incomparable master' but added, 'I reckon, as you do also, that there is still something to do after him'.[1] Over twenty years later, when Fromentin was recommending that Berchère receive the Legion of Honour, his arguments in favour of the work his friend had produced made few extravagant claims for its exceptional qualities but rather stressed his assiduous consistency in making his intimate view of Egypt known to the public.[2] Acknowledging that Berchère's merits were as a colourist rather than as a draughtsman, Fromentin wrote that Berchère's painting could not be measured by individual examples, but as the continuous production of conscientious craftsmanship. Berchère got the award as requested, perhaps as much for the Egyptian sketchbook he had offered the Empress Eugénie as for the quality of his work.

Berchère's early art education was in Paris, first under Charles Renoux, then with Jean-Charles-Joseph Rémond, who also taught Fromentin. Like Fromentin, Berchère had personal predilections which led him away from the neo-classicism of Rémond's teaching to the naturalism of the Barbizon painters, though he did make one attempt in 1841 at the *Prix de Rome* in Historical Landscape. Except for the end of his life, when he developed an attachment to still life, Berchère remained a landscape painter. He travelled south to Spain in 1847, and in 1849-50 visited Egypt, Syria, Asia Minor, Turkey, Greece and its islands, and Venice. Berchère's first Salon appearance was in 1843, when he showed a view of the Auvergne, and he exhibited regularly thereafter, winning a Second Class Medal in 1859, and further awards in 1861, 1864, and 1878, in addition to the aforementioned Legion of Honour in 1870.

In the early 1850s Berchère and Fromentin shared the studio of their mutual friend Gustave Moreau, while he was away in Italy; Berchère also engraved two Moreau drawings of historical subjects. Berchère exhibited his first Orientalist work, *Jacob's Well, between Kan Leban and Naplous (Syria)*, in the 1852 Salon. In 1856 he was in Sinai with Léon Belly; he also visited Lower Egypt with Belly, Gérôme (q.v.), and Bartholdi, the sculptor of the Statue of Liberty. In 1859 Ferdinand de Lesseps chose Berchère to record the various stages of the cutting of the Suez Canal. Berchère published an account of that Eastern trip as *Le Désert de Suez, cinq mois dans l'Isthme*, in the form of letters to Fromentin, to whom the book was dedicated, and who had already published two travel books of his own. Berchère's book is eloquent about the desert, admiring:

> its unexpectedness, its grandiose poetry, its mirages and shifting reflections... The desert insinuates itself into your affections, and you feel that, however stark and Godforsaken it may appear, it is actually alive and throbbing with a life that is peculiar to it.[3]

Berchère returned to Egypt with Fromentin, Gérôme and Belly for the opening of the Canal in 1869 as a member of the official party. When Fromentin was ill on the boat at Thebes, Berchère stayed behind to care for him. Berchère was a middle-of-the-road Orientalist, undistinguished but sound, neither academic nor experimental. His Oriental scenes often represent the desert, though by adding figure groups, bits of architecture or ruins, a few palms, he produced not the 'grandiose poetry' of desert sublime but the pared-down verse of postcard picturesque. His handling is loose and vigorous, with colour and texture much more noticeable than drawing, atmosphere more prominent than anthropological detail.

1. Eugène Fromentin, *Correspondance et Fragments Inedits*, edited by Pierre Blanchon (Paris 1912), p. 2.
2. Eugène Fromentin, *Oeuvres Complètes*, edited by Guy Sagnes (Paris 1984), p. 1119.
3. Quoted in Lynne Thornton, *The Orientalists, Painter-Travellers* (Paris 1983), p. 94.

Bibliography:
Bernard Prost, *Catalogue illustré des oeuvres de Narcisse Berchère* (Paris 1885).

1 An Eastern Scene with Minaret

Oil on canvas, 41 x 32cm.
SIGNED: lower right, *Berchère*.

PROVENANCE: Sir Alfred Chester Beatty, by whom presented to the Irish Nation, 1950 and transferred to the National Gallery of Ireland, 1979.

LITERATURE: *Catalogue of the Chester Beatty Collection* (Dublin 1950) no. 2, p. 5; *National Gallery of Ireland, Illustrated Summary Catalogue of Paintings* (Dublin 1981), no. 4210, p. 11.

National Gallery of Ireland (cat. no. 4210)

In this typical small work Berchère used the shadows created by the overhanging architecture of an Arab town to establish his composition in opposition to the strong sunlight. The dark openings of merchants' stalls diminish diagonally on the right, a long shadow is cast downward by an unseen building on the left, and the viewer's eye follows this convergence, behind the lady who gracefully wields a wide load on her head, into the sheltered passage, where the picture's deepest shadows frame its brightest light. Berchere's structure is deceptively simple, but effective, just as his summary characters, many of whom lack features, are gracefully expressive in their natural and varied poses.

A similar, slightly larger scene, entitled *Merchants and Strollers in a Street Near a Mosque* was sold in the Cambacérès Sale, Paris, January/February, 1930, lot IV.

2 An Arab Caravan resting near the Shore

Oil on canvas, 81 x 101 cm.
SIGNED: lower left, *Berchère*.
PROVENANCE: Sir Alfred Chester Beatty, by whom presented to the Irish Nation, 1950 and transferred to the National Gallery of Ireland, 1979.

LITERATURE: *Catalogue of the Chester Beatty Collection* (Dublin 1950) no. 1, p. 5; *National Gallery of Ireland, Illustrated Summary Catalogue of Paintings* (Dublin 1981), no. 4209, p. 11.

National Gallery of Ireland (cat. no. 4209)

The title appears somewhat deceptive. Quite likely the boats have anchored at the left, leaving passengers to pull up the hem of their robes, pick up their small children and other worldly possessions (in one case a huge trunk) and disembark through a fairly long expanse of shallow water which stretches across about half the picture. The foreground group on the right look to be greeting the arrivals, the seated figures selling eating fowl or drinking water or offering more sensual gratification, while the Arabs on camels may be peddling trade or transport. Those receding in the right distance are probably earlier arrivals.

Berchère frequently depicted the dramatic Egyptian juxtaposition of the Nile with desert surroundings, emphasized by Arabs mounted on their tall camels. (In the previous painting and most of his other works, Berchère tended to exaggerate the height of those beasts; here they look ready to go stand in the water like great herons.) Along with the masts of anchored boats, they provide the only vertical accents in a landscape that is unremittingly horizontal. More than any narrative hints, the picture aims to convey a sense of the hot haze which descends from the dominant sky (occupying over two thirds of the composition) onto the river below.

Alexandre Bida

1823, Toulouse (Haute-Garonne) — 1895, Buhl (Alsace).

Bida is not well-known today, but he provides a remarkable example of an Orientalist who made a long and successful Salon career purely as a draughtsman. Van Gogh classed him in the company of Fabritius as a *'petit maître'* and both Baudelaire and Fromentin (*q.v.*) felt that Bida captured many of the nuances of colour with just black and white.

Much of Bida's early education came from his uncle, Abbé Regis Bida, professor at a seminary in Charleville and later canon of Rheims cathedral, with whom Alexandre was sent to study. For a while the young Bida even dreamed of following his uncle into the church, and his later Biblical illustrations may distantly reflect his early fervour. On his return to Toulouse he persisted in academic pursuits, learning Latin and Greek; but he decided he was not cut out for academic life either and went to Paris in order to further his lifelong interest in drawing.

In Paris Bida became a pupil of Delacroix (*q.v.*), and stayed with that great master for two years.[1] Although deeply devoted to his teacher, Bida seems to have been little influenced by him, except in choice of subject matter; Bida's work comes much closer to that of Decamps (*q.v.*), whose celebrated sequence of nine Samson drawings for the Salon of 1845 may well have stimulated the young draughtsman. In 1843 Bida made his first important Eastern journey, travelling initially to Venice, then on to Constantinople and Syria. His Salon debut came in 1847, the same year as Fromentin's first appearance, when Bida exhibited two drawings inspired by his visit to Constantinople. The following year he was awarded a Second Class Medal for his five Eastern drawings, which cited as inspiration Nerval's *Scènes de la vie orientale,* an early version of his *Voyage en Orient* (1851). In 1849 Bida's single Oriental submission was bought by the State, whose patronage was to continue through much of his career. In 1850 Bida made his second visit to the East, a journey to Egypt that resulted not only in further Orientalist works for the Salon but also in a collaborative book he published with E. Barbot, *Souvenirs d'Egypte.* During the 1850s Bida shared a studio with Gustave Ricard at the same address as Puvis de Chavannes.

Bida's third Eastern trip was his most wide-ranging - first to Constantinople and the Crimea, then on horseback to Syria, Palestine, and Lebanon, in the latter part of the journey sharing the tents of the desert Bedouin whose territory he traversed. This visit had substantial results. In the Salon/International Exhibition of 1855 Bida was awarded a First Class Medal and the Legion of Honour for his four Orientalist drawings and three portrait pastels, one of which represented the Count de Mornay, Delacroix's Moroccan companion and owner of one of the Eastern scenes Bida exhibited that year. Two of Bida's drawings were accompanied by explanatory quotes from *Le Nil* by Maxime Du Camp, who had made an Egyptian journey with Gustave Flaubert.

The 1857 exhibition was also very successful for Bida; his *Wall of Solomon* showing Jews at the Wailing Wall, became perhaps his most famous work and was reproduced as an enormous etching by Goupil. In the subsequent Salon Baudelaire saluted the 'remarkable intensity and depth' of Bida's drawings, so accurate that the subjects' race, religion, and native country were obvious without recourse to the works' titles.[2]

In 1861 Bida made his fourth and final trip to the East with a view to illustrating the Bible. He travelled in the Holy Land, where he met and compared notes with the celebrated scholar Ernest Renan, there researching his controversial *Life of Jesus,*[3] and made a return visit to Egypt. Back in France, New and Old Testament subjects began to feature in Bida's Salon exhibits. His illustrated edition of the Gospels was published by Hachette in two volumes in 1873 and his pictures were re-used in many subsequent French and English editions of the Bible. Bida's twenty-eight illustrations for the works of Alfred de Musset, published by Charpentier in 1865-6, comprised another important illustrative project. The Goncourts complained that the thirty thousand francs Bida was paid, comparable to prices demanded for Salon *grandes machines*, was far more than the poet ever got for his writing.[4]

Like his friend Fromentin, Bida was an artist of literary refinement. He wrote

1. *L'Atelier d'Eugène Delacroix par Maurice Sand*, Fondation George et Maurice Sand, Gargilesse, p. 7, has a 'Bidat' in 1840 as one of the 'Anciens', in his list of past and present Delacroix pupils.
2. Charles Baudelaire, 'Salon de 1859', *Oeuvres Completes*, vol. II, ed. Claude Pichois, Pleiade (Paris 1976) pp. 648-49
3. Renan had originally been sent to Syria on an archaeological expedition by Napoleon III, before going to Palestine and writing his *Life of Jesus.*
4. Eugène Fromentin, *Oeuvres Complètes*, ed. Guy Sagnes (Paris 1984), p. 1118.

verse and at age forty-eight translated into alexandrines the fourth book of the *Aeneid*; he also illustrated and adapted into modern prose and verse *Aucassin and Nicolette*, a medieval *chante-fable* detailing the star-crossed romance between the son of a French lord and a captured Saracen girl. Little-known at Bida's death were his forty watercolours after Shakespeare and illustrations for Molière. Most of the last two decades of Bida's life were spent in the Alsatian countryside, although he continued to show in the Salon and to visit his friends in Paris. In his successful recommendation of 1870 that Bida be promoted to Officer of the Legion of Honour, Fromentin wrote that Bida was without question the premier draughtsman of France, who used black and white 'like a palette'.[5]

Baudelaire was right to single out the 'intimate expression' of the figures in Bida's works. Almost all of his drawings stress the interaction of a few characters, their fairly simple backgrounds mainly exercises in light and shadow, after the example of Bida's favourite artist Rembrandt, one of whose works he journeyed to Dresden six months before his death to copy. A handsome portrait drawing of Bida by Henri Regnault (*q.v.*) is in the Louvre *Cabinet des Dessins*.

5. *Ibid.*

Bibliography:
Alexandre Bida, Studio Sale, 26-30 April, 1895, Paris. Introduction by André Michel.
Jules Claretie, 'Les Dessins de M. Bida', *Peintres et Sculpteurs Contemporains* (Paris 1873), pp. 126-30.
Eugène Delacroix: Son Atelier et la critique d'art, Musée Eugène Delacroix, June-August, 1967.
Gaston Paris, 'Souvenirs sur Alexandre Bida', *Gazette des Beaux-Arts*, 1er avril, 1895, Tome 13, troisième période, pp. 332-45.
The Second Empire: Philadelphia, Detroit, Paris, October 1978 - July 1979 p. 365.

Fig. 32 Photograph of an Eastern street musician (Author's collection)

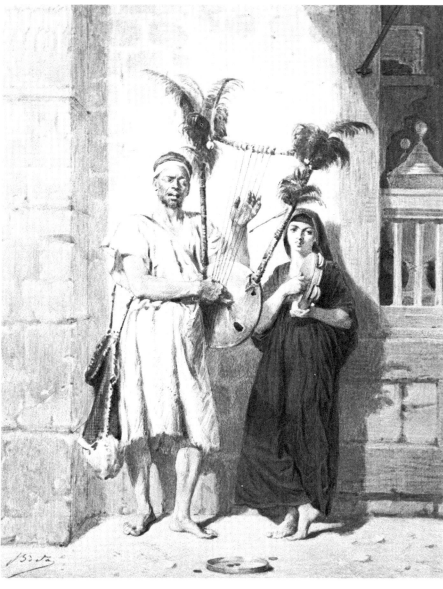

3 The Blind Musician

Black chalk and ink touched with white on card, 30.9 x 23.9 cm.

SIGNED: lower left, *Bida*.

PROVENANCE: Christies' sale, 18 January 1972, lot 65; Rodney Searight Collection.

EXHIBITED: 1980-1981, *A Middle Eastern Journey: Artists on their travels from the collection of Rodney Searight* (Catalogue by Rodney Searight and Jennifer M. Scarce), Edinburgh and Norwich, no. 44, p. 13.

LITERATURE: Philippe Jullian, *The Orientalists* (Oxford 1977), p. 183 (illus.); Briony Llewellyn, *Catalogue of the Searight Collection*, (forthcoming).

Searight Collection, Victoria and Albert Museum, London

1. Photograph courtesy of Luke Dodd, Strokestown House.

Accompanied by an unveiled young woman, who somewhat listlessly provides percussion, a blind bearded busker plucks the strings of an exotic Eastern instrument, a kind of cross between a lyre and a primitive six-string banjo. Its sounding board of stretched skin is a circular shape which echoes not only the accompanying tambourine but also the shallow pan which has caught two of the four coins cast by passing patrons. The instrument is festooned with ostrich feathers and, apparently, two medallions. The singer wears a simple coarse tunic and supports under his right shoulder a sack only slightly filled, which may well contain his meagre worldly goods. The execution of the drawing is highly skilled and controlled, the strings of the instrument carefully ruled. Yet despite the obvious message of visual authenticity it aims to project, Bida's original impression has clearly been crafted into the structures of 'art'. The background wall exists mainly as theatrical scenery to set off the principals, both of whom, on an income of a mere four copper coins or so, appear entirely too well fed, healthy and clean. The woman has a soulful idealized beauty not far removed from that of Bouguereau (see no. 6), while, with only slight modifications of dress, the musician looks strong enough to participate in epic Neoclassical conflict. A roughly contemporary photograph (Fig. 32)[1] shows, similarly posed and performing, the harsher ragged reality of an Eastern street musician. The juxtaposition of an aged, infirm or blind Oriental with a youthful companion was a fairly common subject (see also O'Kelly, no. 78). Dating the drawing is difficult; Briony Llewellyn thinks that it may be a rejected possible drawing for *Souvenirs d'Egypte*, which Bida published with E. Barbot in the early 1850s, while Philippe Jullian suggested it was done c. 1860.

Rosa Bonheur

1822, Bordeaux, — 1899, Chateau de By, near Fontainebleau.

Inevitably feminism has led to revaluations of and new perspectives on Rosa Bonheur, who constitutes a cultural phenomenon of considerable importance, both heroine and victim of the longstanding difficulties women have faced in the pursuit of a career in painting. Germaine Greer has argued that Bonheur's unorthodox escape from her own family into a sequence of all female *ménages* provided her with 'a fostering environment, almost unique in the annals of gifted unmarried women'[1], free from the usual female obligations to feed and sew, nurse and clean. At the same time Greer shrewdly suggested that the extraordinary praise Bonheur received as an unprecedented phenomenon, the 'greatest woman painter', operated on one level as a strategy that not only absolved her enthusiasts from resurrecting and reconsidering any previous women artists for comparison[2] but also allowed Bonheur to be set up as some arbitrary absolute standard by which subsequent women painters could be found wanting.[3]

Bonheur's father Raimond was a Bordeaux artist, whose idealistic pursuit of his progressive social views often caused him to neglect both his family and his painting. The title of a landscape he submitted to his first Salon, *A Pilgrim without Shelter in the Storm* (1831), and a pamphlet he co-authored that same year, *The Notebook of the Theogynodemophile*, who was described as 'the friend of God, women and the people',[4] exemplify his sympathetic, naive and impractical nature. Rosa was the eldest of four children, all of whom became artists: Auguste (2 years younger), Isidore (5) and Juliette (8).

Bonheur's mother Sophie had met Raimond as his pupil and was gifted artistically and musically — she sometimes supported the family by giving piano lessons. When the young Rosa had difficulty learning to read, her mother taught her the letters of the alphabet using corresponding pictures of animals, such as C for *chat*, and her early attachment to animal images grew into the central fact of her creative life. In a sense she chose to become an 'animal', in her search for a simplified art and existence free from the conflict, hunger and suffering that had so troubled her father in the human species in general, as well as in his own family in particular. Bonheur was astute enough to acknowledge later that, in her career as an animal painter, and her life-style as an animal lover, she had made a decision to opt out of the difficulties of a more conventional existence, characterising herself variously as 'a dog', 'a tortoise', 'a bear', 'an old owl',[5] and 'an old rat, who after sniffing about over hill and dale retires quite satisfied to his hole, yet in reality somewhat sad to have seen the world without taking part in it'.[6] Some of her statements jokingly acknowledged her deep affection for animals as a kind of sexual sublimation, 'the fact is, in the way of males, I like only the bulls I paint',[7] and 'I had for the stables a more irresistible taste than ever a courtesan for the royal or imperial antechamber'.[8] Even her close female friendships and celebrated cross-dressing (for which she secured a special police permit, signed by her doctor, 'for health reasons'[9]) seem to have been motivated less by a dislike of and a desire to avoid men, than a refusal to accept the consequent conflicts, upsets and excitement that ritually attended traditional approaches to sexual difference.[10]

Bonheur's first Salon appearance was in 1841, when she showed a painting of *Rabbits Nibbling Carrots* (Musée des Beaux-Arts, Bordeaux) and a drawing of *Goats and Sheep*; she would exhibit in every succeeding Salon until 1855. By that time she had been taken under the wing of the dealer Ernest Gambart. During the next fourteen years he paid her well over a quarter of a million francs for twenty-one pictures, which were, in turn, disposed of for more than a million francs during the last quarter of the century, mainly to English and American patrons.[11] Bonheur polished rather than developed her talents, which lay mainly in great precision and accuracy of drawing, and a considerable gift for portraying animal personality and depicting animal motion. She was quite uneven as a colourist, rather better when she was younger; her *Labourage Nivernais* (Musée National du Château de Fontainebleau) of 1848, seen by many as the painted counterpart to George Sand's famous peasant novel *La Mare au Diable*,[12] brought her 3,000 francs as a commission from the 1848 Republican government at the same time as Daubigny was getting 500 francs for one of his

1. Germaine Greer, *The Obstacle Race* (London 1979), p.21.
2. *Ibid*, p. 75.
3. *Ibid*, p. 320.
4. Alfred Boime, 'The Case of Rosa Bonheur: Why Should a Woman Want to be More Like a Man?' *Art History*, vol. 4, no. 4 (December 1981), n. 18, p. 406.
5. *Ibid*, p. 395.
6. Dore Ashton and Denise Brown Hare, *Rosa Bonheur, a Life and Legend* (New York 1981), p. 159.
7. Theodore Stanton, *Reminiscences of Rosa Bonheur* (New York 1910), p. 366.
8. Ashton and Hare, *op. cit.*, p. 10.
9. The health certificate is reproduced in Stanton, *op. cit.*, p. 364, and in Ashton and Hare, *op. cit.*, p. 57.
10. Several men, including Frederick Goodall (*q.v.*), who painted Bonheur's portrait when she visited England, described her as quite coquettish and charming in her behaviour towards them.
11. Jeremy Maas, *Gambart: Prince of the Victorian Art World* (London 1975), p. 82.
12. Bonheur was constantly compared to Sand, a woman she much admired.

pictures;[13] and it is an impressive image. Her greatest work, the only time where her ambition really stretched her ability, was *The Horse Fair* (Metropolitan Museum, New York) an obvious attempt to place herself in the artistic line of the Parthenon frieze, Leonardo's *Anghiari* and Gericault's *Riderless Horse Race*. Although the painting was ultimately marketed successfully by Gambart, Bonheur initially had trouble selling it, and for the rest of her life settled for safer works, painstakingly crafted, limitlessly repeated. Delacroix (*q.v.*), in an exhibition of 1849 was pleased by the juxtaposition of one of his imagined lions alongside a group of accurate Bonheur cows, writing:

> there is something in painting other than exactness and precise rendering of the model.[14]

And certainly her obsession with visual fidelity, translated into careful finish, did limit the scope of her expression. Ruskin's claim that she would never be able to represent animals properly because she had never learned to paint humans [15] seems less just, since, on many significant levels animals *were* more important than humans to her.

In 1889 Bonheur painted Buffalo Bill when his Wild West Show visited Paris. The Wild West was in many ways America's Exotic East, and an extraordinary poster of the time shows Bonheur seated at an easel before her Buffalo Bill portrait, flanked, on the right, by a dashing mounted Buffalo Bill, and on the left, by a paunchy Napoleon, who also sits astride a white horse.[16] The equivocal image, balancing two quite different sorts of colonial conquerors with the diminutive French artist as the equating sign, or common denominator, suggests, with some justice, that her art was less about true liberation than about the conventional male exercise of power and authority.

13. F21 file no. 16 of *Archives Nationales*, quoted in T.J. Clark, *The Image of the People* (London 1973), no. 10, pp. 32 and 193.
14. Eugene Delacroix, *Journal* (Paris 1932), vol. 1 (5 March 1849), p. 271.
15. John Ruskin, *Academy Notes, Notes on Prout and Hunt and other Art Criticisms, 1855-1888* (London 1904) (Collected Works, vol. XIV), pp. 173-74.
16. The poster is illustrated on page 156 of Ashton and Hare, *op. cit.*

Bibliography:
Alfred Boime, 'The Case of Rosa Bonheur: Why Should a Woman Want to be More Life a Man?', *Art History*, vol. 4 no. 4 (December 1981).
Anita Brookner, 'Ploughing a provincial furrow', *Times Literary Supplement*, (16 October 1981), p. 1189.
Anna Klumpke, *Rosa Bonheur, sa vie, son oeuvre* (Paris 1908).
Theodore Stanton, *Reminiscences of Rosa Bonheur* (New York 1910).

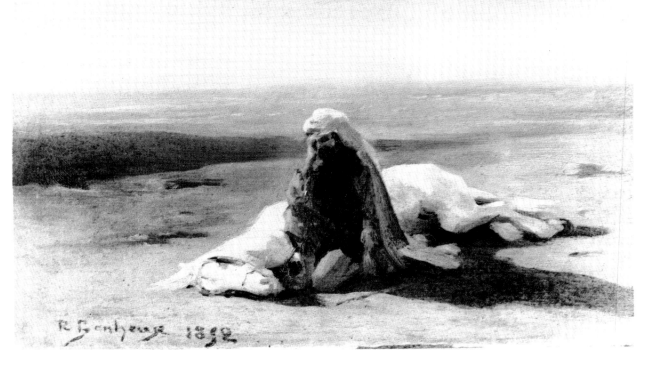

4 Arab and a Dead Horse

Oil on canvas, 20 x 34 cm.

SIGNED AND DATED: lower left, *R. Bonheur 1852.*

PROVENANCE: anonymous sale, Christie's, 16 June 1877, lot 46 bt. Morley. W. G. Herbert from whom purchased by George Holt; Miss Emma Holt, by whom bequeathed to the Walker Art Gallery, 1944.

LITERATURE: *Walker Art Gallery Foreign Schools Catalogue* (Liverpool 1977), no. 184, p. 26.

1. Albert Boime, 'The Case of Rosa Bonheur: Why Should a Woman Want to be More like a Man?', *Art History*, vol. 4, no. 4 (December 1981), pp. 387-98.
2. Following her father home from a visit to her mother's grave, she pitied her preoccupied papa and thought that she would soon be on her own: 'Then my affection for him gave me the idea of placing my feet in his footsteps. Whence came this thought, surprising for a child? Perhaps from my mother'. Anna Klumpke, *Rosa Bonheur, sa vie, son oeuvre* (Paris 1908), p. 164, cited in Boime, *op. cit.*, p. 389. Her mixed identifications with and devotion to both parents are conveyed in this story.
3. Reproduced in Theodore Stanton *Rosa Bonheur: Reminiscences* (London 1910), p. 39. The drawing is by Paul Chardin.
4. Klumpke, *op. cit.*, p. 168, cited in Boime, *op. cit.*, p. 389.
5. See Gerald Ackerman, *Jean-Léon Gérôme* (London 1986), no. 220, p. 232, colour pl. p. 90.

This painting is unusual in Rosa Bonheur's work for two reasons, first its Eastern subject, and secondly the fact that it was not done from life studies. With regard to the latter characteristic, her handling is unusually fluid; she commonly carried over into her painting the fanatic precision of her drawing. Here with considerable economy of means she has depicted an Arab alone in a desert at sunset, devastated at the loss of his white horse. Although his sadness could well stem from the fact that his own death must inevitably follow, the context of the picture suggests mainly mourning for his beloved animal. Supported by his right hand, his eyes fall and his head drops; he crouches on his left knee, his useless crop fallen at his side.

In terms of pictorial subject matter the East was traditionally an arena in which sensitive issues of politics and sexuality could be treated without serious attempts to understand their relevance to contemporary Western society or the artist's own psychology. Granted the fact that this small picture is an exceptional item, a work completely of the artist's imagination, its content can possibly be read symbolically. Two remarks from Albert Boime's rich article 'The Case of Rosa Bonheur' can be invoked: first, that her father provides 'the key to understanding her personality', and secondly, that a 'fundamental trait' of her work is 'the personalization of animals'.[1] Applying these points to this spontaneous image of grief suggests that it may be read as an allegory of her own deep sorrow not only at the relatively recent death of her father (1849) but also her lasting sadness from the much earlier death of her mother. So that the picture evokes not only her father (and herself)[2] grieving over her mother, but also Rosa alone grieving over her father. Like all good Saint-Simonians, and the Arab in the picture, her father Raimond sported a beard, while the Arab's anthropologically suspect turban is surprisingly like the eccentric bonnet and headgear Rosa herself wore.[3] The white horse is an appropriate symbol both for her mother, who appeared to her dressed in white in a dream,[4] and continued as her 'guardian angel', and also for her father, the quixotic crusader for social change.

A remarkably similar subject, entitled *In the Desert* was painted twenty years later by Jean-Léon Gérôme.[5]

Richard Parkes Bonington

1801, Arnold, near Nottingham, — 1828, London

Although not yet twenty-seven when he died, Bonington had already brought a special brilliance to English and French painting. With the slightest irreverent addition, one could borrow for him the self-penned epitaph of John Keats, also dead of consumption only a few years earlier, half a year younger:

> here lies one whose name was writ in water(colour).

For although Bonington did work in oil, like Turner (q.v.) his watercolour mastery informed and influenced his painting in the other medium.

Bonington's feckless father had a gift for art — he exhibited a landscape at the Royal Academy in 1797 and a portrait in 1808 — but was, in the words of the Redgraves, 'one of that unhappy class born to be the torment of others'.[1] He lost his job as governor of Nottingham county gaol, in which post he had succeeded his father, and by bad behaviour broke up a school run by his wife. The family fled to France, where the father started a lace factory in Calais, and Richard studied with Louis Francia, who later instructed Wyld (q.v.). The wayward father then moved them to Paris, where his son, only fifteen, began working in the Louvre. Delacroix (q.v.) much later gave an account of meeting him there, noting the stunning copies the silent youth made after Flemish landscapes in watercolour, then an English novelty.[2] According to Delacroix, Bonington worked with Baron Gros around 1820. Originally annoyed by Bonington's failure to conform to academic norms, Gros saw one of his watercolours for sale in a shop and, embracing Bonington before the other students, advised him to go his own way. From the start Bonington had no trouble selling his work through dealers like Schroth, one of the first establishments to satisfy a new public enthusiasm for drawings and small pictures.

In 1825 Bonington and Delacroix met in England, where they worked together copying Dr. Meyrick's extraordinary collection of armour. Back in Paris later that year, the two worked together in Delacroix's studio. Writing after Bonington had left, Delacroix said:

> There's an awful lot to be gained from the company of that droll fellow, and I swear I'm all the better for it.[3]

Bonington first exhibited at the Salon before he was twenty, and in 1824 received, along with Constable and Copley Fielding, a gold medal for his contribution, official recognition that reflects the stimulating effect English landscape painters had on the early development of the famous French nineteenth century school. At about the same time Bonington also worked on Baron Taylor's celebrated *Voyages pittoresques dans l'ancienne France*, to which, among others, Dauzats (q.v.) also contributed. Bonington only began working in oils around 1824-25; perhaps Delacroix traded tips in oils for tuition in watercolour. Bonington's first English exhibition at the British Institution in 1826 included two French coastal views. The following year he showed at the Salon two Venetian scenes inspired by a visit to Italy, two historical subjects, a view of Rouen Cathedral and *The Tomb of Saint-Omer*. Some of these works he re-exhibited in 1828 at the Royal Academy, where he had made his first appearance the year before. Bonington's genre and historical pieces not only reflected his strong interest in drama, which he almost followed as a career instead of art, but also relate closely to contemporary work done by Delacroix. Indeed Delacroix's *Marino Faliero* in the Wallace Collection has been described as 'Bonington's Masterpiece'.[4]

In 1827 Bonington set up a Paris studio in St. Lazare, where he worked continuously on his many commissions. But he soon became extremely ill and went into an irreversible decline that ended with his death back in England. Perhaps appropriately: more than any other painter he had successfully linked the artistic schools of the two countries, but it is as one of the jewels in the English watercolour tradition that he shines the brightest, undimmed by aged decline or excessive production.

1. Richard and Samuel Redgrave, *A Century of British Painting* (London 1947), p. 409.
2. Eugène Delacroix, *Correspondance*, ed. André Joubin (Paris 1938), vol. IV (30 November, 1861), pp. 285-9. This important letter was written in response to a request for details about Bonington from the famous art critic and historian Théophile Thoré; he later republished it in his *Histoire des peintres de toutes les Ecoles*.
3. *Ibid*, vol. I (31 January 1826), p. 173.
4. A painting of *The Doges Palace* given to Bonington in the National Gallery of Canada in Ottawa (reproduced in *The National Gallery of Canada: Catalogue of Paintings and Sculpture*, 1959, p. 57) has exactly the same setting as Delacroix's famous picture.

Bibliography:
A. Dubuisson and C.E. Hughes, *Richard Parkes Bonington: His Life and Work* (London 1924).
Atherton Curtis, *Catalogue de l'Oeuvre Lithographié et Gravé de R. P. Bonington* (Paris 1939).
Carlos Peacock, *Richard Parkes Bonington* (London 1979).
Marcia Pointon, *The Bonington Circle: English Watercolour and Anglo-French Landscape* (Brighton 1985).
Andrew Shirley, *Bonington* (London 1940).
R. P. Bonington, 1808-1828, Castle Museum and Art Gallery, Nottingham, 10 April-22 May, 1965.

Fig. 33 Richard Parkes Bonington, *The Chibouk,* oil on canvas (sold, Sotheby's, New York, 24 February 1988).

5 The Chibouk

Oil on canvas, 24 x 29.2 cm.

PROVENANCE: Messrs. Agnew, London, from whom purchased, 1902.

EXHIBITED: 1937, *An Exhibition of Pictures and Drawings by Richard Parkes Bonington and his Circle,* Burlington Fine Arts Club, London, no. 30; 1966, *Bonington: Un Romantique Anglais à Paris,* Musée Jacquemart Andre, Paris, no. 82, p. 35.

LITERATURE: Andrew Shirley, *Bonington* (London 1940) pl. 97, p. 104; *National Gallery of Ireland Illustrated Summary Catalogue of Paintings* (Dublin 1981), no. 537, p. 14.

National Gallery of Ireland (cat. no. 537)

1. Sotheby's, New York, 24 February 1988, lot 17. I am grateful to Mark Murray for showing this painting to me.
2. According to the entry in the Burlington Fine Arts exhibition of 1937 the identical orientation of the Dublin picture and the Lane lithograph suggests that the print was based on the Dublin work and not the Sotheby painting. The measurements of the picture in the sale of Lawrence's collection of 15 May 1830, no. 87 (12¼" x 15¼") show that it could only be the Sotheby painting; and, since prints often reverse compositions, there is the possibility that the Dublin picture is a copy made *after* the Lane lithograph, in which case it could not be by the artist himself (who was dead), but, most likely, by his unscrupulous father, who was known to forge his son's work. The handsome Dublin painting has never previously been doubted, but there are bothersome details. Its freedom might be explained by its being the original sketch; but it lacks the interest in specific and accurate detail that in one sense was the whole point of the exercise.
3. Robaut, no. 977, p. 256, generally dated 1825, illustrated in colour in *Tout l'oeuvre peint de Delacroix* (Paris 1981), pl. X (no. 111).
4. Eugène Delacroix, *Correspondance,* ed. André Joubin (Paris 1838), vol. IV (30 November 1861), p. 288.

The Dublin painting is one of two known versions of the subject. A slightly larger composition, in reverse (Fig. 33), recently sold in New York by Sotheby's [1], once belonged to Thomas Lawrence and Samuel Rogers. It was also possibly the *Turk* that was exhibited in the British Institution in 1829, the year after Bonington's death. A lithograph by R.J. Lane in *Imitations of Sketches by Modern Artists* (London 1829), identified as reproducing the Lawrence-Rogers painting, reverses the composition and thus comes close to the Dublin work.[2] A less exact variant is the watercolour in the Wallace Collection of a *Turk Reposing*, orientated in the same direction as the Sotheby picture.

The Wallace Collection also owns a watercolour of a lovely female counterpart, called *Medora* after the heroine of Byron's *The Corsair*. Both of these watercolours are dated 1826, which, although Bonington's signatures and dates are often suspect, can be taken as a reasonable date for the two oil paintings. Thus they were done just after the period in which Bonington and Delacroix worked together in the latter's Paris studio, when they both executed paintings of Count Palatino in exotic costume. The Bonington reclining Turk has a counterpart in a handsome small Delacroix of a seated Turk in the Louvre,[3] and Delacroix's justly famous *Woman with a Parrot* (Musée des Beaux-Arts, Lyons), a nude odalisque, also came out of that exciting stint of shared enthusiasm for exotic stuffs. Bonington was at the same time working on genre and historical scenes, mostly on a similarly diminutive scale, while Delacroix leapt right from the small studio sketches into the middle of an enormous Salon extravaganza like his *Sardanapalus*. Bonington occasionally thought he should be doing the same, according to Delacroix, who endeavoured to reassure his younger friend that what he did was not only special but in its own way almost perfect:

I used to say to him sometimes, 'You are king in your own realm and Raphael could not have done what you do. Don't worry about other people's qualities or the proportions of their pictures, since your own are masterpieces.[4]

Adolphe William Bouguereau

1825, La Rochelle — 1905, La Rochelle.

Bouguereau's father was of English descent, hence perhaps the anglicized 'William' by which the artist became known. Théodore Bouguereau was a La Rochelle wine merchant, who moved his family to the nearby town of Saint-Martin on the *Ile de Ré* before William was eight. Like Bida (*q.v.*) Bouguereau was educated by an uncle who was a clergyman, and he received his first art lessons from Louis Sage, an Ingres pupil. By Bouguereau's sixteenth birthday his father had shifted the family to Bordeaux, where he sold olive oil. There Bouguereau attended the municipal school of drawing and painting and was taught by Jean-Paul Alaux.

Some years later in 1846 his instructor recommended him to the studio of François-Edouard Picot, who in turn gained him a place as the ninety-ninth of a hundred students accepted for the *Ecole des Beaux-Arts*. The first prize Bouguereau won as a student there was for perspective, while most of his later ones were for figure studies or compositions. In his initial attempt at the *Prix de Rome* in 1848 Bouguereau was second runner-up, in his second he did not place, and on his third try, although the Grand Prize was given to Paul Baudry, there was an extra vacancy at the Villa Medici and a second Grand Prize was awarded to Bouguereau. Having finally planted his foot on the yellow-brick road to official success, Bouguereau never again left the path. He was awarded the Legion of Honour in 1859 and in 1876 became both an officer of the Legion of Honour and a member of the Institute, claiming a chair which his discouraged fellow *Rochelais* Fromentin (*q.v.*) was too weary to contest.

The year before Bouguereau had become a Professor at the *Ecole des Beaux-Arts*, and he also taught for many years at the Academie Julian, which was attended by Lavery (*q.v.*), Melville (*q.v.*), and many other English and American students. Among the latter group was Elizabeth Jane Gardiner, whom Bouguereau married after his wife died and who painted in a startlingly similar style to her husband.

Bouguereau's success was abetted as much by new reproductive methods as from official endorsement. Like Gérôme, (*q.v.*) Bouguereau had his work popularized by his dealer Goupil, who created and fed a popular demand for Bouguereau's imagery through the sale of prints and photographs. Direct in sentiment, slightly oblique in sexuality, and painstaking in technique, Bouguereau tugged at the heartstrings, gently aroused the libido, and impressed the eye. The qualities that endeared him to the public in his own day have damned him in ours, but there are signs of a reassessment, and not just from uncritical champions. E. H. Gombrich over twenty-five years ago called accusations of insincerity or untruthfulness in Bouguereau's paintings 'nonsense', and thought that disgust with them as cloying was an 'adult' disdain for the visually obvious, 'a surfeit of oral gratification' which rejects a childish regression to the sweet bond of mother and child, one of Bouguereau's favourite subjects.[1]

More recently Henri Zerner and Charles Rosen have suggested that Bouguereau created not so much high art in the academic tradition as 'a very original form of kitsch' that is 'impressive, disquieting and, above all, modern'[2]. The imagery Goupil reproduced to boost sales and add to royalties was in turn taken up by advertisers who pirated Bouguereau types, poses, and compositions for their publicity. Thus, functioning as a fertile fount of low art imagery, Bouguereau curiously undermined the very tradition he was seen to embody.

1. E.H. Gombrich, 'Psycho-Analysis and the History of Art', in *Meditations on a Hobby Horse* (London 1963), p. 38.
2. Charles Rosen and Henri Zerner, *Romanticism and Realism* (London 1986), p. 209.

Bibliography:
William Bouguereau, Paris, Montreal, Hartford, 9 February, 1984 — 13 January 1985.
Charles Vendryes, *Catalogue illustré des oeuvres de W. Bouguereau* (Paris 1885).

Fig. 34 Print after Bouguereau, *Pomegranate Seller* (Witt Library, London).

6 The Pomegranate Seller

Pencil with white highlights on grey paper, 29.7 x 24.8 cm.

SIGNED: lower right, '*Wm Bouguereau*'.

PROVENANCE: purchased, 1965.

Visitors of the Ashmolean Museum, Oxford

1. Another exception was the painting of a *Standing Algerian Girl* sold at Sotheby/Parke-Bernet in New York on 16 January 1975, lot 143.
2. *William Bouguereau*, 1984-85 exhibition catalogue, *op. cit.*, fig. 105, p. 135.
3. *Ibid*, no. 66, p. 196.
4. Charles Vendryes, *Catalogue illustré des oeuvres de W. Bouguereau* (Paris 1885) p. 53. Vendryes also lists for 1875 another Eastern subject *The Oriental Woman of Granada*, but I have not been able to locate this painting.
5. The other main use of the pomegranate is as a symbol of the resurrection.

Eastern subjects are not common in Bouguereau's work, [1] yet in both pose and expression this seated figure is consistent with many of the artist's paintings of Western types. To give two examples: the breakfasting young heroine of *Le dejeuner du matin*[2] is seated on the ground in a similar fashion and engages the spectator with an identical soulful stare, while the girl sitting on a rock *Au bord du ruisseau*[3] clasps the ankle of her bare foot in much the same way. Bouguereau has less adopted the conventions of Orientalist painters than he has dressed and made up one of his own typical females to play act an *Orientale*. (Renoir did much the same thing at about the same time). The recurrent child-woman gaze, which clearly engages the spectator rather than reflecting back into itself, is intensified by the darker eyes and complexion of the unfamiliar role. If emotionally the Oriental woman reiterates the sentimental-sexual appeal of so many of the artist's subjects to the parent-lecher in the male viewer, stylistically she demonstrates Bouguereau's almost disdainful ease with, and control of, the difficulties associated with two-dimensional representation. His depiction of hands and, especially, feet, the bane of unsure figure draughtsmen, is masterful; without a rule, the perspective of the receding architecture is rendered with economy and precision; delicate white highlights are used sparingly but effectively, notably on the medals which decorate the woman's necklace and on her nose, cheek and chin; and a few quick scribbles immediately behind her effectively suggest flaking plaster on the wall.

A black and white print from an unidentified German periodical in the Witt Library (Fig. 34) indicates the painting for which the drawing is a study. A less clear lithograph of the same picture entitled *The Pomegranate Seller*, in Charles Vendryes' 1885 catalogue of Bouguereau's work,[4] is dated 1875 and listed as belonging to the King of Holland, in which Royal Collection it probably remains over a hundred years later.

The pomegranates apparently on offer in the basket here might carry one of their two principal symbolic suggestions, that of chastity[5]. As Greuze had understood so well the century before, Bouguereau knew that innocence had its own special sexual zing for certain sensibilities.

48

Hercules Brabazon Brabazon

1821, Paris, — 1906, 'Oaklands', Battle, Sussex.

Reading like a misprint, Brabazon's unforgettable and absurd double name resulted from a condition of his Irish uncle's will, which required him to replace his surname of 'Sharpe' when his older brother died and he inherited his mother's family property in Connaught. Eleven years later he also came into his father's Sussex estates at Oaklands and was to be financially independent for the rest of his life. Never married, he led a privileged existence devoid of almost any obligations. Earlier he had attended Harrow and taken an honours degree in mathematics from Trinity College, Cambridge, but for the rest of his lengthy existence — he was almost eighty-five when he died — did pretty much as he pleased. What pleased Brabazon was travelling, playing the piano, conscientiously filling nearly eighty commonplace books with clippings and *aperçus*, and painting watercolours. The last occupation he and others regarded as the most significant.

Upon leaving university Brabazon had rejected his father's urgings to go to the bar and instead had travelled to Rome, where he stayed for three years and studied painting with J. H. D'Egville and Alfred Fripp, the first and last formal training he received. The death of his brother brought about his name change and altered the direction of his life and art. The budding professional became the 'perfect amateur'.[1] He travelled to Spain, where he discovered Velazquez, who, after Turner, would remain his greatest enthusiasm. Henceforth, Brabazon's only study would be via his summary 'interpretations' of the works of other masters. He did over a thousand of these 'transcripts into his own language',[2] almost half his total output.

Moving in cultivated society, Brabazon met many famous people. He knew Ruskin well and travelled with him in France. The distinguished critic is reported to have said to a mutual friend in 1882: 'Brabazon is the only person since Turner at whose feet I can sit and worship and learn about colour'.[3] Easily depressed by bad weather Brabazon sought the sun; and it was almost inevitable that an interest in North Africa should evolve out of his devotion to Spain and Italy.

Brabazon visited Algeria in 1868, and journeyed up the Nile in 1874 and 1877. Apart from the general broadening of his style as he got older, his approach to Oriental subjects seems no different from his views of the Northern Mediterranean, dealing as they do with the same problems of representing strong sunlight and colour via the luminosity of the watercolour medium. Brabazon's favourite contemporary painter is said to have been Claude Monet.

Brabazon's debut as a professional artist came at the astonishing age of seventy. Proposed by Wilson Steer, he was elected a full member of the New English Art Club. His two works for their winter show were well-received; George Moore called him 'our modern Lazarus', and found it appropriate that 'the present generation, with its love of slight things, came upon this undiscovered genius'.[4] Brabazon's two works in the winter show of 1891 were followed by two more in the summer exhibition of 1892, and a group of friends, led by John Singer Sargent, persuaded him, overcoming his considerable reluctance, to have a one-man show at the Goupil Gallery. Sargent, who once did a superb portrait drawing of Brabazon,[5] contributed an introduction to the catalogue, where Brabazon's lifelong freedom from economic worries was seen as the precondition for 'the exclusive following of a personal inspiration'.[6] Some critics were even more effusive; D. W. MacColl in the *Spectator* called Brabazon 'the best watercolour painter we have had since Turner'.[7]

As Oriental images and as pictorial craft, Brabazon's watercolours superficially reflect back to some of the century's earliest and richest examples of the 'experienced' Orient: Delacroix's rapid and exciting sketches from his Moroccan journey. In intention and expression, however, they are far removed from the passion and excitement of that artist and are almost closer to the colour snapshot of today's travelling camera buff, a swift slight record of one of many passing exotic sensations.

1. C. Lewis Hind, *Hercules Brabazon Brabazon, 1821-1906, His Life and Art* (London 1912), pp. 6, 26.
2. Martin Hardie, quoted in Hind, *op. cit.*, p. 26. Seven of the National Gallery of Ireland's seventeen Brabazon watercolours are interpretations.
3. Hind, *op. cit.*, p. 6.
4. George Moore, 'The New English Art Club', published in *The Spectator*, (December 1892), reprinted in *Modern Painting* (London 1898), pp. 208-20.
5. Reproduced as the frontispiece in Hind, *op. cit.*
6. Goupil exhibition, December 1892, quoted in Hind, *op. cit.*, p. 85.
7. Quoted in Hind, *op. cit.*, p. 87.

7 The Lion Courtyard, the Alhambra, Granada, Spain

Pencil and watercolour on paper, 34.7 x 25.2 cm.

INITIALLED: lower left in blue crayon, *HBB*, lower right in pencil, *HBB*.

INSCRIBED: in brown ink over pencil, *Alhambra*.

PROVENANCE: Mrs Brabazon Combe, the niece of the artist, by whom presented, in memory of her husband, Harry Trewythen Brabazon Combe, 1926.

LITERATURE: *National Gallery of Ireland Illustrated Summary Catalogue of Drawings, Watercolours and Miniatures.* (Dublin 1983), no. 2763, p. 21.

National Gallery of Ireland (cat. no. 2763)

Spain is not strictly speaking a part of the East, but the Islamic conquest in the ninth century made it the most important site of Arabic art and learning in Europe. For many Grand Tour travellers, the Alhambra Palace became that first taste of Oriental culture which stimulated more extended visits to North Africa and the Holy Land. 'Alhambra' is a Christian corruption of 'Al Qal'a al-Harma', which means 'the red castle', a name suggested by the colour of the clay which went into its construction.

The Lion Courtyard, or Court of the Lions, is the most famous of all sights in the Alhambra. In the centre is a fountain falling into a twelve-sided bowl above twelve hieratic lions who spout water between their teeth. A poetic inscription on the side of the bowl wonders what further extremes of ferocity these animals might have expressed had not their respect for the caliph restrained them. Shallow channels circulate the cooling water out in all four directions.

Chateaubriand wrote a famous poem about the Granadine Moors entitled 'Le Dernier des Abencérages', while Victor Hugo rhapsodized about the Alhambra in his poem 'Grenade' from *Les Orientales* (1829). Washington Irving published his *Chronicle of the Conquest of Granada* in 1829 and his *Tales of the Alhambra*, dedicated to the painter David Wilkie (*q.v.*), appeared in 1832. For many other Romantic writers it became an essential place of pilgrimage. Artists such as David Roberts (*q.v.*), J. F. Lewis (*q.v.*), Gustave Doré, and Henri Regnault (*q.v.*) used their skills to make its beauties more widely known.

Brabazon's first visit to Spain was in 1848, after his three years of study in Rome, and he was to return frequently. It is quite likely that this work is earlier than the other watercolours on display, since the drawing is so predominant. In many ways it is more of a tinted drawing than a watercolour, since slight touches of blue for the small patch of sky and the capital, and light green and terracotta for the floor tiles are the only deviation from the pervasive pale grey-green wash that shades the composition. Although skilful and reasonably controlled, the drawing is just a bit tentative, again suggesting that it might come reasonably early in the artist's long career. The strongest part of the picture is its left-central focus, the fountain, which is starkly set off and defined by the dark shadows beyond.

8 The Market at Boulac, near Cairo

Watercolour over pencil on white paper, 17.6 x 21.8 cm.

INITIALLED: lower left, in pencil, *HBB.*

INSCRIBED: lower right, in brown wash, *Boulac.*

PROVENANCE: Mrs. Brabazon Combe, by whom presented, in memory of the artist, 1926.

EXHIBITED: 1975, *Hercules Brabazon Brabazon (1821-1906),* National Gallery of Ireland, no. 2757.

LITERATURE: *National Gallery of Ireland, Illustrated Summary Catalogue of Drawings, Watercolours and Miniatures* (Dublin 1983), no. 2757, p. 20.

National Gallery of Ireland (cat. no. 2757)

Brabazon's two watercolours of Boulac were probably done together on either his 1874 or 1877 visit to Egypt. They form an interesting contrast: blue sky is important in both, along with a subsidiary use of red; but whereas the green in the other work gives an open, spacious feel to the drawing, here dark browns, applied with a fairly ferocious freedom, are used to suggest the intense activity and close crowding of the *souk.*

9 Boulac, near Cairo, from the Town Wall

Watercolour over pencil on white paper, 30.2 x 21.9 cm.

INITIALLED: lower left in pencil *HBB.*

INSCRIBED: lower left in brown watercolour over pencil *Boulac.*

PROVENANCE: Mrs. Brabazon Combe, by whom presented, in memory of her father, Alexander Lambert of Brookhill, Co. Mayo, 1926.

EXHIBITED: 1975, *Hercules Brabazon Brabazon (1821-1906),* National Gallery of Ireland, no. 2766.

LITERATURE: *National Gallery of Ireland, Illustrated Summary Catalogue of Drawings, Watercolours and Miniatures* (Dublin 1983), no. 2766, p. 21.

National Gallery of Ireland (cat. no. 2766)

Set approaching the town, this bright scene has a free pencil underdrawing. Blue doubles for the sky and major shadows on the ground, and also, dark and intense, defines many of the figures' garments. The clothes also feature strong red, diluted into pink stripes on the tower of the mosque, whose dome sports a thick white highlight. The light and airy atmosphere is quite different from the dark focus of the other Boulac scene.

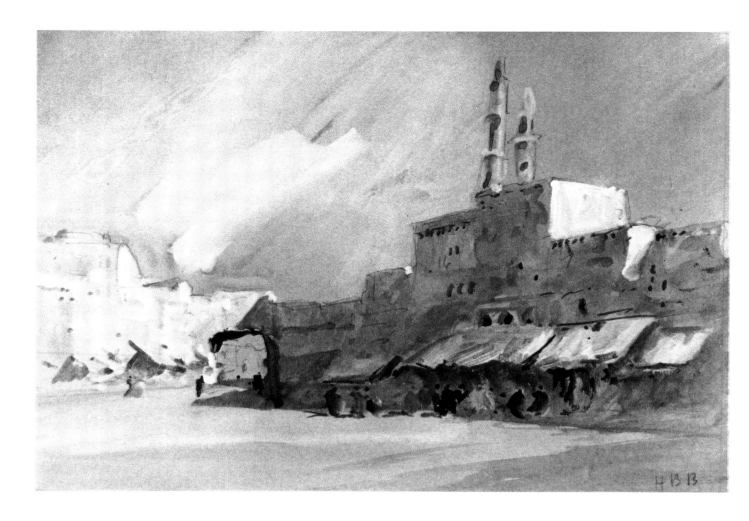

10 Near the Cemetery, Cairo

Gouache on paper, 21.5 x 31.5 cm.

INITIALLED: lower right, in blue pencil(?), *HBB*.

PROVENANCE: Victor Waddington Galleries, Dublin, where purchased, 1936.

LITERATURE: *Cork Art Galleries* (Cork 1953), p. 17 (cat. no. 248).

Crawford Municipal Gallery, Cork

The line between watercolour and gouache in Brabazon's work is a difficult one to fix, but in this drawing colour has been laid on with such opacity that the original paper has been all but concealed. The sunlight comes in from the right and has been established by the geometric opposition of grey shadow and white highlights on the buildings, and, to a lesser extent, on the minarets beyond. Many Eastern travellers remarked how the strong Oriental light tended to drain away colour, and it is only against the shadow of the bazaar stalls that the bright reds, blues and blacks of the Arab robes stand out. Brabazon has suggested the shapes of these figures with the effortless ease of a Guardi, but there is little fancy in his approach, rather a fresh and atmospheric evocation of late afternoon on a hot Eastern day.

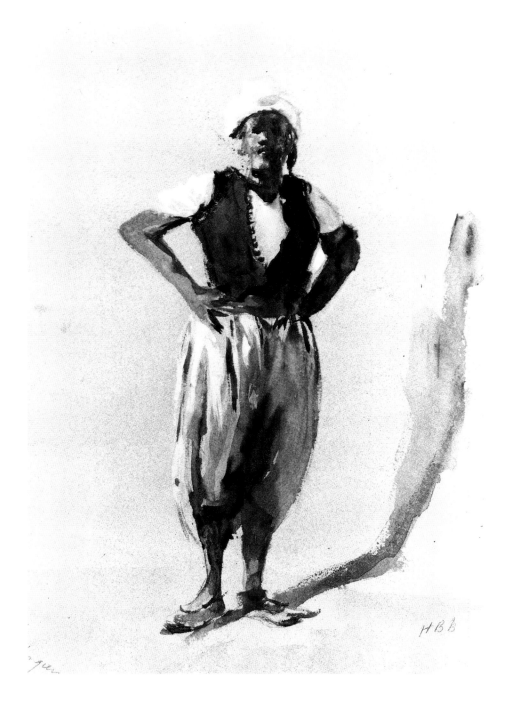

11 Man in Tangiers

Watercolour on blue paper, 50.5 x 35.5 cm.

INITIALLED: lower right, in pencil, *HBB*
(possibly again even further down).

INSCRIBED: lower left, in pencil, *Tangiers.*

PROVENANCE: Mrs. Brabazon Combe, by
whom presented, in memory of the artist,
1926.

EXHIBITED: 1975, *Hercules Brabazon Brabazon
(1821-1906)*, National Gallery of Ireland,
no. 2755.

LITERATURE: *National Gallery of Ireland
Illustrated Summary Catalogue of Drawings,
Watercolours and Miniatures.* (Dublin 1983),
no. 2755, p. 20.

National Gallery of Ireland (cat. no. 2755)

This striking watercolour is at once the simplest, the largest and the most impressive Oriental work by Brabazon in the collection of the National Gallery of Ireland. Drawing with the brush — the only hint of pencil is on the soles of the feet — Brabazon has dashed off a study of presence, personality and beauty. He mixed saturated wet washes with dry strokes to establish his figure and added a bent shadow, almost as an afterthought, to situate him in an undefined space, a bold stroke which stands as a kind of comment on an environment where blinding sun dissolves normal form and articulates only in terms of insubstantial shadow. Although in style the work stands comfortably alongside the likes of Lavery *(q.v.)* and Brabazon's friend Sargent, in economy of statement it recalls the wonderful early 1860s works of Manet, such as the *Fifer* (Musée d'Orsay, Paris).

Richard Dadd

1817, Chatham — 1886, Broadmoor

Any artist named 'Dadd' who committed patricide under indirect orders from the Egyptian god Osiris would be assured enduring renown. When the same man, classed 'among the dead' by the *Art Union* the year he was institutionalized for his crime, survived over four additional decades, during which he produced some of his most arresting work, he must be considered unforgettably eccentric, even amongst the rare breed of painters.

Dadd's father Robert was a chemist and geologist, with an unfortunate incidence of mental illness in his family — four of his seven children were to die insane. Richard grew up in Chatham and Rochester, but the family moved to London in 1834, where he enrolled at the Royal Academy Schools in 1837. As a student he was a founder member of 'the clique', an informal group that also included W. P. Frith and Augustus Egg. According to Frith:

> Dadd was my superior in all respects; he drew infinitely better than I did, and in my many pictorial difficulties a tap at my wall would bring my friend with ready suggestions to my relief.[1]

Dadd's skills won him medals at the Royal Academy, as well as earning him a commission to decorate Lord Foley's town-house at Grovesnor Square with over one hundred subjects taken from Tasso's *Gerusalemme Liberata* and Byron's *Manfred*.

In 1842 Dadd was recommended by David Roberts (*q.v.*) as a 'fit and suitable person'[2] to accompany Sir Thomas Phillips, the Mayor of Newport, Wales, who had been knighted for his control of the Chartist riots, on his tour of the East. Together they travelled through Switzerland, Italy, Greece, Turkey, Syria, Palestine and Egypt. Dadd was terrifically stimulated by the Orient; a long letter to Frith from his steamer off the coast of Jaffa suggested that he had already reached a fevered pitch:

> At times the excitement of these scenes has been enough to turn the brain of an ordinary weak-minded person like myself, and often I have lain down at night with my imagination so full of wild vagaries that I have really and truly doubted of my own sanity. The heat of the day, perhaps, contributed somewhat to this...[3]

and later in the same letter:

> ...could you but glance on the princely beggary of these imperial ragamuffins, you would beat your breast and gnash your teeth until they came through your lower jaw! Then listen to wild sounds of the tabor, and see the strange dresses of these street musicians; see bubbling water, see bright, green trees, dazzling dresses, stately camels, all shook up in such inextricable confusion that you lay down your reason and implore the passenger to hold you tight, lest you should indulge in any rabid feelings towards your linen.[4]

With the possible exception of Flaubert who a decade later compared his initial Eastern encounter to being hurled into the middle of a Beethoven symphony, a 'bewildering chaos of colours' which left the imagination 'dazzled as though by continuous fireworks',[5] it is difficult to think of another Westerner who showed him/herself so eloquently overwhelmed by the strangeness of the Orient.

Unfortunately in Dadd's case, his excitement was more than his sensibility could bear, and signs of instability, messages from Osiris, began to appear in Egypt. A distraught Egg announced to a disbelieving Frith soon after Dadd's return to London that Dadd had gone mad during his journey. At first there was little evidence of illness. For the competition to decorate the Houses of Parliament, Dadd prepared a cartoon of St. George in which the only noticeable eccentricity was the dragon's inordinately long tail.[6] But growing symptons of what was a form of schizophrenia ultimately resulted in a total breakdown, and Dadd's father took him to the country in order to seek the advice of a specialist. The evening of their arrival at Cobham, Surrey, Dadd killed his father, seeing him as an incarnation of the Devil, and fled to France, where he was caught near Fontainebleau attempting to cut the throat of an unfortunate

1. W. P. Frith, *My Autobiography and Reminiscences*, vol. II (New York 1888), p. 132.
2. *Ibid*, p. 131.
3. *Ibid*, p. 138. Frith italicizes all this passage and a bit more, as prophecy of the future insanity.
4. *Ibid*, p. 139.
5. Francis Steegmuller, editor and translator, *Flaubert in Egypt* (London 1972), p. 79.
6. W. P. Frith, *op. cit.*, p. 134, recounts that one of the English papers said that the tail of Dadd's dragon 'was as long as O'Connell's (O'Connell had an enormous Irish following, which was called his *tail* by the profane).'

Bibliography:
Patricia Allderidge, *The Late Richard Dadd, 1817-1886* (The Tate Gallery 1974).
Angela Carter, *Come Unto These Yellow Sands* (Newcastle-upon-Tyne 1985). In the author's own words this radio play is actually 'a piece of cultural criticism in the form of a documentary-based fiction', whose title is taken from one of Dadd's most famous pictures (its title in turn from *The Tempest* by Shakespeare).
David Greysmith, *Richard Dadd* (London 1973).

fellow traveller. After an extended extradition, Dadd was returned to England and sent without trial to Bethlem, a mental hospital in Lambeth, where he stayed for twenty years.

Dadd continued to produce works of considerable originality and fantasy after his internment; he was particularly encouraged at Bethlem by Dr. William Hood after Hood's appointment as the resident physician in 1852. In 1864 Dadd was transferred to the recently established Broadmoor Criminal Lunatic Asylum, where he continued to produce artworks. The last years of his life saw a relaxation of his illness but also of his creative invention; his death was caused by tuberculosis.

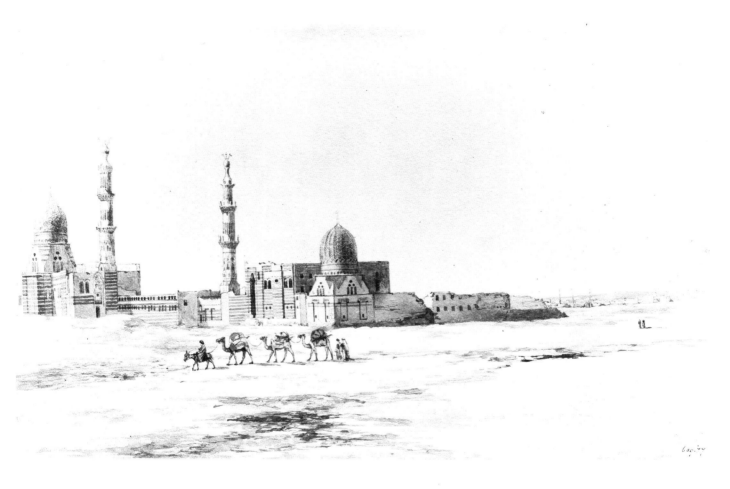

12 Tombs of the Khalifs, Cairo

Watercolour, 24.1 x 36.8 cm.

INSCRIBED: lower right, accession number in ink, and collector's mark.

PROVENANCE: Purchased, 1877.

EXHIBITED: 1974, *The Late Richard Dadd, 1817-1886*, Tate Gallery, London, no. 86, p. 75-76.

LITERATURE: Patricia Allderidge, *op. cit.*, as above; *British Watercolours in the Victoria and Albert Museum* (London 1980), p. 97; Angela Carter, *op. cit.*, p. 28 (illus).

Victoria and Albert Museum, London

1. W. P. Frith, *op. cit.*, p. 134.

Although this watercolour is related to a view in a sketchbook, also in the Victoria and Albert Museum, the 1974 catalogue entry suggests that it may also have been done on-the-spot rather than copied from the pencil sketch. Dadd saw the Tombs of the Khalifs (actually the Mameluke Sultans) outside Cairo sometime between 24 and 30 January on his way back from a trip up the Nile. He later attributed the onset of his illness to excessive sun suffered during a day's drawing in Egypt, spent executing drawings such as this. The drawing itself is a careful, somewhat dry account of a famous site, and the three perfectly synchronised camels set before it, who do not appear in the sketchbook composition, may have been added from the artist's imagination. It is a skilful example of the 'experienced' East, competent but uninspired; the demon sun soon unleashed was not yet in evidence. Nor was it even immediately after Dadd's return to London: Frith mentioned a 'spiritless and poor' picture Dadd was painting after his arrival, 'a very prosaic scene — a group of Eastern people with camels, a view of Cairo in the background', which could have been worked up from this drawing or any one of several others done on his trip.[1]

13 'Fantasie de l'Hareme Egyptienne'

Watercolour, heightened with white, on pale blue-green paper, 25.7 x 17.9 cm.

INSCRIBED: top right, *Fantasie de l'Hareme Egyptienne — par Monsr Rd Dadd — quasi — Octobre — 1865 — / · Broadmoor — Berks ·*.

PROVENANCE: purchased, 1935.

EXHIBITED: 1974, *The Late Richard Dadd, 1817-1886*, Tate Gallery, London, no. 195, p. 130.

LITERATURE: Patricia Allderidge, *op. cit.*, as above: David Greysmith, *op. cit.*, pp. 125, 181 (illus. pl. 96); Philippe Jullian, *The Orientalists* (Oxford 1977), p. 144 (illus. p. 99).

Visitors of the Ashmolean Museum, Oxford

1. The title of the companion work reads *Fantasie Egyptienne, par Monsr Rd Dadd . Broadmoor . Berks . Sepr 2nd 1865.*, Patricia Allderidge, *op. cit.*, no. 194, pp. 129-30.
2. *Ibid*, no. 84, p. 75.

Soon after his transfer to Broadmoor, Dadd did a remarkable pair of drawings on coloured paper. In both he employed a stippling process as painstaking and delicate as the execution of a Renaissance silverpoint. The paradoxical combination of precision and softness produced by his technique is particularly appropriate to the dreamlike subject matter of this work, and is far more fantastic than in the companion drawing. Done a month earlier and bearing a similar title,[1] the other work shows a group of men in Eastern dress standing before an open gate which leads to the courtyard of a house set above the quay of a port. The Tate Gallery Catalogue suggested that the Oxford drawing represents the interior of the palace whose gateway was featured in the earlier work, though there is no obvious indication of narrative or visual continuity between the images.

The interior scene is certainly the more unusual work, whose hallucinatory attention to details of flowers, fruit, clothes, and musical instruments only makes it seem the more surreal. The distant view through a sequence of elaborate arcades, with pseudo-*tughra* over the paired columns of the last, to an austere river scene, where the wind fills the butterfly-wing sails of a single felucca — recalls the landscape backgrounds of fifteenth-century Flemish paintings at the same time as it forecasts the desolate shores in the depths of Dali's compositions.

It would take a Gerard de Nerval to do literary justice to the iconographic richness and suggestion of this picture. Could the most obvious male, the bearded man penitently crossing his hands on his breast, possibly represent Dadd himself, who on his Oriental trip two decades earlier wore a fez with handkerchiefs round it as part of his travelling outfit?[2] The really powerful presence is the figure crouched directly below the distant mountian, his or her incandescent eyes shining out of the shadow of a covered face. Whatever Dadd may have intended in this creation, it is certainly possible to read it as the most effective visual incarnation or artistic simulacrum of his own Eastern demon, who stole his reason and ordered his father's death. The stare of this sinister central figure is echoed by that of the splendid Persian cat, luxuriantly extended in regal ease before the 'oud in the left foreground.

If many Western travellers could have equalled, or even excelled, the exhibited drawing Dadd did on his Egyptian journey (no. 12), no other Orientalist could have produced an image remotely resembling this. As revealed in this drawing, the East of poor Dadd's warped imagination was the stuff of magical and spectacular dreams.

Adrien Dauzats

1804, Bordeaux — 1868, Paris

Like David Roberts (q.v.), Dauzats' initial development as a theatre decorator gave him a head start and a distinctive slant in representing the unusual character and dramatic scale of Eastern scenery. Working in the wings helped him to develop not only rapid execution but also a sophisticated mastery of perspective that was extremely useful in structuring the unfamiliar in terms of an impressive picturesque.

As a child, Dauzats was gifted in mathematics, and from that aptitude it was a simple step to his early progress in the study of perspective. From 1821-23 he worked under the direction of Olivier, the chief decorator of the *Grand Théâtre* in Bordeaux. Dauzats moved on to Paris to improve his artistry, working at the *Théâtre des Italiens* in 1824, then at the *Théâtre de Pont-Audemer*. In about 1825 he entered the studio of Julien-Michel Gue. Dauzats was one of a number of artists, including Bonington (q.v.) who were commissioned by Baron Taylor to illustrate *Voyages pittoresques et romantiques dans l'ancienne France* (1828). His association with Baron Taylor continued with a joint expedition to Egypt, Judea, Palestine and Syria in 1830, and to Spain in 1833 and 1835-7. Baron Taylor had been sent by the French Government to Luxor to negotiate and oversee the transport of one of a pair of obelisks back to Paris (the 75-foot monolith now stands in the *Place de la Concorde*). Taylor published his account of the journey in 1839 and in the same year Dauzats illustrated and co-wrote with Alexandre Dumas his *Nouvelles impressions de voyage. Quinze jours au Sinai* about the same trip. Dumas generously later acknowledged that he had relied as much on Dauzats' drawings as upon his own experience: 'The truth is that it was in the portfolios of Dauzats that I saw Palestine'. [1]

Dauzats had not just become an illustrator; he also exhibited regularly at the Salon, winning a Second Class Medal in 1831, a First Class Medal in 1835, and gaining the Cross of the Legion of Honour in 1837. In 1839 Dauzats made an important journey in the entourage of the Duke d'Orléans to Algeria, the first French expedition to go deep into that country since the conquest. The poet-novelist Charles Nodier's account of the trip, *Journal de l'Expédition des Portes de Fer*, published in 1844, was illustrated by Decamps and Raffet, as well as Dauzats. By now a committed traveller, Dauzats made further journeys to Sicily, Belgium, Germany, England, though asthma and a weak heart limited his mobility as he got older.

From the mid-1840s Dauzats became one of the best friends of Delacroix (q.v.), their closeness documented in that artist's *Letters* and *Journal*. Dauzats helped Delacroix with the background architecture of his painting *The Two Foscari* (1855; Musée Condé, Chantilly) and possibly several others. His connections both with the House of Orléans and his native city of Bordeaux were also useful to Delacroix in selling his work. Delacroix exhibited frequently in Bordeaux and in 1852 the Museum there bought his *Greece on the Ruins of Missolonghi* of 1827. Dauzats also got for Delacroix Goya's Bordeaux series of bullfight etchings. In Delacroix's will Dauzats was one of seven men selected to classify his work for sale, for which job each man received an important drawing.

Dauzats' Salon success continued, with medals in 1848 and 1855; and he was active not only in provincial art activities but also in Salon jury reform and service. Towards the end of his life he was commissioned by a Bordeaux collector to paint four pictures from the *Thousand and One Nights*, and he was trying to finish *Sinbad the Sailor*, now in the Bordeaux Museum, only three days before he died. Although renowned principally for his sweeping landscape vistas and dramatic architectural views, Dauzats was a skilful draughtsman of figures. According to Philippe Burty, 'No one, except for Eugène Delacroix, caught more accurately the ferocious revery or the fatal indifference of the Mohammedan'. [2]

1. Philippe Burty, introduction to Dauzats' atelier sale. Paris, Hotel Drouot, 1-4 February, 1869, p. vi.
2. *Ibid*, p. vii.

Bibliography:
Théophile Gautier, 'Dauzats', *Le Moniteur*, 24 February, 1868; reprinted in *Portraits contemporains* (Paris 1874), pp. 353-54.
Paul Guinard, *Dauzats et Blanchard, peintres de l'Espagne romantique* (Paris 1967).

14 Les Portes de Fer
(The Gates of Iron)

Watercolour touched with white, 24.3 x 32.1 cm.

SIGNED, DATED AND INSCRIBED: lower left, *Bibans/A. Dauzats. 1846.*

PROVENANCE: Duc de Montpensier; Rodney Searight Collection.

EXHIBITED: 1980-1981, *A Middle Eastern Journey: Artists on their travels from the collection of Rodney Searight* (catalogue by Rodney Searight and Jennifer Scarce), Edinburgh and Norwich, no. 11, p. 6.

LITERATURE: Briony Llewellyn, *Catalogue of the Searight Collection*, (forthcoming).

Searight Collection, Victoria and Albert Museum, London.

This view is one of several done in oil and watercolour by Dauzats to record the spectacular river cutting called the *Biban al-Hadid* or the *Portes de Fer*, which is located in the Jurjura mountains in Kabylie, Algeria. A sequence of such scenes were used as illustrations 167-171 in Charles Nodier's 1844 book, *Journal de l'Expédition des Portes de Fer*, and a set of watercolours now in Versailles of the same subject were shown in the 1841 Salon (nos. 472-6). Notable oils of the same subject can be found in Lille, (Musée des Beaux-Arts) and Chantilly (Musée Condé). The French Army had captured this pass only in October, 1839. Dauzats shows them dwarfed by the overhanging rocks, which wage a war of their own with the jagged slopes opposite: as in the work of Martin (*q.v.*), nature provides a battle as well as a battleground. Wading along in knee-deep water, the soldiers hug the walls to avoid enemy musket fire, diminutive and insignificant amidst the frozen drama that surrounds them. For Philippe Burty, Dauzats' canyon scenes possessed a 'terrible beauty':

> Nothing is more astonishing than to see the regiments file one by one through the constricted corridors to contest the heights and overthrow the Arabs.[1]

1. Philippe Burty, introduction to Dauzats' *atelier* sale, Paris, Hotel Drouot, 1-4 February 1869, p. viii.

Alexandre-Gabriel Decamps

1803, Paris[1] — 1860, Fontainebleau

Decamps was the first of the important French nineteenth century painters to visit the East. Every listing of primary Orientalists up to the middle of the century inevitably began with the trio of Decamps, Delacroix *(q.v.)* and Marilhat; and in his lifetime he was seen as almost equal in importance to the mighty duo of Delacroix *(q.v.)* and Ingres. Therefore it is sad to note that the most important recent assemblage of Orientalist work omitted him altogether, and contemporary viewers tend to overlook his pictures. History has not treated this innovative and eccentric artist kindly.

He was never one for rules. His father was a *rentier*, or tenant farmer, near Paris, who sent his son to a small village in his native Picardy to teach him the hardships of peasant life; instead the young Decamps ran wild, neglecting his studies and developing a distaste for regular habits and the customs of polite society. His own artistic interests initially were traditional, but as a student under Abel de Pujol he quickly reacted against academic convention and started to form the style which would make him famous. Like Delacroix he painted the Orient before he ever saw it, beginning in the early 1820s. He made his Salon debut in 1827 with *Soldier of the Vizier's Guard* and a French hunt scene. That same year he left for Greece with the marine painter Ambroise-Louis Garneray on a government commission to produce work commemorating the Battle of Navarino, then went to Smyrna, where he improvised a studio for a while. After his return, he soon became known for his Turkish scenes, starting with *The Turkish Patrol* (Wallace Collection, London) in the Salon of 1831.

Decamps did not merely satisfy but actually helped create a public and critical enthusiasm for things Eastern. As an artist he had two principal strengths: a strong, accurate and expressive gift as a draughtsman, and an experimental, improvisational approach to the handling of paint. In his own words: 'I walk grasping, staggering, without direction, without theories'.[2] His handling was partly inspired by Rembrandt, as was also his use of dominant shadow to set off his action and detail. Decamps made several visits to Italy in the 1830s. He shared the common artistic aspiration to be accepted as a History Painter and made several attempts, such as his *Defeat of the Cimbri* in the 1834 Salon or his spectacular series of Samson drawings in the 1845 Salon, to be recognized as more than a painter of Oriental genre. Yet he was honoured and successful principally as a painter of Turkey, as well as French hunting scenes, animals (which he portrayed at least as profoundly as Rosa Bonheur, *(q.v.)*), well-dressed monkeys engaged in all sorts of human activities, and scenes from literature and the *Bible*.

From 1846 Decamps frequented Fontainebleau, where he operated on the fringes of the Barbizon group, stealing in 'like a thief' at night to visit Millet. By this time he was disillusioned and a bit cynical, and in 1853 he closed his Paris studio to live in the forest fulltime. He did not lack for honours — Second Class Medal in 1831, First Class Medal in 1834, Legion of Honour in 1839, Officer of Legion of Honour in 1851 and in the 1855 Universal Exhibition one of three Medals of Honour for his *fifty* paintings on display — but the fact that he received all his awards as a genre artist rankled, much as it had Greuze a century before. It took a bolder, more bombastic artist like Courbet, most of whose technical 'innovations' with palette knife and loaded brush had already been explored by Decamps, to explode, or at least seriously assault, the distinction between genre and history painting. In 1852 the acerbic Gavarni rated Decamps as the only great painter of the day;[3] Gavarni's close friends the Goncourts saw in Decamps' paintings the qualities not only of Hugo's poetry,[4] but also of their own writing,[5] and even an accurate anticipation of photography.[6]

Decamps died suddenly after a fall from a horse during a hunt. Much of his late works were lost when his widow's house was destroyed in the Prussian siege of Paris. According to Burty, Decamps' inspiration had failed completely at the end of his life, and he had bought and retouched paintings by Joseph Beaume and Edouard Frère in order to pass them off as his own. The Goncourts called Decamps' decline 'one of the saddest endings of a great painter'.[7] Decamps' younger brother Maurice-Alexandre, who predeceased him by eight years, was an art critic and essayist.

1. All authorities on Decamps list his birthdate as 3 March, except Mosby, who states it was 3 May.
2. C.H. Stranahan, *A History of French Painting* (New York 1888), p. 227.
3. Edmond and Jules de Goncourt, *Journal* (Paris 1956), vol. I (4 June 1857) p. 362.
4. *Ibid*, vol. I (4 March 1860), p. 713.
5. *Ibid*, vol. II (28 May 1864), p. 48.
6. *Ibid*, vol. II (17 April 1867), p. 333.
7. *Ibid*, vol. I (12 May 1861), p. 918.

Bibliography:
Dewey F. Mosby, *Alexandre-Gabriel Decamps, 1803-1860*, Ph. D. thesis, 1973, reprinted New York 1977.

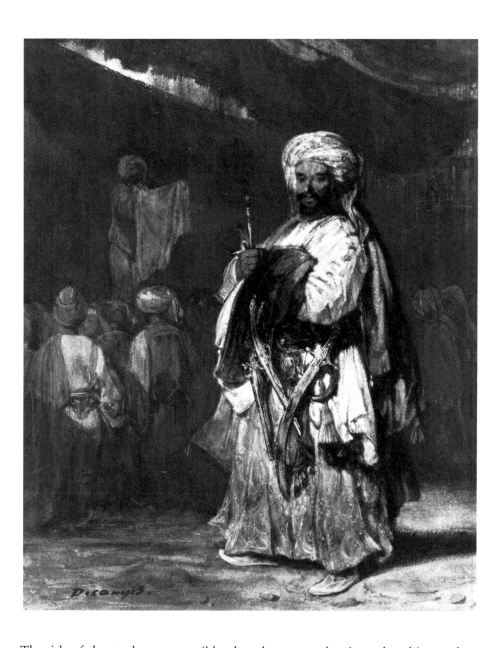

15 A Merchant in an Oriental Bazaar

Watercolour with body colour and some oil,
23.9 x 18.2cm.

SIGNED: lower left, *Decamps*.

PROVENANCE: purchased, 1963.

Visitors of the Ashmolean Museum, Oxford.

The title of the work seems sensible, though one wonders just what this merchant might be selling — that bolt of blue cloth folded over his right forearm, or some portion of the veritable arsenal of weaponry he carries? He might be a fashion swell, but, even in a bazaar plagued with thieves, two pistols, two scimitars and a curved dagger could be called carrying personal ornament and security to extremes. Although a 'drawing', this picture displays Decamps the painter, with its amazing range of tone and texture. The work on the curved sword and pistol is absolutely typical of the artist's ability to suggest the sheen of intricate metalwork with dragged highlights, while a variety of brush improvisations establish the folds, colours and textures of the Arab's richly-varied outfit. The shine of the drawing, particularly the central figure, reveals that Decamps worked the paper with oil, enhancing its colouristic and textural splendour.

As is often the case with Decamps, the importance of his principal is established against background shadow, in which can be seen, some distance off, a crowd gathered around a man on a platform above, who may be vending his wares or performing conjuring tricks. Decamps' central figure has no time for such distractions, though while walking along he has temporarily turned his attention to the viewer, offering perhaps a wry comment or a commercial proposition.

Like many genre artists, Decamps did a large number of single figure compositions, which were quick to execute and easy to sell. An example of an oil of this type is his *Janissary* of 1827 in the Wallace Collection.

16 A Turkish Village

Etching, 31 x 44.6 cm.

INITIALLED: lower right, in reverse.

PROVENANCE: Mr. de Courcy Donovan, from whom purchased, 1971.

LITERATURE: Henri Beraldi, *Les Gravures du XIXe siecle: guide de l'amateur d'estampes modernes* (Paris 1886), vol. V, no. 19, p. 150; *National Gallery of Ireland Illustrated Summary Catalogue of Prints and Sculptures* (Dublin 1988), no. 20, 332, p. 105.

National Gallery of Ireland (cat. no. 20,332)

Edmond de Goncourt, who much admired Decamps as a painter, found him feeble as an etcher. His etchings, Goncourt said, looked as if they had been 'scratched with a drawing pin'.[1] Decamps was not a productive print-maker, and *A Turkish Village* is one of only twenty listed by Beraldi, who stated it was published in the series 'Les Artistes contemporains' in 1847. Yet even if no masterpiece, it is an attractive and skilfully drawn work. Around a central column converge the diagonals of the foreground street's upward incline, the gentle slope of a stable roof and the descending wall of a staircase. The shadow cast by the shed sets up a principal tonal contrast with the sunlit buildings beyond, where summary lines suggest a wealth of detail: two women, one with a waterjug on her head, a stork on the roof, two old Arabs making their weary way up the steps. The seated boy minding the donkeys is less expressive; his blank moronic stare contrasts with the intelligent, sensitive eyes of the beasts he oversees. The three endearing donkeys provide a range of poses and activities, eating, resting and braying a spectacular protest at their sorry lot, their mood and personalities established by their large, lovely ears, which dip and rise like the wings of soaring birds.

A painting of 1833 showing the same subject, reversed, is in the Wallace Collection; it was exhibited in the Salon of 1834. Another version in the Kröller-Müller Museum, with the same composition, was probably done by another artist after the print.

1. Edmond and Jules de Goncourt, *Journal* (Paris 1956), vol. IV (5 March 1891), pp. 54-55.

Edmé-Alexis-Alfred Dehodencq

1822, Paris — 1882, Paris

Dehodencq is probably the only artist apart from the short-lived Chassériau who made a serious attempt to extend the dynamic line or rich colour which Delacroix (*q.v.*) had brought to the depiction of Eastern scenes. His considerable skills were not always equal to his late-Romantic ambitions, and he was not widely appreciated or successful in his own time, nor has he been since. Like Decamps he was recently ignored by a major Orientalist show, yet his artistic weight and significance as a painter or draughtsman of Eastern subjects were almost as noteworthy in the second half of the century as were those of Decamps in the first.

Dehodencq's parents owned a Paris café. He entered the studio of Léon Cogniet in 1839, and his first Salon entry included a religious work and a painting of Dante; two Salons later, he won his first award, a Third Class Medal, for a picture of St. Stephen. In the 1848 Revolution Dehodencq was seriously wounded; offered the Legion of Honour for his heroism, he refused it, saying he would prefer to win it as a painter. Soon after he went to Spain for the first time, where he met his wife, and adored Velazquez and Goya. Throughout his career, Spanish scenes, particularly of bullfights, would be prominent. His Spanish work was especially admired by Manet, who wrote back from his own visit there:

> What a street, what people. Dehodencq has observed very well. There are some who don't believe in miracles. Well, as for me, after Dehodencq, I do believe in them.[1]

Dehodencq made his first visit to Morocco in 1853 and returned there every year for the next decade. In comparing Dehodencq's relationship with Morocco to that of Delacroix, Gabriel Séailles wrote that Dehodencq did not just pass through, but actually settled there:

> He had his friendships, his daily routine. Morocco was for him reality itself, what he saw every day for months, for years. He looked closely at the faces of the men; he distinguished between the races which pressed around him; hundreds of times he saw concerts, singers, dances, all the ceaselessly recurring episodes of Moroccan life.[2]

Dehodencq showed his first Eastern scene in the Salon of 1855; it was greeted with great enthusiasm by Théophile Gautier:

> 'The Jewish Concert at the Home of the Moroccan Caid' proclaims an astonishing ethnographic aptitude on the part of M. Dehodencq, a profound sensitivity to different races... M. Dehodencq has instantly achieved African familiarity.[3]

What Gautier saw as a spectacular ability in portraying race today sometimes seems closer to caricature, and Dehodencq's wide-eyed, smiling Negroes in particular can appear almost comic. But his *Oriental View* in Troyes,[4] an abstract clash of light and shade, with a single, insignificant seated figure, demonstrates a modern ability to reduce the Eastern experience to pictorial essentials.

For the rest of his career Dehodencq mixed mainly Oriental scenes with Spanish works; one of his grandest and most arresting images, *The Farewell of King Boabdil to Granada* of 1869 (Musée d'Orsay, Paris), successfully combines the two. Like Delacroix, Dehodencq employed his Spanish experience to paint pictures from the life of Columbus.

In 1865 Dehodencq won a First Class Medal for two major Eastern social events he painted, and, with Fromentin (*q.v.*) strongly pleading his case, he was awarded the Legion of Honour in 1870. Fromentin was among Dehodencq's closest friends, godfather to one of his daughters, his advocate for government commissions, and during a moment of extreme financial duress, the anonymous purchaser of a large *Fête Juive* composition.[5] In gratitude Dehodencq presented Fromentin with a handsome self-portrait. For Dehodencq portraiture was mostly a private matter of

1. 'Lettres d'Edouard Manet sur son voyage en Espagne', *Arts*, (16 March 1945).
2. Gabriel Séailles, *Alfred Dehodencq: l'Homme et l'Artiste* (Paris 1910), pp. 129-30.
3. Théophile Gautier, *Les Beaux-Arts en Europe* (Paris 1855), p. 83.
4. Illustrated in *Equivoques*, Paris, Musée des Art Decoratifs (1973).
5. Gabriel Séailles, *op. cit.*, p. 147.

6. *Ibid*, p. 181.
7. *Ibid*, p. 184.
8. *Ibid*, p. 185, 'Il sut faire pleurer et chanter la couleur.'

Bibliography:
Véronique Prat, *Alfred Dehodencq*, Mémoire de l'Ecole de Louvre (Paris 1977).

family and close friends, such as *Théodore de Banville* (1870; Versailles), but he brought to it a distinct aptitude.

Like many Orientalists, Dehodencq much admired Rembrandt; near death he is reported to have uttered, 'above all Rembrandt, Rembrandt, I would almost say nothing but Rembrandt'.[6] At Dehodencq's death, Banville provided the funeral oration, saying that for Dehodencq Spain and the Orient 'drew him like countries already encountered and understood';[7] his poem for the artist's tomb credited Dehodencq with the ability to make colours 'weep and sing'.[8]

17 Studies of a Seated Arab

Brown ink and wash on paper, 20.1 x 30.1 cm.

INSCRIBED: lower right, in pencil (post 1910), *Le Marchand de Bijoux? Dehodencq/Séailles, p. 148.*

PROVENANCE: purchased, 1964.

Visitors of the Ashmolean Museum, Oxford

The pencil inscription added to the bottom of the drawing attempts to relate it to a Dehodencq painting, *The Jewelry Seller, Tangier*, illustrated in Gabriel Séailles' 1910 monograph on the artist.[1] The picture shows a wily merchant crouching on a shelf in the shade of his shop, like a predator in his lair, dangling beaded jewelry before two lovely young women, one of whom reaches out her right hand to examine the merchandise, while the other glances seductively over her left shoulder at the spectator. The suggested association is reasonable, since the merchant is the most obviously similar single figure in any composition reproduced in that standard study of the artist; but two of the most consistent characteristics of the Arab repetitively examined in this drawing — his gaze over his right shoulder and his clasped hands holding in his right leg — would be completely out of place as part of the painting's narrative. The drawing is more likely a study for a figure in one of Dehodencq's compositions of the *Moroccan Storyteller*, the first version of which was done for the Prince of Portugal in 1858 and subsequent versions executed in 1866-70 and 1879. In that composition several seated foreground figures as well as more distant ones in windows are found in similar poses.

There can no quibbling, however, with the attribution given in pencil. Dehodencq's distinctive drawing style, a dynamic, exploratory quest for form, is instantaneously recognizable; like the colour in his paintings, it connects to some of the exciting works of Delacroix (*q.v.*). In this drawing Dehodencq may have started with the central bottom study, perhaps a portrait taken from life, then gone on to consider not just the problem of the face, but also of the twisting pose of the body, with the figure's back pushing against the wall, while his arms restrain his right leg. The least detailed drawing on the extreme left suggests that a distant, vestigial ancestor of the pose might be a Michelangelo Medici tomb figure. The distinction of Dehodencq's drawing was noted early in his career by Champfleury, who on 1 October, 1848, said of a Dehodencq work: 'Such a drawing is worth many large paintings.'

1. As the inscription says, the painting, which Séailles dated c. 1865, and which belonged to M. Morel d'Arleaux, is illustrated on page 148.

Auguste Delacroix

1809, Boulogne-sur-Mer — 1868, Boulogne-sur-Mer

Blessed (or cursed) with the greatest name in French Orientalism, Auguste Delacroix almost inevitably made a Moroccan visit sometime in 1850 and afterwards added Eastern scenes to the pictures of fishermen and laundresses of his native Boulogne and of Normandy for which he had become known from his first Salon appearance in 1835 until his last in 1865.

Although he also worked in oils, Delacroix was appreciated principally as a watercolourist. His first Oriental scene, *Halt of the Caravan*, appeared in the 1850-51 Salon; he had failed to exhibit in 1849, quite likely on account of a visit to Tangier which began then. In the Salon of 1852 all three of his contributions were Moroccan scenes. After that the mix varied. In 1859 he showed a *Negro Dancers at Tangier*, the same year as Fromentin (*q.v.*) exhibited his highly successful *Negro Entertainers among the Tribes*.

Delacroix's last Salon appearance consisted of two drawings which demonstrated his divided interests: one of a *Tempest* continuing his theme of the sea, the other, a *Spahi*, reflecting his Eastern subjects. In his last years he suffered a form of paralysis and had to draw with his left hand: the Museum at Boulogne has a watercolour by him inscribed: *A. Delacroix, sinistra pinxit, 1866.*

Delacroix was reasonably successful well before he began painting Eastern scenes, winning a Third Class Medal in 1839, a Second Class Medal in 1841 and a First Class Medal in 1846. The more famous Eugène was annoyed by the similarity of their names, and in his *Journal* (t. III, p. 92) irritably described seeing, on 27 September, 1855, one of Auguste's works which had been wrongly sold as an 'Eugène'.

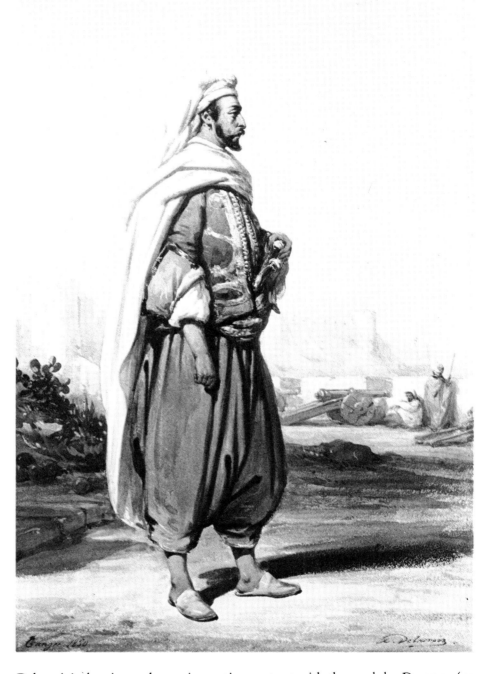

18 A Moroccan Amir

Watercolour and bodycolour, over pencil, on paper, 42 x 27.3 cm.

INSCRIBED AND DATED: lower left, *Tangier. 1850*; signed lower right, *A. Delacroix*.

PROVENANCE: Duc de Montpensier; Rodney Searight Collection.

EXHIBITED: 1980-1981, *A Middle Eastern Journey: Artists on Their Travels from the collection of Rodney Searight* (catalogue by Rodney Searight and Jennifer Scarce), Edinburgh and Norwich, no. 3, p. 5.

LITERATURE Briony Llewellyn, *Catalogue of the Searight Collection* (forthcoming).

Searight Collection, Victoria and Albert Museum, London.

Delacroix's drawing makes an interesting contrast with the work by Decamps (no. 15), also in the exhibition. Both show bearded Orientals, in ornate, billowing costumes; both set their single principal figure in an obviously Eastern setting. There, however, the similarity ends, for whereas the Decamps Arab is full of dynamic implications — the step he is about to take, the speech he is about to make, as his eyes warily engage the viewer — the Delacroix figure is portrayed in profile, which distances him and defines him more as a type than a personality. Delacroix's sunlit Amir could easily appear in a book of Eastern costume, while Decamps' dark merchant would be right at home as the scheming protagonist in a narrative. Delacroix's background, which is there principally to give credibility to his study of ethnic type and dress, does show his light and deft touch with the watercolour medium.

Eugène-Ferdinand-Victor Delacroix

1798, Charenton-Saint-Maurice — 1863, Paris

The current drift in art historical studies away from the individual can scarcely do justice to creators such as Delacroix. Like Neoclassical painting without David, Orientalism without Delacroix is drastically diminished in artistic weight and richness, a distinctly more minor phenomenon. No artist produced Eastern subjects of greater depth or breadth; no artist better exemplifies the three approaches — imagined, experienced, remembered — of this exhibition's title.

Delacroix's education and intelligence made him probably not only the most articulate French artist of the first half of the century but also the last great literary painter, whose work was informed by, in Théodore Silvestre's eloquent phrase, 'an indescribable and undeniable spirit of rivalry with the written word.'[1] Artistically Delacroix was a pupil of Guérin, but the most important aspect of his stay in Guérin's studio was meeting Géricault. Fromentin (*q.v.*) was not the only one who suggested[2] that Géricault actually helped Delacroix paint his first great Salon success, *The Barque of Dante* (1822; Louvre, Paris), whose Michelangelesque figures and Caravaggesque lighting had been employed a few years earlier by Géricault in his grandiloquent *Raft of the Medusa*. What was distinctively Delacroix's own in the painting was its colour, including the waterdrops he copied from Rubens' Marie de Medici series; the sinister sulphurous fires in the background recurred almost like a signature in several of Delacroix's other works. His first major Eastern subject was exhibited in the following Salon of 1824, inspired by the Greek rebellion against the Turks. *Scenes from the Massacre at Scio* (Louvre, Paris) erased much of the good-will his first picture had gained; Gros, who had praised the *Dante* as a 'chastened Rubens' called *Scio* the 'massacre of painting'. For *Scio* Delacroix borrowed Eastern paraphernalia from his friend M. Auguste, and either inspired by Constable's *Hay Wain* exhibited in the same Salon or simply pursuing his own original bent, he demonstrated a remarkable use of colour in the shadows cast by the bright Oriental stuffs. What probably rankled the artistic establishment more than the picture's intense tones and its slightly suspicious politics was its lack of conventional compositional structure: unusually for a vertical painting, it lacked a strong centre, or any centre at all. Delacroix constructed many of his pictures, particularly Oriental ones, on principles of dynamic movement and colour, rather than building with the usual academically-sanctioned horizontal and vertical blocks. In the subsequent Salon Delacroix became even more controversial with what he called his 'Massacre no. 2': the *Death of Sardanapalus*. As with Delacroix's original interest in the Greek rebellion and other early Orientalism, the inspiration was Byronic.

Sardanapalus is arguably not only Delacroix's most magnificent Oriental subject, it is possibly the grandest of all Orientalist paintings. The whole picture is a web of dramatic, curving motion and exciting colour, with the Potentate's massive diagonal bed a spacious ironic reversal of Gericault's *Raft*. To repeat Lorenz Eitner's felicitous formulation, colour provides not only the motor but also the structure of Delacroix's painting.[3] The authorities were not pleased with Delacroix's eccentric progressivism and issued strict personal orders that he was to water his wine in future, a verdict he claimed reinforced his conviction that what he had done was right. But despite his brave words, *Sardanapalus* was to remain his wildest work, the most spectacular surface dazzle the nineteenth century side of Jackson Pollock.

If Byronic Romanticism, filtered through his own imagination, had pushed, Delacroix to the most radical of his Oriental pictures, his visit to Morocco as part of the entourage of the Comte de Mornay (luckily the painter Isabey had declined the first invitation) was to begin a whole new phase of Eastern works. Principal among them are the wonderful sketchbooks, which represent perhaps the most exciting, least mediated of Western visual responses to the Arab world. Not that Delacroix lacked preconceptions: his letters spent considerable time classifying the Moroccans as 'natural man' or as ancient Greeks and Romans. In contrast to the eloquent cultural constructs of the *Letters*, the *Journal* is mainly a succession of staccato colour notes and observations to complement the drawings Delacroix was making, the rapid watercolour which intensely but not narrowly epitomise the East experienced, though

1. Quoted in Claude Roger-Marx, *Eugène Delacroix: Les Graveurs francais nouveaux*, no. 2 (Paris 1929), p. 15.
2. Louis Gonse, *Eugène Fromentin* (Paris 1877), p. 124.
3. Lorenz Eitner, introduction to *Delacroix*, exhibition catalogue for the Edinburgh Festival (1964), p. 9.

the artist himself fretted that they fell far short of the actual impressions he had received.

Two of Delacroix's most important Moroccan paintings can be considered as adjuncts to the work done on his journey, since he took such considerable and untypical pains to make them as strictly accurate as possible. The *Women of Algiers* (Salon of 1834; Louvre) used a number of drawings and notes to reconstruct the interior of a Jewish Harem, while the *Jewish Wedding* (Salon of 1838; Louvre) followed exactly an Algerian watercolour of a courtyard in order to depict an event Delacroix had witnessed. Noticeable in these works is the overall muted quality of the tones, despite the inventive use of colour in the details. They have the 'grey of Nature' Baudelaire noted in Delacroix's 1845 *Sultan of Morocco*(Musée des Augustins, Toulouse), a work also directly based on a Moroccan sight but less specifically tied to notions of perfect fidelity. In the same 1845 Salon Delacroix exhibited *The Last Words of Marcus Aurelius* (Musée des Beaux-Arts, Lyons), and his approach to Ancient Romans in this painting, as well as to Genghis Khan, Achilles and a host of other characters who populate the Walls, ceilings and lunettes of his major decorative schemes of the 1840s and 1850s, was almost certainly enriched by his experience of living Arabs. Yet as Delacroix continued to undertake Eastern subjects he became less concerned with exact recreation of his own Moroccan visit and more with tapping his memory quite freely in terms of pictorial construction and colouristic invention. As with his animal paintings, he was not after precision but animation.

In Delacroix's last great murals for the chapel in Saint-Sulplice, Heliodorus is chased from a Temple of exotic Eastern architecture, while Jacob frantically waltzes with the Angel on a grassy knoll above the dusty cavalcade of an Oriental caravan carrying his worldly wealth. To the end of his life Delacroix employed the East as a crucial vehicle for his profoundest feelings, the setting for his most epic dramas. Among Western painters, he was at once the East's most powerful ruler and loyal subject.

Bibliography:
Lee Johnson, *Delacroix* (London 1963).
Lee Johnson, *The Paintings of Delacroix, a Critical Catalogue* (Oxford 1981 & 1986), 4 vols.
Jonathan Mayne, 'Delacroix's Orient', *Apollo* (September 1963), pp. 203-7.
Alfred Robaut, *L'Oeuvre Complet de Delacroix* (Paris 1885).
Maurice Serullaz, *Delacroix* (Paris 1981).
Jack Spector, *The Death of Sardanapalus* (London 1974).
Frank Trapp, *The Attainment of Delacroix* (Baltimore 1970).

19 Head of a Woman in a Red Turban

Oil on canvas, 41.3 x 35.2 cm.

SIGNED AND DATED: lower left, *Eugène Delacroix/1831*.

PROVENANCE Frédéric Villot sale, 11 February, 1865, lot 6; Luquet sale, 30 March, 1868, lot 34; Giroux sale, 7 March, 1884, lot 26; Armand Doria sale, 4 May, 1899, lot 140; Bénézit; Alfred Daber, from whom purchased January, 1962.

EXHIBITED: 1885, *Eugène Delacroix*, exhibition to raise money for a Delacroix monument, Ecole des Beaux-Arts, Paris, no. 64; 1907, *Eugène Delacroix*, Cassirer, Berlin, no. 12; 1962, *Oeuvres de Delacroix à Maillol*, Galerie Daber, Paris, no. 3; 1963, *Delacroix, ses maîtres, ses amis, ses élèves*, Galerie des Beaux-Arts, Bordeaux, no. 17; 1964, *Delacroix*, The Arts Council of Great Britain, Edinburgh and London, no. 26; 1968, *Gifts to Galleries: Works of Art Acquired with the Aid of the National Art-Collection Fund for Galleries outside London*, Liverpool, no. 26.

LITERATURE: Alfred Robaut, *op. cit.*, nos. 358 and 450, pp. 98, 120, 484; Raymond Escholier, *Eug. Delacroix* (Paris 1963), p. 101 (illus.); Raymond Escholier, *Delacroix et les femmes*, (Paris 1963), p. 73; Lee Johnson, *Eugène Delacroix, a Critical Catalogue*, (1981), vols. I and II, no. D-14, pp. 232-33, pl. 181; Maurice Serullaz, *Delacroix* (Paris 1981), no. 120, p. 183; *Tout l'oeuvre peint de Delacroix*, (Paris 1981), no. 219, p. 100.

Bristol City Museum and Art Gallery

Although in the Edinburgh Delacroix exhibition of 1964 Lee Johnson catalogued this painting as an authentic work, he has demoted it to 'doubtful' in his recent authoritative survey of the paintings. Its pedigree can hardly be bettered; the picture belonged to Delacroix's one-time close friend Frédéric Villot, the rather infamous Louvre restorer, whose wife, Pauline, Delacroix liked even better. Villot catalogued the work for his sale as having been painted by lamplight in 1831, and Johnson has used the circumstantial evidence of sale catalogue descriptions to deduce that the signature in the lower left is a false one added sometime between 1868 and 1873, perhaps to confirm Villot's dating. For Johnson the spurious signature suggests early uncertainty about the painting's authenticity, which he feels is substantiated by:

> a heaviness in the modelling, especially in the neck, hair, and turban, and by other crudities of handling, such as the ear and the wide brushstrokes across the bottom of the canvas.[1]

While it is presumptuous to disagree with such a distinguished scholar in his speciality, I accept the Bristol picture as authentic. Since its history rules out the possibility of the painting being anything other than a work contemporary with Delacroix (and an important testimony points to its being his), the sceptic is faced with the far-from-simple task of offering a credible alternative artist. One man's heaviness and crudity are another's power and bravura; in Delacroix the four often go together. If the loose vigour of the handling leaves room for debate, the overall conception seems to me pure Delacroix. The dramatically lit and tilted head swathed around its neck in dark fabric effectively functions as a *concetto* for decapitation, recalling the violence of *Sardanapalus*. The picture has some similarities with a Delacroix painting focusing on the face of a *Dead Woman* (Private collection, Paris) dated in the late 1820s by most scholars, but Johnson has doubted this work as well.[2] Escholier tentatively suggested that the *Woman in a Red Turban* might be Mme. Dalton.[3] Since the work was done for Villot, could the model not have been his wife? There are some similarities with her etched portrait;[4] a drawing of a woman in similar Eastern attire identified as Mme Villot (Eugene Thaw Collection)[5] shows a much slimmer face, but the rounded appearance of the painted head undoubtedly owes a lot to foreshortening and the dramatic light.

1. Lee Johnson, *op. cit.* (1981), p. 233.
2. *Ibid*, p. 230-31, no. 8, pl. 181; also Robaut, *op. cit.*, no. 1311, p. 350; Serullaz, *op. cit.*, no. 83, p. 121; *Tout l'oeuvre*, *op. cit.*, no. 166, p. 96. Robaut is the only one who dates the picture late, on the basis of an inscription on the back of the canvas.
3. Escholier, *Delacroix et les Femmes, op. cit.*, p. 73.
4. Robaut, *op. cit.*, no. 454, p. 121.
5. Illustrated, Escholier, *op. cit.*, facing p. 96.

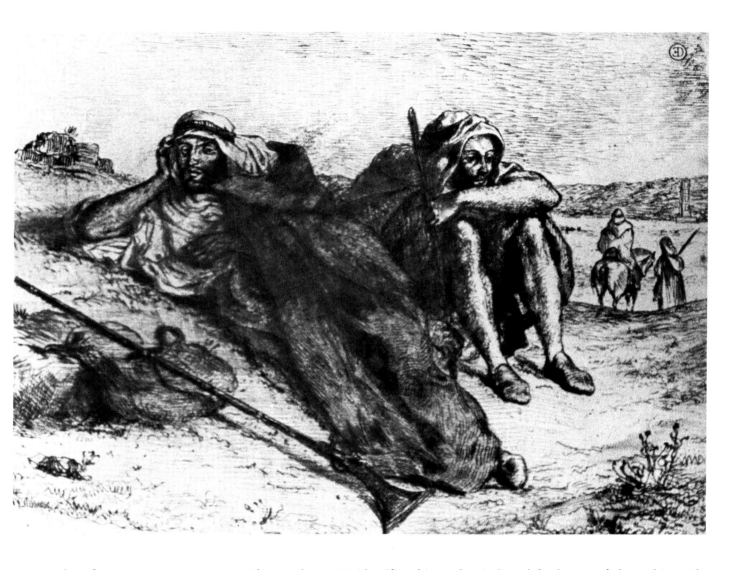

20 Arabs of Oran

Etching, 14.4 x 19 xcm.

SIGNED: lower right, *Eug. Delacroix.*; upper right, encircled monogram.

EXHIBITED: 24 September, 1987- 10 January, 1988, *Eugene Delacroix. Themen und variationem arbeiten auf papier*, Stadische Galerie im Stadelschen Kunstsinstitut, Frankfurt am Main, no. H20.

LITERATURE: Delacroix, *Journal, op. cit.,* vol. 1 (13 June 1847), p. 316; Alfred Delteil, *Le Peintre-Graveur* (Paris 1908), vol. III, no. 20; Alfred Robaut, *L'Oeuvre Complet de Delacroix* (Paris 1885), no. 462, p. 123; Claude Roger-Marx, *Eugène Delacroix: les Graveurs francais nouveaux*, no. 2 (Paris 1929); p. 49.

The Chester Beatty Library, Dublin

1. *Eugène Delacroix, Themen und variationem, arbeiten auf papier, op. cit,* nos. H19, H21.
2. Lee Johnson, *The Paintings of Delacroix: A Critical Catalogue,* vol. III (Oxford 1986), no. 357, p. 170, and vol. IV, pl. 172.
3. Eugène Delacroix, *Journal* (Paris 1980), 1 vol. (13 January 1857), p. 612.

The number '197' identifies this as the sixth and final state of the etching. The watercolour study from which this print was taken, with the composition predictably reversed, is reproduced in Raymond Escholier's *Delacroix* (Paris 1929, vol. II, p. 66, as *The Halt*), and was sold by the Reid Gallery, London, in 1960. Another similar drawing was done later in 1837.[1] In the print Delacroix has exchanged a shorter staff for the slender musket that more closely parallels the reclining Arab's diagonal length; his outward arresting stare in the drawing becomes an inward reflecting gaze in the print. An oil convincingly identified by Lee Johnson as for the Salon of 1835[2] has two very similar figures, but with a sword alongside the reclining Arab.

Delacroix saw both drawings and prints as having strengths distinct from those of painting:

> One must always return to the means appropriate for each art, which constitutes the language of that art. What is a drawing in black and white if not a convention to which the spectator is accustomed, which does not prevent his imagination from seeing in this complete translation of nature a total equivalence. The same is true of etching.[3]

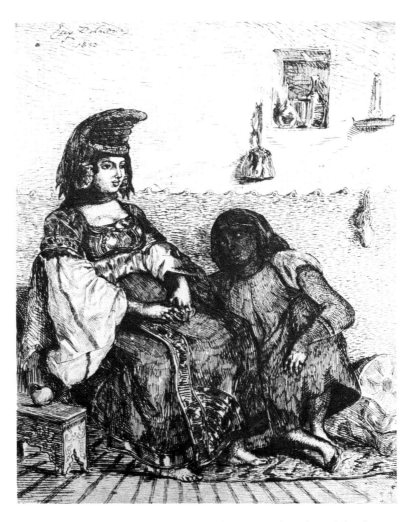

21 Jewess of Algiers

Etching, 19.3 x 14.5 cm.

SIGNED AND DATED: upper left, *Eugène Delacroix/1833*, and upper right, encircled monogram.

LITERATURE: Alfred Robaut, *L'Oeuvre Complet de Delacroix* (Paris 1885), no. 461, p. 123; Alfred Delteil, *Les Peintres-Graveurs*, (Paris 1908), vol. III, no. 18; Claude Roger-Marx, *Eugène Delacroix: les Graveurs français nouveaux*, no. 2 (Paris 1929), p. 43.

The Chester Beatty Library, Dublin

According to Delteil's description, this is the fourth and final state of Delacroix's etching, evidenced by the '171' in the upper right. The harem which Delacroix visited and depicted in his *Women of Algiers* was Jewish, and the central figure seated placidly here like a Christmas doll above the baleful stare of her servant is certainly related to those ladies, painted the following year. The juxtaposition of a fair-skinned Eastern woman decked out in her finery alongside a black attendant was to become a commonplace of Orientalist painting.

Delacroix saw etching as less a means of mass reproduction than a quite different art form:

> Etching is a true translation, that is to say, the art of taking an idea from one art form into another. The language of the etcher, and it is there that his genius reveals itself, does not consist in merely imitating by means of his art the effects of painting, which is another language. He has, if one can speak thus, his own language, which is a faithful translation of the work which he imitates, letting his own special feeling break through.[1]

Whether this work represents a successful translation or a drawing gone stale and overworked is a matter of opinion. Edmond de Goncourt judged Delacroix's efforts as a printmaker extremely harshly:

> Delacroix's work is stupid, stupid! Yes, stupid: spiritless, lifeless, heavy and laboured.[2]

The counterpart to colour in many of Delacroix's black and white drawings is their linear dynamism, a quality sometimes lost in the more careful finish demanded of the etched print.

Almost twenty years later, Delacroix reversed and reworked the duo in this etching for a painting of 1852 (Lee Johnson, *The Paintings of Eugène Delacroix, op. cit.*, 1986, vol. III, no. 388, pp. 195-6, and vol. IV, pl. 196.)

1. Eugène Delacroix, *Journal* (Paris 1980), 1 vol. (25 January 1857), pp. 619-20.
2. Edmond and Jules de Goncourt, *Journal* (Paris 1956), vol. IV (5 March 1891), p. 55.

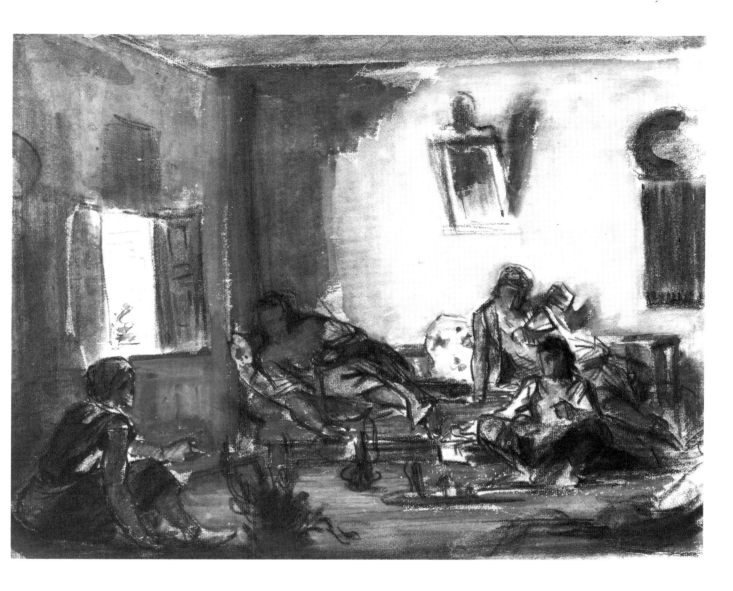

22 Women of Algiers

Watercolour and black chalk on paper,
21.5 x 28 cm.

PROVENANCE: Mr. E. Van Wisselingh, from
whom purchased.

LITERATURE: Alfred Robaut, *L'Oeuvre Complet
de Delacroix* (Paris 1885), no. 480, p. 128; John
Rowlands, ed. *Master Drawings and
Watercolours in the British Museum* (London
1984), pp. 141, 143, no. 137.

John Rowlands, following Alfred Robaut, considers this drawing a study for the *Women of Algiers* (Salon of 1834; Louvre) done on the spot in July, 1832. For me it lacks the precision of Delacroix's studies from life, however freely executed, and has more the appearance of compositional exploration for a painted work, whether the first great *Women of Algier* or even the later variant which Delacroix painted in 1849 (Musée Fabre, Montpillier). In fact, many of Delacroix's life drawings from Algiers come remarkably close to the finished poses of his famous 1834 Salon picture. This drawing has little in common with the painting, except for numbers — three women and a servant — and an interior setting. One of the women lazily reaches for an *ibriq*, a ewer with which to wash her hands, while the seated servant holds out her left hand to what may be a small cooking fire. As an exercise in light and shade, simplified form and colour, and related rhythms and movement, this drawing anticipates the twentieth-century Oriental works of Henri Matisse.

Baron Vivant-Dominique Denon

1747, Givry, near Chalon-sur-Saône — 1825, Paris

Courtier and collector, adventurer and aesthete, *savant* and survivor, Vivant Denon was one of the most remarkable men of his era, or rather eras, since his career spanned successfully the stormiest shifts in his country's political history. Years later Anatole France justly assessed Denon's life as 'a kind of masterpiece'.[1]

Denon began his career under Louis XV, first as a page, then as a gentleman-in-waiting. He was made master engraver to Mme de Pompadour and helped her reproduce gems from her collection. When she died, Denon was sent to the French Embassy in St. Petersburg, where Talleyrand was ambassador. Upon the death of Louis XV, Denon switched to the Embassy in Stockholm. After returning to France for a mission to Switzerland, he went to Naples, where he lived for seven years as the French *chargé d'affaires*. In Naples he was responsible for the illustration of the *Voyage pittoresque de Sicile* begun by Fragonard's friend the Abbé de Saint-Non. From Naples, Denon went to Rome, where he stayed for some time with the Ambassador; either in Rome or Naples he became friends with Jacques-Louis David, who was studying in Italy after winning the *Prix de Rome* in 1775. On Vivant Denon's return to France, he was made an Academician on the basis of a few mediocre paintings and his work as an etcher, especially his copies after Rembrandt.

Soon after his artistic honour, Vivant Denon decided to give up his diplomatic career and went to Venice, Florence and Switzerland, making a pilgrimage to see Voltaire, whose portrait he etched. He returned to France after hearing that his property had been confiscated by the Revolution. Although his intimate association with royalty might well have led to the guillotine, Denon enlisted David's support and soon he was engraving costumes after David's designs for revolutionary pageants;[2] once he was received by a skittish Robespierre in the same apartments in which he had served Louis XV.[3] Denon did one of the liveliest engravings after David's unfinished epic work, *The Oath of the Tennis Court*,[4] and also spent long hours at the revolutionary Tribunal, executing, under the cover of his hat, a remarkable series of drawings of the titled and famous about to be executed. So much sudden and unforeseen death must have made an impression; although interested in survival, Denon never took any trouble over personal safety, nor demonstrated any fear of death: 'He was brave and tasted danger like the salt of pleasure'.[5]

In 1797 at a ball given by Talleyrand, Denon gave his own glass of lemonade to a thirsty young general. By the end of the ensuing cordial conversation, Denon had once again hitched his wagon to the brightest of rising stars. In 1798 he was invited by that general, Napoleon Bonaparte, to join the Egyptian Campaign, and, assured that he would have freedom with regard to his time and movements, he accepted.

Voyage dans la Basse et la Haute Egypte pendant les campagnes du général Bonaparte not only prophesied, it almost defined the nature and scope of nineteenth-century Orientalism. Already in his fifties, Denon brought to his extraordinary new experiences both detachment and enthusiasm, wit and sensitivity, learning and feeling. Unquestionably he was part of an imperial/colonial incursion, but he reported French atrocities and applauded Egyptian and Mameluke virtues with a candour which would shame some modern correspondents. His real job, though, was to document the wonders of the new land; to that task he brought the considerable gifts of a draughtsman capable of working in an assortment of styles, whether drawing a desert locust lifesize or rendering the horizontal sweep of a Nile landscape containing the Pyramids in a drawing no bigger than a finger. As a source of visual and written information about ancient and modern Egypt, Denon's *Voyage* is extremely rich; as a document of Western colonialism it is remarkably self-critical; as the record of an exceptional sensibility it is quite special.

Denon's career was far from over. In 1803 he was made a member of the Institute, filling one of four new chairs created by Napoleon, who, in 1804, appointed him Director General of Museums. An 1811 drawing by the Strasbourg painter Zix shows Denon in a cavernous neo-classical storeroom, surrounded by Egyptian, Roman and Napoleonic casts and objects, with opened books about Bonaparte's conquests, penning plans on a sheet headed 'Musée Napoleon'.[6] On campaigns in Austria, Spain and

1. Anatole France, 'Notice Historique sur Vivant Denon' (Paris 1890), p. VIII.
2. Etienne Délécluze, *David, son école et son temps* (Paris 1855), p. 318.
3. Lady Sidney Morgan, *France*, 4th ed., with additional notes, vol. II (London 1818), pp. 109-12.
4. Illustration no. 230 in *'Le Serment du Jeu de Paume' de Jacques-Louis David* by Philippe Bordes (Paris 1983).
5. Anatole France, *op. cit.*, p. XI.
6. The drawing is in the *Cabinet des Dessins* of the Louvre. It is reproduced on page 28 of Peter Clayton's *The Rediscovery of Ancient Egypt: Artists and Travellers in the 19th Century* (London 1982), which contains other interesting material on Denon.
7. The sale of Denon's collection comprised four substantial catalogues in 1826. In addition to the descriptions of France and Lady Morgan, both *op. cit.*, there are accounts of its contents in Ulrich Richard-Desaix, *La Relique de Molière du cabinet du Baron Vivant Denon* (Paris 1880), and in J. Chatelain, *Dominique Vivant Denon et le Louvre de Napoléon* (Paris 1973).

8. Anatole France, *op. cit.*, p. XI.
9. Lady Morgan, *op. cit.*, p. 113. The remarkable Lady Morgan, whose portrait by Berthon is in the National Gallery of Ireland, was an Irish patriot who wrote novels (among others *The Wild Irish Girl*, 1806, and *The O'Briens and the O'Flahertys*, 1827, both subtitled 'A National Tale'), and works relating to art *(The Life and Times of Salvator Rosa*, 1824), while running Dublin's most substantial Salon. Lionel Stevenson's *The Wild Irish Girl: The Life of Sydney Owenson, Lady Morgan (1776-1859)* (London 1936), tells her story.

Bibliography:
Cecil Gould, *Trophy of Conquest: Napoleon I and the Creation of the Louvre* (London 1965).
J. Christopher Herold, *Bonaparte in Egypt* (London 1962).

Poland, Denon accompanied Bonaparte and gathered art for the great museum. After Waterloo, Denon fought fiercely against the repatriation of every individual item. When the final battle was lost, he did not choose to become a favourite of Louis XVIII, who had left him in his post, but resigned to devote himself to his own extraordinary collection. For the last ten years of his life he lived quietly on the Quai Voltaire, amidst thousands of remarkable items, including medals, marbles, enamels, vases and bronzes housed in Louis XIV's Boulle cabinets, choice paintings from Giotto to Guercino, fragments of the bones of El Cid, Héloïse and Abelard, Molière and La Fontaine, half of one of Voltaire's teeth and a drop of Napoleon's blood. [7] What would appear as wretched excess in a less remarkable figure seems only just deserts for this exceptional man who 'judiciously tasted all the pleasures of the senses and of the mind';[8] Lady Morgan, who eloquently appreciated his three thousand years worth of treasures, rated them as less valuable than one hour of his conversation.[9]

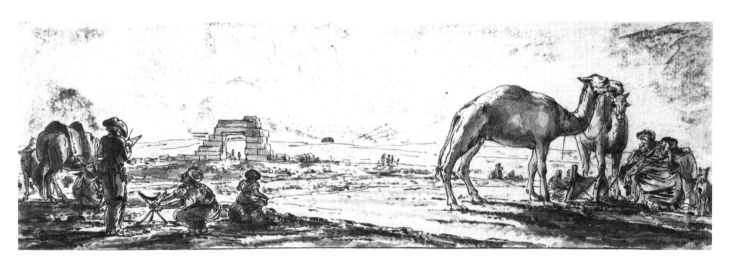

23 Vivant Denon Drawing the Ruins of Hieraconpolis at Sunset

Ink and wash drawing on tracing paper with oxidised white highlights, 11 x 32.5 cm.
PROVENANCE: acquired, 1836.

Trustees of the British Museum, London.

1. The recent invaluable *User's Guide to the Department of Prints and Drawings in the British Museum* by Antony Griffiths and Reginald Williams (London 1987) incorrectly states that the Denon drawings were done for the later *Description de l'Egypte*, when in fact they were used only in his own publication, which stole a march on the subsequent scholarly effort, and which, although originally printed on a similarly grand scale, was to be published in a much more manageable size in English within a year of its initial appearance.

The description of this drawing, engraved as plate 54bis in the original edition of Denon's *Voyage*,[1] reads as follows:

> The ruins of Hieraconpolis: they consist of a single gate, much damaged, and of a shape hardly worth recording; around this isolated fragment are seen only a few very worn capitals, a few formless granite fragments, and a large quantity of bricks which proclaim the existence of an extensive city in antiquity. As all that would provide a dull picture, I have added a few groups of all that comprised my entourage during the period of its great splendour: my servant, my little negro, my horse, my donkey, and my portable stool which solely made up my studio; I am shown with my scrappy outfit, the inevitable outcome of my continuous marching, of the loss of my equipment, and of the little time and attention I could devote to my own needs; preoccupied with my drawings and my journal, I had time only for them; I never was without my portfolio, I carried it everywhere, and at night it provided me with a pillow; by the end of the campaign its weight had considerably increased; my essential items, similar to those of Robinson Crusoe, consisted of two two-shot pistols, a sabre, a few cartridges, a moneybelt containing a hundred gold *Louis*, to pay for my transport following the army in case I was wounded, a spoon, a fork and a silver cup, drawing and writing paper, both used whenever the infantry was allowed

a moment to catch their breath during the marches: thus did I work on my journal and my drawings, that they might have, if not the virtue of perfection, at least the freshess of the moment and the truth of nature.[2]

In the drawing one attendant looks after Denon's horse while the other sets up his camp stool. The small negro sits atop a *darabukka* (see Fromentin, no. 29), which the French engraver later misread as a basket. Denon stands, leaning slightly over his drawing. He wears a military hat and coat, with two pistols slung on his right side, and a sword and pouch on his left; on his feet are Eastern slippers and his baggy trousers may be pantaloons.

Denon's account occupied itself with the left side of his drawing. He neglected to mention the time of day, indicated by the distant sunset, nor did he describe the balancing group of two old Bedouin, one of whom is smoking a long pipe, squatting between their camels and a saluki. Denon had mixed feelings about the Bedouin. Often much annoyed by their attacks and primitive ways, he still admired their openness and independence:

> Devoid of religious prejudices and external cuts, the Bedouin are tolerant: a few revered customs serve as their laws; their principles resemble virtues which are sufficient for their loose fellowship and paternal government...Can one hate such a people, however ferocious they may otherwise be? And what an advantage their austerity gives them when contrasted to the needs we have created for ourselves. How can we convert or subjugate such men? Could they not always castigate us for sowing rich harvests on the tombs of their ancestors?[3]

For their splendid camels, Denon felt no ambivalence:

> I there came to know, to revere that patient animal which nature seems to have placed in this region to atone for her error in creating a desert.[4]

Only a few other examples in the British Museum's collection of Denon's work are done in a similar style, on the same sort of paper (*e.g.*, nos. 91, 92).

2. Vivant Denon, *Voyage dans la Basse et la Haute Egypte pendant les campagnes du général Bonaparte* vol. I (Paris 1802), xvj (xvi).
3. *Ibid*, p. 43.
4. *Ibid*, p. 5.

24 Views from the Nile, with a Cross-Section of the Great Pyramid and Plans and Elevations of two of its Chambers

Four drawings in pen and wash on white paper, 29.1 x 46.8 cm.

PROVENANCE: acquired, 1836.

Trustees of the British Musuem, London.

Although individually the six different drawings on this single backing sheet are not exceptional, together they constitute an impressive assemblage of the range and richness of Denon's approach. By their shape if not their size, the little landscapes effectively suggest wide expanse with an economic play of line above and below the horizon. The top two, representing a *View of Salmia, on the Left Bank of the Nile*, are consecutive, and appear together with the tomb diagram as plate 20 (indicated by the top inscription) in Denon's original edition. The lower left drawing, a *View of Pyramids of Sakkara and Gizeh*, with the three receding dhows, also appears as the left half of a drawing on plate 20, while the lower right landscape, a *View of the Pyramids, Ascending the Nile*, appears as part of a scene in plate 19.

Denon's impressively accurate[1] drawing of the interior passage of the Great Pyramid was based on measurements he made by walking: the descending entrance, 65 paces, he has marked as 160 feet; at the end of this passage he found the two huge granite blocks he has indicated, which somewhat delayed his progress. The second, ascending passage, which he found twenty-two feet up, extended for 120 feet, coming to a landing which measured about fifteen feet square. A downward opening called the 'well' he determined to be relatively shallow by dropping a stone down it. At the end of a horizontal gallery 170 feet long came what Denon called the *Queen's Chamber*, though today it is regarded as one of two abandoned alternatives to King Cheops' final resting place. The plan and elevation of this room (indicated on the drawing by nos. 4 and 5) show its floor turned up by tomb robbers. The King's true chamber came at the end of a large and magnificent staircase, 180 feet long, with a thin spearheaded ceiling (no. 6) that tapered upward sixty feet tall. On the platform at the top of this staircase the principal sepulchre had originally been blocked with a thick chunk of granite like an immense chest. Denon ironically mused that it had taken great labour both to construct it and to break through: 'Here superstitious zeal has been opposed to intense avarice, and the latter has prevailed'. The King's final chamber was nearly twice the size of the alternate below, eighteen feet tall, thirty-two feet long, fifteen feet wide. Denon's no. 10 is its plan, no. 11 its section.

The unusual juxtaposition of conscientiously-measured plans and quickly-sighted riverscapes makes an interesting visual mix and points at the variety and richness of Denon's approach and achievement, an impressive blend of careful archaeology and spontaneous art. Few subsequent Orientalist writers or artists could claim to have taken greater pains over or responded more freshly to the Eastern environment.

1. Such is my unprofessional opinion, taken in comparison to the diagram illustrated in W.V. Davies' *Pocket Egypt* (London 1986).
2. Vivant Denon, *Voyage...*, *op. cit.*, vol. I, vj (vi).

Mariano-Jose-Maria-Bernardo Fortuny y Marsal

1838, Reus — 1874, Rome

Fortuny was born in Taragona, the son of an artisan. Orphaned in his youth, he still managed an early start as an artist, studying first at age nine with Domingo Soberano, then with the miniaturist Antonio Basso. In 1853 he entered the Barcelona Academy, where he was taught by Claudio Lorenzale, a follower of the German painter Overbeck, and the following year he was at the School of Fine Arts of San Jorge in Barcelona. In 1858 Fortuny won a scholarship to Rome, but in 1859 was in Morocco with the Spanish military expedition under General Prim, who was later the subject of Regnault's (q.v.) most stirring portrait. Fortuny returned to Morocco two years later to paint a panorama commemorating the Spanish victory at Tetuan on 4 February, 1860. Although he never completed that large-scale commission (for which his payments were revoked in 1865), the studies he made for it were useful in works of a more manageable size.[1]

During a visit to Paris in 1866 Fortuny met the influential dealer Goupil, who also profitably marketed, among others, Bouguereau (q.v.) and Gérôme (q.v.). With the latter as well as with Meissonier, Fortuny became friendly and in 1867 he signed a contract with Goupil. That same year he had married Cecilia Madrazo, daughter of the portrait painter Federigo Madrazo, who was also Director of the Prado. Fortuny's first major show for Goupil in 1870 caused a sensation. Théophile Gautier wrote that Fortuny's name was on the lips of everyone in the Parisian art world, describing him as a:

> painter of marvellous originality, an accomplished talent already sure of himself, even though the artist has hardly attained the age limit of a student competing for the *Prix de Rome*.[2]

Gautier went on to describe one of Fortuny's works as 'a sketch by Goya taken and retouched by Meissonier'.[3]

Fortuny's flashy style, a second generation Romantic colourism with bravura brushwork, a synthesis distantly comparable to that of Schreyer (q.v.), was quite seductive for a generation of talented young artists that included not only the Frenchmen Regnault, Benjamin Constant, and Georges Clairin, but also a whole host of Italians. Fortuny's sales were based to a large extent upon American patrons, like the expatriate William Hood Stewart[4], and he shunned the Salon. The money he made enabled him to fill studios in both Paris and Rome (the latter documented in a series of extraordinary contemporary photographs) with a fantastic accumulation of bric-a-brac. In the 1870s Fortuny revisited Morocco and Tangier, where he saw Clairin and Regnault, and worked in Granada to be near the Alhambra. His unexpected death in 1874 stunned the Paris art world, much as Regnault's had earlier; his son, Mariano Fortuny y Madrazo, became not only a successful painter but an internationally famous fashion designer of exceptional originality, who is today better-known than his father.

1. Fortuny's failed project was taken up again, with predictably explosive results, by Salvadore Dali in 1957. His *Battle of Tetuan*, 304 x 396 cm., was recently sold at Sotheby's New York (12 November 1987, lot 92a).
2. Gautier, *Journal Officiel* (19 May 1870), quoted in Baron Davillier, *Fortuny, Sa Vie, Son Oeuvre, Sa Correspondance* (Paris 1875), p. 55.
3. *Ibid*, p. 61.
4. See W.R. Johnston, 'W.H. Stewart, the American Patron of Mario Fortuny', *Gazette des Beaux-Arts* (March 1971), pp. 183-88.

Bibliography:
N.R.E. Bell, *Representative Painters of the XIXth Century* (New York 1899), pp. 193-96.
Baron Davillier, *Fortuny, Sa Vie, Son Oeuvre, Sa Correspondance* (Paris 1875).
Baron Davillier, *Fortuny 1838-1874* (Milan n.d. (c.1931)).
Claude Ressort, *Mariano Fortuny et ses amis francais* (Musée Goya, Castres 1974).
Charles Yriarte, *Fortuny — Les Artistes célèbres* (Paris 1886).

25 The Cafe of the Swallows

Watercolour with touches of oil over pencil on paper, 50.3 x 40 cm.

SIGNED: in monogram, lower right, in black wash over brown ink.

PROVENANCE: Percy French, who bought it from a pupil of Fortuny in 1868; Miss K.E.S.A. ffrench, 1939.

EXHIBITED: 1974, *Mariano Fortuny et ses amis français*, Musée Goya, Castres, no. 81.

LITERATURE: *National Gallery of Ireland Illustrated Summary Catalogue of Drawings, Watercolours and Miniatures* (Dublin 1983), no. 2971, p. 145; Raymond Keaveney, *Master European Drawings from Collection of the National Gallery of Ireland* (Washington 1983), pp. 180-1.

National Gallery of Ireland (cat. no. 2791)

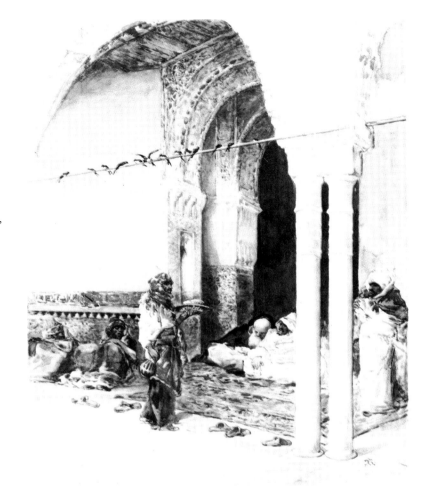

1. Gautier's review, from the *Journal Officiel* of 19 May 1870, is quoted in Baron Davillier, *Fortuny, sa vie, son oeuvre, sa correspondance* (Paris 1875), p. 56. Davillier lists a *Cafe des Hirondelles* from 1866 as belonging to M. W. Stewart (p. 149), but the Stewart watercolour is the one now in Baltimore, and is dated 1868 (see W.R. Johnston, 'W.H. Stewart, the American Patron of Mario Fortuny', *Gazette des Beaux-Arts* (March 1971), pp. 183-88.
2. Illustrated in Baron Davillier, *Fortuny, 1838-1874* (Milan n.d.), pl. 16, and in Donald Rosenthal, *Orientalism* (Rochester 1982), no. 128, p. 132.

This watercolour is the original version of a composition Fortuny copied two years later and exhibited in his important 1870 show for Goupil in Paris. According to the inscription on the back by Percy French, this work was painted in Madrid in 1866; the second version, dated 1868 (Walters Art Gallery, Baltimore) was one of three watercolours mentioned by Gautier in his review of the 1870 exhibition as possessing 'a strength of tone which rivals oil'.[1] In fact, the richness of the red, the shine of the silver Arabic on the wall tiles, and the deep black of the swallows in this version suggest that Fortuny actually did use a bit of oil in its execution. The title of one of the other watercolours mentioned by Gautier — *The Kief*, an Eastern state of completely relaxed ease — could almost be used for this composition. Apart from the waiter standing with a carafe and a tray, there is nothing to indicate the consumption or sale of food and drink, almost all potential customers having nodded off to sleep. On the left, two figures, one a negro, sit leaning against the wall. Facing the waiter, up two or three steps covered by a carpet, is seated an old man whose black burnous makes him look almost like a Dominican, slouching into the fellow beside, attired totally in white and fingering a string of worry beads. Four of the abandoned *babouches* at the bottom of the steps probably belong to them. Standing beyond the paired columns is a slightly sinister figure, who lightly touches his scimitar.

The tie-rod on which perch the birds who give the cafe its name is misunderstood, Fortuny first drawing it continuously, then attempting both to hang it before the impost block as well as have it penetrate from the side for architectural support. In the Baltimore second version,[2] which is the same size and nearly identical, he has separated the two functions by breaking the consecutive line. In representing a sunlit courtyard the artist employed surprisingly cool tones of silvery blue-green, offset only by the few touches of red. In 1869 Fortuny's friend Eduardo Zamacois y Zabala copied the second version of this composition in oil (ex-coll: Metropolitan Museum, sold Christie's, London, 20 January 1980, lot 114).

Eugène-Samuel-Auguste Fromentin

1820, La Rochelle — 1876, La Rochelle

Fromentin twice found resonant counterparts to the deep love he bore the sweeping plains, wide skies and vast seas of his native La Rochelle: once, in the beclouded marshes and blistering desert of the Algerian Sahel and Sahara, and, again, about twenty-five years later, in the calmer Low Countries of Belgium and Holland. The former sparked two travel books and a lifetime's production of Orientalist pictures; the latter inspired his rich and famous art volume *Les Maîtres d'Autrefois*.

From his youth Fromentin demonstrated academic intelligence and literary talent. His father, a doctor and director of a local mental hospital, found a successor in his elder son Charles; Eugène was to be a lawyer. Faced with his son's belated decision to become a painter, Dr. Fromentin sent him to the studio of the classical landscapist Charles Rémond in an attempt to determine the character of his artistic production. Fromentin soon shifted to more fruitful study with Louis Cabat, a naturalistic landscape painter. Fromentin's conflict with his father, an amateur artist who had himself studied under Bertin, was to be supplemented by struggles within himself. Self-doubt and disillusionment were to characterize Fromentin the artist, the writer, and the man even at the height of his fame.

Fromentin's first Salon was 1847, when he exhibited three works. One, *A Farm near La Rochelle* (private collection, England), was a rare painting in which he represented the countryside he knew so well. The other two Orientalist subjects were the direct outcome of a clandestine visit he had made with a friend and fellow painter to Algeria, a trip he repeated on longer journeys in 1847-8 and 1852-3. Fromentin's popular acceptance can be gauged from the 1850-1 Salon, when he showed eleven Orientalist pictures. His early manner owed much to Decamps (*q.v.*), Diaz, and Marilhat (*q.v.*). Those works were painted in a forceful, almost crude manner, with a rough impasto that contrasts noticeably with the refinement of his later work.

The Salon of 1859 saw Fromentin crowned with critical and official success. He won a First Class Medal and was awarded the Cross of the Legion of Honour. Baudelaire said that Fromentin's Arabs possessed ' that gravity and patrician dandyism which characterises the chiefs of powerful tribes',[1] while the young Degas wrote to their mutual friend Gustave Moreau: 'In my opinion Fromentin nearly steals the show'.[2]

The 1863 Salon contained three of Fromentin's most important mature works, all scenes of Arabs and horses: *The Quarry* (Musée d'Orsay, Paris), *Arab Falconer* (Chrysler Museum, Norfolk), and *Arab Camp at Dawn* (whereabouts unknown). After 1863 his works fall into a successful *juste milieu* series of *Oriental genre* that the artist tried to break with more dramatic compositions. But public expectation and established success created an artistic trap, a difficulty described by his friend Maxime Du Camp:

> Whatever he suggested he would get the reply, 'No, do us one of your Algerian things. You know, one of those little horses with glossy coats you're so good at.' So he would curse, and for the hundredth time begin to paint the little white horse, the little blue sky, the little silvery ford, the little tree unknown to botanical science, and the little Arab boy with bare arms. One day when he had just finished one of his pretty canvases he showed it to me, and shrugging his shoulders impatiently said, 'I am condemned to this forever'.[3]

In addition to dramatic ideas like *L'Incendie* (see no. 32) and *Land of Thirst* (versions in Musée d'Orsay and Musée des Beaux-Arts, Brussels) never exhibited in Fromentin's lifetime, he also attempted to alter his subject matter in 1868 with a large Salon painting of *Centaurs* (Petit Palais, Paris); the resulting critical condemnation inspired an eloquent letter of defence from Odilon Redon but convinced the artist he should abandon mythological subject matter. Since painting and prose were so intimately linked in Fromentin, hints of all these artistic departures can unsurprisingly be found in his travel books, written over a decade earlier.

Visits to Egypt in 1869 with Berchère (*q.v.*) and Gérôme (*q.v.*) for the opening of the Suez Canal and to Venice in 1870 gave Fromentin the opportunity to relocate

1. Charles Baudelaire, 'Salon de 1859', in *Oeuvres Completes*, ed. Claude Pichois, vol. II (Paris 1976), p. 650.
2. Theodore Reff, 'More Unpublished letters of Degas', *Art Bulletin*, vol. 51, (September 1969), p. 205.
3. Maxime Du Camp, *Souvenirs littéraires*, vol. II (Paris 1906), p. 202

4. Eugène Fromentin, *Lettres de Jeunesse*, ed. Pierre Blanchon (Paris 1909), p. 94.
5. Henry James, *The Painter's Eye*, edited by John L. Sweeney (London 1956), p. 116

Bibliography:
Eugène Fromentin, *Lettres de Jeunesse*, edited by Pierre Blanchon (Paris 1909).
Eugène Fromentin, *Correspondance et fragments inedits*, edited by Pierre Blanchon (Paris 1912).
Eugène Fromentin, *Oeuvres Complètes*, edited by Guy Sagnes (Paris 1984).
James Thompson and Barbara Wright. *La Vie et l'oeuvre d'Eugène Fromentin* (Paris 1987).
Barbara Wright, *Eugène Fromentin: A Bibliography* (London 1973).
Barbara Wright, *Eugène Fromentin: Correspondance Générale* (forthcoming).

his subject matter, but in both cases critical disapproval sent him back to the same sort of work that had made him famous. His two major works for the 1874 Salon (see no. 34) were both called *Algeria Remembered*, and memory was all his life a cardinal artistic process and device: as early as 1843 he had described memory as 'an admirable optical instrument'.[4]

An anonymous review he wrote of the 1876 Salon asked why Fromentin dealt with faraway rather than French subjects; had he not died prematurely that same year, he might have attempted visual counterparts to the brilliant descriptions of local landscape that appear in his autobiographical novel *Dominique*.

Although his literary works are relatively few and his paintings have recently increased in price and popularity, Fromentin is still better known today as a writer than as an artist. One of his first serious attempts at criticism, a review he wrote of the Salon of 1845, contrasts interestingly with Baudelaire's initial effort of the same year. Fromentin's two travel books, *A Summer in the Sahara* and *A Year in the Sahel*, were received with unanimous praise, particularly from Gautier, himself the acknowledged master of travel literature. *Dominique*, Fromentin's only novel, was read in one sitting by an enthusiastic Flaubert, and called 'a singularly exquisite and perfect work' by Henry James.[5] And *The Masters of the Past Time* remains almost unique in embodying the perceptions of a fine painter in the prose of a distinguished literary stylist.

Fig. 35 Eugène Fromentin, *Self Portrait (?) as an Arab*, drawing (Private collection).

26 Self-Portrait (?) as an Arab

Crayon on tracing paper, 10 x 9.5 cm.

STAMPED: lower right, stamp of 1877 Fromentin *vente* (Lugt 957).

PROVENANCE: Family of the artist.

LITERATURE: James Thompson and Barbara Wright, *La Vie et l'oeuvre d'Eugène Fromentin* (Paris 1987), p. 145 (illus.).

Private collection

1. Illustrated in Thompson and Wright, *op. cit.* (1987), p. 74.

This drawing dates from Fromentin's third and final visit to Algeria, in 1852-3. Identification as a self-portrait can only be tentative; there are other similar studies (Fig. 35) which look somewhat less like the artist. It was, however, common for Western travellers to adopt Eastern costume. Among writers Sir Richard Burton, Edward Lane and Gérard de Nerval are only a few famous ones who 'went native'; J.F. Lewis (*q.v.*) is the artist perhaps most famous for his local costume, but most of the artists in this exhibition tried it either seriously or in fun: the Louvre owns a drawing of Delacroix (*q.v.*) by Pauline Villot in an *'iqaal* and *kaffiyya* and Fromentin drew his painter — companion Auguste Salzman on his second Algerian journey *en Turc*.[1] But even if Fromentin's representation here was of an Arab who came out looking remarkably like the artist himself, a point about the painter's deep empathy for and identification with the East and desert Arabs is still established.

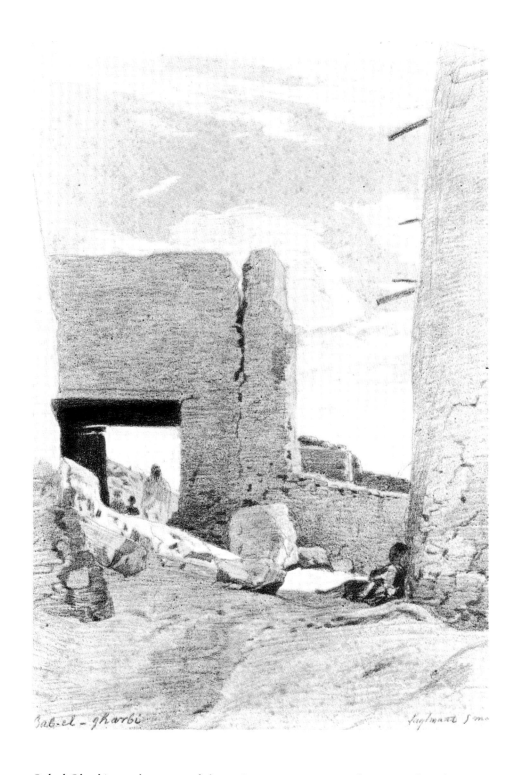

Bab-el-gharbi

Laghouat 5 ma

27 Laghouat: Bab-el-Gharbi

Crayon with white highlights on grey paper,
47.5 x 31.5cm.

INSCRIBED AND DATED: lower left, *Bab-el-Gharbi*; lower right, *Laghouat 5 mai* (sic);
lower right *vente* stamp (Lugt 957), no. 102
(from posthumous sale of 1877).

PROVENANCE: Fromentin, studio sale, 3
February, 1877, no. 305; collection of the
artist's family.

LITERATURE: James Thompson and Barbara
Wright, *La Vie et l'oeuvre d'Eugène Fromentin*
(Paris 1987), pp. 120 (illus.), 132.

Private collection

Bab-el-Gharbi was the name of the major Western gate to the town of Laghouat (or El-Aghouat). The date on the drawing is incorrect, as Fromentin had not yet arrived there by 5 May — he probably meant 5 June. The composition follows an upward diagonal incline to the left centre, where a small rectangular aperture divides into two broken triangles, one consisting of the grey of the paper and representing a distant slope, the other of white highlights and suggesting clouds beyond. The white shape is juxtaposed with Fromentin's dense black crayon to create a simple geometric clash of light and dark, which is emblematic of the distilled visual opposition of his final Algerian journey during which he experienced temporary blindness. The figures in the drawing — a young Moor resting in the shadow of the right wall, under the darkened gate a ghostly Arab who overlaps the grey and white shapes, and, finally, two silhouettes set against the hill beyond — are almost lost in the monumental yet rich opposition of sun and shadow, of structure and sky.

80

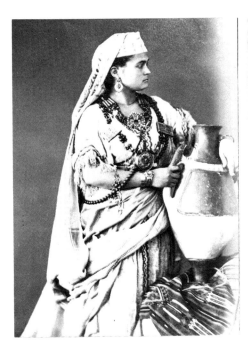

Fig. 36 Photograph of a Berber woman holding a Kabyl water jug (Author's collection).

28 Kabyl Water Jug

Oil on canvas, laid down on panel,
21 x 14 cm.

INSCRIBED: lower left, *0,50c.*

PROVENANCE: family of the artist.

LITERATURE: James Thompson, 'Un autre Fromentin', *Revue de l'Art* (1986), pp. 32, 36 (no. 10); James Thompson and Barbara Wright, *La Vie et l'oeuvre d'Eugène Fromentin* (Paris 1987), pp. 134-35, 139 (illus.).

Private Collection

Kabyl pottery is the only indigenous Algerian ceramic, a vernacular variant on Greek and Roman amphorae. The viewpoint taken of this one conceals a matching symmetrical handle on the opposite side; the notation in the lower left indicates a height of fifty centimetres. Pots were hand-modelled in clay by Kabyl women. They were then polished with a smooth stone, and simple geometric patterns in earth colours of yellow, brown, black and red were painted on with a primitive goat hair brush. Afterwards they were piled on an open fire to harden. Filled with water they could weigh nearly sixty kilos, a considerable burden for the unfortunate Kabyl female to bear. A roughly contemporary photo (Fig. 36) shows a bejewelled Berber woman supporting a pot of similar type.[1]

1. Photo courtesy of Luke Dodd, Strokestown House.

Fig. 37 Photograph of a group in North Africa with a man holding a *darabukka* (Author's collection).

29 Darabukka

Oil on canvas, laid down on panel, 22.9 x 14.6cm.

INSCRIBED: lower left, *0,41c*.

PROVENANCE: family of the artist.

Bibliography:
James Thompson, 'Un autre Fromentin' *Revue de l'Art* (1986), pp. 32, 33; James Thompson and Barbara Wright, *La Vie et l'oeuvre d'Eugène Fromentin* (Paris 1987), pp. 134-6, 139 (illus.), 186.

Private collection

1. Eugène Fromentin, *Oeuvres Complètes*, edited by Guy Sagnes (Paris 1984), p. 1226.
2. The most obvious scene into which the *darabukka* would have fitted is Fromentin's *Bateleurs Nègres* of the 1859 Salon (private collection, Algeria); but he painted instead a simple cylinder for the central musician's percussive instrument.

The *darabukka* is one of the most distinctive North African drums. It can be constructed of pottery or of wood, sometimes decorated with mother-of-pearl or tortoise shell inlay. The lower end is left open, the top covered in fishskin. Suspended under the left arm by a strap, the *darabukka* is played with both hands. It was seen as a typical Oriental instrument, and Berlioz specified that one was to be used in the 'Slave Dance' of *The Trojans*. A photograph owned by Fromentin (Fig. 37) shows the central member of a seated group holding just such a drum.

The oil sketches of the *Darabukka* and the *Kabyl Jug* are interesting as specific contradictions of Fromentin's professed attitude to the depiction of Eastern subjects. In a discussion of three principal painters in *Une Année dans le Sahel*, his assessment of Delacroix as a superior Orientalist to Marilhat and Decamps was based on the fact that Delacroix was the most general, the least specific of the three. For Fromentin the proper representation of the East was less a matter of exact accessories than it was of a personal response to place. In his anonymous Salon review of 1876 he argued that a preoccupation with eccentric Oriental paraphernalia produced 'ethnography and not art'.[1] The fact that he indicated the measurements of each object suggests that they were not simply rainy day still lifes, or even limbering-up exercises for landscapes. But in the future compositions where he might reasonably have employed these studies in an attempt to lend a scene 'authenticity', Fromentin remained true to his own argument, ignoring or forgetting them.[2]

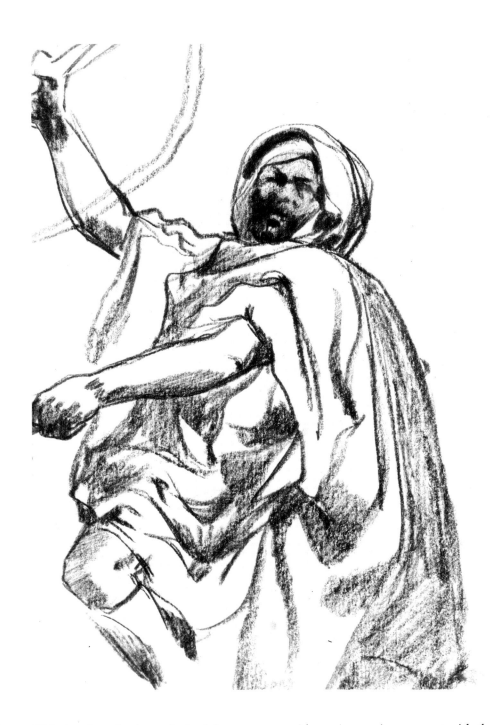

30 Arab Horseman Raising his Rifle

Charcoal on paper, 30 x 20 cm.
PROVENANCE: family of the Artist.

Private collection

This drawing of a dynamic Arab horseman provides an interesting contrast with the tranquil grace of Fromentin's study for *The Quarry* (no. 31). The Arab warrior's raised right arm, which, as the lowered parallel arcs of a strap indicate, brandishes an unseen musket, again aligns him with a diagonal; but his left arm, far from reinforcing that orientation, as in the other work, is set in the opposite direction, creating, in conjunction with his turning head, a sense of dramatic motion. Such is its lively spontaneity, this vigorous study may well have actually been done in Algeria, or expanded from a smaller drawing Fromentin executed there. It was upon sources such as this (a related, contemporary drawing is illustrated in Thompson and Wright, *La Vie et l'oeuvre d'Eugène Fromentin*, p. 141, upper left) that the artist drew many years later when he painted his *Fantasia* for the 1869 Salon (Musée des Beaux-Arts, Poitiers).

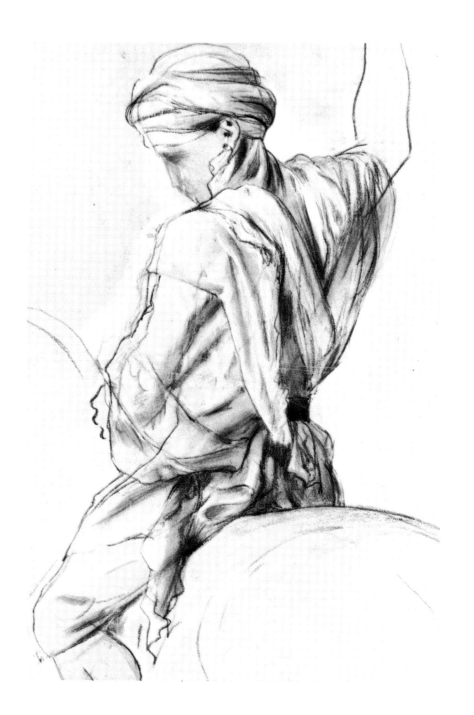

31 Study for a figure in 'The Quarry'

Charcoal on paper, 47 x 30 cm.
PROVENANCE: family of the artist.

Private collection

1. Illustrated in Philippe Jullian, *The Orientalists* (Oxford 1977), p. 52, and in James Thompson and Barbara Wright, *La Vie et l'oeuvre d'Eugène Fromentin* (Paris 1987), p. 188.

Since Fromentin's death, *The Quarry* has been his most reproduced and famous painting. Apart from its prominent public exposure in Paris first at the Luxembourg, then the Louvre, and now the Musée d'Orsay, the work also represented a reasonable reconciliation of the two great styles that preceded it. For a decade or two before and after the middle of the nineteenth century, the artistic equivalent of squaring the circle was to try and successfully combine the styles of Ingres and Delacroix. Chassériau built his short but productive career partly in pursuit of such a noble and contradictory aim. The carefully worked-out contours of the figures and the nervous white stallion, as well as the precise ordering of the composition itself, reflect the formidable old apostle of line, M. Ingres, while the sketchier landscape and figures just emerging in the back left are motifs more akin to Delacroix. This drawing is one of several for the central horseman, who helps establish the painting's main diagonal axis. Here Fromentin was finding the form of his principal protagonist; a finished study of the same figure, squared for transfer, is in a private collection in Paris.[1] The extensive preparatory work Fromentin did attests that he laboured harder over *The Quarry* than on almost any of his other pictures. His reward was its purchase from the State for seven thousand francs.

84

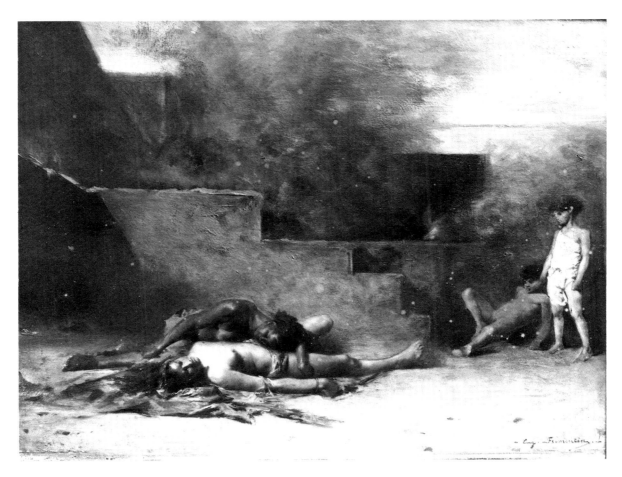

32 Oriental Battle Incident

Oil on panel, 31 x 41 cm.

SIGNED: lower right, *Eug. Fromentin*.

PROVENANCE: Fromentin sale; Lepel Cointet; sale, Paris, 1881; sale, Paris, 3 May 1895; Sir Alfred Chester Beatty, by whom presented to the Irish Nation 1950, transferred to the National Gallery of Ireland, 1978.

EXHIBITED: 1877, Posthumous Fromentin Exhibition, Ecole des Beaux-Arts, Paris, no. 34, p. 36.

LITERATURE: *Catalogue of the Chester Beatty Collection* (Dublin 1950), no. 25, p. 7; Pierre Moisy, 'L'Incendie: Notes sur un tableau d'Eugene Fromentin', *Archives de l'Art Français*, T. XV, nouvelle période, 1978; *National Gallery of Ireland Illustrated Summary Catalogue of Paintings* (Dublin 1981), no. 4233, p. 56; James Thompson and Barbara Wright, 'Les Origines du tableau "L'Incendie" dans l'oeuvre d'Eugène Fromentin', *Ecritures*, II (Paris 1985), pp. 225-270.

National Gallery of Ireland (cat. no. 4233)

1. Fromentin studio sale, Paris, 30 January — 3 February 1877, nos. 27 and 32, p. 12.
2. Illustrated in Thompson and Wright, *op. cit.* (1987), p. 230.

In the absence of the two larger sketches of the same subject which appeared in Fromentin's studio sale,[1] this small panel is the most complete document of the artist's project for a scene of Oriental death and destruction he was trying to paint around 1867. Despite the fact that in a preliminary drawing[2] a tent stake had appeared near the two women, Fromentin has here shifted his setting to the courtyard of a house. Four principals people the uncertain architecture of the painting. In the left foreground, painted with fluid ease, are two women, nearly or recently dead, lying together. One of them, fair-skinned, is flat on her back facing upward, her left foot drawn in so that her knee inclines about thirty degrees to her body. Atop her, in a contrast of skin tones, is a negress, her head resting on a cloth that covers the paler woman's crotch, her left arm dangling over the other's right leg, which continues the long horizontal line of their combined bodies.

Echoing the grouping of the two women are two young boys in the right middle ground. One youthful figure, in fact, presents almost a mirror image of the recumbent Caucasian, with one leg extended, one drawn back. His pose, like hers, suggests an element of sexual invitation, though more likely he is shrinking away, or extending an extremity to test the lifelessness of her inanimate form. The other, paler boy stands flat-footed at his fellow's shoulder, hands at his sides, gazing intently at the same scene. While the two women lie convincingly and solidly on the ground, the reclining boy seems to float above it, and the dirt floor becomes the perpendicular of the wall without a juncture.

Though the meaning of the painting is initially as unclear as the smoke that obscures its centre, it can be connected to a passage in Fromentin's *Un Été dans le Sahara* written over a decade before. There the painter related an incident in which two French soldiers, who had secretly enjoyed the favours of two El-Aghouat women, returned to their house during a military siege to find them dead. Fromentin's description reads:

> The two women were stretched out motionless, one on the paving stones of the courtyard, the other at the foot of the stairway, down which she had rolled, head first. Fatma was dead; M'riem was dying. Both were without

85

3. Fromentin, *Oeuvres Complètes*, op. cit., p. 94.
4. In an early manuscript draft, there was a dead child in the scene, perhaps the ancestor of the very-much-alive duo in the painting. See Thompson and Wright, *op. cit.* (1985) p. 261.
5. Francis Haskell has proposed in 'A Turk and his Pictures in Nineteenth-Century Paris' *(Oxford Art Journal*, vol. 5, no. 1 (1982), pp. 40-7), that Courbet's extraordinary painting of two sleeping nude women (Petit Palais, Paris), which was painted for Khalil Bey, was partly inspired by the Ingres *Turkish Bath* (Louvre, Paris), which the collector already owned. I make the more tenuous suggestion that Fromentin might have hoped to sell his finished *L'Incendie* to Khalil Bey (who had already paid extravagant sums for his work) as a refined restatement of a Courbet-style group set in the East.

headdresses, earrings, ankle bracelets or pendants to hold their *haïks*; they were nearly nude and their clothes consisted simply of a sash surmounting their bare hips.[3]

The women's deaths are explained in the book by another body of a male fugitive,[4] whose flight had precipitated the intruders' slaughter. Fromentin has omitted the additional corpse, and his picture's lack of the narrative's clarity (and implicit criticism of the French Army) is part of its dramatic undoing. Another part is its lack of compositional structure. The picture is divided by the rigid and awkward geometry of the irregular stairs which descend diagonally from left to right in the centre of the painting. There is an unhappy air of indecision about this piece of architecture, as there is also in the handling of the buildings in the background, whose masses are lost in the smoky mess of the fire that gave the painting its French title '*L'Incendie*' (The Conflagration). Yet the two graceful women, whose juxtaposed and contrasting sensuality[5] is dampened only somewhat by their joint demise, are among the most memorable figures Fromentin ever painted; and even if he failed in his aspiration to paint dramatic action, he did manage in this picture to distil successfully some of the terrible beauty of its aftermath.

33 Crossing the Ford in Algeria

Oil on canvas, 73 x 103 cm.

SIGNED: lower left, *Eug. Fromentin*, and dated lower right, *1869*.

PROVENANCE: Isaac Pereire; Mme. Gustave Pereire; sale, Paris, 4 June 1937; Sir Alfred Chester Beatty, by whom presented to the Irish Nation, 1950, transferred to the National Gallery of Ireland, 1978.

EXHIBITED: 1877, Posthumous Fromentin Exhibition, Ecole des Beaux-Arts, no. 36, p. 37; 1930, *Centenaire de la Conquête de l'Algérie*, Petit Palais, Paris, no. 220.

LITERATURE: Louis Gonse, *Eugène Fromentin* (Paris 1881), p. 99; Henri Roujon, *Fromentin, Les Peintres illustres* (Paris n.d.), pp. 54, 57-8; *Catalogue of the Chester Beatty Collection* (Dublin 1950), no. 24, p. 7; *National Gallery of Ireland Illustrated Summary Catalogue of Paintings* (Dublin 1981), no. 4232, p. 56; James Thompson and Barbara Wright, *La Vie et l'oeuvre d'Eugène Fromentin* (Paris 1987), p. 221 *(illus.)*.

National Gallery of Ireland (cat. no. 4232)

1. Fromentin's 1869 Salon paintings were *A Fantasia in Algeria* (Musée des Beaux-Arts, Poitiers) and *Halt of the Mule Drivers* (present whereabouts unknown).
2. Henri Roujon *Fromentin: Les Peintres illustres* (Paris n.d.), pp. 54, 57.
3. Eugène Fromentin, *Correspondance et Fragments Inédits*, ed. Pierre Blanchon (Paris 1912), p. 220.

Following a series of attempts to inject greater drama in his work with compositions like the National Gallery of Ireland's *Oriental Battle Incident*, Fromentin returned in this picture to business-as-usual. And if he did not seek kudos for it in the 1869 Salon, it is not significantly different in style or content from the two he sent.[1] In the eyes of at least one writer, Henri Roujon, this was nothing less than the artist's finest production:

> the masterpiece of Fromentin, where the qualities of composition, of drawing, of colour reveal themselves with the most relief, is, on the advice of all the painters, who alone are capable of appreciating at the same time the skill and the art of a painting, *Crossing the Ford*.[2]

One wonders to which painters Roujon possibly could have been talking; perhaps he was a close friend of the Pereire family. Otherwise it is hard to credit such an inflated opinion of a typically competent but undistinguished picture. This painting represented part of Fromentin's admission that he was not a dramatic painter and that what the public wanted they would get. He did work hard on it; one letter describes five days spent repainting every single figure from one end to the other because it was 'dull'.[3]

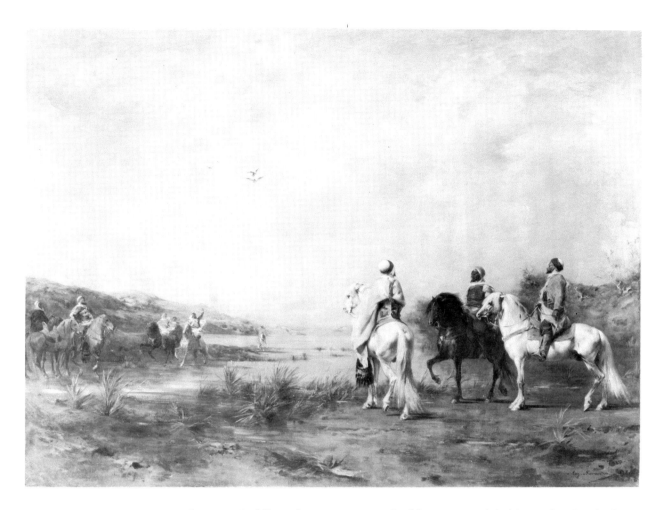

34 Falcon Hunt; Algeria Remembered

Oil on canvas, 111 x 152 cm.

SIGNED AND DATED: lower right *Eug. Fromentin.-74.-*

PROVENANCE: Laurent Richard sale, Paris, May 1878; Secretan sale, Paris, 1889; Isaac Pereire, Paris; Mme Gustave Pereire sale, Paris, 4 July 1937; Sir Alfred Chester Beatty, by whom presented to the Irish Nation, 1950, and transferred to the National Gallery of Ireland, 1978.

EXHIBITED: 1874, Salon, no. 755, p. 109; 1877, Posthumous Fromentin Exhibition, Ecole des Beaux-Arts, no. 6, p. 30; 1930, *Centenaire de la Conquête d'Algérie,* Petit Palais, Paris, no. 219.

LITERATURE: *Catalogue of the Chester Beatty Collection,* (Dublin 1950), no. 23, p. 7; *National Gallery of Ireland, Illustrated Summary Catalogue of Paintings* (Dublin 1981), no. 4231, p. 56; Honor Quinlan, *Fifty French Paintings from the National Gallery of Ireland* (Dublin 1984), p. 32 (illus.); James Thompson and Barbara Wright, *La Vie et l'oeuvre d'Eugène Framentin* (Paris 1987), pp. 296-8, 305 (illus.).

National Gallery of Ireland (cat. no. 4231)

1. Louis Gonse, *Eugène Fromentin* (Paris 1881), p. 81.
2. *Ibid.,* p. 36.
3. The inscription occurs in the Harvard University Library's copy of the exhibition catalogue, n. 6, p. 26.

The 1874 Dublin *Falcon Hunt* was paired by Fromentin's biographer Louis Gonse with the Chantilly *Heron Hunt* of the 1865 Salon as one of the artist's two great hunt scenes. Gonse paralleled their size, colour, execution, silvery light, their low horizons and importance given to the sky — 'loaded with transparent vapours and luminous, like carded wool' — and finally their similar landscapes — 'exact, real and striking, yet invented'.[1] Earlier he had invoked Daubigny as a rare peer of Fromentin's atmospheric background, and he also compared the light to Claude and Turner.[2] The two hunts are indeed similar. Slight compositional differences include greater movement in the Chantilly picture, both of near and far horsemen, while the Dublin painting has more landscape under its higher horizon, with the marshes less a reflecting continuation of the sky. As might be expected the later work is slicker; a critical viewer of the 1877 retrospective wrote 'a little hard' alongside it in his catalogue.[3]

For the 1874 Salon Fromentin entitled this painting simply *Algeria Remembered,* and an accompanying work in Kansas City *The Ravine; Algeria Remembered;* the repetition stressed not only the nostalgic quality of this exercise in reclaiming his grand painterly style of the 1860s but also the visual nostalgia of the pictures themselves. These 1874 paintings are in one sense the last great summation of Fromentin's Algerian experience, and the wistful sadness that has so often been seen in Fromentin's work by his critics here is an appropriate accompanying quality for a fond farewell to a country which had meant so much to him.

In the family collection there are pencil studies of the left foreground horseman seen from the rear.

Jean-Léon Gérôme

1824, Vesoul — 1904, Paris

In spite of a long period of critical derision (still active in many quarters) as widespread as the praise he enjoyed in his lifetime, Gérôme is today a dominant Orientalist, if dominance can be measured in frequency of reproduction. Just as the dealer Adolphe Goupil found the style of his son-in-law Gérôme ripe for his pioneering efforts at image dissimulation in photos and photo-engravings (both as an income source and a means of popularizing his paintings), so today, accompanying the resurgence in value of Gérôme's paintings, practically every travel book, exhibition catalogue or art book dealing with the East dons the cloak of miraculous multi-coloured clarity that is instantly recognizable as the work of Gérôme, his pupils, or his immediate followers.

Gérôme was the son of a prosperous goldsmith-jeweller. At school he studied classics; when he received his *baccalaureat* at sixteen his father rewarded him with not only a box of paints but also a small painting by Decamps, which he had picked up in Paris, to copy. Encouraged by his father, Gérôme entered the studio of Paul Delaroche. As a favourite pupil of Delaroche, Gérôme accompanied him to Italy for a year in 1834 — Gérôme became the last descendant of a 'licked-finish' family of painters that had begun much earlier in the century with Delaroche's father-in-law Horace Vernet. After his year in Italy, Gérôme returned to Paris and joined the studio of Gleyre so that he might compete for the *Prix de Rome*. Gérôme was only with Gleyre three months, failing to win the prize, and never acknowledged a debt to the influential Swiss painter who later taught Edward Poynter (*q.v.*), as well as Monet and Renoir.

Gérôme's first Salon picture *The Cock Fight* (Musée d'Orsay, Paris), which featured a nude Greek youth and his girlfriend more than the battling bantams, was badly hung, but it was spotted by Gautier and highlighted in *La Presse*, resulting in a sensational debut. The success of this work encouraged Gérôme and like-minded fellow students to produce more paintings of a similar sort, a frivolous, sexy vision of antiquity with careful attention to finish and detail. Some of this group, who were called the 'Neo-Greeks' or the 'Pompeians', like Hamon, Boulanger, or Bouguereau (*q.v.*), painted similar subjects the same way for the rest of their lives.

Gérôme did aspire to paint major events from antiquity and history rather than genre scenes, but his approach, a kind of anecdotal reportage, lacked proper pictorial rhetoric or alternative skill with dynamic movement. Alongside his enormous, ponderous *Age of Augustus* (7 × 10 m, Musée de Picardie, Amiens) in the International Exhibition of 1855 he slipped in his small *Recreation in a Russian Camp* (private collection, France), a scene inspired by his trip to the Balkans in 1853 and the first of a long series of ethnographic works. In an attempt to keep his recreations as 'authentic' as possible Gérôme did much travelling, including six months in a rented boat on the Nile in 1856, and return trips to the Near East in 1862, 1868, 1871, 1872, and 1874; he also visited Constantinople and Asia Minor in 1871 and 1875.

1863 was an important year for Gérôme. In January he married Marie Goupil, whose dealer father had so much to do with Gérôme's success, particularly in selling his paintings abroad. In that same year Gérôme was made a Professor at the *Ecole des Beaux-Arts*. He took his teaching seriously and saw himself under obligation to maintain the same academic standards under which he had been trained: a succession of highly-skilled pupils who painted rather like him was the result. In 1865 Gérôme became a Member of the Institute, and there similarly exercised his considerable strength for tradition against all dissenting approaches, from Courbet, to Manet, to Monet.

Gérôme's Oriental works were generally of a small saleable size; like many other artists, he often used Parisian ethnic types attired in costumes from his own vast collection of Eastern clothes. His background settings, sketched on the spot or copied from photographs, some of which he took himself, were painstakingly rendered, and, according to Richard Ettinghausen, a distinguished scholar of Islamic art, quite accurate:

On the whole... Gérôme's Near Eastern scenes seem to be reliable and

therefore preserve visually a way of life current in Cairo and Istanbul about one hundred years ago.[1]

Among Gérôme's common subjects were *Almehs* or dancing girls, *Bashi-Bazouks*, Turkish Irregulars who lived by plunder, *Arnauts*, Albanian soldiers in the Turkish Army, and *Hamman* or bath scenes; many of these were posed and composed in patterns and proportions derived from Dutch seventeenth century painting. One of Gérôme's favourite outdoor subjects was the king of desert beasts, the lion, with which he had an almost totemic identification, partly on account of his names, Léon = lion and Gérôme = St. Jerome, for whom the lion is a constant pictorial companion.[2]

Gérôme continued to paint historical pictures, doing an interesting series of death scenes in 1867, beginning with the *Death of Caesar* (Walters Art Gallery, Baltimore), *It is Finished (Golgotha)*, a lost work that cleverly shows only the cast shadows of the three crosses as the Romans and the rest of the crowd retreat into an eerily-lit landscape, and finally *The death of Marshal Ney*, (City Art Gallery, Sheffield), where Gérôme's portrayal of the victim face down in the mud almost led to a duel with his titled grandson over the indignity done to this ancestor.

Linda Nochlin has argued that Gérôme's 'strategy' was to make viewers forget that there was any 'bringing into being' of his work:

> A 'naturalist' or 'authenticist' artist like Gérôme tries to make us forget that his art is really art both by concealing the evidence of his touch, and, at the same time, by insisting on a plethora of authenticating details.[3]

Nochlin further argued that Gérôme's paintings may most profitably be considered 'as a visual document of nineteenth-century colonialist ideology, an iconic distillation of the Westerner's notion of the Oriental considered in the language of a would-be transparent naturalism'.[4]

Nochlin did well to remind us of Gérôme's craft, of his artful skill in constructing pictures we are meant to believe as real. That he practiced what seems in her eyes an almost reprehensible deception on his unsuspecting viewer would possibly surprise many of those spectators and the artist himself, who placed a high value on the performance and appreciation of such skills, particularly when the illusion in whose services they were enlisted seemed to come alive.

Towards the end of his career Gérôme increasingly worked in sculpture, some of it the extraordinary mixture called *chryselephantine*, a technique of including gold and ivory in a work that was used by the ancient Greeks. But perhaps since none of the ancient work survived, Gérôme's efforts appear impure and excessive to the modern eye; he also lacked, it must be said, the great Greek sculptors' sense of form. One of Gérôme's last sculptures, an equestrian statue of *Napoleon entering Cairo* (82.5 cm. high, Ackerman, no. S 38, pp. 322-23), which he showed at the Salon of 1897, a hundred years after the event represented, nicely closed the great century of Orientalist adventuring and visual recreating, which the conquering French general had instituted and which the imposing French academician brought to a diminished end.

1. Richard Ettinghausen, 'Jean-Léon Gérôme as a Painter of Near Eastern Subjects', in *Jean-Léon Gérôme (1824-1904)*, Dayton-Minneapolis-Baltimore, 1972-73, introduction and commentaries by Gerald Ackerman. Linda Nochlin ('The Imaginary Orient', *Art in America*, vol. 71 (May 1983), p. 191, n.7), in consultation with Edward Said, disagrees.
2. See Albert Boime, 'Jean-Léon Gérôme, Henri Rousseau's "Sleeping Gypsy" and the Academic Legacy', *Art Quarterly* (Spring 1971), pp. 3-29. According to Ackerman, between a third and a half of Gérôme's total output was Orientalist.
3. Linda Nochlin, *op. cit.*, p.122.
4. *Ibid*, p. 119.

Bibliography:
Gerald Ackerman, 'Gérôme, the Academic Realist', *Art News Annual*, vol. 33 (1967).
Gerald Ackerman, *Jean-Léon Gérôme* (London 1986).
Fanny Field Horing, *The Life and Works of Jean-Léon Gérôme* (New York 1892).
Paul Lenoir, *The Fayoum, or Artists in Egypt*, translated by Mrs. F.C. Hory (London 1873).
Jean-Léon Gérôme, exhibition catalogue, Musée de Vesoul, 1981.

35 Guards at the Door of a Tomb

Oil on canvas, 81 x 65 cm.

SIGNED: lower left, *J.L. Gérôme.*

PROVENANCE: Hotel Drouot, Paris, sale, 18 March 1933, no. 30; Sir Alfred Chester Beatty, by whom presented to the Irish Nation, 1950, and transferred to the National Gallery, 1978.

LITERATURE: *Catalogue of the Chester Beatty Collection* (Dublin 1950) no. 26, p. 7; *National Gallery of Ireland, Illustrated Summary Catalogue of Paintings* (Dublin 1981), no. 4234, p. 61.

National Gallery of Ireland (cat. no. 4234)

Facing into the sun, a sentinel stands solemnly, his face a mask of dutiful concentration, before the door to a tomb. His right arm hides in his wide sleeve, his left steadies the barrel of a musket that is taller than he is. His fellows have officially or informally decided it is time for a break. Collapsed under the heat, they look out with bored disdain. Rubbing his bare feet together, the negro is stretched out almost as comfortably as the dog in front of him, who closes its eyes in sleepy contentment at the sun's warmth. The negro rests his head in his right hand on the first step, not far from the slender, graceful curve of his rifle, decorated in silver. The third man sits with his knees drawn in, flashing white teeth amidst his dark beard. His blunderbuss leans against the wall; above are four handprints of the faithful. The guards' ethnic types are as diverse as their poses; the common cause of their religion has brought them together.

Beyond to the right two figures, one on a donkey, descend the shadowed street, under a projecting window with *mashribiyya* and the Mameluke minaret of a mosque stands out against the clear sky. Above the recessed door six suspended chains with ornamental balls hang from a wooden frame. Oil lamps, only two of which have the same shape, swing from four of them, while two seem to have lost their attachments. The interior of the arch over the door is decorated with stalactite squinches, opon which cast shadows form complex and confusing abstract patterns.

Ackerman did not list this picture in his catalogue of Gérôme's work. The painting in his catalogue which comes closest to this one in subject matter is number 501, dated before 1881, entitled *Portal of the Green Mosque (Sentinel at the Sultan's Tomb).* Included in that picture are a standing guard with two dogs, a black one sitting, and a brown-and-white one sprawled on the ground. Narcisse Berchère (*q.v.*), whose finish is so different from Gérôme's, employed a similar composition, with a standing and a seated man in the doorway and two seated women, in his painting *Gate of the Tomb of Murad Bey in Cairo* (Musée Magnin, Dijon).

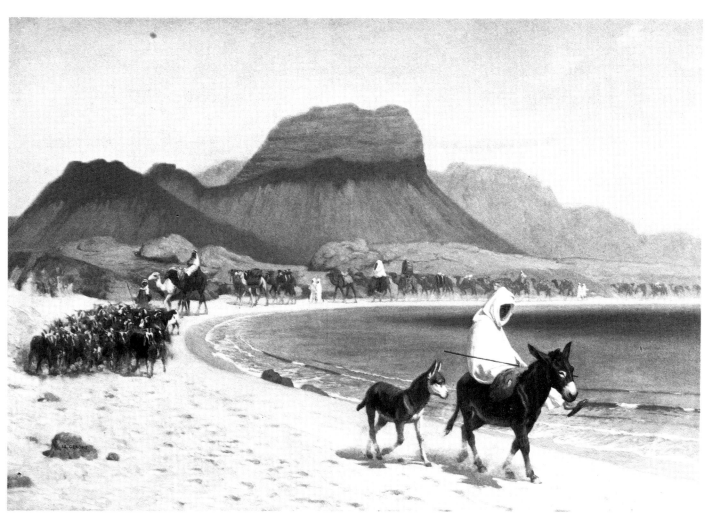

36 The Gulf of Aqaba

Oil on canvas, 60 x 81 cm.

SIGNED: lower left, in a rock, *J.L. Gérôme.*

PROVENANCE: Sir Alfred Chester Beatty, by whom presented, 1953.

LITERATURE: *National Gallery of Ireland, Illustrated Summary Catalogue of Paintings* (Dublin 1981), no. 1256, p. 61; Gerald Ackerman, *Jean-Léon Gérôme* (London 1986), no. 443, p. 280.

National Gallery of Ireland (cat. no. 1256)

Along the curve of the gently lapping gulf comes a caravan. Leading the way, much closer to the viewer than the rest, are a man and two donkeys, each of whom the artist has given distinct personalities. Garbed in white and holding a staff, the man gazes downward almost petulantly, perhaps lamenting his long journey, while riding sideways on his donkey, idly flapping one of his slippers. His donkey looks long-suffering and determined, proceeding briskly to a fixed destination, while its following colt is simultaneously more jaunty and hesitant, turning with interest to observe the motion of the water. In the left middle distance a herd of goats crowded together come directly toward the spectator. They are followed in slowly diminishing size by a stately procession of camels and men. Centring and stabilizing the composition above the oval motion is a *mesa* which rises like a mushroom to dwarf the figures below. As usual the dexterity and craft of the artist have been deployed to heighten the scene's sense of actuality, from the skein of white foam where the gulf meets the shore, to the dusty blur of sand kicked up by animal legs. Yet Gérôme's paint is certainly there to be read as such, for anyone hazarding a closer look.

Ackerman dates this picture c. 1897, the same year as two versions of *The Flight into Egypt* where Mary rides through the desert on a similar diminutive donkey, and also the same year as *The Entry of Christ into Jerusalem*, where Christ too is mounted on a donkey — a white one — followed by its foal.

A modern 'deconstruction' of this picture might argue that it is set outside history by its choice of unchanging landscape and the Biblical suggestiveness of nomadic herds and caravan. Yet Gérôme's crisp precision of vision, far from sending us back into time, has almost the opposite effect, so that his religious scenes are awkwardly jolted forward towards the nineteenth century, where his genre scenes remain. Arch anti-Impressionist that he was, Gérôme conveyed in this picture more a sense of what he might have seen on a hot desert day than a time capsule to transport the viewer back to the days of the patriarchs.

Frederick Goodall

1822, St. John's Wood, London — 1904, St. John's Wood, London

Goodall was part of an artistic family: his father Edward was an engraver, his two brothers Edward and Walter were artists, and his two sons Frederick Trevelyan and Howard both made successful starts as painters before dying young, the former in Capri aged twenty-three, the latter in Cairo aged twenty-four. Frederick Goodall was longer-lived and more successful than any of his family, though the enormous prosperity he enjoyed during the lifetime of his dealer Ernest Gambart ended with that man's death; and Goodall suffered a humiliating bankruptcy of £11,886 7s 10d two years before he himself died.[1]

Goodall possessed the sort of talent which developed quickly and soon lapsed into repetition and minor variation. Taught by his father, he was exhibiting watercolours from the age of fourteen. In 1838 he travelled in Normandy, and soon after visited Brittany and Ireland, where he found the natives 'a guileless open folk, who wore their hearts on their sleeves,' adding 'their ignorance was supreme'.[2] Irish scenes figured among his genre paintings of the 1840s (e.g. *Connemara Girls* at the Royal Academy in 1844).

In 1856 Goodall met Rosa Bonheur (*q.v.*) and painted her portrait when Gambart brought her to England; she noted his clumsy outdoor sketching apparatus and sent him one of her own, which he found 'invaluable'[3] on his two expeditions to Egypt. The following year Goodall visited Venice, and the year after, 1858, made his first Egyptian journey, which was to be so important for his art. His initial excitement was intense albeit banal:

> I could not refrain from exclaiming aloud at the different scenes that met my eye — 'How beautiful!' 'How gloriously picturesque!' 'What colour!' 'What costumes!' 'What character!' until my dragoman must have thought he had got charge of a lunatic. The fact was I was perfectly bewildered at the novelty of everything, and felt absolutely convinced that the people had never been painted, that practically I was on virgin soil, with a free hand.[4]

He ran into his friend Carl Haag (1820-1915), a fellow Orientalist, and the two of them visited the Pyramids together, camping by the Sphinx. There Goodall made studies of the Bedouin; he found their draperies 'classical' but also 'grand and suggestive of figures in the Bible'.[5] Haag travelled on to Jerusalem, while Goodall stayed in Cairo to work in the streets, once narrowly escaping a rock attack from an elderly iconoclast when the guard assigned to protect him fell asleep.

Goodall did at least a sketch a day, and upon his return to London had a hundred and sixty. Gambart offered to buy the lot for £5,000; but for the moment Goodall kept them to turn into larger paintings, a continuous process throughout the 1860s. At the end of the decade, Frederic Leighton seconded Francis Grant's proposal that fifty of Goodall's studies be shown together at the Royal Academy's new premises at Burlington House, a singular honour. By this time Gambart had bought all the sketches for £6,000 and by the end of the exhibition he had sold all of the fifty on show. Goodall's first large scale Oriental work at the Academy was *Early Morning in the Wilderness of Shur* (Guildhall Art Gallery, London), exhibited in 1860; Landseer praised the camels, Roberts (*q.v.*) the overall picture, and it sold for a large sum. Goodall had found a successful niche as an Orientalist, though he hardly extended or improved upon that impressive initial effort.

His second journey to Egypt came in 1870, when he 'lived with' the pastoral Bedouin on the border of the Desert near Sakkara for three months. He found their daily task of tending sheep, grinding corn, and spinning the wheel 'exactly as it is described in the Bible'.[6] In fact Goodall resided in the house of the French archaeologist Mariette Bey who was at that point marooned in Paris by the Franco-Prussian war. Only a year after Thomas Cook's ran their first tour to Egypt, Goodall decried the growing commercialization, mentioning a golf course constructed close to the Pyramids, a tramway running right up to them, a new hotel erected nearby, and the names of London businesses painted in huge letters on the monuments' steps.

For most of the next three decades Goodall was a considerable success and a major art establishment figure, satisfying a public taste for endless variations on Eastern and Biblical scenes with carefully-constructed pictures, clear in story and direct in sentiment, long on craftsmanship and short on creativity. In his heyday he was said to have attained an average income of £10,000 a year; he bought an estate in Harrow, where his friend Norman Shaw built an impressive residence. But by 1890 he had to give up his splendid house and return to live in Gambart's old London place, and by 1899 he was earning barely £1,000 a year, while spending twice as much.[7] Without his dealer to look after his financial interests, his bankruptcy became inevitable, the sad end to a creditable if uninspired career.

1. Jeremy Maas, *Gambert: Prince of the Victorian Art World* (London 1975), p. 285.
2. *The Reminiscences of Frederick Goodall, R.A.* (London 1902), p. 27.
3. *Ibid*, p. 127.
4. *Ibid*, p. 67.
5. *Ibid*, p. 80.
6. *Ibid*, p. 101.
7. Jeremy Maas, *op. cit.*, p. 285.

37 Evening Prayers in the Desert

Watercolour on white paper, 60.1 x 40.2 cm.

INITIALLED AND DATED: lower left, *FG 1893* (initials overlapped).

PROVENANCE: Lady Martin, by whom bequeathed, 1907.

LITERATURE: *National Gallery of Ireland, Illustrated Summary Catalogue of Drawings, Watercolours and Miniatures* (Dublin 1983), no. 2616, p. 184.

National Gallery of Ireland (cat. no. 2616)

1. *The Reminiscences of Frederick Goodall, R.A.* (London 1902), p. 115.
2. Whereabouts unknown, photograph in the Witt Library, London.

In his *Reminiscences* Goodall described how immediately after his return from his second visit to Egypt in 1871 he set to work on a picture entitled *The Head of the House at Prayer*, based upon a study he had made of the sheikh at the camp of Sakkara, showing the Arab standing 'bolt upright on his carpet, looking intently towards the East'.[1] Although this watercolour done a decade later shows its principal kneeling, it probably represents a later permutation of that original idea. Another ancestor of Goodall's composition is Müller's major figure piece of 1843, *Prayers in the Desert* (City Museum and Art Gallery, Birmingham), where the nearest of a group of seven Arabs bowing in different poses on a carpet outdoors is quite similar to Goodall's single figure. There is an exact counterpart to the camel behind the kneeling Arab in an earlier composition by Goodall of 1880 entitled *Moving to Fresh Pastures*,[2] where the 'ship of the desert' is mounted by an Arab leading his family and flock to new grazing.

In the National Gallery watercolour, the sunset twilight, when the true Islamic believer must say the fourth of his five daily prayers (others come at dawn, noon, mid-afternoon, and night) is represented by the pink and blue colours seen on the mountains and, more softly, in the clouds of the evening sky, itself a pale green. In this austere setting, the Arab and his camel provide the only ornament, with his rug, bordered in white with red flowers, a portable oasis of stylised vegetation. Temporarily discarded are his thong sandals embroidered in green and white, his red leather belt and jewel-encrusted dagger. While his tethered camel echoes his gaze to the East with haughty dignity, the Arab rests his hands on his knees, wrapped in a handsome *abaya*, a robe of cream and golden brown wool, a sash containing Koranic verses ending in braided leather straps across his chest, his black beard full, his head, even mostly concealed by his turban, clearly shaven. If a romantic image, it is also a respectful one, the elegant Arab in his 'Sunday best' set against the infinite wastes of his barren environment.

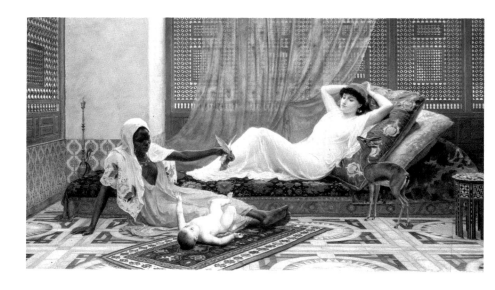

38 The New Light in the Hareem

Oil on canvas, 122.7 × 215.3 cms.

PROVENANCE: purchased from the artist 1884, £1,000.

EXHIBITED: 1884, Royal Academy, no. 235; 1884, Walker Art Gallery Autumn Exhibition, Liverpool, no. 112.

Courtesy of the Trustees of the National Museums and Galleries on Merseyside (Walker Art Gallery)

1. Reproduced in Mrs. Russell Barrington, *Life, Letters and Work of Frederic Leighton* (1906), vol. 2, facing p. 256. Goodall was a great admirer of Leighton's work, see Frederick Goodall, *Reminiscences* (1902), pp. 204ff. The artist's sister Eliza Goodall, however, exhibited a *Light of the Harem* at the 1848 Society of British Artists, no. 149, and J. W. Chapman showed a *Light of the Harem* at the 1871 London International Exhibition, no. 454. The original Light of the Harem was Nourmahal in Thomas Moore's poem *Lalla Rookh* of 1816.
2. *Saturday Review*, (4 May 1889), p. 530. Goodall's *Gilded Cage* of 1898 was yet another Harem scene; see Goodall, *op. cit.*, p. 392, for a description; a version was in the Sotheby's London sale, 26 November 1985, lot 27.
3. Goodall, *op. cit.* (1902), p. 386. The artist also noted that *The New Light in the Hareem* with his *Flight into Egypt* of the same date were his favourite pictures up to that time, Goodall, *op. cit.*, p. 180. See also Anne Crosthwait, 'Goodall and the Cult of Egypt', *Country Life* (17 July 1969), p. 182.
4. *Art Journal* (1884), p. 209, which however also noted its popularity; *Portfolio* (1884), p. 122; *Illustrated London News* (3 May 1884), p. 419.
5. *Athenaeum* (31 May 1884), p. 701. Graham Reynolds, *Victorian Painting* (1966), p. 144, also observed that the light in this painting was that of an English drawing room.
6. *Magazine of Art* (1884), p. vi.
7. The catalogue entry on the picture has been compiled by Edward Morris, Acting Keeper in the Walker Art Gallery, Liverpool.

The title may have been suggested by Frederic Leighton's *Light of the Hareem* of 1880.[1] Goodall's *Pets of the Hareem* of 1889 showed an odalisque lounging on an eastern sofa feeding an ibis and a monkey.[2] Presumably these paintings were derived from the sketches made by the artist during his Egyptian tours of 1858-1859 and 1870. *The New Light in the Hareem* was described by the artist himself thus:[3]

> *The New Light in the Hareem*, the new light being an infant lying on a rug on his back, and amused by his negro nurse with a live pigeon which she is holding in her hand, the lady of the harem lying on a couch embedded with the softest pillows covered with beautiful Persian embroideries. In this picture there is the gazelle that Sir William Flower so kindly procured for me from the Zoological Gardens to paint from, which I had in my studio for several days. The lattice of the *Musharabea* was an elaborate piece of work. The whole picture is full of detail. It was purchased by the Walker Art Gallery of Liverpool.

Most reviewers were content merely to describe the painting when it was exhibited at the 1884 Royal Academy.[4] The *Athenaeum*[5] was, however, more analytical:

> Smoothness and dexterity which, when unsympathetically applied, fail in the painter's hands, are not wholly unfortunate under other circumstances. No one paints so smoothly, and few owe so much to dexterity as Mr. F. Goodall, who, however, in *A New Light in the Hareem* (235) has made a hit, because his work has an animated motive, a certain kind of grace, and cheerful tone and colour. The new "light" is a stout baby, whose long-limbed mother reclines on a couch, while a highly polished negress plays with the child kicking on a very neat carpet. Everything in the room is neat, clean, and elegant, but except the furniture and *bric-à-brac*, which might have been bought in Oxford Street, there is nothing especially Oriental in the character and motive of the design of this the most respectable picture in the exhibition, which is so thoroughly suggestive of the lamp that we soon tire of it.

The *Magazine of Art*[6] was more hostile noting that the selection of this painting for the permanent collection of the Walker Art Gallery was "none of the happiest". A sketch for the painting was at Sotheby's, Belgravia, 20 May 1975, lot 86 (repr.).[7]

Gustave Guillaumet

1840, Puteaux (Seine et Oise) — 1887, Paris

Guillaumet became an Orientalist almost by accident, yet in a relatively short career he produced perhaps the most thorough and accurate painted record of Algerian life in the second half of the nineteenth century. The son of a prosperous dyeing manufacturer in Puteaux, Guillaumet demonstrated at an early age his aptitude for drawing with a painstaking copy of an engraving after Poussin. His father discouraged his career aspirations several times but finally allowed him to enter the *Ecole des Beaux-Arts*, where he was taught by François-Edouard Picot, who also taught Bouguereau (*q.v.*), by Barrias, and finally by Abel de Pujol. Guillaumet succeeded brilliantly as a student, winning five medals in a row in 1859-60, three for the figure and two for landscapes. His next obvious step was to obtain the *Prix de Rome* and become a history painter, a direction projected by his three pictures in the Salon of 1861: *The Destruction of Sodom*, *The Burial of Atala* and *Macbeth and the Witches*. But Guillaumet's submission for the Rome Prize in 1861 narrowly missed winning; and he left the school, upset at what he felt was an unfair decision.

He determined soon after in 1862 to go to Rome on his own. A terrible snow storm on the way provoked an impulsive decision to visit Algeria instead, a choice that determined the course of his entire artistic production. After his arrival he travelled in the Sahara all the way to Biskra, where he caught malaria and had to spend three months in a military hospital. Nonetheless his fascination with the new country was complete. His *Evening Prayers in the Desert* (Musée d'Orsay, Paris), a picture which carried over into an Eastern scene some of the dramatic rhetoric of his earlier works, had a favourable public response in the 1863 Salon and was bought by the state. Guillaumet returned to Algeria before the 1865 Salon, when he won a medal for his *Arab Market in the Plain of Tocria* (Musée des Beaux-Arts, Lille). Soon after, he made his third journey to North Africa, and before he died had visited there ten times. In 1868 Guillaumet sent to the Salon his most unique and powerful picture *The Sahara*, now known as *The Desert* (Musée d'Orsay, Paris, see Scott essay, Fig. 12), a bold attempt to render the vast and empty landscape of the desert without resorting to picturesque conventions. The only obvious signifiers are the camel carcass and the nearly indecipherable calligraphy of a distant caravan; otherwise it is an almost abstract attempt to portray the sublime, worthy of inclusion in Robert Rosenblum's hypothetical progression from Friedrich to Rothko.

Guillaumet never surpassed the originality of that work, but he continued to visit and paint Algeria, particularly the scenes of poverty and rural agriculture that were shunned by other Orientalists in their search for more colourful and eccentric subject matter. In 1869 he was awarded a medal for his pictures of *Famine* and *Work on the Moroccan Frontier*. Guillaumet's strong academic background stood him in good stead; even as his brushwork broadened and his atmosphere softened, his works, albeit based on direct observation, retained qualities of careful composition and construction. In 1872 Guillaumet won a Second Class Medal and in 1878 was awarded the Legion of Honour and a Third Class Medal at the International Exhibition. Soon after he felt that he made a personal breakthrough in terms of his Eastern perceptions, though, apart from a loosened style, no great shift is noticeable today.

In 1886 Guillaumet finally completed the Italian journey he had undertaken almost a quarter of a century before, but his death soon after prevented any possible belated influence of the Renaissance masters. In his *Tableaux Algériens* ('Algerian Pictures') Guillaumet set out poetically to supplement or parallel his visual portrayals with verbal ones, thus providing the most thorough-going word-and-image depiction of the East outside Fromentin (*q.v.*), whose most worthy pictorial and literary successor he was. In proportion to his conscientious and highly-skilled written and painted work, Guillaumet is one of the most undervalued French Orientalists.

Bibliography:
Gustave Guillaumet, *Tableaux Algériens*, prefaced by a note on Guillaumet's life and work by Eugène Mouton (Paris 1888).
Charles Saunier, *Anthologie d'Art français, la peinture — XIXe siecle* (Paris n.d.), vol. II, facing p. 188.
Lynne Thornton, *The Orientalists, Painter-Travellers* (Paris 1982), pp. 147-48.

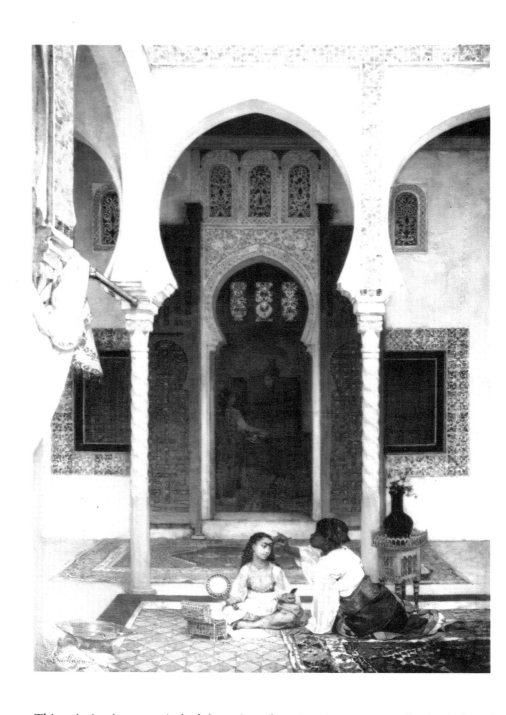

39 Women in an Eastern Courtyard

Oil on canvas, 104 x 73 cm.

SIGNED: lower left, *Guillaumet.*

PROVENANCE: Sir Alfred Chester Beatty, by whom presented to the Irish Nation, 1950, and transferred to the National Gallery of Ireland, 1978.

LITERATURE: *Catalogue of the Chester Beatty Collection* (Dublin 1950) no. 27, p. 7; *National Gallery of Ireland, Illustrated Summary Catalogue of Paintings* (Dublin 1981), no. 4235, p. 67.

National Gallery of Ireland (cat. no. 4235)

This painting is not typical of the artist, whose interiors were usually the darkened hovels of common desert folk rather than this sumptuous, airy courtyard, luxuriously carpeted and decorated with tiles and stuccoed tracery. Seated cross-legged under a bowed and pointed arch and in front of a similarly-shaped doorway, which establish the central vertical axis of the composition, is a young girl, wistfully inclining her head towards a negress, who leans with a twist of her larger body to paint the eyebrows of her mistress. Alongside her is a *tabouret* or small table supporting a graceful vase full of flowers. The eye penetrates deeper to perceive a receding servant carrying a salver at her side. In the best tradition of Delacroix's *Women of Algiers,* the forbidden mysteries of female sexuality are suggested in terms of surrounding architecture, all graceful layered apertures and inviting darkened interiors.

The only exhibited Salon picture whose title might fit this work is *Interior in Algiers* of 1874. The detail of the painting would suggest a reasonably early date, since Guillaumet's style did broaden as he got older. Of all visiting French painters, Guillaumet was perhaps the most familiar with Algerian life, and some of that ease is conveyed in this tranquil scene, which compares interestingly with the *Arab Weaver* (no. 55) done over a decade later by the Algerian-born Armand Point.

Osman-Edhem-Pasha-Zadeh Hamdy Bey

1842, Constantinople — 1910, Constantinople

A remarkable man of varied gifts, Osman Hamdy Bey during his productive life was a painter, architect, archaeologist, poet, writer, museum director and collector. His father, the Grand Vizir Musir Ethem Pasha, sent him to France to study law, but like Fromentin *(q.v.)* Hamdy Bey left legal studies to become a painter. While in Paris for more than a decade, he was trained by the eminent academics Gustave Boulanger, Paul Baudry and Jean-Léon Gérôme *(q.v.)*.

After his return to Constantinople in 1869, Hamdy Bey was charged with introducing ambassadors to the Sublime Porte (1871-75), and he also commenced his ethnographic and archaeological activities, co-authoring a book on Turkish costume in 1873. He was named in 1881 the First Director of the Imperial Ottoman Museum, an institution of which he can be considered the virtual creator. He headed major excavations in Asia Minor and Syria, where he made important finds, several of which he published in collaboration with Theodore Reinach (1893). In 1883 Hamdy Bey was appointed a director of the Imperial School of Fine Arts, and in 1908 he was made President of the Society of Turkish Artists. He was also a corresponding member of England's Royal Academy.

Married to a French woman, Hamdy Bey entertained visiting European Orientalists in grand style amidst his impressive collection of Islamic carpets, ceramics, costumes and weapons. He continued to paint throughout his career and exhibited his work in many European capitals.

What is special about Hamdy Bey as an Orientalist is the extent to which a native Easterner adopted and mastered so many of the typical western approaches to his country, as a painter, archaeologist, museum administrator and collector. Yet despite the obvious technical debt his pictorial work owes to his French teachers, there is a telling difference in content, a kind of reticence and oblique Eastern tact, particularly in his depictions of women, which makes his work ripe for resurrection, reassembling and further study.

Biblilography:
A. Thatasso, 'Les Premiers Salons de Constantinople', *L'Art et les Artistes* (Paris, April 1906).
A. Thatasso, 'O. Hamdy Bey', *L'Art Ottoman, les peintres de Turquie* (Paris n.d.).
Lynne Thornton, *La Femme dans le peinture orientaliste* (Paris 1984).

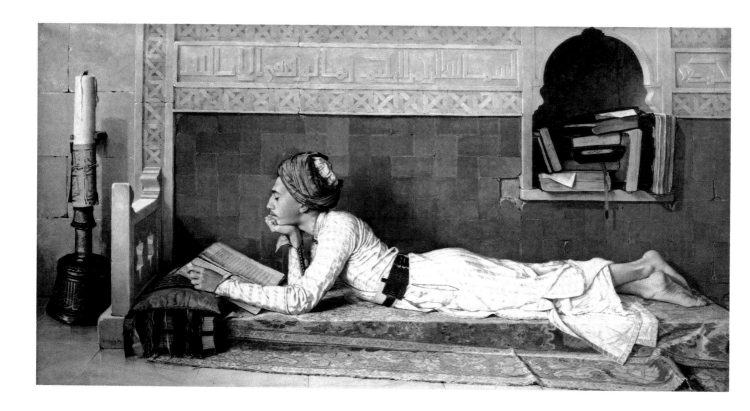

40 A Young Emir Studying

Oil on canvas 120.7 x 222.2 cm.

SIGNED: lower left corner, *O Hamdy Bey/1905.*

PROVENANCE: purchased from the Liverpool Autumn Exhibition, 1906, by Sir John Brunner, and presented to the Walker Art Gallery the same year.

EXHIBITED: 1905, Société des artistes français, Paris, no. 908; 1906, Royal Academy, no. 237; 1906, Walker Art Gallery Autumn Exhibition, Liverpool, no. 23.

LITERATURE: Review in *Art Journal* (1906), p. 168; *Walker Art Gallery Foreign Catalogue* (Liverpool 1977), p. 90.

Courtesy of the Trustees of the National Museums and Galleries on Merseyside (Walker Art Gallery)

Hamdy Bey's painting is a masterful demonstration of the representational finesse of French Salon painting, a worthy extension of artists like his teacher Gérôme *(q.v.).* Yet despite its painstaking technique both in terms of subject and presentation, this work has an understatement of content that could be called modesty, a familiar ease with its subject uncommon among Western Orientalists. Even if the viewer is overwhelmed with 'Easterness' in the exotic fabrics, architectural ornament and metal candlestick (of whose accuracy one feels absolutely confident), there is nothing sensational about the image of quiet contemplation and scholarship, not the sort of subject normally produced by Western Orientalists. A contemporary critic, reviewing the painting in the Royal Academy Exhibition, was most impressed by the artist's reproduction of accessories, and assessed it overall as 'a curious and effective picture'.[1] Perhaps its 'curiosity' consisted partly in its unusually quiet and intimate approach to the wondrous East.

1. Rudolf Dircks, *The Art Journal,* (1906).

Solomon Alexander Hart

1806, Plymouth — 1881, London

Hart was not a conventional Orientalist, but he used his Jewish background to depict subjects centred around his own faith, and later painted some history pictures containing an Eastern dimension. During a period when 'Israelites'[1] were admitted neither to Parliament, nor any offices of state, nor to the colleges of Oxford or Cambridge,[2] Hart became the first (and in his lifetime only) Jewish Academician, being elected an Associate in 1835, a full Academician in 1840, and serving as Professor of Painting from 1854-63, succeeding C.R. Leslie. Perhaps his most distinguished contribution to the Royal Academy was as its Librarian from 1865 until his death, during which time he effectively established its library as a book collection of consequence.

Hart's father Samuel began as a worker in silver and gold, became a mezzotint engraver, and studied painting under James Northcote in London in 1785. When father and son left Plymouth for London in 1820, Samuel taught Hebrew while his son prepared the drawings which got him admitted as a Royal Academy student in 1823. His first exhibited work was a miniature portrait of his father, shown in Somerset House in 1826; his first painting which attracted wide public notice was *Interior of a Polish Synagogue*, afterwards known as *The Elevation of the Law* (Tate Gallery), shown in 1830. To avoid being typecast as a painter of religious works, Hart undertook subjects from Shakespeare (*The Quarrel Scene between Wolsey and Buckingham*, Royal Academy, 1834), Sir Walter Scott, and English History (*Richard the Lionhearted receiving the Medicated Cup from Saladin*, Royal Academy, 1835). After a visit to Italy in 1841 he added scenes from the lives of Galileo, Raphael and Benvenuto Cellini to his repertoire. Between 1826 and 1880 he is said to have publicly exhibited 180 pictures, most of them large-sized scriptural or historical subjects.[3]

Hart's *Reminiscences* give anecdotal accounts of some of his friends and contemporaries, while W.P. Frith's *Autobiography* mentions some of the infuriating prejudice Hart had to face.

1. So was Hart commonly referred to, even by friends such as Wilkie.
2. W.P. Frith, *My Autobiography and Reminiscences,* vol. II (New York 1888), p. 95.
3. R.F. Graves, *Dictionary of Artists* (London 1884), p. 109.

41 Othello and Iago

Watercolour on paper, 42.5 x 33.5cm.

SIGNED AND DATED: lower left, *S.A. HART 1857.*

PROVENANCE: William Smith Bequest, 1876.

LITERATURE: *Bryan's Dictionary of Painters and Engravers* (London 1904), vol. II, p. 18; *British Watercolours in the Victoria and Albert Museum* (London 1980), p. 174.

Victoria and Albert Museum, London

1. *Catalogue of the Remaining Works of Solomon Hart, R.A., deceased*, Messrs. Christie, Manson & Woods, Saturday, 30 July 1881, lot 200.
2. *The Reminiscences of Solomon Alexander Hart*, R.A., edited by Alexander (London 1882), p. 138.

In 1855 at the Royal Academy and again in 1862 at the International Exhibition, Hart showed a painting of *Othello and Iago* of which this later watercolour is quite likely a diminutive.[1] When that work was sold with the other contents of Hart's studio in 1881, the Shakespearean citation given was to Act IV, scene iii, where Iago sows further seeds of doubt about Desdemona in Othello's mind:

Oth.: What dost thou say, Iago?
Iago: Did Michael Cassio, when you woo'd my lady, know of your love?
Oth.: He did, from first to last, why dost thou ask?
Iago: But for the satisfaction of my thought; no farther harm.

Other references suggest that the scene depicted actually comes from Act III, scene iii, where Iago makes his famous ironic admonition to 'beware jealousy', 'the green-eyed monster which doth mock / That meat it feeds on'. Iago's lightly raised right hand might suit the latter dialogue better, though equally it could represent his hypocritical attempt to close the first conversation.

Hart was an avid theatre-goer. In his *Reminiscences* he discusses several famous actors with whom he was friendly, and cites a peerless production of *Othello*, 'the most perfectly sustained representation that it has ever fallen my lot to behold'[2], with Edmund Kean in the title role, Charles Young as Iago and Charles Kemble as Cassio.

Apart from Biblical characters, Othello is perhaps the strongest male Oriental archetype, a counterpart to Cleopatra in suggestive power. Among Orientalists,

Delacroix (*q.v.*) and Chassériau made the Moor the subject of several works, and Dehodencq (*q.v.*) also painted him. Brave and simple, passionate and violent, but above all *black* (a fact Iago never lets us forget), Othello is a quintessentially different or 'other' Oriental, even if he does hail from Venice, Europe's gateway to the East; and it is the single reminder retained from his North African roots, the fatal magic handkerchief which an Egyptian sorceress presented to his mother, that precipitates his downfall. On one level *Othello* can be read as a treatise on the difficulty of racial integration, or, as Germaine Greer has recently argued, a timeless depiction of prejudice;

> The ethical notion of evil as defective, absurd, and inconsistent is Aristotelian, but the embodiments of these characteristics in an agent, which makes possible the dynamic presentation of evil as an active force, is Christian. We no longer feel, as Shakespeare's contemporaries did, the ubiquity of Satan, but Iago is still serviceable to us, as an objective correlative of the mindless inventiveness of racist aggression. Iago is still alive and kicking and filling migrants' letter boxes with excrement.[3]

Hart, whose own understanding of prejudice would have been both subtle and profound, has not emphasized Othello's blackness at all. His hero looks like a handsome Indian prince (or, perhaps, even a Jew) whose loose robes and gentle Eastern thoughtfulness contrast with the tight, dynamic, Cromwellian militarism of the beady-eyed Iago.

3. Germaine Greer, *Shakespeare* (Oxford 1986), p. 48. In a recent production of *Othello* in Johannesburg, both the director Janet Suzman and the lead actor John Kani stated that they saw strong parallels between the universal themes of racism and evil as handled by Shakespeare and as manifested in contemporary South Africa (*New York Times*, 26 October 1987 p. C-16).

Edward Lear

1812, Bowman's Lodge, Upper Holloway — 1888, San Remo

For concision, precision and suggestiveness, it is hard for any short biography to rival W. H. Auden's 1939 poem 'Edward Lear':

> Left by his friend to breakfast alone on the white
> Italian shore, his Terrible Demon arose
> Over his shoulder; he wept to himself in the night,
> A dirty landscape-painter who hated his nose.
>
> The legions of cruel inquisitive They
> Were so many and big like dogs: he upset
> By Germans and boats; affection was miles away:
> But guided by tears he successfully reached his Regret.
>
> How prodigious the welcome was. Flowers took his hat
> And bore him off to introduce him to the Tongs;
> The demon's false nose made the table laugh; a cat
> Soon had him waltzing madly, let him squeeze her hand;
> Words pushed him to the piano to sing comic songs;
>
> And children swarmed to him like settlers. He became a land.

'His friend' was Franklin Lushington, for whom Lear's deepest love dared not speak its name; the 'Terrible Demon' his epilepsy, from which he suffered as many as twenty attacks a month;[1] 'damned dirty landscape-painter' he overheard himself called by another English traveller in Calabria[2] and subsequently adopted as a sobriquet. His 'most elephantine nose'[3] was a lifelong subject of merciless self-mockery, and inspired the most alarming, funny and sad of all his nonsense creations, the Dong (the demon of the third verse). Lear did dread large dogs and noisy Germans ('Germen, Gerwomen, and Gerchildren') along with 'monx' (monks) and complacent clerics, while the affection of his many English and Irish[4] friends was miles away because Lear's bronchitis and asthma kept him, first for winters, then year-round, in warmer Mediterranean climes. Probably from his own sadness came the gift of making others laugh with his inventive nonsense writing and impromptu performances on the piano. Auden's magical conclusion describes such transubstantiation: out of Lear's itinerant, alienated and often very unhappy life he produced an extensive imaginative creation, visual and verbal, which delighted not only the friends and children of his own time but also those of every generation to come.

Lear was the second youngest of twenty-one children born in twenty-four years to his mother (fifteen survived). Small wonder that he was farmed out to his eldest sister Ann, twenty-one years older, when he was four. Among his early heroes were Byron and Turner (whom he once heard sing at a party). His earliest artistic work was drawing detailed studies of flora and fauna, which he did with such skill that he got commissions from the Zoological Society. His first independent effort, *Illustrations of the Family of Psittacidae, or Parrots* was, like much subsequent work, more successful artistically than financially. His growing reputation as a zoological/ornithological draughtsman gained him an invitation from the heir to the Earl of Derby, Lord Stanley, who was a keen naturalist and had built up a unique private menagerie, to stay at Knowsley and draw the animals. Initially sent to eat with the servants, Lear first charmed the children, then the adults, with his delightful humour. And so he spent days drawing the Whiskered Yarke, the Eyebrowed Rollulus and the Lelerang and passed the evenings inventing the equally improbable characters of his limericks, eventually published in 1846 as the work of 'Derry down Derry'. A visit to Ireland in July and August, 1835, when he walked through the Wicklow Mountains to Glendalough with Arthur Stanley, and filled a sketchbook full of drawings, may well mark the beginning of his serious interest in landscape, though it was the following summer in the Lake District that he declared his career intentions. Ill health soon sent Lear to Italy, and although for a few years he was based in Rome,

1. Vivien Noakes, *Edward Lear* (London 1979), p. 132. As a child Lear sometimes had several attacks a day.
2. Angus Davidson, *Edward Lear: Landscape Painter and Nonsense Poet* (London 1968), p. 47.
3. Vivien Noakes, *op. cit.* (1979), p. 33.
4. One of Lear's best friends was Chichester Fortescue ('40scue'), who became a Liberal MP, Secretary of State for Ireland, and Lord Carlingford. Lear visited him in Ireland in 1857.

his peripatetic existence had truly begun. The incessant travels which filled the rest of his life may have been stimulated originally by ill-health and financial stringency (living abroad was cheaper, and exotic landscapes easier to sell), but they were also fuelled by a boundless joy of discovery, and a recurrent discontent (the depressive moods he called 'the Morbids') to which prolonged stays in a single place left him prey:

> Perhaps after all, the less one stays in places one likes the better — & so one escapes some pain. Therefore wander.[5]

Lack of proper artistic training embarrassed Lear (as it did, to a lesser extent, Fromentin, q.v.) and in 1850 he sat with boys twenty years younger for the examinations to enter the Royal Academy. Although admitted, he did not stay for long, having found a mentor in the Pre-Raphaelite painter William Holman Hunt, whom he subsequently addressed with genuine respect as 'Pa' or 'Daddy'. Lear hoped to work with Hunt on his second visit to Egypt in December, 1853; he also met Thomas Seddon (q.v.) on that trip. Seddon's description makes Lear sound like the Quangle Wangle:

> He wears a straw hat, with a brim as large as a cart-wheel, with a white calico cover. He was called up the Nile *Abou lel enema el abiad seidy soufra*; which being interpreted means, the father with the white turban like a table.[6]

Seddon also remarked that Lear had given up oil painting (part of his programme to be considered a more serious and consequential artist), in order to produce 'an enormous number of sketches, which are quite interesting'. Lear always felt obliged to try and paint important and expensive landscape oils. His luck in successfully selling a few made him struggle even more persistently, though neither in his lifetime nor subsequently have his large works rivalled his sketches in either public affection or critical esteem. One of the delightful ironies of Lear's life is that a man of such precarious health and so many illnesses (malaria and syphilis are also probable) could live to such a ripe old age, or that a man so often and so easily discouraged could produce so much in the way of finished and suggestive work. He visited India when he was over sixty, accompanied by his faithful Suliot servant of twenty-five years.

Lear's later years were spent in two residences on the Italian Riviera, the Villa Emily and the Villa Tennyson, the first named after the adored wife of the esteemed poet, the second perhaps jointly honouring both. A remark quoted to him and transformed into the refrain of a typically whimsical poem, 'How pleasant to know Mr. Lear', accurately describes the response of those directly acquainted with him as well as the reaction of many subsequent devotees who have taken the time to 'peerose' the rich verbiage of his 'jurnles' or 'admyer' the almost endless number of his 'pigchers'.

5. Vivien Noakes, *op. cit.* (1979), p. 182.
6. *Memoir and Letters of the late Thomas Seddon, Artist, by his Brother* (London 1858), p. 60.
7. Vivien Noakes, *op. cit.* (1979), p. 143.

Bibliography:
Vivien Noakes, editor. *Edward Lear, 1812-1888*, exhibition catalogue, Royal Academy, London, 1985.

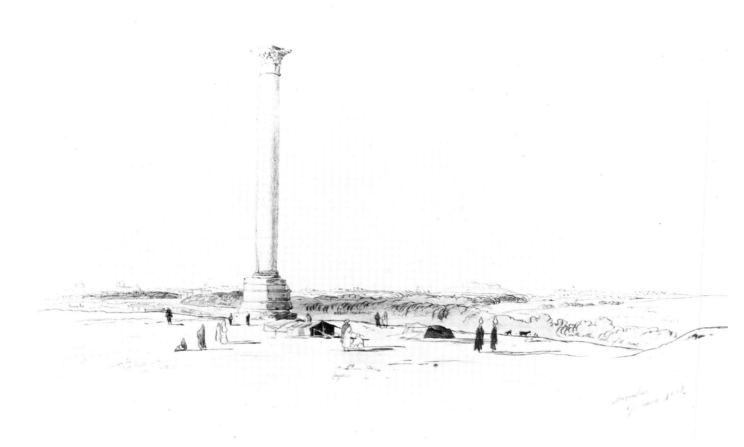

42 Pompey's Pillar

Pencil, brown ink and watercolour, 33.7 x
51.4cm.

INSCRIBED AND DATED: lower right, in ink,
Alexandria/ 17 March. 1858., with extensive
further notes in pencil.

PROVENANCE: The Earl of Northbrook, by
whom presented, 1910

LITERATURE: *The Tate Gallery Collections:
British Painting, Modern Painting & Sculpture*,
5th ed. (London 1973), p. 50.

The Trustees of the Tate Gallery

A distinctive aspect of Lear's creativity is the way in which words and images
constantly intertwine, amplifying or supplementing each other, whether in his
nonsense rhymes and their complementary illustrations or in the preliminary landscape
drawings where words took the place of time-consuming detail. In Lear's own
inimitable way, comic spelling crept in, the ground littered with 'rox' under an
expansive 'ski'. There is no attempt at humour in the extensive annotations to this
swift drawing, unless in the confusing 'sent sont' which appears twice in the foliage.
The column's shaft, made of a single block of red granite, appeared to Lear as 'pale
chocolate', and other colour indications include 'whiter' (on the base of the pillar),
'light of deep blue sky / which is paler and a little less at x' (a spot marked well
to the right above the horizon), 'brown' written on the tent, 'olive colour' on the
foliage, and 'slope of green fields'. Other notes identify buildings with numbers placed
on the horizon, label small objects like 'pigeons', locate distances of major space
definers (the trees are 'on the other side of the road') or designate the texture and
appearance of an area hardly marked ('barish, grassy, gravelly'). Figures clearly were
added after the main lines of the landscape had been established. This drawing would
be one of the first Lear did after his arrival for the third time in Egypt, since he docked
at dawn in Alexandria on 17 March, going on to Cairo for nine days until his steamer
departed for Jaffa, and his further travels in the Holy Land and Petra. Pompey's Pillar
was one of the most celebrated monuments in Egypt, even though the monolithic
Corinthian column was Roman (Denon, *q.v.*, who was singularly unimpressed, traced
its fame to partly-knowledgeable scholars in the fifteenth century). The graffito shown
in Lear's drawing on the base of the pillar had been remarked by Thomas Seddon
five years earlier when he described the monument:

> Its present object seems to be to immortalise 'G. Burron' or 'W. Thompson',
> whose names are painted in letters two feet high on the pedestal.[1]

Many artists have added colour notes to their rapid sketches, but it is rare to
find, as is so often the case in Lear, words given such prominence at the same time
as they act so integrally with the image, in a kind of descriptive dialogue between
the verbal and the visual.

1. *Memoir and Letters of the late Thomas
Seddon, Artist, by his Brother* (London
1858), p. 30.

43 Jerusalem

Watercolour and bodycolour on paper, 17.8 x 37.5cm.

INITIALLED AND DATED: lower left, twice, *EL 1858/1862*.

PROVENANCE: Sir H.J. Storks, who bought it from the artist; Lt. Col. H. K. Sadler DSO, by whom bequeathed, 7 December, 1961.

LITERATURE: *British Watercolours in the Victoria and Albert Museum* (London 1980), p. 223.

Victoria and Albert Museum, London

Soon after his arrival in Jerusalem in March 1858, Lear spent Palm Sunday crossing the Valley of Jehosophat to the Mount of Olives, ascending to the spot from which Christ must have seen the city when he came from Bethany. The view extended beyond Jerusalem to the Dead Sea:

> clear pale milky far blue, with farther pale rosy mountain - fretted & carved in lovely shadow forms, - this long simple line melting into air towards the desert.[1]

On his return visit, Lear contrasted the 'melancholy glory' and 'exquisite beauty' which the exterior of Jerusalem presented with the 'squalor & filth', the 'clamour & uneasiness' of the interior.[2]

This drawing represents Lear's original visual experience once removed (hence the double date), for it is from a series of copies of his own works done for quick sale which he called 'Tyrants'.[3] Having failed in the summer of 1862 to sell his laboured oil of *The Cedars of Lebanon* at his over-ambitious price of seven hundred and thirty-five pounds, Lear realized that he must try to produce 'vorx of hart' in far greater numbers at far lower prices. His solution was to undertake large quantities of copies from earlier drawings, in an assembly-line procedure, where all were brought along in similar stages. The first group, from which this drawing comes, consisted of sixty works, done in two batches of thirty. Two years later he did another set and over a decade later did a group of a hundred and twenty, using a ten-stage process he outlined in his diary. It is estimated that over the last twenty-six years of his life he may have done as many as a thousand.

For his first batch Lear hoped to get ten or twelve guineas a drawing. He was pleased with the completed ensemble: 'I have made a really remarkable gallery of watercolour works', he wrote to Fortescue. Among the people interested in the pictures, he noted the purchaser of this work, Sir H.J.K. Storks, High Commissioner for the Ionian Islands: 'His delight in looking over the drawings was very marked — and at once he bought one of Jerusalem and one of Corfu'.[4]

Lear suffered through the execution of his Tyrants, and they did not help his reputation as an artist, even if they aided his financial survival. Yet his own pleasure at the results he often achieved has been re-experienced by succeeding collectors and viewers. What is remarkable about his assembly-line exoticism, totally removed from the original motif, is the fairly high standard he consistently reached, a 'remembered Orient' of reasonable freshness and credibility.

1. Vivien Noakes, *Edward Lear, op. cit.* (1979), p. 155.
2. *Ibid*, p. 160.
3. Vivien Noakes, ed., *Edward Lear, 1812-1888*, Royal Academy, 1985, p. 126, no. 39a, for almost all the information that follows.
4. *Ibid*, p. 126.

John Frederick Lewis

1805, London — 1876, Walton-on-Thames

The son of an engraver, Lewis was born in the same house as Edwin Landseer, who was a childhood friend. Lewis' own initial success also came as an animal painter; he exhibited and sold a study of a donkey's head at the British Institution before he was fifteen, thereby gaining his father's permission to become a painter instead of an engraver. As his fame as an animal artist spread, Lewis did animal backgrounds for Thomas Lawrence and sporting subjects commissioned for George IV at Windsor. Lewis had an early predilection for watercolour and was made an associate of the Watercolour Society in 1827 and a full member in 1829.

European travels, first to Switzerland and Italy, then to Spain in 1832-34 expanded Lewis' subjects to include local figure compositions, with such productive success that he was nicknamed 'Spanish' Lewis. Among other publications he brought out *Sketches and Drawings of the Alhambra* (1835). From 1838-50 Lewis absented himself from the London art scene, partly for health reasons, first residing in Rome, then Constantinople, where he met and bid farewell to Wilkie (*q.v.*), who later died on his way home. Lewis then based himself in Cairo, with intermittent travels up the Nile. In *From Cornhill to Grand Cairo,* Thackeray included a comic portrait of Lewis, who, he claimed, lived 'like a languid lotus eater'.[1] Lewis' marriage to an Englishwoman precipitated his return to London in 1851 after an absence of well over a decade. A watercolour of *The Hareem* which had preceded him, caused a sensation. After his re-election to the Watercolour Society following his extended exile, Lewis replaced Copley Fielding as its president in 1856. That same year he exhibited *A Frank Encampment on the Desert of Mount Sinai, 1842* (Mellon Art Center, Yale University), which sent Ruskin into one of his ultimate encomia:

> I have no hesitation in ranking it among the most *wonderful* pictures in the world; nor do I believe that, since the death of Paul Veronese, anything has been painted comparable to it in its own line.[2]

Ruskin's excessive praise of a rather dry and stilted production does pinpoint Lewis' gift as a decorative colourist. Gautier, in a more perceptive remark, described Lewis' work as joining to the qualities of a European artist a combination of 'Chinese patience and Persian delicacy'.[3]

Fearing the potential for fading in Lewis' watercolours, Ruskin had urged him to switch to oils; Lewis himself told Holman Hunt that he had found English art in the 'woefullest condition' and felt obliged to move into the medium. The financial incentive as well as the greater glory of oils may also have played a part, for in 1858 Lewis resigned his Watercolour Society presidency and membership and undertook to become an equally renowned Royal Aademy exhibitor in oils. He was elected an associate the following year and a full member in 1865, after which he exhibited annually, maintaining if not extending the celebrity established by his earlier Eastern sketches. In terms of the quantity and quality of his production, Lewis was probably the finest English Orientalist figure painter. Ruskin thought his development of his skills was complete:

> I believe John Lewis to have done more entire justice to his powers (and they are magnificent) than any other man among us.[4]

Certainly Lewis managed the difficult task of working in considerable detail and finish to produce a result that was rich rather than oppressive. Yet his achievement is even greater in his sketches, an astonishing mixture of spontaneity, perception, accuracy and suggestion, than in the frequently stagey theatricality of his laboured oils, where the Western artist himself became almost a species of Eastern craftsman, patiently fitting and polishing the infinitely complex inlays of his compositions.

1. William Makepeace Thackeray, *Notes of a Journey From Cornhill to Grand Cairo, Works*, vol. V (London 1900), p. 729. Lewis is referred to as 'J_____'.
2. John Ruskin, *Academy Notes* (London 1904), p. 74.
3. Theophile Gautier, *Les Beaux Arts en Europe* (Paris 1855), p. 100.
4. Richard and Samuel Redgrave, *A Century of British Painters* (London 1947), p. 412.

Bibliography:
Maj. Gen. J. M. Lewis, *John Frederick Lewis, RA, 1805-1876* (Leigh-on-Sea 1978).
Richard and Samuel Redgrave, *A Century of British Painters* (London 1947), pp. 411-14.

44 Interior of the tomb of Sultan Bajazet, Constantinople

Watercolour over pencil on paper, 34.5 x 51.5 cm.

SIGNED AND INSCRIBED: lower right, in pencil, *Tomb of Sultan Bajazet/"El Hassem" / J F Lewis*. (Accession number, above in ink, 718.77.)

PROVENANCE: purchased 1893.

LITERATURE: *British Watercolours in the Victoria and Albert Museum* (London 1980), p. 228.

Victoria and Albert Museum, London

Lewis structured this composition around the right central Mihrab, whose surrounding rectangular borders alternate decorative strips with dancing Arab characters, suggested with consummate skill by Lewis' small sable brush. The dour figure on the right, whose robes dissolve in wet wash, unhappily registers the artistic intrusion. He stands a step below the polygonal platform upon which the Sultan's tomb, covered by a zigzag patterned fabric, below an oil lamp chandelier, rests and rises, tilted upward in the Eastern fashion. Normally the tomb would be topped by a turban; here are seen only some luxurious clothes. Two windows with circular stucco tracery allow in some light, but the principal illumination originates from the right and in front, where large open doors have allowed in the sun along with the infidel artist. Jean-Léon Gérôme (*q.v.*) was later to paint similar subjects, also with a solitary mourner.[1]

1. See Gerald Ackerman, *Jean-Léon Gérôme* (London 1986), nos. 266-67, pp. 242-43.

45 Egyptian Children

Pencil, black and red chalk and gouache,
32.5 x 22.3 cm.

PROVENANCE: purchased, 1942.

Visitors of the Ashmolean Museum, Oxford

The drawing contains two children and the ghost of a third on the lap of the seated child. Both lean against a wall of massive stone blocks, on which are carved ancient reliefs. The extrovert energy and tension of the striding Egyptian kings and the upright strength of the architecture they decorate contrast with the introverted, almost disconsolate gazes and slumping poses of the young girls. Often in his sketches Lewis struck a more profound psychological note than in the shallow frozen smiles seen frequently in his finished oils.

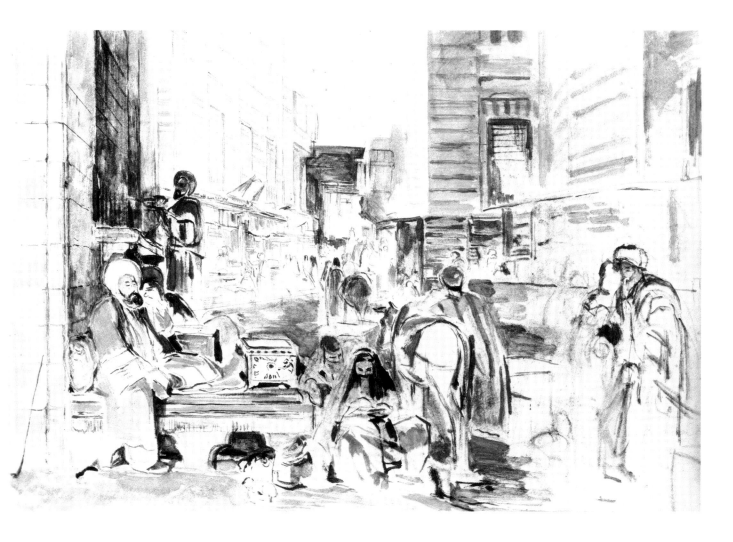

46 The Street and Mosque of the Ghoreyah, Cairo

Gouache, pencil and black chalk on paper, 29 x 39.8 cm.

PROVENANCE: Mrs. J. F. Lewis, by whose executrix presented, 1907.

LITERATURE: *City of Birmingham Museum and Art Gallery: Illustrations of One Hundred Watercolours in the Permanent Collection* (Birmingham n.d.), p. 26.

Birmingham City Museum and Art Gallery

1. Christopher Forbes, *The Royal Academy Revisited* (London 1975), no. 40, pp. 96-97 and p. 171, colour plate XIII. The painting is watercolour and oil on paper and measures 75.5 x 103 cm. It is also reproduced as fig. 45, cat. no. 516, in Maj. Gen. J.M. Lewis, *John Frederick Lewis, R.A., 1805-1876* (Leigh-on-Sea 1978).

Formerly though to be a study for *The Doubtful Coin* (Birmingham City Museum and Art Gallery), this drawing in fact was employed for a picture now in the Forbes Collection.[1] Probably executed or at least begun on-the-spot, the drawing is far less anecdotal than the finished composition. Ruled pencil lines establish the perspective of the architecture, but even in the regular alternating pink and blue-grey stripes of the building there is a lively variation in thickness and texture of the paint applied. The drawing is not a polished system of colour harmony, but rather a wonderfully varied and expressive ground of brush activity. The most exciting part of this work-in-progress is the truly experimental amalgam of blurred black chalk and vigorously-rubbed dry brush on the right. In the finished painting two veiled women diagonally importune the merchant on the left, intently observed by an older Arab seated close alongside. The second man is almost invisible under his green turban in the drawing, and a lovely patterned box stands between the sellers and the central seated women, who are self-absorbed. Below the platform on which the merchant sits, Lewis has suggested a confrontation between two cats with the dry-brush economy of a Rembrandt or a Japanese Master. In its unstructured yet coherent variety, this drawing can be read as a surprising, unconnected anticipation of the incessant animation and soft centre (also a seated woman in a voluminous costume) of Manet's celebrated *Musique aux Tuileries* (National Gallery, London), where the progressive Frenchman crammed the crowded movement of a *souk* into Paris' most fashionable park.

Prosper-Georges-Antoine Marilhat

1811, Vertaizon (Auvergne) — 1847, Paris

When William Müller (*q.v.*) wrote back to London from Paris on 30 April, 1844, describing but not naming a French artist he admired:

> The man I like paints views of towns on the Nile, and it is curious they are *highly* finished pictures: he paints the skies the last thing; his execution is wonderful, and his figures are also very fine.[1]

he must have been speaking of Prosper Marilhat, who that year showed three Egyptian scenes at the Salon. Over a decade later, Fromentin (*q.v.*) also discussed Marilhat without naming him. In *Une Année dans le Sahel*, Fromentin considered three Orientalist painters: the landscape painter (Marilhat), the genre painter (Decamps) and the history painter (Delacroix). Anticipating his own painter-writer status, Fromentin said of Marilhat:

> His work is the exquisite and perfect illustration of a voyage for which he himself could provide the text, for he has the same sharp glance, the same vivacity of style and expression as a writer as he has as a painter.[2]

Fromentin admired the precision and clarity of Marilhat's vision, an approach to place so particular that Fromentin thought Marilhat's landscapes were 'nearly like portraits', though the ones he found the most outstanding were 'those untitled works of unspecified locations'.

Marilhat became the most famous French Orientalist landscape painter of the first half of the century. In a short lifetime he perfected a distinctive style that managed to remain painterly and also convey a strong sense of accurate realism.

Marilhat was the son of a banker and grew up in a chateau in the Auvergne. At school in Thiers he was taught by a mediocre but enthusiastic Italian named Valentini who was also the instructor of Charles Blanc. Marilhat began more serious studies with Camille Roqueplan at age 18 and two years later in 1831 showed his first work, a view of Auvergne, at the Salon. At about the same time he was hired as a draughtsman to accompany the scientific expedition to the East led by Baron Karl von Hugel, a botanist-politician-soldier. The group departed in April, 1831, for Greece, Egypt, Syria, Lebanon, and Palestine, Marilhat then returning to Egypt from Jaffa rather than accompanying the Baron to India. Marilhat was much taken with Egypt, and in 1832 was in Alexandria 'painting portraits in order to live and doing studies in order to learn'.[3] He prolonged his stay until 1833, returning to Paris on the ship *Sphinx*, which carried back the Luxor obelisk Baron Taylor and Dauzats (*q.v.*) had been sent out to take.

Marilhat's four sunlit Egyptian landscapes in the 1834 Salon were a revelation to the critics, close on the success of Decamps' (*q.v.*) dark Turkish scenes and the same year as Delacroix's (*q.v.*) heady interior, *Women of Algiers*. Reaction was extremely favourable, particularly that of Gautier, who pursued his recurrent theme of delayed repatriation:

> I believed that I had just come to know my true fatherland, and when my gaze detached itself from this ardent painting, I felt as if I had been exiled.[4]

Marilhat continued to exhibit. Chantilly owns, among others, paintings from his 1835 (*The Countryside around Rosetta Remembered*) and 1840 (*Street in Cairo*) Salons, the Louvre his outstanding 1840 Salon picture (*Ruins of the al-Hakim Mosque*), and the Wallace Collection several fine examples of his work. Not long after his arrival back in France, Marilhat showed signs of mental instability, coincidentally about the same time as the breakdown of Dadd (*q.v.*). His moment of greatest triumph — the eight paintings he showed in the 1844 Salon — was soured by irrational fretting over what he saw as his insufficient renown. An envisioned return to Egypt never took place; instead, through the intercession of Prosper Merimée and Corot, Marilhat was awarded a compassionate annual pension by the government. But unlike Dadd, his mental deterioration precipitated physical collapse, and he died even younger than his friend Chassériau (see Fig. 24a, Thompson essay).

1. N. Neal Solly, *Memoir of the Life of William James Müller* (London 1875), p. 218.
2. Eugène Fromentin, *Oeuvres Complètes* (Paris 1984), p.324. Marilhat's letters were much praised and quoted by Gautier earlier, but they were never published.
3. Quoted in Lynne Thornton, *The Orientalists: Painter-Travellers*, (Paris 1983), p. 34.
4. Théophile Gautier, *Portraits Contemporains* (Paris 1874), p. 239.

Bibliography:
Théophile Gautier, 'Marilhat', *Revue des Deux Mondes* (July 1848), pp. 56-75. Reprinted in *Portraits Contemporains* (Paris 1874), pp. 234-264.
H. Gomot, *Marilhat et son oeuvre* (Clermont-Ferrand 1884).
Danielle Menu, *Prosper Marilhat (1811-1847) Essai de Catalogue*, Université de Dijon, UER de Sciences Humaines, 1972.
Pierre Miquel, *Le Paysage français au XIXe siècle, (1824-74). L'Ecole de nature* (Maurs 1975), vol. II, pp. 346-59.
Prosper Marilhat, exhibition catalogue, Musée Bargouin, Clermont-Ferrand (1973); Prosper Marilhat, *atelier* sale, 13-15 December 1849, Paris.

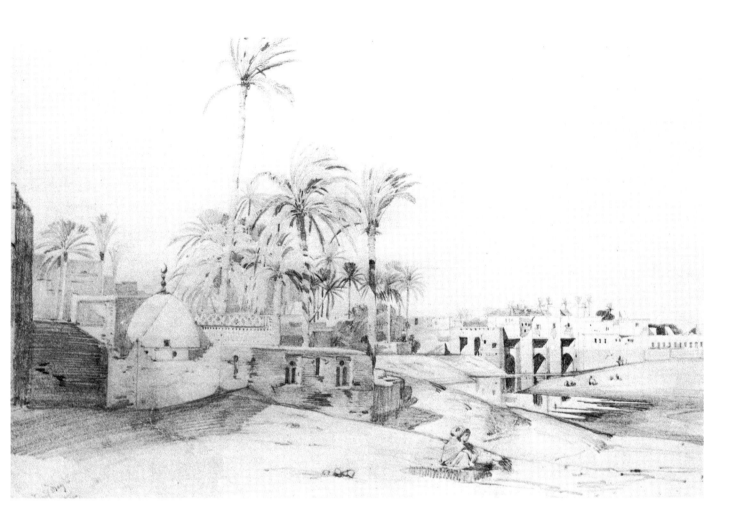

47 Entrance Gate to the Palace of Cherif Bey, Asyut

Pencil on white paper, 26.8 x 43 cm.

INSCRIBED: lower right, *la porte d'entrée/au Palais de Cherif Bey/Chekh mountaet(?) Siout.*

PROVENANCE: M. Strange; Searight Collection.

LITERATURE: Briony Llewellyn, *Catalogue of the Searight Collection* (forthcoming).

Searight Collection, Victoria and Albert Museum, London

That Marilhat's drawings share some of the same qualities as his paintings, such as visual sensitivity and accuracy, is hardly surprising, since in many instances they provided the raw material of which, back in France, several paintings were made.

In the black and white dynamics of this drawing, shade is the great definer of space, shape, and form; Marilhat wasted little time worrying about the texture or material being of any object or surface, seeing everything in terms of the amount of light it reflected or shade it absorbed. There is sensitivity in the staccato patterns the palms cast on each others' trunks, in the sheen of still water left in a dried-out riverbed; everywhere the artist's pencil was crisp and controlled, yet expressive, far from flat or neutral.

This drawing was done in Egypt only slightly before William Wyld (*q.v.*) was painting his watercolour (no. 70) in Algeria.

John Martin

1789, Haydon Bridge (nr. Hexham), Northumberland — 1854, Douglas, Isle of Man

Martin was born the fourth son and thirteenth child of a poor fencing master. He came from a remarkably eccentric family. His eldest brother William had printed over two hundred pamphlets on his inventions, life and philosophy; his brain, teeming with original ideas he seldom followed up and accused others of stealing, ultimately tipped into madness. Styling himself 'Philosopher Conqueror of All Nations' he walked the streets of Newcastle, an enormous homemade gong hung upon his breast, on his head a helmet of tortoise shell, mounted and bound in brass. The second brother Richard was a soldier who fought at Waterloo, published poetry, and was said by John to have written a pamphlet on Perpetual Motion.[1] Jonathan, the third brother, achieved fame, or infamy, as an incendiary, his Methodist fundamentalism having sparked an openly declared and sadly successful plan to burn York Minster on 1 February, 1829. Granted that John Martin lived his life 'in the shadow of the toppling tower of lunacy',[2] the distinctive and unusual character of his art hardly seems surprising, perhaps a therapeutic release from, or transformation of, the dark visions which ruinously afflicted his brothers.

Martin was first apprenticed to a coach painter, then an Italian china painter, who took him to London. Martin's first exhibited picture, a conventional landscape, went to the Royal Academy in 1811; the following year he showed what he considered his first works, two landscapes featuring the extraordinary subject matter and scale that would be especially associated with him for the rest of his career. One scene, *Sadak in Search of the Waters of Oblivion*, was Biblical, while the other, *Tales of the Genii*, was an Oriental fantasy. Martin's distinctive approach — brooding, dark canvases with supernatural shafts of light, fantastic architecture and dramatic perspective — gained him great success, although he quarrelled with the Royal Academy and exhibited more frequently at the British Institution.

Martin did original mezzotints and copies of his paintings in that medium, which not only made him large sums of money but also popularized his work. He received £2,000 for his twenty-four illustrations for Milton's *Paradise Lost*, a joint undertaking with Richard Westall (*q.v.*); they also worked together on John Hobart Caunter's *Illustrations of the Bible* (1835-36, II vols.), to which Martin contributed twenty pictures.

Martin's inventiveness was not confined to painting; like his brother William he published pamphlets, on cleaning up London's water supply by disposing of its sewage properly, on iron ships, and on safer ventilation in coal mines.

Described by Frith as 'certainly one of the most beautiful human beings I ever beheld'[3] Martin was small, enthusiastic, tenacious and combative. Haydon, who held serious reservations about Martin's art, said:

> That fellow should have wings; he is an extraordinary genius in his way.[4]

There was certainly a critical reaction against Martin's great popularity. John Cause, a contemporary animal painter, comically mocked Martin's 'feo faw fum style'.[5] Palgrave condemned Martin's work as 'the Mechanical Sublime'.[6] For Ruskin they were 'as much makeable to order as a tea tray or coal scuttle'.[7] Charles Lamb derided Martin's 'phantasmagoric tricks' in making him the subject of his essay on 'The Barrenness of the Imaginative Faculty in the Production of Modern Art',[8] and Hazlitt accused Martin of wearying the imagination instead of exciting it.

An eloquent supporter, Lytton Bulwer, whose writing shares some of his friend Martin's qualities, declared him:

> the greatest, the most lofty, the most permanent, the most original genius of his age...Vastness is his sphere, yet he has not lost or circumfused his genius in its space; he has chained, and wielded and measured it, at his will, he has transfused its character into narrow limits; he has compassed the Infinite itself with mathematical precision... Alone and guideless he has penetrated the remote caverns of the past and gazed on the primeval shapes of the gone world.[9]

In our own century Francis Klingender has argued that the productions of this prodigious inventor reflect the Industrial Revolution: 'he gave to Hell the image of industry'.[11]

1. Ruthven Todd in her excellent essay 'The Imagination of John Martin', *Tracks in the Snow* (London 1946), p. 99, believes that the Perpetual Motion studies were only done by William.
2. *Ibid*, p. 97.
3. W. P. Frith, *My Autobiography and Reminiscences* (New York 1888), vol. I, p. 47.
4. Tom Taylor, ed. *Life of Benjamin Robert Haydon from his autobiography and journals*, vol. II (London 1853), p. 100, cited in Todd, *op. cit.*, p. 116.
5. Ruthven Todd, *op. cit.*, p. 109.
6. *Ibid*, p. 95.
7. John Ruskin, *Academy Notes, Notes on Prout and Hunt and other Art Criticisms, 1855-1888* (London 1904) (Collected Works, vol. XIV).
8. See the Rev. Canon Ainger, ed. *Charles Lamb: Complete Works and Correspondence*, vol. II (London 1883-8), p. 166.
9. E. Lytton Bulwer, *England and the English*, vol. II (London 1833), pp. 211-12; cited in Todd, *op. cit.*, p. 116.
10. Francis Klingender, *Art and the Industrial Revolution* (London 1947), pp. 103-08.

Fig. 38 John Martin, *Moses Dividing the Waters of the Red Sea*, watercolour (Victoria and Albert Museum, London).

48 Destruction of Pharaoh's Host

Watercolour with some oil over pencil on paper, 15.5 x 20.6 cm.

SIGNED: lower right, *J. Martin*.

PROVENANCE: Thomas Balston, by whom bequeathed, 1968.

LITERATURE: Pierre Georgel, review of 'Berlioz and the Romantic Imagination', *Revue de l'Art*, no. 8 (1970), p. 78 (illus.); *British Watercolours in the Victoria and Albert Museum* (London 1981), p. 249.

Victoria and Albert Museum, London

This watercolour is one of a pair, the other (also in the Victoria and Albert Museum, Fig. 38) showing the preceding incident of Moses lowering his long rod to spread the waters of the Red Sea for the Israelites to cross. This, the more dramatic of the two, is probably earlier than the (at least) two other versions of the same subject: a large watercolour of 1830,[1] and the mezzotint for the Martin-Westall (*q.v.*) *Bible Illustrations*, published in 1835-6. In the watercolour, the turbulent sea is dominant, not only submerging the Egyptians but rising well above Moses to the raised horizon. The mezzotint is closer to this work as a composition, though the promontory on which Moses stands juts out less dramatically and his own upward gesture, solemn and hieratic, lacks the balletic dynamism of a concert conductor seen in his pose in this picture.

Though a diminutive work, the achievement of Martin in creating a sense of great scale here is impressive. To indicate the engulfed Egyptians he began the front half of a horse, but followed it with a succession of dots to indicate the trailing host. He similarly created an uncountable crowd of Israelites, safe onshore, in a receding stream of humanity. Three palm trees droop in stages toward the sea, the only clear indicator, apart from the barren landscape, that the picture is set in the East. The drawing is built around three compositional constructions: the outcrop, which culminates, like the surging prow of a ship, in Moses' dramatic downward gesture; the resulting swirl of the collapsed opening over the hapless army of the Pharaoh; and, finally the even grander curve of the sky's cosmic swirl, which suggests not only the setting but also the source of the power Moses exercises.

The imagery in Martin's dramatic depiction may well have influenced the angle from which Cecil B. De Mille shot his similarly spectacular scene in his two versions of *The Ten Commandments* (1923 and 1956). The event would have been made memorable for Martin not only by the Biblical account but also from the lines of Milton's *Paradise Lost*, which he and Westall also illustrated:

> ...With perfidious hatred they pursued
> The sojourners of Goshen, who beheld
> From the safe shore their floating carcasses
> And broken chariot wheels. (i. 308-11)

Some sense of Martin's style in larger oil paintings can be gained by visitors to the National Gallery of Ireland from viewing the Irish artist Francis Danby's *Opening of the Seventh Seal*, the masterpiece of Martin's able rival in apocalyptic scenes.

1. 57 x 85cm., current location unknown. illustrated in *Apollo* (September 1954), p. 55 as Leger Gallery, 'Picture of the Month'. Also illustrated in William Feaver, *The Art of John Martin* (Oxford 1975), p. 91.

Arthur Melville

1855, Loanhead-of-Guthrie, Angus — 1904, Witley, Surrey

Arthur Melville rose from humble Scottish origins to achieve considerable, if incomplete success, following less dramatically the pattern set by Wilkie (*q.v.*) over half a century before. Like Wilkie, Melville was naturally gifted with a brush, though he was unwilling to freeze the spontaneity of his original impression in polished academy oils. He remained, and was justly celebrated, as a virtuoso watercolourist, with a distinctive technique that mixed precise control and expressive freedom.

Melville was the fourth of seven children born to a coachman. Apprenticed by his family to a grocer, he had determined early to be an artist, and six nights a week for three years walked sixteen miles to attend evening art classes in Edinburgh. Later in 1874 he became book-keeper to a shop closer to the city, and continued his studies in the life school of the Royal Scottish Academy, where he was taught by John Campbell Noble, R.S.A.. In 1875 Melville had a small oil hung in the Royal Scottish Academy, which was bought by his father's employer. With the money saved from that and subsequent sales, Melville planned to go to Paris. When in 1878 his painting *The Cabbage Garden* was hung in the Royal Academy in London, Melville packed up his meagre belongings, including the Scotsman's essential plaid and Bible, and went to Paris.

In Paris Melville studied at the *Academie Julian*, a veritable artistic factory of distinguished artists from France and abroad (George Moore and John Lavery, *q.v.*, were among the many who worked there). Ironically, since watercolour had evolved as a quintessentially English practice, Melville made his first significant steps in that medium in Paris. In Melville's first year in France, he visited Fontainebleau, and settled there permanently in 1879 at Grez-sur-Loing, which contained a colony of foreign art students, particularly from America and the British Isles, and where Melville met his famous fellow Scotsman Robert Louis Stevenson. In 1880 Melville returned to Edinburgh and showed three French landscape oils at the next exhibition of the Royal Scottish Academy. After only a few months in Edinburgh, he set out in 1881 for Egypt. Melville had intended to visit Egypt for four months, but ultimately stayed two years. He worked hard at his art, but was also a considerable social success among the colonial community. Robust and charming, he made friends easily; and in his letters and diaries, whist, tennis and billiards are mentioned almost as often as art. During an excursion to Luxor, Melville met Sir Flinders Petrie, with whom he stayed for some weeks during the opening of the tomb of Rameses II.

In an effort to capture the effect of the blinding Egyptian sunlight, Melville extended his watercolour technique. He evolved a method of first saturating his paper repeatedly with Chinese white, before painting on the umbers that so often provided a basic background, and finished with the bright coloured patches which animate his works. Almost a year after his arrival, he fell seriously ill for the first time in his life. What began as a bladder infection at one stage required ten operations in seven days and left him considerably weakened. After a winter of recuperation, he set out for Suez and took a boat down the Red Sea to Jedda (where cholera prevented him disembarking), Aden, and as far as Karachi in India. Hardly hesitating, he sailed back to Muscat, where his notes on a 'wonderfully picturesque' bazaar show that his time in Egypt had not jaded his response to Eastern life:

> The Arabs with their pistols, spears and swords, dark skins and supple drapery were a feast for the Gods. Nothing could be more striking.....Wild sons of the desert they looked.[1]

Melville then proceeded up the Tigris River to Bagdad, where he found one of the East's most fabled cities a disappointment. Hoping for an enchanted spot out of the *Arabian Nights*, he was unable to perceive any difference from Cairo:

> There was the same crowd of Mahomedans evidently pursuing the same mode of life as in Egypt. I have become too familiar with the Arab to be reminded of the characters in the Arabian Nights. Besides there is so little of the marvellous about the building that one's imagination comes to a sudden stop for want of proper surroundings. Mud and dirt abound everywhere.[2]

1. A.E. MacKay, *op. cit.*, p. 41.
2. *Ibid*, p. 45.

Still he stayed to work, producing between five and eight large sketches a week. In his journal he reckoned each sketch to be worth thirty pounds;[3] two weeks before his departure from Bagdad he had sixty in hand and hoped by his return to carry a 'cartload'[4]. From Bagdad, Melville took the caravan route to Constantinople. His journal details his desert life, an irregular and colourful string of exotic experiences interspersed with bouts of fever; his adventures, if lacking in the necessary magic, were themselves dramatic enough to frame an *Arabian Nights* tale. Once he narrowly escaped capture by more than a hundred bandits in a furious chase with gunshots whistling past his head. Later he was captured by other brigands and left naked to die in the desert. Crawling to the nearest village he was so solicitously attended that a few days later, still stiff and weak, he was able to join the local Arabs in a punitive expedition that recovered his personal belongings, including his Bible and precious Scottish plaid, the latter picturesquely marked by a bullet hole.

From Constantinople Melville returned home through Europe; he was much impressed by the work of Velazquez in Vienna, and he also stopped in Strasbourg and Paris. Back in Scotland, Melville associated with some other young Scottish painters who came to be known as the 'Glasgow School': 'his big, handsome, courageous cavalryman presence infested all the group with the *joie de vivre* and the self-assurance it badly needed'.[5] Their personal variant of French Impressionism and Bastien-Lepage plein-airism met with a hostile reception from conservative Scottish (and occasionally also English) critics. Nonetheless, Melville's work did sell, and in 1889 he moved to London. In 1890 he extended his range of strong sunlit scenes with a visit to Spain and Algiers, and on another Spanish visit in 1893 went to Tangier. Earlier he had exhibited in the important opening exhibition of the Grafton Gallery in London, alongside the likes of Degas (whose great *L'Absinthe* was on show) and Whistler. Melville's Spanish visits inspired a sequence of watercolours centred on the bullfight, perhaps the only works which rival his Oriental subjects in vivacity and power. *Behind the Scenes after the Bullfight*, with the animal's carcass being laboriously dragged away, is a work of considerable force.

In his later years Melville increasingly painted in oils. From 1901-04 he worked on a series of four large-scale pictures based on the birth of Christ which he called the *Christmas Carols* (examples in the National Gallery of Scotland and Aberdeen Art Gallery). Broadly and simply painted, unfinished in fact, they demonstrate the same process of attempting to re-invigorate and modernise history painting that had been seen in France in the mid-century work of Millet, Degas and others. There is little of the Orient in these interesting failures, though the artist's ever-present sharpness of eye came closer to revivifying the old Christian story than does Tissot's (*q.v.*) careful archaeology.

On his last visit to Spain in the summer of 1904, Melville and his wife, whom he had painted as a child in 1883 and married in late 1899, contracted typhoid fever, though the symptoms only appeared after they had returned to England. The painter died in Surrey, while his wife survived to raise their infant daughter. Recently derided by the critic of an eminent Sunday paper as 'the height of watercolour nastiness',[6] Melville was, in fact, a splendid and innovative technician, whose somewhat distanced and slightly slick vision of the East nevertheless offers a distinctive and evocative finale to a century of 'Oriental sensations'.

3. *Ibid*, p. 48.
4. *Ibid*, p. 47.
5. *Ibid*, p. 65. The quote came from an unidentified member of the Glasgow School and appeared in *The Scottish Review* (3 October 1907).
6. William Feaver, 'Art for Wets', *The Observer* (26 April 1987), p. 21.

Bibliography:
Agnes Ethel MacKay, *Arthur Melville, R.W.S., A.R.S.A.* (Leigh-on-Sea 1951).
Arthur Melville, catalogue of an exhibition at Dundee Museums & Art Galleries by Gerald Deslandes, 1977.

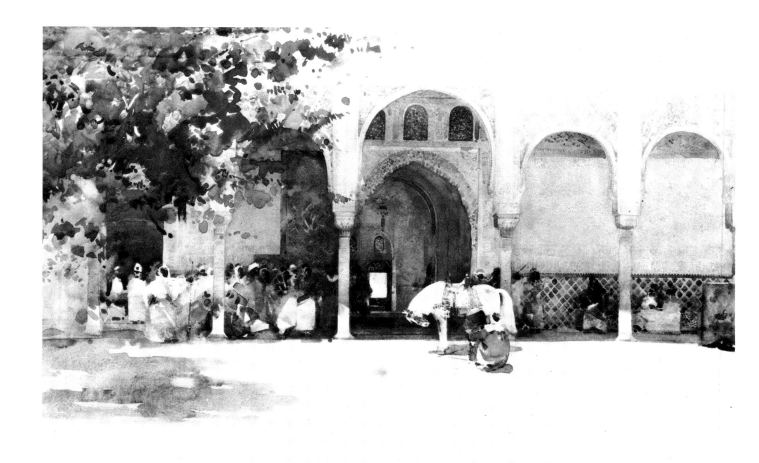

49 Waiting for the Sultan

Watercolour, 54 x 76.5cm.

SIGNED AND DATED: lower left, *Arthur Melville/1891.*

PROVENANCE: Dr. John Kirkhope, by whom bequeathed, 1920.

EXHIBITED: 1906, *Exhibition of the Collected Works of Arthur Melville*, Royal Institute of Painters in Watercolours, London, no. 336; 1907, Royal Glasgow Institute of the Fine Arts, no. 30; 1908, Scottish National Exhibition, Edinburgh, no. 613; 1911, Scottish Exhibition, Glasgow, no. 690; 1935, *Glasgow: A Century of Art*, no. 78; 1939, Royal Academy, London, no. 607.

LITERATURE: A.E. MacKay, *Arthur Melville, R.W.S., A.R.S.A.* (Leigh-on-Sea 1951), p. 157; Lynne Thornton, *The Orientalists, Painter-Travellers* (Paris 1983), p. 195 (illus.).

National Galleries of Scotland

Waiting for the Sultan, done soon after Melville's visit to Algiers, demonstrates a mature mastery of his watercolour technique, with its particularly distinctive blend of freedom and control. The former quality can be seen in the flickering foliage of the left foreground tree and the loose movement of some figures; the latter is detected in his crisp delineation of delicate architectural detail, and, particularly, in the precise shapes of column bases, or the lovely horse, or the curious middle rectangle, which is either a mirror or an opening beyond, on which, perhaps, the whole picture's cast attend expectantly. Yet without the given title, such a psychological centring of the watercolour would be almost unthinkable; Melville's art is essentially visual, more about lazy, sultry sunlight than the anxiety or excitement surrounding the imminent arrival of a powerful Sultan. The freedom in the sketches of Melville or Brabazon (*q.v.*) did not exist to encourage the viewer's imagination but rather to include colour and atmospheric suggestion far beyond the resources of a photograph.

Luc-Olivier Merson

1846, Paris — 1920, Paris

Over twenty years younger than Bouguereau (q.v.), Merson ceaselessly pursued academic principles of acceptable subject-matter and careful execution well into the twentieth century, becoming, as one favourably-disposed critic described him, 'the ingenious hermit of contemporary art'.[1] Merson's father Olivier (1822-1902) had begun as a painter but turned to art criticism. In one of his books *La Peinture en France*, inspired by the 1861 Salon, he defended classical academic teaching against its detractors, and established a traditional artistic position which strongly influenced his son.

Merson was taught by Lecoq de Boisbaudran and Georges Chassevent at the *Ecole des Arts Décoratifs* and then by Isidore Pils at the *Ecole des Beaux-Arts*. He had Greek subjects accepted for the Salon while still a student, starting with *Leucothea and Anaxandra* in 1867, *Penelope* in 1868, and *Apollo Destroyer* in 1869. in 1869 he also won the *Prix de Rome* with his picture of *The Soldier of Marathon* (Ecole des Beaux-Arts, Paris), dying of exhaustion, having presented his message after his twenty-six mile run. In Italy Merson was excited by *quattrocento* art. His 1872 Salon painting, *St. Edmund, martyred King of England* (Musée des Beaux-Arts, Troyes), with its ninth-century subject, anticipates some of the *fin-de-siècle* symbolist medievalism. *The Vision*, which won him a first class medal in the following Salon, portrayed a 14th century legend, with a female saint fainting in front of a full-size crucifix, Christ disengaging his right hand to bless her while three angels provide musical accompaniment. In the 1878 Salon, *The Wolf of Gubbio* (Musée des Beaux-Arts, Lille) shows the formerly rampaging beast not only domesticated but beatified by St. Francis, a thin halo over its head as it accepts its agreed ration from the butcher and tamely allows a small Italian girl to stroke its back. Merson received the Legion of Honour in 1881, the same year as he exhibited another episode from the life of St. Francis, *St. Francis Preaching to the Fish* (Musée des Beaux-Arts, Nantes). His *Rest on the Flight into Egypt* (see no. 50) in the earlier Salon of 1879 was a rare excursion into an East he had never visited, made possible by its nondescript nocturnal desert landscape and acceptable by its traditional Christian subject, albeit treated with his typically unorthodox narrative slant.

What appealed to both critics and the public in Merson's works was the exact and careful detail of the settings he created for his subjects, which gave them 'in spite of their archaic subjects and their painstaking execution, a sense of something seen'.[2] It was a related renewal of old subjects (by distinctly different means) which Degas had abandoned as hopeless in the 1860s and Tissot attempted later with his New and Old Testament illustrations (see Tissot no. 64).

Merson showed rarely in the Salon after 1881, even though he was made a Member of the *Institut* in 1892, a Professor at the *Ecole des Beaux-Arts* in 1894, and an Officer of the Legion of Honour in 1900. During this time he stayed extremely busy with a wide range of decorative commissions, designing everything from ornate borders of art magazines, to church windows and mosaics, to two large murals for the *Théâtre National de l'Opéra Comique* (*Music in the Middle Ages* and *Poetry in Antiquity*), to the hundred-franc note. Merson was also a productive book illustrator, working on Hugo's *Notre Dame de Paris* and Flaubert's *St. Julian the Hospitaler*, as well as works by Boileau (1889) and Musset (1911). In 1903 he returned briefly to the Salon with an *Annunciation* and a small satirical composition entitled *Dead?*, presenting Truth and Justice in the final throes of agony. Quite out-of-step with the art of his time, Merson resigned in 1911 as a Professor, in protest against the changed course of artistic instruction and relaxed admission standards.

1. Raymond Bouyer, 'Luc-Olivier Merson', *Gazette des Beaux-Arts*, 5e série, v. I (1921), p. 34.
2. Charles Saunier, *Anthologie d'Art Francais, La Peinture - XIXe siècle*, vol. II (Paris n.d.), p. 208.

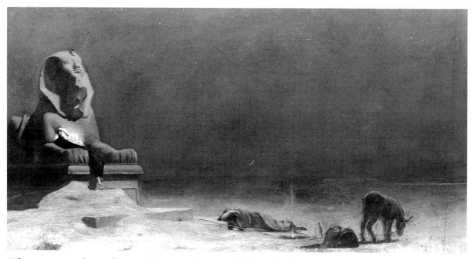

50 Rest on the Flight into Egypt

Oil on canvas, 76 x 133.5cm.

SIGNED AND DATED: lower right, *LUC OLIVIER MERSON / MDCCCLXXIX.*

PROVENANCE: sale, Sotheby's, London, 25 November 1981, lot 45.

EXHIBITED: 1879, Salon, no. 2112, p. 177.

LITERATURE: C.H. Stranahan, *A History of French Painting* (London 1889), p. 438; Raymond Bouyer, 'Luc-Olivier Merson', *Gazette des Beaux-Arts*, 5e serie, v. I (1921), p. 41, 39 (illus.); Philippe Jullian, *The Orientalists* (Oxford 1977), p. 67 (illus.); Michael Holroyd, *The Genius of Shaw* (London 1979), p. 50, 51 (illus.); *Chers Maîtres & Cie: Peintures françaises de 1818 a 1914 dans les collections du Musée des Beaux-Arts Jules Cheret* (Nice 1979), no. 75.

Private collection

1. In her short 1889 biography of Merson, C.H. Stranahan (see 'Literature') mentioned only this picture. Merson is less known today, but some people might recognise this painting who have never heard of the artist.
2. Whereabouts unknown. A print after the painting is reproduced in the Witt Library, London.
3. Quoted by Michael Holroyd, *The Genius of Shaw*, p. 51; Holroyd cites critical associations made between Caesar and the unborn Christ and Cleopatra and the Virgin. Gerald Ackerman *(Jean-Léon Gérôme*, (London 1986), p. 222-23, no. 175), wrongly supposed Shaw to have been inspired by Gérôme's 'Oedipus', which shows a solitary mounted Napoleon facing the Great Sphinx.

There are at least four other versions of this painting, in Nice (see 'Literature') in the Museum of Fine Arts, Boston (acc. no. 18.652),in the Hearst Collection, California, and one sold recently at Sotheby's (see 'Provenance'). Either this or the Boston picture appear to be the 1879 Salon original.

Following on his success the previous year with *The Wolf of Gubbio* (Musée des Beaux-Arts, Lille), Merson consolidated his reputation with *Rest on the Flight into Egypt*. Its popularity, to which the copies attest, was enhanced by the widespread sale of Merson's engraving after it, and it remains probably Merson's most famous single work.[1] The reasons for its relative celebrity are not hard to understand, for it is a most effective image. The radiant Christ child and moonlight combine to illuminate a solemn Sphinx in an eerie, otherwise empty desert landscape of immense nocturnal atmosphere, paradoxically rendered with painstaking precision. The Sphinx represented is, of course, not the Great Sphinx (see Seddon, no. 63, and Hone, nos. 74 and 75) but possibly the alabaster Sphinx of Memphis, about the same size as the work in the painting, though in a different setting.

Egyptian monuments viewed at night were a favoured subject of Narcisse Berchère (*q.v.*), who in the 1859 Salon set under a crescent moon his *Colossi of Memnon on the Plain of Thebes During the Flooding of the Nile*, in the 1864 Salon showed *Twilight (Lower Nubia)* which contained two Sphinxes as surrounded by Arab shepherds and their flocks, sleeping around three small fires, whose smoke ascends straight up in the night sky, and finally in 1878, the year before Merson's painting, displayed a *Ramesseum* where the famous arcade fronted with columnar statues was seen under a full moon with resting Arabs and camels.

Following on the success of his *Rest on the Flight into Egypt* Merson painted a related scene, *In the Shadow of Isis*[2]. Seated on the forehead of a fallen colossus in the shaded corner of some Egyptian ruins while clasping the Christ child to her left breast, Mary stares fixedly at a sculptured relief of the Egyptian goddess Isis, nursing *her* son Horus at *her* left breast. Thus the clever conceit of the painting is to represent Mary as a mother figure following on from the sunny glory of the archetypal Egyptian mother goddess. To the left Joseph is stretched out on the ground in a pose only slightly altered from the earlier work, his head propped up on his right elbow.

Much later a print after the Merson painting inspired the opening scene of George Bernard Shaw's *Caesar and Cleopatra*, as the dramatist revealed in a 1918 letter he wrote to Hesketh Pearson:

> The Sphinx scene was suggested by a French painter of the Flight into Egypt. I never can remember the painter's name, but the engraving, which I saw in a shop window when I was a boy, of the Virgin and child asleep in the lap of a colossal Sphinx staring over a desert, so intensely still that the smoke of Joseph's fire close by went straight up like a stick, remained in the rummage basket of my memory for thirty years before I took it out and exploited it on the stage.[3]

It is only appropriate that the National Gallery of Ireland should now show a painting which helped stimulate the work of one of its greatest benefactors.

William James Müller

1812, Bristol — 1845, Bristol

Müller's father was a Prussian scientist who was forced to leave Danzig by the Napoleonic invasion. John Samuel Müller settled in Bristol, married a local woman, and became curator of the Bristol Museum. He illustrated his own publications in natural science, and his three sons followed their father's interests in different ways, the eldest, Henry as a doctor, William as an artist, and Edmund as first doctor, then artist. William's inclination toward art was manifested early. He is said to have helped his father with his scientific drawings at age nine, and a careful drawing he did at age twelve for the scholar J. C. Prichard, prophetically of a mummy case with its hieroglyphics, gained him a much-prized box of paints. His first important teacher was the landscape painter James Baker Pyne.

Müller grew to be an unusual character, exceptional in appearance and behaviour. He sported a monocle to correct his short-sightedness and, with one eye brown and one grey, claimed flippantly that he saw colour through one and form through the other. It has been suggested that Müller's short-sightedness actually helped him to simplify landscape, allowing him to seize upon nature's broadest aspects.[1] In his short lifetime he was famed for the speed of his work, and known particularly as an original and brilliant sketcher, who could produce in three or four hours a painting which might have taken another artist as many days. Working with his left hand, Müller possessed what one of his pupils admiringly called 'wonderful power of wrist'.[2]

Müller's first Royal Academy exhibit in 1833 was a large landscape of *The Destruction of Old London Bridge*, executed while the event was taking place. In June, 1833, he went to Wales and made his only trip to Ireland, going straight to Dublin, visiting 'the Museum of Pictures, which was then open'.[3] 1834-35 found him touring Europe, especially Italy. After three years in which he turned out Italian scenes in Bristol, he sought the wider horizons of the East, stopping to copy old masters at the Louvre *en route* to Athens. Müller worked for six weeks in Greece, mainly on the Acropolis, but Egypt produced such a powerful impression on him immediately afterward that he made little artistic use subsequently of his Greek sketches (there were about fifty of them in his posthumous sale[4]). When he disembarked in Alexandria he was overwhelmed by the visual variety, 'humanity put into a kaleidoscope', and was saved from the loss of his possessions only by the appearance of the man who became his trusted servant Aleck, in Müller's description 'Friday' to his 'Robinson'.[5]

Müller brought with him other literary and visual preoccupations: the markets and bazaars formed 'the most perfect pictures for Rembrandt',[6] the Bedouin provided 'scriptural subjects of a very high class'[7], and 'a Holy Family is found in every Arab village'.[8] 'Although no figure painter',[9] he was particularly fascinated by the slave market, where he could see salesmen expose their human merchandise suddenly and utterly, leaving the young Englishman to imagine from the female slaves' fine features and figures 'the warmth of passion they possess'.[10] Müller chartered a boat to go up the Nile; 'shooting, sketching and smoking'[11] he took twenty days to reach Dendura. On the way he noted the 'smiling melancholy'[12] of the Sphinx; later in London 'the Sphinx' would become his nickname.

After returning to London, Müller based most of the new pictures he exhibited on his Egyptian experiences, his most repeated subjects being *Chess Players*, *Slave Markets* and bazaar scenes. In 1840 he was sent to France to do a series of illustrations based on the reign of Francis I for a book published the following year. Müller also made frequent trips to North Wales, which he saw as the 'English Switzerland'.[13] By 1843, the inspiration of his initial Oriental trip was beginning to wear thin. For a major composition, *Prayers in the Desert* (City Museum and Art Gallery, Birmingham), he sought out Eastern-looking models in London to pose, and he even tried to move from contemporary genre to Biblical subjects, with two scenes from the life of Moses (despite an earlier *Good Samaritan*, Biblical scenes were uncommon in his work).

An opportunity to return to the East arose when the archaeologist Charles Fellows was ordered by the British government to take an expedition for the remainder of

1. N. Neal Solly, *Memoir of the Life of William James Müller* (London 1875), p. 30.
2. *Ibid*, p. 166.
3. *Ibid*, p. 24.
4. *Ibid*, p. 335 ff.
5. W. Müller, 'An Artist's Tour in Egypt', *Art-Union* (September 1839), p. 1313.
6. Solly, *op. cit.*, p. 67.
7. *Ibid*, p. 67.
8. *Ibid*, p. 71.
9. *Ibid*, p. 77.
10. *Ibid*, p. 77.
11. *Ibid*, p. 79.
12. *Ibid*, p. 79.
13. *Ibid*, p. 146.

the Xanthian marbles he had discovered in 1841-2. Fellows urged Müller to join him, though he already had a topographical draughtsman and Müller was obliged to pay his own expenses. Müller took his favourite pupil Harry Johnson along on this trip, departing in September, 1843, via Paris, Marseilles, Malta, Smyrna and Rhodes. Fellows discouraged Müller from making detailed delineations of the tombs and temples, a request with which the artist gladly complied, describing such careful outline studies as 'taking medicine'.[14] Despite inclement weather on 'an extensive plain, abounding with wild boar, leeches and fever',[15] Müller and Johnson lived in a tent while the rest of the party resided in houses, and the two artists fraternized with the Yurooks or Zingaris, wandering local tribes. Back in England with a 'browned face', Müller referred to the sketches he had made as 'spoils',[16] but saw a serious difference between them and the booty brought back by the accompanying archaeologists:

> I have truly taken away much, but not, like those armed with authority, torn from earth the monuments of the past, and made spots dear to us from historical associations a wilderness, that but records the evils they have done. Their sins be upon their own heads.[17]

Müller was invited to show all his Xanthian sketches at the Graphic Society's 'Thatched House' at the end of 1844. Some oils based on those works were well hung at the British Institution in 1845, but at the following Royal Academy exhibition he was so discouraged at how badly placed his paintings were that he talked of emigrating to St. Petersburg. His disappointment coincided with the onset of a serious circulatory illness that extinguished his hopes to revisit Egypt and ended in his early death.

14. *Ibid*, p. 184.
15. *Ibid*, p. 191.
16. *Ibid*, p. 219.
17. *Ibid*, p. 226.

51 Valley of the Tombs of the Queens

Watercolour, 26 x 41.5 cm

INITIALLED AND INSCRIBED: on the right in ink,
*Egypt/WM. 1839/Valley of/the tombs of/the
Queens.*

PROVENANCE: John Henderson, Esq., by whom
bequeathed.

LITERATURE: N. Neal Solly, *Memoir of the Life
of William James Müller* (London 1875), pp. 70,
226; Laurence Binyon, *Catalogue of Drawings
by British Artists of Foreign Origin working in
Great Britain in the Department of Prints and
Drawings in the British Museum*, vol. III
(London 1902), p. 121.

Trustees of the British Museum, London

On the back of this drawing Müller wrote a note in pencil dated 4 January, 1839. The part of the inscription which relates to this drawing reads as follows:

> Returning from the Tombs, or Valley of the Tombs of the Queens, I made a little *detour* for the purpose of gaining a view of the valley, as also of some of the ravines in the immediate neighbourhood...The moon rising with its chaste light formed a most agreeable contract of colour, and created a scene which I imagine I may never find again. The obscurity of the valley corresponds with its history and gloom — its occupants being the dead, once the mighty and the powerful, their names now forgotten, with their virtues and their crimes; and the foot of the stranger turns slowly and dissatisfied that he can form but the most imperfect idea of their extent, magnitude, and number. With such ideas I will seek my little cabin to reflect.[1]

Solly described this sketch as 'rough' but 'very impressive', adding:

> The effect represents the last rays of the setting sun throwing a crimson glow on the tops of a range of mountains, in the far distance the moon is just rising, and deep below a valley is already wrapped in the shadows and mystery of the coming night.[2]

One of the most impressive things about this watercolour is the adventurous way in which a visually sensitive and technically skilled artist has attempted to represent the emptiness or void of the desert landscape. Emboldened perhaps by the freedom of Turner (*q.v.*) but shunning that artist's sense of cosmic drama, Müller has made a highly original attempt to deal sensitively with a different sort of prospect than he was accustomed to depict, one for which pre-existing artistic signposts or schemata did not exist. In short, he was trying to produce a new type of landscape painting to deal with a new type of landscape, before the conventions of the 'Eastern picturesque' became firmly established.

1. Solly, *op. cit.*, p. 70.
2. *Ibid*, p. 266.

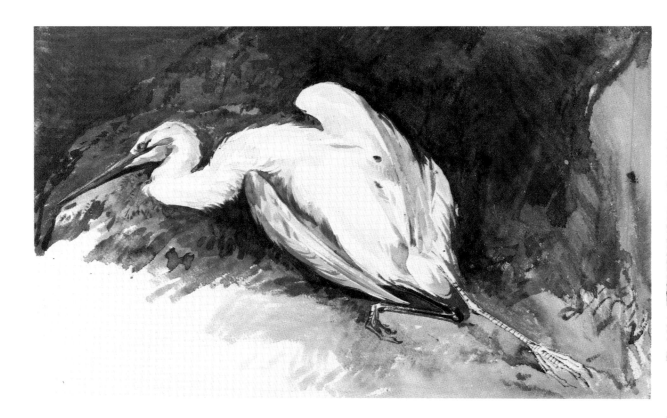

52 Great White Heron Shot at Xanthus

Watercolour, 30.8 x 48.8 cm.

PROVENANCE: John Henderson, Esq., by whom bequeathed.

LITERATURE: N. Neal Solly, *Memoir of the Life of William James Müller*, (London 1875), p. 260; Laurence Binyon, *Catalogue of Drawings by British Artists and Artists of Foreign Origin Working in Great Britain in the Department of Prints and Drawings in the British Museum*, vol. III (London 1902), p. 124.

When he was not sketching on his Eastern travels, Müller seems to have spent much of his time shooting, not only for pleasurable relaxation but also as a means of pursuing the natural history interests he inherited from his father. In his boat on the Nile in 1838 he found 'little to do but shoot from its windows at crocodiles, pelicans and other birds'.[1] He affectionately referred to his favourite rifle as 'Tom'.[2] Benjamin Johnson, father of Müller's pupil Harry, presented him with another weapon before the journey to Lycia,[3] and Harry Johnson has described Müller's efforts as artist-naturalist during their stay:

> every bird shot that seemed to him at all rare or interesting was sketched and not infrequently skinned and preserved.[4]

Müller paralleled shooting and art when he described his disappointment in not having a loaded weapon at hand to bag a particularly large vulture as being comparable to the regret he felt at seeing a beautiful view without his sketching equipment.[5]

In this study, Müller has disposed the great white heron[6] in an upward, halting diagonal, towards a corner of blue that suggests the sky from which it has fallen. The left leg, drawn in dry brush, drags backward, while the right is bent almost double, raising its claw in the opposite direction. The serpentine twist of the neck might have ended with the head pointed upwards but instead allows it to fall in another meander, a downward relaxed incline, which, combined with the left eye shut like the shell of a pistacchio nut, makes the fact of death inescapable. A droplet or dot under the left wing may indicate the fatal wound. This subject, whether dearer to Müller's heart as hunting trophy or zoological specimen, certainly brought out the best in his bravura handling, from wet washes to scratchy dry-brush delineation. In such a virtuoso sketch, Müller's accurate and controlled artistry was at it most impressive, a fact he suggested in a letter after his return from Lycia:

> One CAREFULLY drawn fragment with colour — be it of what it may — is worth all, I believe, many men do in their six weeks excursions.[7]

It is not hard to see this image of a fallen exotic bird, blasted from the sky by a tourist, as a symbol of the destruction wrought by the will-to-knowledge, will-to-power of the earnest Western traveller, measured in our own ambivalent responses to the extinction of such a stunning living creature in order to create an admittedly splendid and unquestionably more permanent reminder of its rare beauty.

1. Solly, *op. cit.*, p. 79.
2. *Ibid.*, p. 360.
3. *Ibid.*, p. 180.
4. *Ibid.*, p. 208.
5. *Ibid.*, p. 360.
6. I am grateful to Dr. John Rochford of the Trinity College, Dublin, Department of Zoology, for correctly identifying this bird, traditionally called a 'White Crane'.
7. Solly, *op. cit.*, p. 313.

Alberto Pasini

1826 Busseto (duchy of Parma) — 1889 Cavoretto

Like Schreyer (*q.v.*), but earlier and over a longer period, Pasini was a foreign artist who operated successfully in Paris, exhibiting over fifty works at the Salon during a stretch of more than forty years (1853-97). His Orientalism began with views of specific sites seen on his extensive travels, then became a skilful formula of men, horses and remembered Eastern buildings.

Pasini was orphaned young but managed to study lithography at the Academy of Fine Arts in Parma, illustrating an album on the architecture and history of the region. He left Italy for Paris in 1851, training there under Eugene Ciceri and Eugène Isabey. His Salon debut in 1853 consisted simply of a lithograph entitled *Evening*. Théodore Chassériau introduced Pasini to a diplomat who took him along as part of a French legation to Persia, and Pasini passed a year and a half in Teheran, returning to Paris via the Black Sea and Constantinople. Pasini's first Salon paintings, starting with six Eastern scenes in 1857, were generally of Persian sites, interrupted by four Cairo views in 1861 and Constantinople subjects from 1868. In 1859 he sent a view of the Seine back to show in Torino. He followed a Third Class Medal in 1859 with a Second Class Medal in 1863, another medal in 1864, the Legion of Honour in 1868, and a Medal of Honour as well as appointment as Officer of the Legion of Honour in 1878.

In 1868-9 Pasini returned to Constantinople and he visited Asia Minor, Syria and Lebanon in 1873. Within Europe he frequently travelled to Venice and Spain, on one occasion working in Granada with Gérôme (*q.v.*) for a month.[1] Like Fortuny (*q.v.*), Bouguereau (*q.v.*) and Gérôme, Pasini sold his pictures through Goupil; he also successfully marketed many back in Italy. He divided his time between Paris and a villa he purchased in Cavoretto, near Turin, until he moved back to Italy permanently towards the end of his life.

Pasini's work is sometimes confused with Fromentin's[2] because they shared crisp precision of drawing, particularly the difficult anatomy of the horse, and a deft, light touch with a brush. On the whole, even Pasini's 'remembered' pictures were more specifically set amidst accurate architecture, rather than the uncharted plains of Fromentin's hunt scenes. Pasini's standard of craftsmanship remained consistently high and he managed to vary his subject matter only slightly without ever really going stale.

1. J.L. Gérôme, letter introducing *Alberto Pasini* by Marco Calderini (Torino 1916), p. 7.
2. Philippe Jullian (in *The Orientalists* (Oxford 1977), p. 156) referred to Pasini as 'the Italian Fromentin', a phrase used a century earlier by Charles Blanc (see Marco Calderini, *Alberto Pasini* (Torino 1916), p. 20).

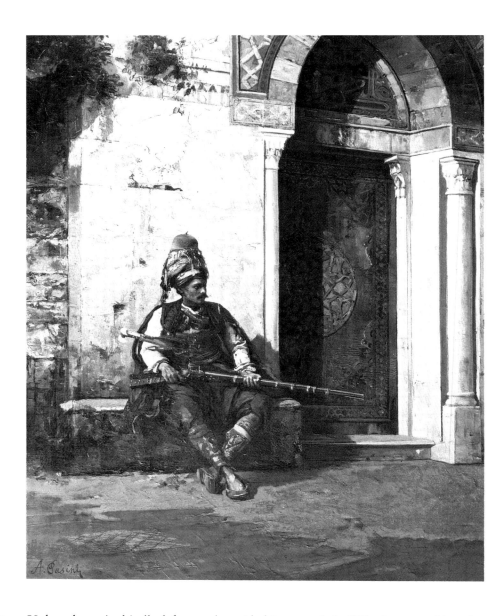

53 An Arab Soldier Seated by a Doorway

Oil on canvas, 41 x 31cm.

SIGNED: lower left *A. Pasini*.

PROVENANCE: Sir Alfred Chester Beatty, by whom presented to the Irish Nation, 1950 and transferred to the National Gallery of Ireland, 1978.

LITERATURE: *Catalogue of the Chester Beatty Collection* (Dublin 1950), no. 63, p. 27; *National Gallery of Ireland, Illustrated Summary Catalogue of Paintings* (Dublin 1981), no. 4269, p. 124; Michael Wynne, *Later Italian Paintings in the National Gallery of Ireland* (Dublin 1986), p. 89.

National Gallery of Ireland (cat. no. 4269)

Unless the artist kindly left one alongside his name, it is difficult to provide a date for many examples of Pasini's work. This seated soldier appears to be the earlier of the Dublin paintings, possibly dating from the late 1860s. Its subject-matter and composition have much in common with Gérôme (*q.v.*), alongside whom Pasini once worked in Granada, while the handling is more like Meissonier's, a similarly impressive mixture of freedom and control. Pasini here created his illusions with brush movement and paint surfaces. The sentinel wears the sort of flamboyant gear that was affected by the Janissaries in Constantinople. Most striking is his extraordinary headgear, a three-layered extravaganza that seems to include a base turban, another fringed turban, and finally a fez to top it all. Alongside this concoction even the extravagant bonnet of Delacroix's Jewess (Delacroix etching, no. 21) palls. The rest of the guard's equipment includes an imposing sword and two pistols shoved into his sash and a cocked musket with a studded stock, which he holds across his waist; his impressive embroidered leggings finish with somewhat insignificant slippers. What is most arresting, perhaps, about this little picture is how Pasini managed to include so much detail without resorting to the 'licked finish' of some Salon artists like Gérôme. Not only the solitary figure but the decorated door and the plastered wall have been described freely yet comprehensively, in terms of form, colour and texture.

124

54 An Eastern Scene

Oil on canvas, 22 x 16 cm.

SIGNED AND DATED: lower right, *A. Pasini 1888*.

PROVENANCE: Sir Alfred Chester Beatty, by whom presented to the Irish Nation, 1950 and transferred to the National Gallery of Ireland 1978.

LITERATURE: *Catalogue of the Chester Beatty Collection* (Dublin 1950) no. 65, p. 27; *National Gallery of Ireland, Illustrated Summary Catalogue of Paintings* (Dublin 1981), no. 4271, p. 124; Michael Wynne, *Later Italian Paintings in the National Gallery of Ireland* (Dublin 1986), p. 89.

National Gallery of Ireland (cat. no. 4271).

If one tried to isolate a single motif which seems to recur most frequently in Pasini's work, it would probably be the door or archway. For many artists (and for most tourists, in all periods, in all places) the essential experience of the East was one of *waiting*, and what Pasini's doorway scenes often appear to suggest is a kind of peaceful interlude between things happening. Here the opening does not lead far, only into a dark shop. Outside in the sun two handsome horses stand saddled and unmounted, while two men, perhaps their owners, converse alongside. In this fresh scene Pasini's fluid brush finds considerable freedom, and there is far less concern for detail than in the seated soldier (no. 53). The panels which block the upper window of the domed tower, for example, are quite possibly *mashribiyya*, the delicately interlaced woodwork shutters of the East, but they have been painted as solid. The painting probably represents an aspect of Constantinople, but it has the look of a scene improvised from cumulative memory rather than copied from original sketches.

Armand Point

1861, Algiers — 1932, Marlotte (Seine-et-Marne)[1]

Point's career illustrates an unusual shift (presaged in this show only by the mad Dadd, *q.v.*) away from an 'experienced' East to an 'imaginary' or at least mystical one. Born in Algeria, Point began his career by painting skilful Oriental genre scenes based on what he saw around him. He exhibited these works in the Salon from 1882; his *Ghisana (Fortune Teller) in Algiers* from the 1883 Salon was sold recently at Sotheby's in London.[2]

In 1888 Point went to France. By 1890-92 his style had altered considerably, and he was producing Post-Impressionist pastels of landscapes and figures. From 1892-96 he went a step further, exhibiting in the Rose + Cross Salon, and participating in the French-based Symbolist movement inspired by the extraordinary mystic, the Sar Peladan, whose published aim was to 'ruin realism' in order to create a school of ideal art. In their goals the artists of this persuasion were greatly influenced by the rediscovered Botticelli, Leonardo (an especial favourite of Point[3]), the writings of Ruskin, and the example of the Pre-Raphaelites.

In 1896, inspired by William Morris, Point formed a group called 'Haute-claire', an applied arts workshop in the forest of Fontainebleau. Point's exhibit for the Salon of Idealist Art of 1898, *The Princess and the Unicorn*, was typical of his medieval revival, which, though clearer and harder, derives partly from Gustave Moreau. A frequent model and ideal female type for Point was Hélène Linder, later Mme Philippe Berthelot.

By 1909 when he painted a watercolour of an Egyptian goddess (probably Isis),[4] Point's Orient had become completely stylized and mystical. Today it is hard to get excited about the cold aestheticism of his later work, but his 1880s Algerian scenes have an easy naturalism few visiting artists achieved.

1. Point's death is also dated in February 1932, with his place of death given as Naples.
2. 18 June 1985, no. 41, oil on canvas.
3. François Fosca remarked cynically in *Gazette des Beaux-Arts*, cinquième période, vol. IX, (1924), p. 329, that Point had aimed to become Leonardo's pupil and had only succeeded in becoming his 'ape'.
4. Sotheby's, London, 26 November 1981, lot 92.

Bibliography:
F. Camard, *Armand Point*, thesis, *Institut d'Art et d'Archéologie*, Paris I.
P. Fort, C. Mauclair, S. Merrill *et. al.* "Armand Point et son oeuvre", *La Plume*, special issue (Paris 1901).

55 An Arab Weaver, Algiers

Oil on canvas, 251.5 x 157.5 cm.

SIGNED, DATED AND INSCRIBED: lower left,
Armand Point/Alger 1886.

PROVENANCE: the family of Jonathan Holden,
Reims, by whom presented to the City of
Bradford, 1906.

EXHIBITED: 1886, Salon, no. 1905, p. 157.

Bradford Art Galleries and Museum

1. Exhibited as *Study of an Interior in
Algiers*, no. 1905, p. 157.

This impressive work was shown in the Salon of 1886,[1] two years before Point arrived in Paris. An old man weaves the edging on some thick red cloth; opposite and slightly further back a young woman winds wool onto a distaff, watched by a child who tends the tea (or coffee) and another young woman who splits a pomegranate. A negress completes the compositional triangle of figures as she carries an enormous bowl up the steps into a darkened interior. The black servant in motion had become a commonplace in Orientalist paintings ever since Delacroix's *Women of Algiers* of 1834, but Point has managed to make her movement seem natural and unstructured, like everything else in this dignified, tranquil scene. Unusual for an Orientalist work is this picture's nicely matter-of-fact quality, which perhaps derives from the artist's own familiarity and ease with the milieu. Despite his handsome range of skilfully-rendered colours and textures, Point has not disposed objects to highlight their exotic splendour but has scattered them naturally in his comfortable space. One of the slippers discarded by the old man or young woman is even cut off by the canvas. Perhaps influenced by photography, Point has portrayed the scene with a far better sense of light and colour, as well as a less self-conscious posing of principals, than the camera lens was yet able to capture.

Sir Edward John Poynter

1836, Paris — 1919, Kensington, London

Poynter had a rich career, occupied with many aspects of art, as a painter, Professor at the Slade School and South Kensington (which included running what became the Victoria and Albert Museum), Director of the National Gallery, and President of the Royal Academy. He was born in Paris and remained his whole life a Francophile in matters of art. He studied in Paris under Charles Gleyre (who also taught Monet and Renoir) and was later responsible for appointing Alphonse Legros and Jules Dalou to influential teaching posts in England.

Poynter was the only son of Ambrose Poynter, a distinguished architect who knew Vivant Denon (q.v.) and Bonington (q.v.) in Paris. Edward was a sickly child; while in Rome for his health in November, 1853, he met Lord Leighton, who was working on his *Procession in Honour of Cimabue's Madonna,* and who got him interested in figure drawing, Poynter's lifelong obsession and speciality. In 1854 Poynter became a student at the Royal Academy Schools. On a visit to France for the Universal Exhibition of 1855, he was much impressed by French art, particularly the Old Testament subjects of Decamps (q.v.). In the spring of 1856 Poynter was back in France to work in Gleyre's studio alongside Whistler, Georges Du Maurier and others in the group portrayed in Du Maurier's famous novel *Trilby.* Poynter stayed there for nearly four years, returning at intervals to London. His first English employment was for the architect William Burges, with whom he worked on Waltham Abbey and painting medieval panels for cabinets. He also did illustrations for magazines and the truncated Dalziels' *Bible Gallery,* for which seven of his twelve contributions were elaborate Egyptian subjects. In the summer of 1859 Poynter set up a studio in Paris and sent a picture to the Royal Academy which was rejected; but he had a work accepted in 1861 and never failed to exhibit for the next forty-eight years.

Poynter's first major success was his emotive 1865 painting of the steadfast Roman soldier in Pompey, *Faithful Unto Death* (Walker Art Gallery, Liverpool). In 1866 Poynter married Agnes Macdonald, whose sister was the wife of Edward Burne-Jones. For the 1867 Royal Academy show Poynter completed *Israel in Egypt,* on which he had been working for five years. It had a spectacular reception, never really surpassed in the artist's long and celebrated career. He followed it with a scene of Rome attacking Carthage, *The Catapult* (1868), which secured his election as an Associate of the Royal Academy. Among several decorative commissions he did was his 1869 mosaic of St. George for the Houses of Parliament. During the 1870s Poynter spent a considerable amount of his time on four major subject pictures, a portrait, and the ornamental decoration for the Earl of Wharncliffe's Billiard Room at Wortley Hall.[1] The pictures, destroyed in the war (except for the portrait) but documented in photographs, were *Perseus and Andromeda* (1872), *The Dragon of Wantley* (1873), *Atalanta's Race* (1876) and *Nausicaa and her Maidens* (1879). All were shown prior to their installation at the Royal Academy, where Poynter was elected an Academician in 1871.

Poynter was made Professor of the Slade School of Art on its foundation in 1871; there he introduced many of the principles of French art teaching he had learned, and, in seeing that his friend Legros was his successor, ensured that his work would not be undone. Poynter left the Slade for the even more influential post in charge of South Kensington, where he made Dalou, like Tissot (q.v.), over in English exile after the fall of the Commune, a professor of sculpture. Poynter's extensive activities as a teacher and administrator restricted his painting, and a major project to develop Alfred Stevens' sketch for the dome of St. Pauls was not carried out. In 1890 Poynter exhibited *The Queen of Sheba's Visit to King Solomon* (Art Gallery of New South Wales, Sydney), an overblown, costume-drama attempt to outdo *Israel* with its more than fifty figures and heads.

Poynter was appointed Director of the National Gallery in 1894, a job he performed for ten years. During that time he bought over five hundred pictures, including several Rembrandts, Titian's *Man with the Blue Sleeve,* works by Antonello, Pisanello, and Mantegna, and the Gallery's first examples of Dürer and Goya. In 1899

1. Alison Inglis, 'Sir Edward Poynter and The Earl of Wharncliffe's Billiard Room', *Apollo* (October 1987), pp. 249-55. All the paintings are illustrated in this article.

Bibliography:
Sidney Colvin, 'English Painters of the Present Day: Edward J. Poynter, A.R.A.', *Portfolio* I (1870), pp. 3-4.
Philip Hamerton, 'Edward J. Poynter, R.A.', *Portfolio* (1877), pp. 11-4.
W. Cosmo Monkhouse, 'The Life and Work of Sir E.J. Poynter', *Art Journal,* Special Number, Easter Art Annual (1897).

he edited the Gallery's first complete illustrated catalogue, and in 1897 was responsible for the arrangement and opening of the Tate Gallery.

On the death of Millais, Poynter was elected President of the Royal Academy in December 1896. His more than twenty years in the chair were rivalled only by Sir Joshua Reynolds and Benjamin West. Poynter was knighted in 1896 and created a baronet in 1902.

56 Israel in Egypt

Oil on canvas, 137.2 x 317.5 cm.

INITIALLED AND DATED: lower right, *18 EJP 67*.

PROVENANCE: Sir John Hawkshaw; J.C Hawkshaw; Sir George A. Touche, by whom bequeathed, 1921.

EXHIBITED: 1867, Royal Academy, London, no. 434; 1951-2, Royal Academy, London, no. 344; 1968-9, Royal Academy, Bicentenary Exhibition, London, no. 345; 1975, *Victorian Olympians*, Art Gallery of New South Wales, Sydney, no. 2; 1983, *The Inspiration of Egypt*, Brighton Museum and Manchester City Art Gallery, no. 343, p. 137; 1984, *The City's Pictures: A Collection of Paintings from the Corporation of London*, Barbican Art Gallery, London, no. 34, pp. 72-73.

LITERATURE: Eric Shane, *The Genius of the Royal Academy* (London 1981), pp. 29-30 (no. 21); Patrick Conner, "'Wedding Archaeology to Art": Poynter's *Israel in Egypt*', *Influences in Victorian Art and Architecture*, Society of Antiquaries (London 1985), pp. 112-20; Vivien Knight, *The Works of Art of the Corporation of London* (Cambridge 1986), p. 236.

Guildhall Art Gallery, Corporation of London

1. "'Wedding Archaeology to Art'": Poynter's *Israel in Egypt*', *Influences in Victorian Art and Architcture*, Society of Antiquaries (London 1985), pp. 113-4.

In the terrible afternoon heat of the Egyptian sun, dozens of half-naked Israelites are dragging a large red granite lion over a smooth roadway of massive paving blocks. Shaded under the white parasol held by his negro servant, an overseer has risen from his stool to extend his lash over the straining backs. Although parallel to the picture plane, the cart is slowly being shifted in a curving path that will follow a distant duplicate lion about to disappear through the partially opened gates of a shadowed doorway, flanked by four colossal seated figures. Ultimately one of the two lions will rest in a row of identical animals, third back on an empty base with unpainted hieroglyphs, that can be glimpsed in the unfinished courtyard beyond, the other presumably fitting somewhere in a matching invisible series opposite. Alongside the near lion a Jewish slave has collapsed in a Raphaelesque pose, and is being given water; at the rear of the procession an Egyptian princess proudly holds her small son up to ape the whipping action of the cruel overseer. Beyond the tortured transport of the statue is a parallel procession of high priests, bearing a holy boat with golden ram's heads at either end, burning incense, and waving large fans of peacock feathers. In the left distance other privileged figures take their ease around a cooling pool amidst several sacred ibises. Accompanying the central activity in the lower right are a kinetic trio of dancer-musicians: a scantily-clad negro clapping his hands, a woman clashing cymbals in a billowing white garment , and a solemn Pre-Raphaelite-type lady in blue holding an *'oud* at her side.

In his elegant, learned and suggestive essay, Patrick Conner[1] has identified the extraordinarily disparate assemblage of buildings from different sites and periods condensed into Poynter's single scene. Among the monuments are the Great Pyramid from Giza, the temple and other buildings from Philae, the Obelisk from Heliopolis and the Pylon Gateway from Edfu. The colossal seated figures on the right were loosely based on the black granite figures of Amenhotep III from Thebes, which, like the 18th dynasty lions from which Poynter derived his centrepiece, are in the British

Museum. Poynter's lodgings were opposite the Museum, and a sketch by the artist of the lion in the collection has appropriately ended up in the Prints and Drawings Department of the Museum.

Undoubtedly there are as many figure quotations as architectural ones in Poynter's crowd; in addition to the central Raphael, an injured slave in the right distance is posed like the newly created Adam in Michelangelo's Sistine Ceiling, while a statuesque woman with a waterjug on her head who looks out from in front of the unfortunate labourers vaguely recalls more modern works like Holman Hunt's *Afterglow in Egypt* (Southampton Art Gallery).

Conner also pointed out that the rows of lions, probably inspired by a similar double series in the Egyptian Court at the Crystal Palace at Sydenham in 1854,[2] do not function logically as tomb guardians, though the near one serves an effective purpose in Poynter's picture by engaging the viewer and focusing the composition while the parallel procession struggles along. According to Conner the eclectic assemblage of this painting includes a possible element of didacticism, but was mainly motivated by 'a desire to incorporate within firmly drawn boundaries all that was most striking and characteristic in an alien civilization'.[3] In a sense it is a successor to the French anthology of Egyptian monuments which opened the *Description de l'Egypte* (see Thompson essay, Fig. 14) over half a century earlier, an extended *musée imaginaire* that appropriated movable monuments and exerted colonial control over those that were too big to shift.[4] Conner also demonstrated that although Poynter's picture offended the sensibilities of some critics with its graphic portrayal of suffering, no connection was made with the picture's modern counterpart, the cruel conscription of *fellahin* to aid in the construction of the Suez Canal.

Yet despite (or perhaps because of) its architectural artifice and political naïveté, *Israel in Egypt* remains not only Poynter's grandest achievement but one of the most impressive and convincing historical dramas of the second half of the nineteenth century. As a minor epic, it closed rather than opened an era of painting, and it had to wait almost a hundred years, until special effects and colour photography were sufficiently advanced, to find its true successor in the Egyptian building scenes from the first half of Cecil B. De Mille's second version of 'The Ten Commandments' (1956).[5]

2. *Ibid*, p. 118 and plate XXCIII.
3. *Ibid*, p. 118.
4. Conner discreetly says 'it may not be entirely coincidental that British economic and political interest in Egypt was growing rapidly at the time.', *op. cit.*, p. 119.
5. De Mille even employed an incident of a fallen slave to demonstrate the superior humanity of the Pharaoh's adopted Jewish son Moses (Charlton Heston) over the cruel Egyptian Rameses (Yul Brynner).

Alexandre-Georges-Henri Regnault

1843, Paris — 1871, Buzenval

Henri Regnault's father was an orphan who became, successively, a mining engineer, a Professor of Chemistry and Physics, Director of the National Porcelain Factory at Sèvres (1854), and President both of the French Academy of Sciences and the French Society of Photography. Henri drew animals in the *Jardin des Plantes* as a child and determined to become a painter, after abandoning an initial interest in sculpture. His father took advice from Ingres and Hippolyte Flandrin and sent his son to study in 1861 with Louis Lamothe, who had taught Tissot (*q.v.*) and Degas. Regnault competed unsuccessfully for the *Prix de Rome* the following year, and again in 1865. He made his Salon debut in 1864 with two portraits, inspired partly by his *Ecole des Beaux-Arts* teacher Alexandre Cabanel. In 1866 Regnault won the *Prix de Rome* for his extraordinary homoerotic version of *Thetis Bringing to Achilles the Arms Forged by Vulcan* (Ecole des Beaux-Arts, Paris). Regnault set off for Rome in March, 1867, not for the last time glad to be forsaking France for a warmer climate.

In Rome Regnault's life-sized, full length portrait of Madame Fouques-Duparc (Château de Compiègne; 1868 Salon) attracted much favourable attention. There too Regnault first became acquainted with Fortuny (*q.v.*), whose flamboyant watercolour technique much impressed him. Regnault completed in Rome his major mythological composition, *Automedon Breaking the Horses of Achilles* (1868; Boston Museum of Fine Arts). Ironically a bad fall from a horse and attacks of fever prompted doctor's orders that he leave Rome. Instead of returning to Paris, Regnault went to Marseilles, then to Spain in search of his friend the painter George Clairin. There Regnault met General Prim, with whom Fortuny had first travelled to Morocco, and gained his permission to paint an equestrian portrait. Although the General himself refused to buy the result, it had a sensational reception at the Salon of 1869 when Regnault sent it back to Paris. In the spring of 1869 Regnault returned to Rome, anxious to work on an unfinished *Judith and Holofernes* he had left behind, but his attachment to Spain soon drew him back there to rejoin Clairin. For Regnault Spain was a part of the Orient: 'The country is superb; it is Africa, Egypt'.[1]

The two friends travelled over the mountains to Granada. There Regnault first encountered the Alhambra (see Brabazon, no. 7), the most astonishing sight of his life, and he professed a temporary conversion to the divinity of Mohammed for having 'inspired such a work as that'.[2] In December, 1869, Regnault made his first visit to Tangier, where he persuaded Clairin to join him and set up house in an Eastern style: 'There are no chairs in the establishment; all European ugliness is prohibited'.[3]

Having sought and obtained permission from Ernest Hébert, Director of the French Academy in Rome, to send his final *envoi*[4] from Tangier, Regnault bought land and built a studio there, where he intended to work at intervals for the rest of his life. His third *envoi* was a full-sized copy of Velazquez's *Surrender of Breda* (Ecole des Beaux-Arts, Paris) to which he added his startling *Summary Execution Under the Moorish Kings in Granada* (Musée d'Orsay, Paris). In the 1870 Salon he showed his contemporary interpretation of *Salome* (Metropolitan Museum, New York).

Although as a *Prix de Rome* pensioner Regnault was exempt from military service, he felt compelled to leave Tangier and fight together with Clairin in the Franco-Prussian War. A week before the capitulation of Paris, Regnault was shot in the left temple and killed instantly. His death was mourned by many contemporaries as the premature end to one of the most promising careers in French art, one in which academic respectability was wed to personal originality. An exception to the widespread panegyrics was provided by Edmond de Goncourt, whose admiration had preceded that of several others, but whose opinion of the retrospective exhibition was that Regnault was 'definitely a decorator rather than a painter'.[5] In light of the subsequent career of Regnault's friend Clairin and related artists like Benjamin Constant, Goncourt's harsh judgment was not totally unwarranted. Regnault's style of controlled spontaneity was fairly set and might not have progressed beyond his personal *juste milieu* synthesis, which would have continued to serve him profitably. Yet Regnault's talent was sufficiently varied that he may well have sprung an artistic surprise or two had he survived.

1. Arthur Duparc, *Correspondance de Henri Regnault* (Paris 1904), p. 297.
2. *Ibid*, p. 302.
3. *Ibid*, p. 338.
4. The *envoi* was a major painted effort sent back to Paris for inspection and assessment annually by each *Prix de Rome* student, Regnault sent *Automedon* his first year, then *Judith and Holofernes*, finally the Velazquez copy *and the Summary Execution* as his final submission.
5. Edmond and Jules de Goncourt. *Journal* (Paris 1956), vol. II (18 March 1872), p. 883.

Bibliography:
A. Angellier, *Etude sur Henri Regnault* (Paris 1879).
Henri Baillière, *Henri Regnault* (Paris 1872).
N.R.E. Bell, *Representative Painters of the XIXth century* (New York 1899), pp. 129-32.
Henri Cazalis, *Henri Regnault, sa vie et son oeuvre* (Paris 1872).
Arthur Duparc, *Correspondance de Henri Regnault* (Paris 1904).
Théophile Gautier, 'Notice: Henri Regnault', preface to posthumous exhibition at Ecole des Beaux-Arts, Paris, (January 1871).
Henri Regnault, *atelier* sale, Paris, Hotel Drouot, 3-4 April, 1872.
Claude Roger Marx, *Les Artistes célèbres, no. XXXIII; Henri Regnault* (Paris n.d.).

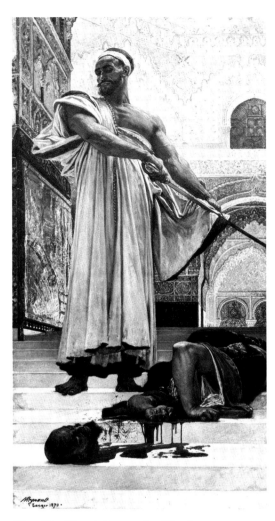

Fig. 39 Henri Regnault, *The Summary Execution Under the Moorish Kings at Granada,* oil on canvas (Louvre, Paris).

57 Study for 'The Summary Execution under the Moorish Kings at Granada'

Ink and brown wash on paper 34.8 x 22.8 cm.

INITIALLED: lower right, in brown wash, *HR*.

PROVENANCE: Mrs. Robert Low, by whom presented.

Trustees of the British Museum, London

1. Arthur Duparc, *Correspondance de Henri Regnault* (Paris 1904), p. 340.
2. *Ibid*, p. 355.
3. *Ibid*, p. 368, and for following quotes from the same letter. Regnault made several statements about the possibility of his early death.

On 17 January, 1870, Henri Regnault wrote to his father from Tangier:

> Finally! I am going to be able to do my last *envoi*, a picture of which I dreamt at Granada and whose execution will be easy here.[1]

It was to be his most ambitious and elevated effort, as he explained a few months later:

> My intention, in fact, is to concentrate in my last *envoi* all my efforts to do a history painting.[2]

Later he argued that since this work would represent him in the Luxembourg Museum, it must be a large and remarkable picture. His most important letter about the painting was written to his friend Cazalis on 22 May, 1870 from Granada. Regnault explained that in his new work the Alhambra or a similar style palace would play an important part. He also made a statement that becomes especially poignant in light of his early death:

> I would like, at least before I die, to have created a serious and important work, of which I am dreaming at this time, and where I would struggle with all the difficulties which excite me.[3]

132

Such a picture, Regnault elaborated, would be 'an enormous canvas where I want to express in paint the whole character of the Arab domination of Spain.' If he failed to find in history a specific event to embody what he wished to express, he planned to invent one which would send hapless critics to 'chapter 59,999 of an undisputed Arab history, destroyed in a fire during the sack of a city'. Among the principal Arab qualities he wished to express were two he underlined; their 'civilisation' and their 'cruelty'. Such a paradoxical juxtaposition is the central conceit of the picture (Fig. 39): the shrieking expressionist splatter of blood and the dark, anguished severed head set against the white marble steps; the strong and graceful, brutal and sensitive executioner wiping his besmirched *flittah* on the hem of his elegant *gandourah*, standing before the superabundant stalactite ceiling based on the Alhambra Hall of the Ambassadors. The simplified message is one of the richest civilisation and the keenest cruelty coexisting in titanic, frightful splendour. For Linda Nochlin, the painting encourages the spectator to identify with the victim, in portraying an 'irrational spectacle'[4] which epitomizes the arbitrary violence of the East as opposed to the rule of law and reason in the progressive West. Although it is certainly true, as Nochlin states, that Regnault never painted 'An Execution by Guillotine under Napoleon III', in spite of the fact that such public spectacles did still occur in Paris, it is also fair to say that Regnault sought to paint an historical drama,[5] whose ancestor would be works such as Delacroix's *Marino Faliero* (Wallace Collection, London), that brought together the most basic brutality and the most sophisticated refinement. In our own time, with brutal bombings and machine gun attacks in hightech airports and luxury department stores, the contrast continues. Regnault himself was not sure he had succeeded. As he wrote to his father:

> It's far from being a masterpiece, and it would be much better done had I not been deprived of white (paint) for such a long time. I will try to do better another time.[6]

Yet with Regnault's premature death *The Execution* became his major artistic testament. As an imagined effort to recreate from personal fantasies about the East a work of powerful impact, it is in some ways the *Sardanapalus* of the second half of the century, compromised perhaps with too much specific, observed accuracy, yet genuinely ambitious, excessive, grand.

This drawing is a study for the executioner, whose 'large pectorals' were admired by Gautier and 'unbelievable deltoids' ridiculed by Paul de Saint-Victor.[7] The simplified shape of the head suggests that Regnault may have made this drawing from a wooden lay figure. Could there also be an unconscious reminiscence of the protagonist from a famous classical sculpture group Regnault would have seen in Rome, the *Gaul Killing Himself and His Wife* (Terme Museum), which, seen from the appropriate angle, displays a similar expanse of muscular torso, diagonally lowered left arm, sword-bearing right hand, and head turned to the left in profile?

4. Linda Nochlin, 'The Imaginary Orient', *Art in America*, vol. 71 (May 1983), p. 130.
5. It is easy to imagine Regnault essaying a major work on the horrors of the siege of Paris, had he survived it.
6. Duparc, *op. cit.*, pp. 383-4. Regnault ran out of white paint in Tangier.
7. *Ibid*, pp. 338, 392.

David Roberts

1796, Stockbridge (near Edinburgh) — 1864, London

David Roberts was the most important and influential English Orientalist landscape painter. Like Dauzats (*q.v.*), his background beginnings in theatrical scenery gave him a bold and facile grasp of perspective and dramatic effect that proved invaluable when confronted with the colossal scale and barren setting of the East's great monuments.

Roberts' life provides a classic Victorian rags-to-riches story of hard work and persistence rewarded. Born the son of a humble Scottish shoemaker, he was apprenticed early to a housepainter and decorator named Beugo, with whom he stayed for seven years. He left to try scene-painting, finding his first job with Bannister's travelling circus for whom he created Baghdad and the scenery for Aladdin and the Forty Thieves[1], then with theatres in Glasgow, Edinburgh, and London. In London he worked first at Drury Lane, later at the rival Covent Garden, producing panoramas and dioramas, for, among other things, the first English production of Mozart's *Abduction from the Seraglio*. Roberts' initial visit to Europe was spent mainly in the coastal towns of Normandy, sketching Gothic churches. That same year he was made a member of the Society of British Artists. He regularly exhibited at their Suffolk Street Galleries and became their first President in 1831. In 1826 Roberts showed his initial effort at the Royal Academy, a picture of Rouen Cathedral. His premier Orientalist painting in 1829 was an imaginery extravaganza of *The Departure of the Israelites from Egypt* (Birmingham City Museum and Art Gallery), which was strongly influenced by John Martin and dealt with a form of historical narrative he did not often reattempt in his career.

At the end of 1832 Roberts went to Spain, and the following Spring visited Tangier and Tetuan. In 1837 he published his Spanish drawings as *Picturesque Sketches in Spain during the years 1832 and 1833*. The year before he had resigned his membership in the Society of British Artists in order to seek the higher honours of the Royal Academy, which he attained as an Associate in 1839 and a full Academician in 1841. Roberts' success with his Spanish works encouraged him to venture farther South and East; he had already worked, along with Turner (*q.v.*) on the 1836 *Landscape Illustrations of the Bible* (see Turner no. 65). In 1838 Roberts left for Alexandria, spending eleven months in Egypt, Sinai, Petra, Jaffa, Jerusalem, Nazareth, Lebanon, and Baalbek, fever preventing him from pushing on to Palmyra and Damascus. Roberts returned with 272 large sketches, a panorama of Cairo, and three full sketchbooks: with the help of lithographer Louis Haghe he turned some of these into the coloured illustrations of his two successful three-volume sets on the *Holy Land* (1842, 1843 and 1849) and *Egypt and Nubia* (1846, 1849 and 1849). Roberts saw his work as a rival to the great French *Description de l'Egypte*, declaring that the illustrations of the French commission were 'very incorrect' and that he had gone to the East to draw the scenes properly.[2] Roberts represented almost every significant archaeological site in Egypt and Palestine, some from several viewpoints. The social and religious undercurrents of the illustrations, analysed in some depth by Kenneth Bendiner [3], have been seen to include a sense of the destructive effect of Islamic domination and Christianity's lost inheritance, as well as a contrast between ancient grandeur and modern decadence, in a way breaking the Egyptian's link with his past while insisting on his direct connection with the Christian subjects of the Bible. Artistically Roberts' experience in the theatre stood him in good stead, allowing him an ease in creating dramatic architectural vistas which, like Piranesi's [4], went beyond the already titanic scale of ancient structures. In a sense his talent 'tamed' or reconstituted the East according to personal picturesque formulae that made its landscape accessible to many less-gifted artists. His travel diaries[5] are not notable for their eloquence but do demonstrate a crisp precision of observation and a store of no-nonsense energy that provide an appropriate accompaniment to his drawings.

Ruskin's reaction to the work of Roberts was in some ways paradigmatic. His initial viewing of the drawings of the Holy Land and Egypt came as a revelation:

> They were the first studies ever made conscientiously by an English painter, not to exhibit his own skill, or make capital out of his subjects, but to give free portraiture of scenes of historical and religious interest.[6]

1. James Ballantine, *The Life of David Roberts, R.A.* Edinburgh 1866), p. 7. It is not clear whether Ballantine or Roberts mixed up Aladdin and Ali Baba.
2. Kenneth Bendiner, 'David Roberts in the Near East: Social and Religious Themes', *Art History*, vol. 6, no. 1, (March 1983), p. 67 and p. 79, n. 2.
3. *Ibid*, pp. 67-81.
4. *Ibid*, p. 79, n. 18, where the sale of Roberts' library is cited to show that he owned virtually every one of Piranesi's published prints.
5. A generous sampling of Roberts' Eastern notes is included in James Ballantine's *David Roberts, R.A.*, (Edinburgh 1866).
6. John Ruskin, *Praeterita*, Collected Works (London 1908), vol. XXXV, p. 262.

Even more interesting was the fact that Ruskin felt that Roberts 'severely restricted method' was adaptable to his own aims as a draughtsman. And though his adoration of Turner caused Ruskin ultimately to damn Roberts [7] as 'a kind of grey mirror', he added with wistful romantic nostalgia:

> he gave the greatness and richness of things, and such height and space, and standing of wall and rock, as one saw to be true; and with unwearied industry, both in Egypt and Spain, brought home records of which the value is now forgotten in the perfect detail of photography...one imagined, serenely and joyfully, from the old drawings, the splendour of the aisles of Seville or the strength of the towers of Granada, and forgot oneself, for a time.[8]

Roberts attempted another great Oriental drama in 1849 *The Destruction of Jerusalem by the Romans* (lost; large sketch in Williamson Art Gallery and Museum), and then spent the 1850s painting Italy, and, finally, London.

The Redgraves have argued that Roberts was not really a landscape painter in the strictest sense, describing his work as 'essentially scenic', almost always consisting of buildings, towns or ruined cities. Noting the uniform atmosphere in his depiction of different sites, from the Nile to the Thames, they compared him with Canaletto: 'less precise than the Venetian, less minute in his detail, but also less conventional'.[9]

7. Ruskin, *op. cit.* p. 625, called Roberts 'an oil painter in grey and yellow', while Sir Walter Armstrong in the *Dictionary of National Biography* (London 1909), vol. XVI, p. 1262) cited Roberts' 'defects as a colourist', and Bendiner referred to Roberts as a dull colourist' (*op. cit.*, p. 78). In light of the recent Barbican show, this consistent condemnation is surprising. Roberts did pay little or no attention to atmosphere, and in some of his large late Italian pictures the more ambitious colouring got slightly unbalanced, but in most of his other work, his colour was, as Ingres might have said, apposite and appropriate to his excellent drawing.
8. Ruskin, *op. cit.*, p. 404.
9. Richard and Samuel Redgrave, *A Century of British Painters* (London 1947), p. 407.

Bibliography:
James Ballantine, *Life of David Roberts, R.A.* (Edinburgh 1866).
Helen Guiterman and Briony Llewellyn, *David Roberts*, London, Barbican Art Gallery 1986-7.

58 Wady Dabod

Pencil and watercolour on paper,
20.8 x 34.3 cm.

INSCRIBED: lower left, in pencil, *Temple at
Wady-Dabod / Nubia.*

SIGNED: lower right, in pencil, *David Roberts
R.A.*, (lower right, in ink, accession number
D.418.99).

PROVENANCE: purchased, 1899.

LITERATURE: David Roberts, Louis Haghe, and
William Brockedon, *Egypt and Nubia*, vol. II
(London 1849), illus. 31; *British Watercolours
in the Victoria and Albert Museum* (London
1980), p. 319.

Victoria and Albert Museum, London

This drawing became one of the illustrations in Roberts' monumental three volumes on Egypt and Nubia. The accompanying description was written by William Brockedon, F.R.S., but partly based on Roberts' own journals and *Egypt* by Wilkinson, reads as follows:

> On ascending the Nile above Philae the ruins of the Temple of Wady Dabod are the first that present themselves to the traveller. This, like most of the Nubian temples, was never completed. The two outer columns are left rough as they were hewn, and offer evidence of the practice of the Egyptian sculptors to cut the hieroglyphics after the columns were erected.
>
> The Temple of Dabod appears to have been built by an Ethiopian Monarch who succeeded Ergam the contemporary of Ptolemy Philadelphus. It was dedicated to Isis. Augustus and Tiberius added, though they left unfinished, most of its sculptured enrichments. The principal building is a portico having four columns in front, with screens that intervene at the entrance between the centre columns; this led to a central and two lateral chambers, and by a flight of steps to two others above them: there was another chamber immediately over the adytum. A wing was added, at a later period, on the side of the portico. In the adytum, which is plain and unsculptured, Wilkinson states that there are monoliths bearing the names of Physcon and Cleopatra, but Roberts says one has been removed, and describes that which remains as a shrine of red granite, simple and beautiful in design, flanked by two columns with lotus-headed capitals of an early period, and having an entablature with a winged Hebe, and sculpture of Nilus tying the sacred ligatures.
>
> The approach to the Temple of Wady Dabod from the river was by steps to a stone quay, and thence through three pylons at short distances from each other, as represented in the background to the Group (in this work) of the Abyssinian Slaves at Korti. The first pylon is the entrance to the wall of circuit, which encloses the other pylons and the Temple.

Thus was an artist's interpretation given the descriptive gloss of scholarly 'truth'.
This handsome drawing does not reflect the extremes of epic grandeur that are common in Roberts' work, yet it does show the graceful ease with which he approached Egyptian architecture, and, despite its relatively small size, successfully manages to suggest scale. The obvious but effective structuring device is to send the viewer's eye straight as an arrow over the colossal flagstones, through the open courtyard of the symmetrically receding temple, to the doorway beyond, dramatically highlighted in white for maximum contrast with the cast shadow that surrounds it. Having followed that chosen path, the eye can then wander, on less sure footing, with the staggered Orientals: although frequently a poor figure draughtsman, here Roberts showed some of the fluid facility of a Guardi.

59 Portico of the Great Temple at Baalbek

Oil on canvas, 182.2 x 132.1 cm.

SIGNED AND DATED: lower right on fallen architrave, *David Roberts. RA/1840.*

PROVENANCE: Elhanan Bicknell, for whom painted, 1840; E.V. Coleman; Ralph Brocklebank; the sons of Ralph Brocklebank, by whom presented, in memory of their father, 1893.

EXHIBITED: 1840, Royal Academy no. 944; 1855, Exposition Universelle, Paris, no. 951; 1887, Jubilee Exhibition, Manchester; 1901, International Exhibition, Glasgow; 1920, British Art, Whitechapel; 1967, *David Roberts and Clarkson Stanfield: An Exhibition of Paintings, Drawings and Relics*, Guildhall Art Gallery, London, no. 18, p. 13; 1986-87, *David Roberts*, Barbican Art Gallery, no. 177, pp. 74 (illus.).

LITERATURE: David Roberts, Louis Haghe, and George Croly, *The Holy Land, vol. II* (London 1843), illus. 78. *Walker Art Gallery, Illustrated Catalogue of the Permanent Collection* (Liverpool 1927), p. 157; Helen Guiterman and Briony Llewellyn, *David Roberts* (London 1987).

Courtesy of the Trustees of the National Museums and Galleries on Merseyside (Walker Art Galleries)

The ancient city of Baalbek is today located in Lebanon, 56 kilometres (35 miles) northwest of Damascus. Its name comes from the Phoenician sun god Baal or Bel to whom it was once probably devoted. No traces of that Phoenician settlement survive, however, and the ruins date from Greek and Roman times, when it was renamed Heliopolis. The city was later sacked by invaders and wrecked by an earthquake in 1759.

Roberts visited Baalbek from 2-8 May 1839, and the site made a strong impression upon him. He wrote in his journal on 4 May:

> It would be difficult to convey even in drawing any idea of this magnificent ruin, its beauty of form, the exquisite richness of its decoration or the vast magnitude of its dimensions.[1]

Roberts was to paint at least seventeen oils of the city, some of which set its architecture in sweeping horizontal plains. None are, perhaps, more striking than this vertical view, which he considered one of his finest works and which he showed at the Royal Academy the year after his return. The colossal scale of the Corinthian colonnade is emphasized by the small Arabs alongside. Seen from below, the columns diagonally diminish against a light blue sky, while sunlight from the right casts raking shadows which counterbalance the receding perspective of the ruins.

Beneath such ascendent sunlit splendour, Arabs in the foreground take refreshment in the cool vegetation around a dark pond. Roberts' image thus conjoins contemporary Arabs and antique grandeur, though the artist's subliminal message seems less anxious to connect than to contrast and distance the modern nomads from the monumental builders of a bygone classical golden age.

1. Roberts, *Eastern Journal*, MS in Edinburgh, National Library of Scotland, quoted in Guiterman and Llewellyn, *op. cit.*, p. 120.

Adolf Christian Schreyer
1828, Frankfurt-am-Main – 1899, Kronberg-im-Taunus

Schreyer had a traditional art education, first for two years at the Städelsches Kunstinstitut in his native Frankfurt, then at art academies in Düsseldorf and Munich. In 1849 he settled in Vienna, then travelled with the Austrian Prince von Thurn und Taxis through Turkey, Wallachia, and Southern Russia. From 1855-7 he was with the Prince's regiment, which only went to the Eastern reaches of the Danube, as an artist-reporter covering the Crimean War.

Schreyer's early reputation was made with battle scenes and landscapes featuring the horsemen of Eastern Europe. In 1859 he visited Syria and Egypt and in 1861 Algiers. His fascination with the Bedouin – reportedly he mastered several Arab dialects – inspired him to make the mounted Arab a central theme of his painting, though he continued to produce Wallachian, Moldavian and Russian pictures as well.

Schreyer had visited Paris briefly before going to Algeria, and possibly sensed the large market there for Orientalist painting. He worked in Paris throughout the 1860s, winning Salon medals in 1864, 1865, and 1867, until forced to leave by the Franco-Prussian War. Schreyer had held the honorary title of Court Painter to the Grand-Duke of Mecklenburg since 1862, and was a member of Academies in Antwerp and Rotterdam. His work sold well both to rich American collectors and the German aristocracy.

As an artist-adventurer Schreyer somewhat recalls Horace Vernet, his painting has little to do with the 'licked' finish of the famous Frenchman. Instead Schreyer's dynamic, colourful pictures were part of a second-generation Romanticism which derived from Delacroix (q.v.) and included Fromentin (q.v.), with whom Schreyer's work is sometimes confused. Schreyer's Algeria is very much a 'remembered' East. Though he had been studying different types of horses all his life, and prided himself on the accuracy of his Eastern riding accessories, his looseness or handling kept surroundings vague and figures imprecise, a lack of focus that is often appropriate to their dynamic motion. In discussing Schreyer's submission to the 1866 Salon, Théophile Gautier articulated the problems of an action painter:

there is fine movement, prodigious skill, great knowledge of horses, and a lively feeling for military painting, but in such a harrying of men and horses, where to look, on what point, on that which occurs with explosive rapidity, which vanishes as in a dream. If it is fixed it is petrified... everything solidifies, the movement is stopped, and like the painting stays immobile death, one cannot be content with the tumult and fury of a simple sketch. M. Schreyer has not completely conquered the difficulty, but he has gotten past it.

A contemporary British critic, Joseph Beavington Atkinson, argued that Schreyer's work contained an impressive amount of accurate information. The pictures of this, perhaps the most adventurous painter among the Germans, may be said to extend our knowledge of geography. Schreyer, indeed, may be almost said to have played the part of 'Our Special Correspondent'; he has brought from Turkey, Hungary, Bosnia, and Serbia, from Syria, Egypt, and Algiers, ethnographic types, personal incidents, picturesque costumes, and traits in physical geography, which add materially to our knowledge of the earth and its inhabitants.[2]

Yet at the same time as he saw Schreyer's scenes as offering detailed information, the writer argued that his works also possessed a kind of authenticity or integrity which contrasted with the artificial conventions of academic tradition, a return to 'nature' which broke through the imposed rigidity of past art:

And possibly just in proportion as civilisation becomes more artificial, does the artist find it to his profit to revert to states of barbarism. We may have reached the point where the mind rebels against the academic, the symmetric, the architectonic, and so forth, and is glad, as in the free-and-easy compositions

Rowlandson is a somewhat eccentric addition to this exhibition, since his work belongs essentially to the eighteenth century, and he hardly qualifies as an Orientalist. Yet Eastern imagery does figure in his vast output, and his Dublin drawing of two Oriental types nicely bridges the gap between the imagined East of the eighteenth century and the observed East that came to dominate the nineteenth.

It is said that Rowlandson could draw before he could write, a credible claim, since his skills as a visual storyteller often make explanatory words redundant. After attending Dr. Barrow's school in Soho Square with Edmund Burke's son Richard, he went to the Royal Academy in 1772 as a student, accompanied by his friend Jack Bannister, who was to become a well-known actor. The high-spirited duo tormented, among others, the Academy Librarian Richard Wilson. Rowlandson left at sixteen to stay with his aunt in Paris, where he learned French and improved his figure drawing. After two years abroad he returned to the Royal Academy School and rivalled John Mortimer in facility at life-studies. In 1775 Rowlandson began to show regularly at the Academy, with a drawing of a Biblical subject, *Delilah payeth Samson a Visit while in Prison in Gaza*, a lost work said to have been executed in a 'grandiose historic' manner. Ensuing exhibited pictures included portraits and landscapes. His restless nature later inspired a return visit to Paris, as well as trips to Cologne, the Hague, Dusseldorf, Amsterdam and Antwerp, his movements documented by the drawings he did as he went along.

Around 1781 Rowlandson's art began to be more caricatural, and the sixty-seven drawings he made on a trip with Henry Wigstead, a Bow Street Magistrate, were published as *A Tour in a Post-Chaise* (1784). One of Rowlandson's three drawings in the 1784 Academy Exhibition, *Vauxhall Gardens* (Victoria and Albert Museum), established the new combination of humour and topography for which he became famous. The liveliness of Rowlandson's work reflected a comparable vigour in his life, with his companions in art, George Morland and James Gilray, he pursued a merry and dissolute existence, drinking and gambling compulsively. The relatively large legacy of £7,000 left him by his aunt was soon squandered, and he had to pick up his reed pen and paint-box to regain solvency.

Rowlandson became a productive illustrator and satirist. A collaboration with William Combe which began while Combe was in prison, *The Tour of Dr. Syntax in Search of the Picturesque* (1812), proved so popular that it was followed by second and third tours, where Dr. Syntax sought first *Consolation* (1820), then *A Wife* (1821). *The English Dance of Death* (1815-6) and *The Dance of Life* (1816) were among other works done in conjunction with Combe. Rowlandson provided figures for Augustus Pugin's topographical plates in the *Micocosm of London* (1808-11), and also illustrated several of the finest authors of his day, including Goldsmith, Fielding, Smollett, and Sterne. Caricature in Rowlandson's oeuvre was one of the most popular forms of pictorial art, which contained an impressive amount of social information and skills which rivalled the finest Academy painters. Perhaps for that reason he remains the one caricaturist commonly yanked away from his fellows for consideration in surveys of fine art. Though far more graceful than the work of Hogarth, the rhythmic curves and rapid, virtuoso execution of Rowlandson's drawing clearly evolved out of the Rococo, while the expressive distortion he and his fellow satirists pursued provided a crucial liberating influence for the Romantics to come.[2]

1. Though the year of Rowlandson's birth is often given as 1757, on 6 November, 1772, when he was accepted for the Royal Academy Schools, he declared his age as '15 on 14th July last'.
2. E.H. Gombrich made this point in 'Imagery and Art in the Romantic Period' in *Meditations on a Hobby Horse* (London 1962), pp. 120-26, and has amplified it in other articles.

Bibliography:
Joseph Grego, *Rowlandson the Caricaturist*, 2 vols. (London 1880).
Ronald Paulson, *Rowlandson: A New Interpretation* (New York 1972).

1. Théophile Gautier, 'Salon of 1866',
2. J. Beavington Atkinson, *The Schools of Modern Art in Germany* (London 1880), pp. 118-9.

59 Portico of the Great Temple at Baalbek

Oil on canvas, 182.2 x 132.1 cm.

SIGNED AND DATED: lower right on fallen architrave, *David Roberts. RA/1840.*

PROVENANCE: Elhanan Bicknell, for whom painted, 1840; E.V. Coleman; Ralph Brocklebank; the sons of Ralph Brocklebank, by whom presented, in memory of their father, 1893.

EXHIBITED: 1840, Royal Academy no. 944; 1855, Exposition Universelle, Paris, no. 951; 1887, Jubilee Exhibition, Manchester; 1901, International Exhibition, Glasgow; 1920, British Art, Whitechapel; 1967, *David Roberts and Clarkson Stanfield: An Exhibition of Paintings, Drawings and Relics*, Guildhall Art Gallery, London, no. 18, p. 13; 1986-87, *David Roberts*, Barbican Art Gallery, no. 177, pp. 74 (illus.).

LITERATURE: David Roberts, Louis Haghe, and George Croly, *The Holy Land, vol. II* (London 1843), illus. 78. *Walker Art Gallery, Illustrated Catalogue of the Permanent Collection* (Liverpool 1927), p. 157; Helen Guiterman and Briony Llewellyn, *David Roberts* (London 1987).

60 An Arab seen from the Back and a Turk seen from the Front

Ink and wash on paper, 11.4 x 6.9 cm.

SIGNED: lower left, *Rowlandson.*

The Chester Beatty Library, Dublin

1. Lord Byron was one who much preferred Beckford's dark Caliph to Johnson's kind ruler: 'For correctness of costume, beauty of description, and power of imagination, *Vathek* far surpasses all European imitations. As an eastern tale, even Rasselas must bow before it: his happy valley will not bear a comparison with the Hall of Eblis' (Quoted in the 1836 Fifth Edition of *Vathek*).
2. Mary Dorothy George, *Catalogue of Political and Personal Satires*, vol. VII, 1793-1800 (British Museum 1942), no. 9253, pp. 482-83. I am grateful to Stephen Campbell for both these references.

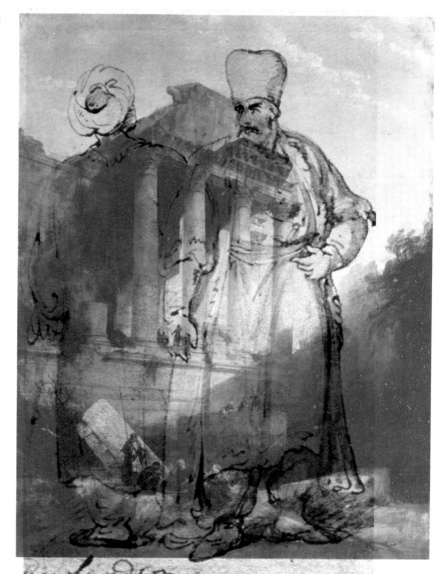

The ancient city of Baalbek is today located in Lebanon, 56 kilometres (35 miles) northwest of Damascus. Its name comes from the Phoenician sun god Baal or Bel to whom it was once probably devoted. No traces of that Phoenician settlement survive, however, and the ruins date from Greek and Roman times, when it was renamed Heliopolis. The city was later sacked by invaders and wrecked by an earthquake in 1759.

Roberts visited Baalbek from 2-8 May 1839, and the site made a strong impression upon him. He wrote in his journal on 4 May:

> It would be difficult ... to convey ... the imposing as well as ... picturesque effect of these beautiful forms. The dull ... richness of its decorated Easter, was ... magnificent ... of its dimensions ...[1]

Roberts was to paint at least seventeen oils of the city, some of which set its architecture in sweeping horizontal plains. None are, perhaps, more striking than this vertical view, which he considered one of his finest works and which he showed at the Royal Academy the year after his return. The colossal scale of the Corinthian colonnade is emphasized by the small Arabs alongside. Seen from below, the columns diagonally diminish against a light blue sky, while sunlight from the right casts raking shadows which counterbalance the receding perspective of the ruins. Beneath such ascendant sunlit splendour, Arabs in the foreground take refreshment in the cool vegetation around a dark pond. Roberts' image thus conjoins contemporary Arabs and antique grandeur, though the artist's subliminal message seems less anxious to connect than to contrast and distance the modern nomads from the monumental builders of a bygone classical golden age.

Although the ethnic identification is conjectural, Rowlandson has clearly established some kind of contrast or opposition. The two figures are a bit like two halves of a playing-card, or rivals in a cartoon or comic film about to back into each other unexpectedly. The sideways scowl of the Turk, along with the tentative touch his left hand gives his sash just below his dagger, suggests he is on his guard, if not ill-at-ease. The flat-footed stance and upward gaze of the Arab implies a calmer state, but it would be dangerous to try and read too much from his back. If Johnson's noble *Rasselas* (1759) and Beckford's sensual *Vathek* (1787, see Westall, nos. 67a,b,c) can be said to offer the polarities of the English eighteenth-century's imagined Easterners,[1] Rowlandson's illustrated Orientals, most often Turks, operate less on the principled plane of the former than the lusty level of the latter. Turks indulging in an embarrassment of unclothed pulchritude appear in his erotic prints more than once (see fig. 21, Thompson essay). Napoleon's Egyptian campaign, where Vivant Denon (q.v.) really started nineteenth-century Orientalism rolling, allowed the massive sinister Turk an artistic role in tormenting the diminutive Frenchman; a print by Rowlandson dated 9 October, 1798, entitled *Fraternization in Grand Cairo: The Mad General and his Bonny-Party likely to become Tame Musselmen*[2] shows Napoleon and his soldiers being tortured or led off for castration by sadistic, subhuman Turks. In 1815, a possible approximate date for this drawing, Rowlandson illustrated a book set well to the East of Turkey, *The Grand Master, or Adventures of Qui Hi in Hindoostan*. A Rowlandson drawing of *A Turk and a Tartar* was sold at Christie's in 1983 (15 November, lot 130).

Adolf Christian Schreyer

1828, Frankfurt-am-Main — 1899, Kronberg-im-Taunus

Schreyer had a traditional art education, first for two years at the Städelsches Kunstinstitut in his native Frankfurt, then at art academies in Dusseldorf and Munich. In 1849 he settled in Vienna, then travelled with the Austrian Prince von Thurn und Taxis through Turkey, Wallachia, and Southern Russia. From 1855-7 he was with the Prince's regiment, which only went to the Eastern reaches of the Danube, as an artist-reporter covering the Crimean War.

Schreyer's early reputation was made with battle scenes and landscapes featuring the horsemen of Eastern Europe. In 1859 he visited Syria and Egypt and in 1861 Algiers. His fascination with the Bedouin — reportedly he mastered several Arab dialects — inspired him to make the mounted Arab a central theme of his painting, though he continued to produce Wallachian, Moldavian and Russian pictures as well.

Schreyer had visited Paris briefly before going to Algeria, and possibly sensed the large market there for Orientalist painting. He worked in Paris throughout the 1860s, winning Salon medals in 1864, 1865, and 1867, until forced to leave by the Franco-Prussian War. Schreyer had held the honorary title of Court Painter to the Grand-Duke of Mecklenburg since 1862, and was a member of Academies in Antwerp and Rotterdam. His work sold well both to rich American collectors and the German aristocracy.

If as an artist-adventurer Schreyer somewhat recalls Horace Vernet, his painting has little to do with the 'licked' finish of the famous Frenchman. Instead Schreyer's dynamic, colourful pictures were part of a second-generation Romanticism which derived from Delacroix (q.v.) and included Fromentin (q.v.), with whom Schreyer's work is sometimes confused. Schreyer's Algeria is very much a 'remembered' East. Though he had been studying different types of horses all his life, and prided himself on the accuracy of his Eastern riding accessories, his looseness of handling kept surroundings vague and figures imprecise, a lack of focus that is often appropriate to their dynamic motion. In discussing Schreyer's submission to the 1866 Salon, Théophile Gautier articulated the problems of an action painter:

> ...there is fire here, movement, prodigious skill, great knowledge of horses, and a lively feeling for military painting; but is such a hurricane of men and horses proper to the domain of art? Can one paint that which occurs with explosive rapidity, which vanishes as in a dream? If it is fixed, made precise or detailed, the action solidifies, the movement is lost, and, like the picture, stays immobile; yet one cannot be content with the tumult and fury of a simple sketch. M. Schreyer has not completely conquered the difficulty, but he has gotten round it.[1]

A contemporary British writer on art, Joseph Beavington Atkinson, argued that Schreyer's work contained an impressive amount of accurate information:

> The pictures of this, perhaps the most adventurous painter among the Germans, may be said to extend our knowledge of geography...Schreyer, indeed, may be almost said to have played the part of 'Our Special Correspondent'; he has brought from Turkey, Hungary, Bosnia, and Serbia, from Syria, Egypt, and Algiers, ethnographic types, personal incidents, picturesque costumes, and traits in physical geography, which add materially to our knowledge of the earth and its inhabitants.[2]

Yet at the same time as he saw Schreyer's scenes as offering detailed information, the writer argued that his works also possessed a kind of authenticity or integrity which contrasted with the artificial conventions of academic tradition, a return to 'nature' which broke through the imposed rigidity of past art:

> And possibly just in proportion as civilisation becomes more artifical, does the artist find it to his profit to revert to states of barbarism. We may have reached the point where the mind rebels against the academic, the symmetric, the architectonic, and so forth, and is glad, as in the free-and-easy compositions

1. Théophile Gautier, 'Salon of 1866', VI.
2. J. Beavington Atkinson, *The Schools of Modern Art in Germany* (London 1880), pp. 118-9.

3. *Ibid*, p. 119.

Bibliography:
'Adolphe Schreyer', extrait des *Annales Historiques et Biographiques*, ed. M. L. Tisseron (Paris 1884-86), pp. 1-8.
Richard Graul, 'Adolf Schreyer', *Die graphischen Künste*, vol. 12, pp. 89-96, 121-128.
Prince Bojidar Karageorgevitch, 'Adolphe Schreyer', *Magazine of Art*, vol. 18 (1895), pp. 133-37.
Fritz Knapp, 'Adolf Schreyer', *Die Künste für alle*, vol. 19 (1904), pp. 139-43.
David Oldfield, *German Paintings in the National Gallery of Ireland* (Dublin 1987), pp. 64-66.
Lynne Thornton, *The Orientalists, Painter-Travellers* (Paris 1983), pp. 60-1.

of Schreyer, to break loose into accident, unforseen incident, or catastrophe.[3]

Such passionate advocacy is touching, yet Schreyer's work hardly seems anthropological, topographical or subversive. Rather he transformed Romantic colourism and spontaneity, and the Romantic nostalgia for the *Noble Arab* into a mannered personal style and a successful commercial proposition.

61 Eastern Soldiers With a Horse Drinking

Oil on canvas, 24.1 x 45.9 cm.

SIGNED: lower left, *Ad. Schreyer*.

PROVENANCE: Cecil King (1881-1942), marine and landscape painter, who bought it in Paris; Sir Alfred Chester Beatty, by whom presented to the Irish Nation, 1950 and transferred to the National Gallery of Ireland, 1978.

LITERATURE: *Catalogue of the Chester Beatty Collection* (Dublin 1950), no. 70, p. 27; *National Gallery of Ireland, Illustrated Summary Catalogue of Paintings* (Dublin 1981), no. 4276, p. 148; David Oldfield, *German Paintings in the National Gallery of Ireland* (Dublin 1987), pp. 64-66.

National Gallery of Ireland (cat. no. 4276)

This scene is a more precise conception than no. 62, perhaps relating to a sketch the artist made of a specific Algerian site, and could well be the earlier of the two works. The wide rectangular shape of the picture stresses the scene's expansive background, the horizon line broken only by the heads of two receding riders, the back and saddle of the drinking horse, and the somewhat tumbledown structure which houses the watering-trough. The owner of the tethered central horse has yielded to this dominant horizontality and reclines comfortably on the ground, idly tracing patterns in the dust with his crop. Scenes of horses being watered, an act which for the desert Arab represented not simply a matter of refreshment but of basic survival in his harsh environment, were a mainstay of Orientalist painting, and Schreyer followed artists from Fromentin (*q.v.*) to Gérôme (*q.v.*) in adopting such a subject.

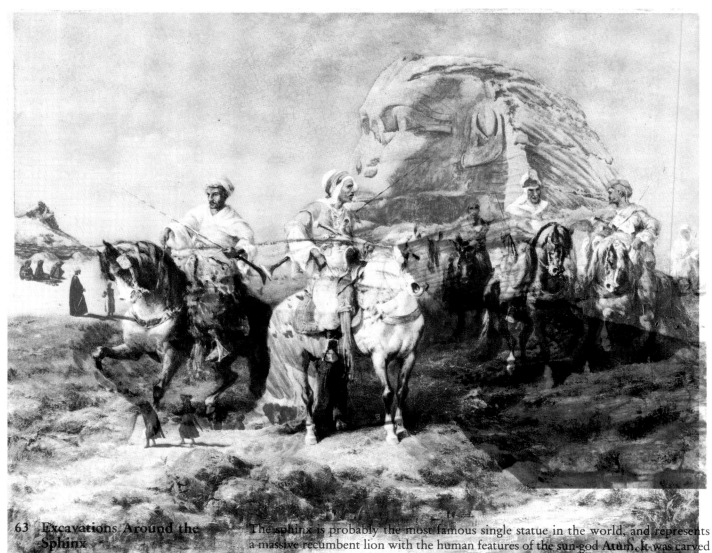

63 Excavations Around the Sphinx

Watercolour and bodycolour on paper, 25.1 x 35.3 cm.

MONOGRAMMED AND DATED: lower left, *TS*

62 ^1854^ **Arab Horsemen**

Oil on canvas, 56.6 x 68.4 cm.

SIGNED: lower right, *Ad. Schreyer.*

PROVENANCE: G.P. Boyce; Miss H.A. Virtue-Tebbs, by whom presented.

EXHIBITED: 1855 Seddon's rooms, London; 1855, Liverpool Academy, no. 456; 1856, Seddon's rooms, London 1984, *The Pre-Raphaelites*, Tate Gallery, London, no. 205.

PROVENANCE: Sir Alfred Chester Beatty, by whom presented to the Irish Nation, 1950 and transferred to the National Gallery of Ireland, 1978.

LITERATURE: Allen Stalley, *The Pre-Raphaelite Landscape* (London 1973), pp. 92b; *Catalogue of the Chester Beatty Collection* (Dublin 1950) no. 69, p. 27; Michelle Verrier, *The Orientalists* (London 1979), pl.; *National Gallery of Ireland, Illustrated Summary Catalogue of Paintings* (Dublin 1981), no. 4275, p. 148; David Oldfield, *German Paintings in the National Gallery of Ireland*, (Dublin 1987), p. 64.

Visitors of the Ashmolean Museum, Oxford.

1. Mariette was given the title of 'Bey' by the Khedive Ismail, Viceroy of Egypt.

National Gallery of Ireland (cat. no. 4275)

According to Camille du Locle, director of the Paris *Opéra-Comique*, Mariette was responsible for the original *Aida* libretto. He signed the contract for the opera with Verdi on behalf of the Khedive, and supervised the design of scenery and costumes, with great attention to archaeological accuracy.

2. *Memoir and Letters of the late Thomas Seddon, Artist, by his Brother* (London 1858), pp. 64-65.

The sphinx is probably the most famous single statue in the world, and represents a massive recumbent lion with the human features of the sun-god Atum. It was carved out of a knoll of rock which had been left untouched by the builders of the Great Pyramid (see Denon, no. 24) when they were quarrying stone for its inner core. Originally it was probably covered in painted plaster. The Sphinx is approximately 240 feet long and 66 feet high, the face, thought to be a portrait of King Chephren as the sun-god, is 13 feet 8 inches at its greatest width. In Egyptian mythology the lion is often a guardian of sacred places; the giant Sphinx thus serves as a sentinel over the Gizeh necropolis.

The composition, style and colour of this painting are absolutely typical of a large number of works by Schreyer, where groups of approximately five to ten Arab horsemen, differentiated mainly by the colour of their mounts, their type of weaponry or their head-dresses, meet, halt or ride full-tilt through a nondescript Eastern landscape. Here, as in Schreyer's other National Gallery of Ireland work, water plays a role, since the stream in the foreground is probably what has brought about an assembly in this place. Perhaps they have watered their animals already; the frisky horses seem prepared to set out again. Particularly handsome is the disciplined white steed in the centre, whose rider may well command the group. He sits back in his saddle with the nonchalant ease of a leader, anchoring the composition, while all around him, other riders attend to horses nervously pawing the ground, their enormous nostrils flared like traffic lights. The stock of the musket slung over the central figure's back overlaps that of his nearest neighbour on the left, while the barrel of his gun, almost as fine as a fishing rod, points diagonally over the rest of his company.

The first modern excavation of the Sphinx was supervised by Captain Caviglia in 1818. When Seddon painted the monument, another was being carried out by Auguste Mariette, known as Mariette-Bey, who was Inspector of Monuments and founder of the Cairo Museums. Seddon himself described the process.

It is very amusing just now to watch the operation which Mr. Mariette (sic) is carrying on for the French Government round the Sphinx, where he is searching for a temple. There are about one hundred children removing the sand. Some light but ten men and bigger boys fill small round baskets with sand, and therefore two groups, one of boys and the other of girls. Some of the older ones lift the baskets on to the heads of the children, who carry them up the slope in two long processions, the head boy and girl singing, and the others all joining in chorus, and laughing and joking and shouting, while two or three majestic old Arabs stand by as overseers, with store of vociferation and blows, not serious, which, coming on their loose drapery, only just keeps them at work, and rather increases the laughter than otherwise.[2]

In Seddon's picture the overseers are placed in the central foreground and to the

3. *Ibid*, p. 119.

Bibliography:

'Adolphe Schreyer', extrait des *Annales Historiques et Biographiques*, ed. M. L. Tisseron (Paris 1884-86), pp. 1-8.

Richard Graul, 'Adolf Schreyer', *Die graphischen Künste*, vol. 12, pp. 89-96, 121-128.

Prince Bojidar Karageorgevitch, 'Adolphe Schreyer', *Magazine of Art*, vol. 18 (1895), pp. 133-37.

Fritz Knapp, 'Adolf Schreyer', *Die Künste für alle*, vol. 19 (1904), pp. 139-43.

David Oldfield, *German Paintings in the National Gallery of Ireland* (Dublin 1987), pp. 64-66.

Lynne Thornton, *The Orientalists, Painter-Travellers* (Paris 1983), pp. 60-1.

1. *Memoir and Letters of the late Thomas Seddon, Artist, by his Brother* (London 1858), p. 3.
2. *Ibid*, p. 60.
3. According to Seddon (*Memoir*, op. cit., p. 32) the watercolour was done at Burton's request to be a frontispiece for his book, *Personal Narrative of a Pilgrimage to El Medinah and Meccah*. There are at least two versions, both in private collections. One (Harvard College Library) has generally been considered a copy, although dated earlier.
4. Frank was an all-purpose Arab term for Europeans.
5. *Memoir*, op. cit., pp. 59-0.
6. Allen Staley, *The Pre-Raphaelite Landscape* (Oxford 1973), p. 10?.
7. *Memoir*, op. cit., p. 137.
8. John Ruskin, *Catalogue of the Chester Beatty Collection* (Dublin 1950), no. 70?, 27; *National Gallery of Ireland, Illustrated Summary Catalogue of Paintings* (Dublin 1981), no. 4276; David Oldfield, quoted in *The Orientalists: Delacroix to Matisse*, Royal Academy (1984), p. 227; I have been unable to trace the Ruskin quotation.

Thomas Seddon
1821, London — 1856, Cairo

Seddon's father was a well-known furniture-maker, whose trade Thomas joined at age sixteen. In 1841 his father sent him to Paris for a year to study ornamental art. Seddon learned fluent French, but, according to his brother, derived no other benefits from 'that gay and seductive capital' except 'a taste for pleasure and dissipation, which unnerved his mind'.[1] Seddon worked as a furniture designer throughout the 1840s, winning a silver medal for his design of a sideboard from the Society of Arts in 1848, and that discipline as a craftsman may have influenced the conscientious care of his approach as a painter. Seddon had been studying life drawing in London and in 1849 he made a tour of North Wales, where he began a serious effort at landscape, which he continued the following year during a visit to Barbizon. In London Seddon had also become friendly with Ford Madox Brown, who served as an instructor in the North London School of Drawing and Modelling which Seddon helped set up for workmen. Over-exerting himself in organizing an exhibition there in 1850, Seddon had a near-fatal attack of rheumatic fever, a shock from which his formerly vigorous constitution never fully recovered. During his recuperation he became quite religious, and his later decision to visit the East probably related to his new-found faith. Seddon's first exhibited picture at the Royal Academy was *Penelope* in 1852, but he soon abandoned classical subjects for landscape. It was after the painting visit to France that he continued on to Cairo, where he hoped to work with Holman Hunt. In Egypt Seddon met Edward Lear (*q.v.*), writing on 30 December, 1853:

> I have been very glad of Lear's arrival, both because his advice as an experienced traveller has been useful and also because I have been able to consult him about the pictures I think of painting.[2]

Seddon painted a portrait of Sir Richard Burton (see Scott essay, Fig. 9), which was copied by Lear,[3] and worked with Hunt around the Pyramids and Sphinx. Although he remained in Egypt for more than a year, Seddon felt that it was completely in decline:

> This country is a spectacle of a society falling into ruins, and the manners of the East are rapidly merging into the encroaching sea of European civilisation. The people themselves seem scarcely to understand how it is that the Frank[4] is greater than the true believer; and yet they know it is so. But Egypt is like a dead nation; neither taste nor manufacturers exist.[5]

Seddon did not find the Holy Land so degenerate, but was surprised by the smallness of the area in which the great events of the Bible took place. Back in London, Seddon set out with such painstaking thoroughness to finish his Eastern works that Ford Maddox Brown described them as 'cruelly PRB'ed'.[6] The Royal Academy evidently agreed, rejecting his *Sunset behind the Pyramids* in 1855; but the following year he had three Egyptian scenes accepted. Ruskin was initially very enthusiastic, according to Seddon. He praised especially Seddon's major landscape *Jerusalem and the Valley of Jehoshaphat* (Tate Gallery) before noting:

> 'Well, Mr. Seddon, before I saw these, I never thought it possible to attain such an effect of sun and light without sacrificing truth of colour'. He said that my *Interior at Cairo* was the most perfect thing that he have ever seen.[7]

both Ruskin, in a flush of early enthusiasm, and Staley in the concluding words to his chapter on the artist use exactly the same words to describe Seddon: 'the purest Pre-Raphaelite landscape painter'.[9]

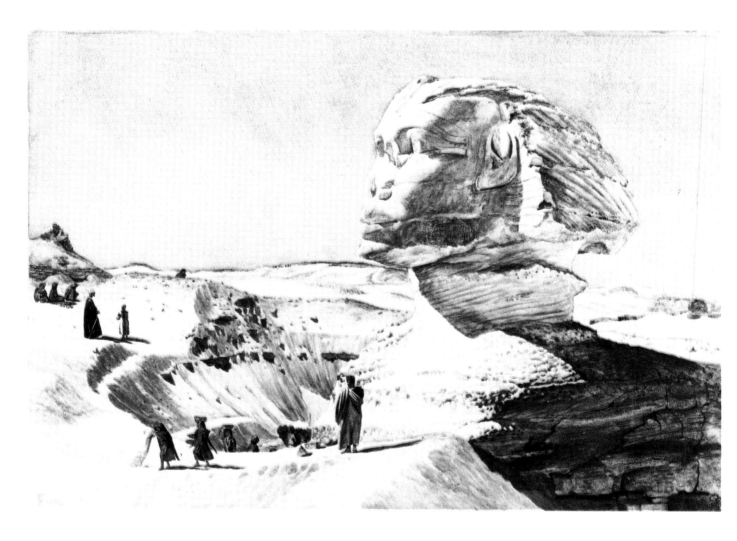

63 Excavations Around the Sphinx

Watercolour and bodycolour on paper, 25.1 x 35.3 cm.

MONOGRAMMED AND DATED: lower left, *TS 1854*.

PROVENANCE: G.P. Boyce; Miss H.A. Virture-Tebbs, by whom presented.

EXHIBITED: 1855 Seddon's rooms, London; 1855, Liverpool Academy, no. 436; 1856, Seddon's rooms, London; 1984, *The Pre-Raphaelites*, Tate Gallery, London, no. 203.

LITERATURE: Allen Stalley, *The Pre-Raphaelite Landscape* (Oxford 1973), p. 99, pl. 50b; Michelle Verrier, *The Orientalists* (London 1979), pl. 4.

Visitors of the Ashmolean Museum, Oxford.

1. Mariette was given the title of 'Bey' by Khedive Ismail, Viceroy of Egypt. According to Camille du Locle, director of the Paris *Opéra-Comique*, Mariette was responsible for the original *Aida* libretto. He signed the contract for the opera with Verdi on behalf of the Khedive, and supervised the design of scenery and costumes, with great attention to archaeological accuracy.
2. *Memoir and Letters of the late Thomas Seddon, Artist, by his Brother* (London 1858), pp. 64-65.

The sphinx is probably the most famous single statue in the world, and represents a massive recumbent lion with the human features of the sun-god Atum. It was carved out of a knoll of rock which had been left untouched by the builders of the Great Pyramid (see Denon, no. 24) when they were quarrying stone for its inner core. Originally it was probably covered in painted plaster. The Sphinx is approximately 240 feet long and 66 feet high, the face, thought to be a portrait of King Chephren as the sun-god, is 13 feet 8 inches at its greatest width. In Egyptian mythology the lion is often a guardian of sacred places; the giant Sphinx thus serves as a sentinel over the Gizeh necropolis.

The first modern excavation of the Sphinx was supervised by Captain Caviglia in 1818. When Seddon painted the monument, another was being carried out by Auguste Mariette, known as Mariette-Bey, who was Inspector of Monuments and founder of the Cairo Museum.[1] Seddon himself described the process:

> It is very amusing just now to watch the operation which Mr. Mariette (sic) is carrying on for the French Government round the Sphinx, where he is searching for an entrance. There are about one hundred children removing the sand. Some eight or ten men and bigger boys fill small round baskets with sand, and there are two groups, one of boys and the other of girls. Some older ones lift the baskets on to the heads of the children, who carry them up the slope in two long processions, the head boy and girl singing, and the others all joining in chorus, and laughing and joking and shouting, while two or three majestic old Arabs stand by as overseers, with store of vociferation and blows, not serious, which, coming on their loose drapery, only just keeps them at work, and rather increases the laughter than otherwise.[2]

In Seddon's picture the overseers are placed in the central foreground and to the

left. The working group appear to be young women, bringing up the heavy baskets of sand on their heads, with one emptying hers down a steep slope in the left foreground. The dry, sunbaked tones of the monument and surrounding desert are set against a sky of intense blue, which a note on the back of the mount reveals was repainted, possibly by the artist himself (Ford Madox Brown helped Seddon rework the skies of two Eastern oils). The sky's strong blue probably just precedes sunset, since the shadows of the monument and workers are long. Seddon had initially been unimpressed by the Sphinx and the Pyramids, writng that they required special effects of light and shade for their poetic power to be revealed.[3]

In this drawing Seddon managed with his careful technique to combine a sense of both the Sphinx's artistry and its geology, in a work of hallucinatory intensity, where the excavators serve not just for scale but also also as modern reminders of the countless anonymous labourers who suffered to create a work of such massive grandeur.

Excavations Around the Sphinx was shown with a number of other watercolours and Seddon's most famous oil *Jerusalem and the Valley of Jehosophat* in his own studio in 1855, at the Liverpool Academy the same year, and again in his studio in 1856

3. *Ibid*, pp. 52-53.

James (Jacques-Joseph) Tissot

1836, Nantes — 1902, Buillon

Tissot was a most unlikely Orientalist, since until the last two decades of his life he showed no interest in the East, painting wistful women from London and Paris society. But a dramatic religious conversion before he turned fifty caught him up in the midst of *fin-de-siècle* occultism and the Catholic Revival, and he made three journeys to the Holy Land as part of a most conscientious (and, in his own lifetime, phenomenally successful) effort at Biblical Orientalism.

Tissot was the son of a prosperous merchant. An indifferent student, he persuaded his father to permit him to study painting in Paris at the Ecole des Beaux-Arts under two different Ingres pupils, first Hippolyte Flandrin, then Louis Lamothe, who also taught Degas. Degas became a good friend of Tissot, painting a memorable portrait of him (Metropolitan Museum of Art, New York) and unsuccessfully urging him to join in the first Impressionist exhibition in 1874. Initially Tissot aimed to be a history painter, but after 1864 he started to specialise in genre, increasingly of contemporary scenes. Despite his adherence to academic tradition in terms of technique, Tissot in his life-style and subject matter followed the image of the 'flâneur' or dandy adopted by more progressive artists of the 1860s like Degas or Manet, with whom he was also on good terms. Tissot's more detailed technique, which featured finished clarity even in depicting distance and atmosphere, made him far more successful than his experimental contemporaries, both with the art establishment and the public of his day, just as it has condemned him for many future viewers. Recently, however, Henri Zerner has felt 'the subtle and disturbing interest of Tissot's troubled psychology'[1] and Michael Levey has suggested that many of Tissot's works effectively embody a languid mood of unsatisfied longings, which his female protagonists both cause and experience.[2]

64 The Sojourn in Egypt, c.1886-94

Oil on canvas, 69.2 x 85.4 cm.

SIGNED: lower left, *J.J. Tissot.*

PROVENANCE: Cecil King (1881-1942), marine and landscape painter, who bought it in Paris; Knoedler and Co. Ltd, London; Sir Alfred Chester Beatty, by whom presented to the National Gallery of Ireland, 1954.

EXHIBITED: 1984, *James Tissot* (ed. by Krystyna Matyjaszkiewicz), Barbican Art Gallery, London 1984.

1. Henri Zerner, 'The Return of James Tissot', *Academic Art, Art News Annual*, XXXIII, (1967), reprinted (New York 1971), p. 181.
2. Sir Michael Levey, 'The Ambiguous Art of Tissot', *James Tissot*, Barbican Art Gallery, 1984, pp. 140-41.
3. Edmond and Jules de Goncourt, Robert L. Sherard, 'James Tissot and his Life of Christ', *The Magazine of Art*, (1894).
4. Henry James, 'Picture Season in London 1877', *The Galaxy* (August 1877), reprinted in *The Painter's Eye* (Cambridge 1956).
5. Oscar Wilde, 'The Grosvenor Gallery', *Dublin University Magazine*, (1877), reprinted in *Miscellanies* (London 1908).
6. Christopher Wood, *Tissot* (London 1986), p. 155, and Michael Wentworth, *James Tissot* (Oxford 1984).
7. The conflict between Church and State, sparked by the Catholic revival, exploded in the Dreyfus trial.

Testament volumes the Professor of Moral Philosophy at the Catholic Institute in Paris described the artist as 'a form of visual theologian', comparing Tissot's four volumes of Bible illustrations to the *Summa Theologica* of Thomas Aquinas.

Tissot made three trips to the Holy Land, in 1885-86, 1889, and 1896. He spent eight years working on the New Testament scenes, first showing them publicly in Paris in 1894. His first exhibition of gouaches of his *Life of Christ* caused a sensation, with some spectators shuffling around the show in tears on their knees. Eventually Tissot was to sell all three hundred and sixty-five drawings to the Brooklyn Museum for more than a million francs. This sum, plus the proceeds from tours of the series and subsequent sales of them in book form, made Tissot a far richer and more famous man than any of his previous paintings ever had. At least two early twentieth century films, one of them D.W. Griffith's *Intolerance*, took visual inspiration from Tissot's pictures. Today the Bible illustrations are among Tissot's least-known or regarded works. Yet in their curious, conscientious attempt to create 'visual literature', they serve as one convenient marker of the end of nineteenth century Orientalism.

Tissot's *Life of Christ* has been called 'a kind of Catholic Baedeker' or 'a kind of sacred travel book,' whose approach to Holy Land sites is similar to that of earlier writers, who mixed in their accounts topographical information, human interest and sacred legend.

Attempting to be singularly original and inspired, Tissot in fact closed all the reader's imaginative doors in producing a group of works whose extraordinary popularity and subsequent oblivion can both be partly explained by the fact that they effectively aped visually the timeworn conventions and clichés of the typical travel book.

8. Perhaps the most spectacularly cinematic of Tissot's *New Testament* scenes is his *View from the Cross* where the dramatic downward perspective taken is Christ's own, and includes his foreshortened feet.
9. Christopher Wood, *op. cit.*, p. 147.
10. Michael Wentworth, *op. cit.*, p. 181.

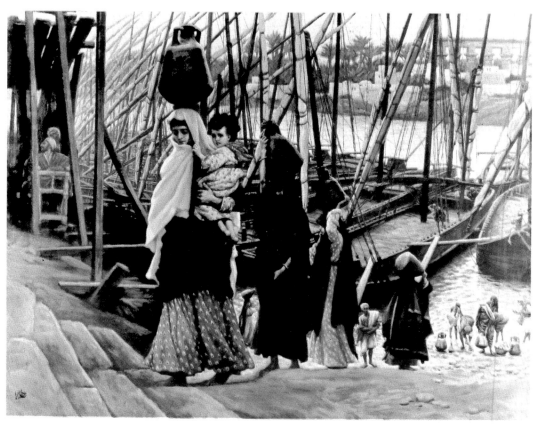

64 The Sojourn in Egypt, c.1886-94

Oil on canvas, 69.2 x 85.4 cm.

SIGNED: lower left, *J.J. Tissot.*

PROVENANCE: Cecil King (1881-1942), marine and landscape painter, who bought it in Paris; Knoedler and Co. Ltd., London; Sir Alfred Chester Beatty, by whom presented to the National Gallery of Ireland, 1954.

EXHIBITED: 1984, *James Tissot*, (ed. by Krystyna Matyjaszkiewicz), Barbican Art Gallery, London, no. 183, pp. 140-41.

LITERATURE: Robert L. Sherard, 'James Tissot and his Life of Christ', *The Magazine of Art*, vol. 18 (1895), pp. 1-12; Cleveland Moffet, 'J.J. Tissot and his Paintings of the Life of Christ', *McClure's Magazine*, vol. XII (March 1899), no. 5, pp. 386-96; *Catalogue of watercolours illustrating The Life of Christ, by James Tissot* (Brooklyn Museum 1922); Willard Erwin Misfeldt, *James Jacques Joseph Tissot: A Bio-critical Study*, PhD thesis, Washington University Dept. of Art & Archaeology, (1971), p. 327; *National Gallery of Ireland, Illustrated Summary Catalogue of Paintings* (Dublin 1981), no. 1275, p. 163; *James Tissot: Biblical Paintings*, essays by Yochanan Muffs and Gent Schiff (New York 1982); Michael Wentworth, *James Tissot* (Oxford 1984), p. 188 and pl. 199; Christopher Wood, *Tissot* (London 1986), p. 150, and pl. 157.

National Gallery of Ireland (cat. no. 1275).

1. Willard Misfeldt's reading of the Tissot will, in his Ph.D. thesis, *James Jacques Tissot: A Bio-Critical Study*, Washington University, (1971), p. 327, suggests there were seven New Testament subjects in the artist's possession at his death.

Tissot reproduced some of his 365 gouache illustrations for the Life of Christ as oils, but the Dublin *Sojourn in Egypt* is one of only three known today: others are *The Journey of the Magi* (The Minneapolis Institute of Arts) and *Christ before Pilate* (private collection, Besançon).[1] In his preface to the *Life of Christ*, Tissot refers to the imagination of the Christian world having been 'led astray by the fancies of artists'. He aimed for nothing less than a dynamic combination of painstaking archaeology and divine inspiration to produce a definitive visual truth. In addition to a combined Latin and French (or English) text, he included detailed commentaries both explaining and justifying his depictions. Mary's effortless ease in carrying a Christ child clearly able to walk on his own at the same time as she transports a water jug which must weigh in the neighbourhood of four and a half stone is explained by her unwillingness to leave her child alone in a strange land; the absent Joseph, Tissot informs us, was probably off making wooden wainscoting for Egyptian houses. The background of the picture is identified by Tissot as the Island of Rhoda, where Moses was said to have been discovered by the daughters of Pharaoh; thus does the artist make the traditional association between Christ and his great Old Testament predecessor. Certainly inspired by his interest in Japanese art and probably under the influence of photography, Tissot has employed an unusual spatial viewpoint, with a startling plunge down to the riverside, a passage marked by the diagonal incline and the diminishing size of the three returning and one descending women with water jugs. Counterpointing their strong clear shapes are the repeated opposing slants of the masts of the Egyptian boats. The modest Mary literally watches her step, but the Christ child strikes a pose reminiscent of his traditional iconographical grouping; he is the only person in the picture who engages the eye of the spectator.

Joseph Mallord William Turner

1775, Covent Garden, London — 1851, Chelsea, London

Born the son of a barber and lacking much formal education, Turner made a career as a painter that was not only prodigiously profitable but also limitlessly productive, inventive and profound. In his lifetime he far outstripped his contemporary John Constable, his only rival for pre-eminence as England's greatest landscapist.

Turner was a prodigy who entered the Royal Academy Schools at age fourteen and had a watercolour in the Academy exhibition the following year. Thomas Malton may have helped Turner achieve an early grasp of perspective, and Turner's visits to Dr. Monro's house, to copy the watercolours of John Robert Cozens and other eighteenth-century landscape artists, did help connect him to a tradition he first extended and then transformed. But like many fine artists, Turner — always pursuing, always observing nature — was his own best teacher, and his endless summer treks of twenty to twenty-five miles a day the length and breadth of the British Isles were followed by extensive travels in Europe, especially Switzerland and Italy.

An associate of the Royal Academy in 1794 and a full academician at a mere twenty-seven, Turner became Professor of Perspective in 1807 and Deputy President in 1845. His association with art officialdom was, overall, one of the most pleasant any great painter has ever enjoyed. Turner's success in the Academy precluded any need to participate in the Society of Painters in Watercolour founded in 1804. After 1802 he seldom exhibited watercolours, which he executed as specific commissions for patrons or printers. Yet as a watercolourist Turner was the most complete practitioner the medium has ever seen, producing a more comprehensive exploration of its effects and qualities than any artist before or since.

Turner's response to and interpretation of nature is similarly rich and varied, though his most characteristic and consistent mature approach could be described as 'apocalyptic sublime', where nature was viewed on a grand scale that dwarfed man and involved a continuous dynamic conflict. Turner's rocks as well as his sea and sky were often the product of powerful motion and opposition. An exaggerated aspect of this approach was developed by artists such as John Martin (q.v.).

Orientalism is not a major strain in Turner's art, though Biblical subjects were considered reasonably often through his cosmic eye, as in the magical *Flight into Egypt* roundel in the Ulster Museum, Belfast. Since Turner's profound empathy for nature, as deep as that of Wordsworth, was the closest he came to conventional religion, it is only appropriate that he employed such feeling from time to time in animating themes and settings taken from the Bible.

Although Turner amassed a large fortune as an artist, he did not significantly alter his lifestyle, nor polish his rough personality. The impeccably correct Delacroix (q.v.) met him only once, recalling:

> He made a mediocre impression on me: he looked like an English farmer, his black coat too big, clumsy shoes, and a cold and hard face.[1]

Turner's will left a generous legacy for struggling artists, which his family successfully overturned, and gave the contents of his studio to the nation, an extraordinary collection it took England a mere hundred and thirty-five years to house properly.

Edmond de Goncourt never met Turner, but found one of the artist's Venetian scenes he saw at a friends an utter revelation, 'one of the ten pictures which have given my eyes great joy'. Searching for a simile worthy of its unique qualities, Goncourt continued, 'it's a picture which appears to have been made by a Rembrandt born in India'.[2]

1. Eugène Delacroix, *Journal*, (Paris 1933), vol. II (24 March 1855), p. 321.
2. Edmond and Jules de Goncourt, *Journal* (Paris 1956), vol. IV (12 August 1891), p. 132.

Bibliography:
Martin Butlin and Evelyn Joll, *The Paintings of J.M.W.Turner*, 2 vols. (New Haven 1984).
John Gage, *Collected Correspondence of J.M.W.Turner* (Oxford 1980).
John Gage, *J.M.W.Turner 'A Wonderful Range of Mind'* (New Haven 1987).
John Ruskin, *Modern Painters*, 4 vols. (London 1846).
Andrew Wilton, *J.M.W.Turner: His Life and Art* (New York 1979).
Andrew Wilton, *Turner and the Sublime* (Toronto-New Haven-London 1980-8).

Edwin Lord Weeks

1849, Boston — 1903, Paris

Weeks is the only American in this exhibition, but like Wyld (q.v.) he was almost an adoptive Frenchman. After 1871 he never again lived in the United States on a permanent basis, spending most of the time he was not travelling in Paris.

Weeks' father was a successful specialty food merchant, who had hoped to have his son succeed him but supported Edwin in his decision to be an artist. Weeks began travelling in 1869, to the Florida Keys and the rain forests of South America; for the next twenty years he would spend much of his time in pursuit of exotic sights and sites. In 1870 he went to Paris to study at the Ecole des Beaux-Arts, with Léon Bonnat as his master. In the same year as his arrival he visited Persia and Egypt, then returned to the *Ecole* through 1870-1. Other Americans with him there included Thomas Eakins, Frederick Bridgeman and H.H. Moore, the latter two also becoming Orientalist painters under the influence of Gérôme (q.v.), who taught them all at the *Ecole*.

In the spring of 1871 Weeks went back to America, set up a small studio, and married, but he was not able to settle down and travelled with his wife to Morocco in 1872. There his entourage encountered difficulties: disease, famine and religious intolerance. Once they were stoned by an angry mob when they entered the sacred gates of Sallee (Weeks' own travel writing demonstrates a fair insensitivity to cultural differences).[1] Weeks may have resided in Morocco for as long as six years — his 1878 address for the Royal Academy exhibition was Tangier. Certainly by 1880 he was back in Paris, where he showed his Moroccan scenes at the Salon as 'Lord Edwin' Weeks, an inversion that the conscious French used intermittently for most of his career.

In September 1882, Weeks set out for India, returning to Paris the next autumn. He exhibited at the 1884 Salon two subjects from India, and returned to that country in 1887. July 1892 saw him visiting Turkey, Persia and India, the trip he turned into his book *From the Black Sea Through Persia and India* (1896), much of which he had published in serial form in American magazines.[2] He also illustrated the writings of others: Marion F. Crawford's *Constantinople* (1895) and Nathaniel Shaler's *Domesticated Animals* (1895).

Weeks showed in almost every annual Salon, winning a Medal of Honour in 1884, a Third Class Medal in 1887 and also a Gold Medal at that year's International Exhibition, and the Legion of Honour in 1896. An 1890 picture of *Lord Edwin at work* shows a regal presence, with a well-groomed beard and curling moustaches, a tightly-buttoned and spotless white smock, natty striped trousers, feet and chair resting on a tigerskin, seated in front of an easel supporting a large finished picture of Indians seated around a pool inside a courtyard. In the 1899 and 1903 Salons, Weeks exhibited paintings illustrating episodes from the *1001 Nights*, a series he might well have extended had he not died. Except for Deutsch (q.v.), no artist in the exhibition showed so radical a shift of subject-matter, reaching beneath his detailed traveller's knowledge into a fantastic dream-world of exoticism.

Like the aforementioned Wyld, Weeks' long French residence caused him to slip through cultural cracks and to enter into part of this work less well-documented than the scholars of his own nation or his adopted one.

1. Kathleen Duff Ganley and Leslie K. Paddock, *The Art of Edwin Lord Weeks (1849-1903)*, University Art Galleries, Durham, New Hampshire 1976, p. 8.
2. *Harper's Magazine*, *Harper's Weekly*, and *Scribner's Monthly*. Both these books were published by Scribner's.

Bibliography
Samuel G. W. Benjamin, *Our American Artists* (Boston 1881), pp. 27-31.
F. D. Millet, *Catalogue of Very Important Finished Pictures, Studies, Sketches and Original Drawings by the Late Edwin Lord Weeks*, New York, American Art Galleries, 1905.
Edwin Lord Weeks, *From the Black Sea Through Persia and India* (New York 1896).
The Art of Edwin Lord Weeks (1849-1903), University Art Galleries, University of New Hampshire, Durham, New Hampshire, 1976.
A Retrospective Exhibition of the Work of Edwin Lord Weeks, St. Louis Museum of Fine Arts, 27 January — 1 March, 1903 (2 — page catalogue, only 9 paintings).
American Artists in Europe 1800-1900, Walker Art Gallery, Liverpool, November 1976 — January, 1977.

Joseph Mallord William Turner

1775, Coventry

Born the son [...] as a painter [...] inventive [...] Constable [...]

Turner [...] and had a [...] may have [...] to Dr. M[...] eighteenth [...] extended and [...] always ob[...] of twenty[...] followed by [...]

An as[...] Royal Academy [...] in 1794 [...] twenty-se[...] Turner became Professor of Perspective in 1807 and Deputy President in 1845. His association with art officialdom was, overall, one of the most pleasant any great painter has ever enjoyed. Turner's success in the Academy precluded any need to participate in the Society of Painters in Watercolour founded in 1804. After 1802 he seldom exhibited watercolours, which he executed as specific commissions for patrons or printers. Yet, as a watercolourist Turner was the most complete practitioner the medium has ever seen, producing a more comprehensive exploration of its effects and qualities than any artist before or since.

Turner's response to and interpretation of nature is similarly rich and varied, though his most characteristic and consistent mature approach could be described as 'apocalyptic sublime', where nature was viewed on a grand scale that dwarfed man and involved a continuous dynamic conflict. Turner's rocks as well as his sea and sky were often the product of powerful motion and opposition. An exaggerated aspect of this approach was developed by artists such as John Martin (q.v.).

A lot of Ruskin for a little Turner, perhaps. But when Rosa Bonheur said that Ruskin saw nature *tout à fait comme un oiseau* (quite like a bird) she got, in this instance, his element — the air — just right. Ruskin employed all the range of his poet-naturalist vocabulary to insist on the accuracy of Turner's celestial observation, ignoring, perhaps tactfully, the more imaginary aspect of *terra firma*, where Turner's lack of actual experience of either deserts or Eastern people is obvious. Turner generally mirrored his cosmological dramas with geological ones, and here he has given his land the textures of disturbed water rather than drifting sand. His foreground, an outcrop dramatically darkened by passing cloud, not only establishes the diminished recession of the rest of the scene but also allows him literally to scatter local colour in the form of exotic dress and objects that signify an Easternness really identified in the distance only by the solitary silhouette of a palm tree planted dead centre.

Orientalism is not a major strain in Turner's art, though Biblical subjects were considered reasonably often through his cosmic eye, as in the magical *Flight into Egypt* roundel in the Ulster Museum, Belfast. Since Turner's profound empathy for nature, as deep as that of Wordsworth, was the closest he came to conventional religion, it is only appropriate that he employed such feeling from time to time in animating themes and settings taken from the Bible.

Although Turner amassed a large fortune as an artist, he did not significantly alter his lifestyle, nor polish his rough personality. The impeccably correct Delacroix (q.v.) met him only once, recalling:

> He made a mediocre impression on me: he looked like an English farmer, his black coat too big, clumsy shoes, and a cold and hard face.[1]

Turner's will left a generous legacy for struggling artists, which his family successfully overturned, and gave the contents of his studio to the nation, an extraordinary collection it took England a mere hundred and thirty-five years to house properly.

Edmond de Goncourt never met Turner, but found one of the artist's Venetian scenes he saw at a friends an utter revelation, 'one of the ten pictures which have given my eyes great joy'. Searching for a simile worthy of its unique qualities, Goncourt continued, 'it's a picture which appears to have been made by a Rembrandt born in India'.[2]

1. Eugène Delacroix, *Journal*, (Paris 1933), vol. II (24 March 1855), p. 321.
2. Edmond and Jules de Goncourt, *Journal* (Paris 1956), vol. IV (12 August 1891), p. 132.

Bibliography:
Martin Butlin and Evelyn Joll, *The Paintings of J.M.W. Turner*, 2 vols. (New Haven 1984).
John Gage, *Collected Correspondence of J.M.W. Turner* (Oxford 1980).
John Gage, *J.M.W. Turner 'A Wonderful Range of Mind'* (New Haven 1987).
John Ruskin, *Modern Painters*, 4 vols. (London 1846), pp. 232-23.
Frederick Goodall, *Reminiscences* (London 1902).
Andrew Wilton, *J.M.W. Turner: His Life and Work* [...]
[...] Bonheur actually intended the remark critically, meaning that Ruskin saw nature with the smallness of vision.
[...] New Haven-London 1980-8).

Edwin Lord Weeks

1849, Boston — 1903, Paris

Weeks is the only American in this exhibition, but like Wyld (*q.v.*) he was almost an adoptive Frenchman. After 1871 he never again lived in the United States on a permanent basis, spending most of the time he was not travelling in Paris.

Weeks' father was a successful specialty food merchant, who had hoped to have his son succeed him but supported Edwin in his decision to be an artist. Weeks began travelling in 1869, to the Florida Keys and the rain forests of South America; for the next twenty years he would spend much of his time in pursuit of exotic sights and sites. In 1870 he went to Paris to study at the Ecole des Beaux-Arts, with Léon Bonnat as his master. In the same year as his arrival he visited Persia and Egypt, then returned to the *Ecole* through 1870-1. Other Americans with him there included Thomas Eakins, Frederick Bridgeman and H.H. Moore, the latter two also becoming Orientalist painters under the influence of Gérôme (*q.v.*), who taught them all at the *Ecole*.

In the spring of 1871 Weeks went back to America, set up a small studio, and married, but he was not able to settle down and travelled with his wife to Morocco in 1872. There his entourage encountered difficulties: disease, famine and religious intolerance. Once they were stoned by an angry mob when they entered the sacred gates of Sallee (Weeks' own travel writing demonstrates a fair insensitivity to cultural differences).[1] Weeks may have resided in Morocco for as long as six years — his 1878 address for the Royal Academy exhibition was Tangier. Certainly by 1880 he was back in Paris, where he showed two Moroccan scenes at the Salon as 'Lord Edwin' Weeks, an inversion the title-conscious French employed intermittently for most of his career.

In September 1882, Weeks set out for India, returning to Paris the next autumn. He exhibited at the 1884 Salon two subjects from India, and returned to that country in 1887. July 1892 saw him visiting Turkey, Persia and India, the trip he turned into his book *From the Black Sea Through Persia and India* (1896), much of which he had published in serial form in American magazines.[2] He also illustrated the writings of others: Marion F. Crawford's *Constantinople* (1895) and Nathaniel Shaler's *Domesticated Animals* (1895).

Weeks showed in almost every annual Salon, winning a Medal of Honour in 1884, a Third Class Medal in 1889 and also a Gold Medal at that year's International Exhibition, and the Legion of Honour in 1896. An 1890 picture of 'Lord Edwin' at 'work'[4] shows a regal presence, with a well-groomed beard and curling moustaches, a tightly-buttoned and spotless white smock, natty striped trousers, feet and chair resting on a tigerskin, seated in front of an easel supporting a large finished picture of Indians seated around a pool inside a courtyard. In the 1899 and 1903 Salons, Weeks exhibited paintings illustrating episodes from the *1001 Nights*, a series he might well have extended had he not died, and, as with Dauzats (*q.v.*), a surprising late approach to the 'imagined' East after a lifetime of accumulating detailed traveller's knowledge.

Like the aforementioned Wyld, Weeks' long French residence caused him to slip through cross-cultural cracks, and a large proportion of his work has yet to be reassembled by scholars or exhibitions.

1. Kathleen Duff Ganley and Leslie K. Paddock in *The Art of Edwin Lord Weeks (1849-1903)*, University Art Galleries, Durham, New Hampshire, 1976, p. 8.
2. *Harper's Magazine, Harper's Weekly*, and *Scribner's Magazine*.
3. Both these books were published by Scribner's.
4. Illustrated in Maurice Hamel, *Salons de 1890 (Société des Artistes Français et Société Nationale des Beaux-Arts)* (Paris 1890), p. 53.

Bibliography:
Samuel G. W. Benjamin, *Our American Artists* (Boston 1881), pp. 27-31.
F. D. Millet, *Catalogue of Very Important Finished Pictures, Studies, Sketches and Original Drawings by the Late Edwin Lord Weeks*, New York, American Art Galleries, 1905.
Edwin Lord Weeks, *From the Black Sea Through Persia and India* (New York 1896).
The Art of Edwin Lord Weeks (1849-1903), University Art Galleries, University of New Hampshire, Durham, New Hampshire, 1976.
A Retrospective Exhibition of the Work of Edwin Lord Weeks, St. Louis Museum of Fine Arts, 27 January — 1 March, 1903 (2 — page catalogue, only 9 paintings).
American Artists in Europe 1800-1900, Walker Art Gallery, Liverpool, November 1976 — January, 1977.

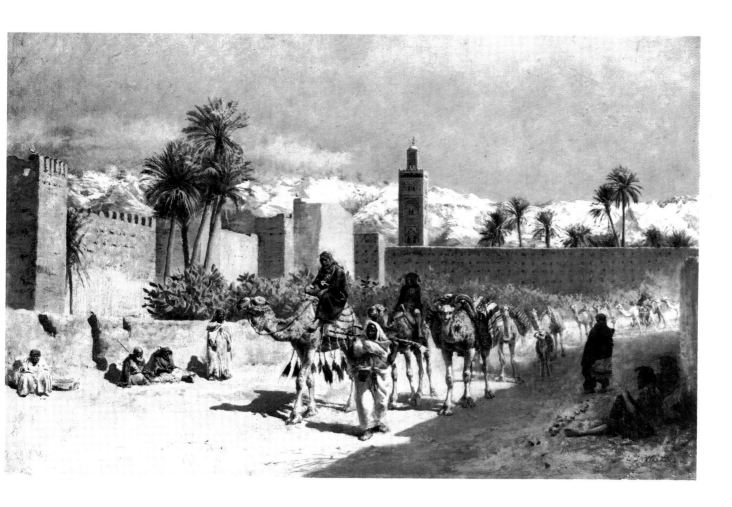

66 A Camel Caravan

Oil on canvas, 61 x 91 cm.

SIGNED: lower right, *E.L. Weeks.*

PROVENANCE: Sir Alfred Chester Beatty, by
whom presented, 1954.

LITERATURE: *National Gallery of Ireland,
Illustrated Summary Catalogue of Paintings*
(Dublin 1981), no. 1532, p. 176.

National Gallery of Ireland (cat. no. 1532)

In the heavy heat of early afternoon a caravan arrives in the street outside the walls
of a fortified city. Two seated men on the right side of the picture have successfully
sought shade, the nearest one casting off his slippers beside him to rest his feet.
Opposite and more conspicuous in the strong sun are a merchant selling fruit and
three beggars, two seated and one standing. At the head of a string of camels, the
only ones who handle the heat with any aplomb, is a travelworn but impressive
Bedouin, attired in a beautifully embroidered haik of dark blue and sporting a massive
dagger. He is flanked by a negro on foot who carries his musket like a cross. On
the second camel sits a tired hooded child; his counterpart among the beasts comes
a bit further along, a shy camel calf whose body is in shadow but whose bemused
head has found the sun. Beyond this dusty scene Weeks has offered a strange and
tantalizing juxtaposition by introducing a distant mountain range covered in snow,
under a haze of cloud which may partly have deposited it. Mediating between
sweltering sand and frozen snow is a transitional area of green, mainly nopal cacti
and palms, some of which rise above the castellated ramparts on the left to overlap
the hills and sky. Apart from the opposition of extreme cold and heat, of distance
and closeness, the picture's primary principle of construction is quite simple: a whole
sequence of strong receding diagonals which move upward from the lower left are
hit head on by the forward thrust of the caravan, to achieve a balance personified
in the striking leader atop his camel, arrested for an instant, forever, against one of
the city wall's strongest bulwarks, midway between the picture's two tallest vertical
accents, the group of palms and the tower of the city's mosque.

The scene looks Moroccan, and may be Marrakech, which is located near the
Atlas Mountains. It probably dates from the late 1870s or early 1880s. The only title
of a Salon work exhibited by Weeks which is remotely similar was a work in the
1882 Salon, *A Caravan from Sudan Arriving at a 'Fonduk' in Morocco*, though there
is no real sign of an inn or resting place in this picture.

153

Richard Westall

1765, Hertford — 1836, London

Westall achieved considerable success as painter, watercolourist and illustrator in his own lifetime, but he died in poverty and today is almost forgotten. He showed over three hundred works in the Royal Academy, where he became an Associate in 1792, and a full Academician in 1794. He was seen as a significant technical innovator in watercolour, and his range and popularity as an illustrator was surpassed only by Thomas Stothard.

Westall's technical education began when he was apprenticed to an heraldic engraver in 1779. The miniature painter John Alefounder noticed his talent and advised him to become an artist. Westall went to evening classes and made such progress that he showed a portrait drawing at the Royal Academy in 1784, and he became a student there the following year. As an exhibitor he made a name first for his large and highly finished watercolours, principally of historical subjects, where his richness of colour and depth of effect was seen as a revelation. He also did portraits and oils of rustic subjects. From 1790-94 he shared a studio on the corner of Soho Square with Thomas Lawrence, and in 1799 he participated in a successful plot, spearheaded by Farington and West, to have James Barry ousted not only as Professor of Painting but also as a member of the Royal Academy, the first and only such expulsion to take place.

Westall was first employed as an illustrator by John Boydell, who commissioned numerous illustrations for Shakespeare from 1795-1802 and five paintings for his famous 'Shakespeare Gallery'. From 1805-9 Westall illustrated several of the Park's 'British Classics' series, and provided pictures for his own volume of poems, *A Day in Spring*, in 1808.

As an illustrator Westall had no special predilection for Eastern subjects,[1] but he did pictures for a Bible in 1813 and again in 1835-6 with John Martin (*q.v.*). He illustrated Johnson's *Rasselas* in 1817 and furnished the frontispiece for the fourth edition of Beckford's *Vathek* (see the following entry) in 1823. He also illustrated the work of Byron (1819), and his portrait of the same poet, engraved in mezzotint by Charles Turner, is fairly well-known.

Westall's large works in oil were not as successful as his watercolours. In the latter medium he was seen as an innovator in figurative works comparable to Girtin and Turner (*q.v.*) in landscape. His light costume dramas presage the intimate, romantic (and much more skilful) work of Bonington (*q.v.*). Westall's figures have a monotonous, mannered prettiness, and are decorative and somewhat dull.

In costume, clarity and simplicity they come out of Neoclassicism, while their elegance of gesture and movement owe as much to Rococo frills as to Romantic fury.

In his later years Westall made a series of unsound dealings in old master paintings and other speculations and lost most of his previous earnings. He was given relief by the Royal Academy and the Duchess of Kent, and shared simple lodgings with his blind sister. One of his last jobs was as instructor in painting and drawing to the Princess Victoria, who was subsequently taught after she became Queen by Edward Lear (*q.v.*). His younger brother William (1781-1850) was a topographical painter who did significant work as the landscape draughtsman on an expedition to Australia.

1. Samuel Redgrave, *A Dictionary of Artists of the British School* (London 1878), p. 466, says that Westall illustrated *The Arabian Nights Entertainments*, but I have not been able to confirm this.

Bibliography:
Jane Bayard, *Works of Splendour and Imagination: the Exhibition of Watercolour, 1770-1870* (Yale Center for British Art 1981), p. 43.
Campbell Dodgson, 'Richard Westall', *Dictionary of National Biography*, vol. XX (London 1909), pp. 1258-59.
Samuel Redgrave, *A Dictionary of Artists of the British School* (London 1878), p. 466.

 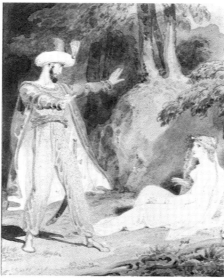 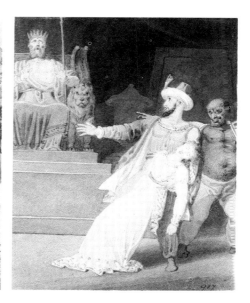

67 Three Illustrations for William Beckford's *Vathek*:

a) The Giaour withstanding the angry and perilous glance of the Caliph without the slightest emotion, while the courtiers fall prostrate with their faces on the ground.
b) Vathek motionless with surprise discovering Nouronihar extended on the ground, trembling and pale.
c) Nouronihar falling into the arms of Vathek, who is asking the Giaour to allow them to depart from the Hall of the Prophet Soliman.
Watercolours, each 12.3 x 9.7 cm.

PROVENANCE: Dyce Bequest 1869.

INSCRIBED: lower right, with Dyce numbers 915, 916 and 917, respectively.

LITERATURE: *British Watercolours in the Victoria and Albert Museum* (London 1980), p. 411.

Victoria and Albert Museum, London

1. I am grateful to Stephen Campbell for his considerable help in preparing this entry.
2. William Beckford, *Vathek*, Fourth Edition (London 1823), p. 12.
3. *Ibid*, p. 158.

William Beckford's *Vathek* emerged from two literary currents — the philosophical Eastern tale as exemplified by Johnson's *Rasselas* and Voltaire's *Zadig*, and the 'Gothic' novel. The latter gratified a taste for the bizarre and terrifying, the Romantic 'Sleep of Reason' which Beckford, the notorious 'Caliph of Fonthill', helped to establish as a literary genre and cultivated in his own private life. Thus English Orientalism came in part from the taste for Gothic fantasy, and Beckford's book is one of the classic evocations of the 'Imaginary Orient'.[1]

Vathek is both a horror story and a megalomaniacal dream of absolute power. The eponymous central character is the intemperate Caliph of Samarah, who is ruled by three passions — the lust for power, a strong sensual appetite and a Faustian intellectual curiosity. At the goading of his mother, a sorceress and fire-worshipper, Vathek abjures Mahomet and makes a pact with a demon known as the Giaour (unbeliever). Following a sacrifice of fifty children, the Giaour promises to lead Vathek to the throne of Soliman, 'the Halls of Eblis and the Palace of Subterranean Fire' and 'the treasures of the pre-Adamite Sultans'. Much of the novel is concerned with Vathek's journey to Istakar, the ruined city of Soliman, from which he descends to the underworld; he takes the princess Nouronihar as his consort and causes the ruin of her family.

Westall's three watercolours were probably offered as alternate possibilities for the frontispiece to the fourth edition of *Vathek*; the given titles represent paraphrased summaries of the action rather than Beckford's actual text. The third one was chosen, engraved by Charles Warren, and published 1 May, 1823, thus giving a *terminus ante quem* for the drawings. The first illustration shows Vathek's initial confrontation with the Giaour.[2] The Caliph sends out his fiercest frown, his upper torso tensed, gripping his sceptre as if prepared to use it as a weapon, and clutching the left arm of his throne as if about to rise. The effect of his terrible gaze has rendered almost all who come under it absolutely prostrate on the steps below, while other bearded courtiers and unseen guards (defined by their lances) cower in the shadows behind. Quite unmoved by the Caliph's grandeur is the grisly Giaour, who holds his grotesquely swollen belly and flashes a mocking, toothy grin. In contrast to the elegant attire of the court his dusky, hairy exposure is positively simian, and his large feet (Westall was rather good at expressive extremities) seem quite capable of grasping a branch or peeling a banana.

In the second drawing Vathek has come upon Nouronihar after her parents had faked her death to release her from his amorous designs.[3] In this picture the electric eye-contact of the principals is set amidst the Rococo frills of the forest glen, which are picked up in Vathek's patterned silk jumpsuit. Hands make the melodrama, while feet are more subtle sexual signifiers, with Nouronihar's left foot discreetly hidden behind Vathek's left leg, and her right, nestled under her left knee and loose white drapery, perhaps the most seductive part of her anatomy; the red hose that cover

155

Vathek's feet transform them into something at least as phallic as the hilt and scabbard of his scimitar.

In the final illustration King Soliman, having spoken of his former magnificence and downfall, raises his hands toward heaven in supplication and reveals within his exposed bosom his heart enveloped in flames, the sight that has caused Nouronihar to swoon.[4] Vathek's gaze reveals his horror at the same sight, which causes him to plead with the Giaour for their release from the frightful realm of Eblis (Satan). The pitiless Giaour denies them the use of the key he clutches and consigns them to a similar flaming consumption. Beckford's unconvincing conclusion suggests that such punishment is appropriate for 'unrestrained passions and atrocious deeds' and 'blind curiosity' (all forms of behaviour he relished) by humans who were created to remain 'humble and ignorant'.

Beckford clearly identified with the figure of Vathek, but others have recognised in the Caliph the character of William Courtenay, later involved with Beckford in a homosexual scandal which brought an end to Beckford's brief political career.[5] The novel was written, reputedly in a single sitting, following a 'voluptuous festival' at Fonthill during the Christmas of 1781; the thirteen-year old Courtenay was among the guests. Fonthill Abbey was decorated for the occasion by Phillip de Loutherbourg, and included an Egyptian Hall and a Turkish Room, continually transformed by uncanny lighting effects. This spectacle provided the inspiration for the 'awful grandeur' of the Halls of Eblis. Over half a century later, a dark wrestling match of nomadic Turks called Zingari would remind the artist William Müller *(q.v.)* of the 'Halls of Eblis'.[6]

By the time of writing *Vathek* at the age of twenty-four, Beckford had become an accomplished amateur Oriental scholar; he had mastered Persian and Arabic and employed an Arab secretary to assist him in his translation of manuscripts brought back from the East by Edward Wortley Montagu. In 1788 in Madrid, Beckford took as a lover a young Muslim named Mohammed.

Beckford originally composed his novel in French, inspired by the example of Voltaire, whom he had met while on the Grand Tour. Despite *Vathek's* gloomy Gothic splendour, the outrageous cruelties it describes can be read to the same ludicrous and ironic effect as the appalling misfortunes suffered by the characters in Voltaire's *Candide*. The first French edition of *Vathek* appeared in 1787 at Lausanne, having been preceded by a pirated English translation, which passed itself off as taken from an original Arabic tale.

4. *Ibid*, pp. 215-16.
5. Mario Praz, Introduction to *Vathek*, published in *Three Gothic Novels* (London 1968), p. 21.
6. N. Neal Solly, *Memoir of the Life of William James Müller* (London 1875), p. 363.

Sir David Wilkie

1785, Cults (Fife) — 1841, at sea, near Gibraltar

Wilkie was the third son of the third wife of a Scottish minister. His early obsession with art — he claimed, as was said of Rowlandson (*q.v.*), he could draw before he could read, and added that he could paint before he could spell — helped him resist family pressure to follow his father's profession. The month of his fourteenth birthday he left home to enter the Trustees' Academy of Design in Edinburgh. After more than four years' study, he came home to paint his first major genre composition, *Pitlessie Fair*, which brought him local renown and sold for £25. In 1805 Wilkie travelled on a packet boat from Leith, outside Edinburgh, to London, where he soon began to study in the Royal Academy Schools. Among his fellow students was Benjamin Robert Haydon, who was initially suspicious of the 'raw, tall, pale, queer'[1] Scotsman, but who became a close friend, leaving in his self-absorbed *Autobiography* several interesting references to Wilkie. After only a year Wilkie caused a sensation and far outstripped his fellows when he exhibited *The Village Politicians*, the first of the hundred pictures he showed at the Academy over the next thirty-six years. Wilkie's genre painting, a kind of Dutch-revival that Sir George Beaumont claimed combined the best of Hogarth and Teniers, brought him instant popularity with both connoisseurs and public. He was elected an Associate of the Royal Academy in 1809 and a full member in 1811. His finances were not secure, though, and an 1812 exhibition in Pall Mall of twenty-nine of his works was unsuccessful.

In 1814 Wilkie went to Paris with Haydon, who described his companion as the 'greatest oddity' in a city full of them, noting Wilkie's:

> horrible French, his strange tottering, feeble pale look; his carrying about his prints to make bargains with print-sellers, his resolute determination never to leave the restaurant till he had got all his change right to a centime...[2]

In 1816 Wilkie visited the Netherlands, reinforcing his ties with its artistic legacy. An appropriate commission for the Duke of Wellington, *The Chelsea Pensioners reading the gazette of the Battle of Waterloo*, which Wilkie began in 1817 and finished in 1821, became one of his most celebrated works. A succession of family deaths in the mid-1820s brought financial distress and ill health, and in 1825 Wilkie returned to Paris, then went further to seek recuperative sun in Italy. After extending his tour to Germany and Austria, he wintered in Rome. In 1827 he shifted to Spain for several months. His Spanish experience not only opened a wide range of subject matter, but his new-found enthusiasm for Titian, Velazquez and Murillo also loosened his style.

In 1825 when Delacroix *(q.v.)* visited Wilkie in London, the young French painter spoke with great admiration of the Scotsman's sketches:

> I had disliked his finished paintings, but in fact his sketches and rough drafts are beyond all praise. Like all painters in all ages, and all countries, he regularly spoils the best things he does. But there is still pressure to be got from this counter-proof of his fine things.[3]

In 1830 on the death of Sir Thomas Lawrence, Wilkie was appointed Painter-in-Ordinary by George IV, an office he retained under William IV (who knighted him in 1836) and Victoria. In 1840 Wilkie left for the East, going through Holland and Germany to Constantinople. Wilkie said his first view of the city 'exceeded in wonder all I have seen'.[4]

During his eventful stay he painted the young Sultan Abdul Medjid and met J.F. Lewis (*q.v.*), whose 'most clever drawings'[5] Wilkie noted. In a letter he wrote back to England, Wilkie indicated that the West owed a debt to a culture he felt it had completely surpassed:

> It is by comparison with the customs and friendships of our native land that we estimate, perhaps unfairly, those of the less advanced race that surround us here, forgetting that the Eastern people were earlier in the advance of civilisation than we, and though now far behind, supplied much of that from which our civilisation has sprung.[6]

1. Tom Taylor, ed. *Life of Benjamin Robert Haydon from his autobiography and journals*, vol. I (New York 1859), p. 36.
2. *Ibid*, vol. II, p. 246.
3. Eugène Delacroix, *Journal* (Paris 1935), vol. I (6 June, 1825), p. 158.
4. Alan Cunningham, *The Life of Sir David Wilkie*, vol. III (London 1843), p. 317.
5. *Ibid*, p. 326.
6. *Ibid*, p. 363.

When Wilkie journeyed onward to the Holy Land, he called his pocket Bible 'the very best' guidebook.[7] Jerusalem reminded him of Poussin:

> a city not for every day, not for the present, but for all time, — as if built for an eternal sabbath; the buildings, the walls, the gates, so strong, and so solid, as if made to survive all other cities.[8]

Wilkie clearly saw his experience of Biblical lands as opening up a whole possibility of new accuracy in representing religious subjects. He suggested that painting, as well as theology, needed a Martin Luther,[9] and may have hoped himself to fulfil such a role. As Horace Vernet had already undertaken to do, and as Tissot (q.v.) and others would attempt later, Wilkie thought the Biblical stories could and should be revitalized through the use of scenes from contemporary Arab life. Three examples of his work published consecutively as lithographs by Joseph Nash, showing a *Nativity* that is little different from the subsequent *Arab Family* followed immediately by an embarrassing *Ecce Homo*,[10] make the loss of a host of Wilkie Biblical subjects all-too-easy to bear. In Egypt Wilkie painted his second Head of State, Pascha Mehemet Ali, made the most delicious tea 'in the world' with Nile water, and admired the size, solidity and elegance of Pompey's Pillar (see Lear, no. 42).[11] On the journey home, he died suddenly on his ship the *Oriental*, soon after it departed Gibraltar. Owing to quarantine his body could not be returned to the island, and so he was buried in Trafalgar Bay, at 36°20′ north latitude and 6°42′ west longitude, an event commemorated in one of Turner's most moving pictures, *Peace-Burial at Sea* (Clore Wing, Tate Gallery).

7. *Ibid*, p. 393.
8. *Ibid*, p. 397.
9. *Ibid*, p. 427.
10. *Sir David Wilkie's Sketches in Italy, Syria & Egypt, 1840 & 1841*, drawn on stone by Joseph Nash (London 1843). The drawings cited are nos. 19, 20 and 21.
11. Alan Cunningham, *op. cit.*, pp. 453, 464.

68 Madame Joséphine, Landlady of the Hotel Constantinople, in a Turkish Dress

Black chalk, red chalk, pencil, ink and blue watercolour washes on buff tinted paper, 47.2 x 33.1 cm.

SIGNED: lower right centre, *D. Wilkie f. Constantinople October 1840*.

PROVENANCE: Mr. and Mrs. W. W. Spooner: presented by Mrs. Spooner, 1979.

EXHIBITED: 1983, *Mantegna to Cezanne: Master Drawings from the Courtauld Collection*, London, no. 126, p. 103.

LITERATURE: *Sir David Wilkie's Sketches in Turkey, Syria & Egypt, 1840 & 1841*, drawn on stone by Joseph Nash (London 1843); Alan Cunningham, *The Life of Sir David Wilkie*, 3 vols. (London 1843).

Courtauld Institute Galleries, London
(Spooner Collection, S. 101)

1. *Sir David Wilkie's Sketches in Turkey, Syria & Egypt, 1840 & 1841*, drawn on stone by Joseph Nash (London 1843). Nash's notes to this plate are listed under no. 24.
2. Alan Cunningham, *The Life of Sir David Wilkie*, vol. III (London 1843), p. 319.
3. *Ibid*, p. 337.
4. *Ibid*, p. 343.

The title of the work comes from the line added by Nash to his lithograph. In his notes to his reproductions he identified Mme Joséphine as 'Madam Giuseppina', the landlady of the hotel in which Wilkie resided in Pera, describing her as a famous beauty 'known to and admired by all European travellers who have voyaged to the banks of the Bosphorous.'[1] Nash went on to say that her features were 'Greek', though his opinion seems based only on the unbroken line of her profile.

Wilkie's own brief references to his accommodation quoted in Cunningham's *Life* are not as clear as Nash's confident assertions. Wilkie arrived in Constantinople on 5 September:

> Our party, on landing, were conducted up an eminence to Pera, to the hotel of Madame Vitali — a lodging-house. Mr. Woodburn and Mr. Miles were accommodated in the hotel, whilst Mr. Repton and I were lodged in a quiet dwelling hard by — all of us dining at the hotel.[2]

Wilkie spent much of October, the date on this drawing, travelling about, but on 17 November he recorded:

> Mr. Woodburn and I continue on here in the house of Madame Giuseppini, surrounded by other travellers, and most kindly entertained by the English residents in this place.[3]

If the two landladies were the same, then the lady in the drawing may have been named Madame Joséphine Vitali.

Wilkie remarked the difficulty of seeing Turkish women without the total covering they wore in the street,[4] and so many of the sketches he did were of Europeans in Eastern costume, in the time-honoured tradition of artists from Van Dyck to Liotard. Mrs. Moore, the enchanting wife of the British consul, and Admiral Walker were among the many he portrayed in Bedouin or Turkish dress.

The subject of Wilkie's drawing is posed in a fashion remarkably similar to a drawing Vivant Denon did over forty years earlier (Fig. 18, Thompson essay), though Wilkie's subject casts her gaze, half-seductive, half-suspicious, back to the spectator. Her lovely hands look unsullied by hard work, and her incredible cuffs would never do for washing dishes. Even in a sketch Wilkie managed to document effectively the splendour of her embroidered dress, which binds, billows and flows from her face to well below her toes.

69 Negro Nurse with a White Baby

Black chalk and body colour on paper, 28.8 x 24 cm.

PROVENANCE: private collection, from whom purchased, 1979.

The National Galleries of Scotland

1. Alan Cunningham, *op. cit.*, vol. III, p. 374.
2. Two versions, one illustrated in Charles Saunier, 'M. Auguste' *Gazette des Beaux-Arts*, vol. LII (1910), facing p. 242, the other in *Voyage de Delacroix au Maroc 1832 et Exposition Retrospective du Peintre Orientaliste M. Auguste* (Paris, Musée de l'Orangerie, 1933), no. 260. The drawing is also called *Two Beauties* and is sometimes seen as an allegorical representation of Europe and Africa.
3. Illustrated in *Equivoques* (Musée des Arts Decoratifs, Paris 1973).
4. Alan Cunningham, *op. cit.*, vol. III, pp. 330-31.

On 28 January 1841, Wilkie wrote in his diary, 'Made a drawing of a child of Mr. James Whittall, and Nurse',[1] a note not precise enough to link it definitely with this drawing, which is perhaps too unfinished to merit even a cryptic mention. An intimate and unfinished example of Wilkie's work, it is quite unusual in subject. The juxtaposition of black and white skin was a major motif in Orientalist art, but most often involved the exposed flesh of mature women in the bath or harem. One of the earliest works to include such a parallel was *The Friends* by M. Auguste,[2] doyen of the young French artists who possessed a romantic attachment to the East. Among the first large scale Salon paintings of a white odalisque attended by a black slave was one shown by Jean Jalabert in 1842.[3] The theme was taken up by many Orientalists, especially Gérôme, while Manet's controversial *Olympia* brought the Eastern motif back to the Parisian *boudoir*. The black, almost invariably in a servile role, was offered as a more muscular, active, coarser counterpart to the soft, slothful and seductive Circassian. It was the sort of strong opposition, like that of sunlight and deep shadow, which visitors saw as typifying the East; certainly it suited their desire to simplify the complexities of a foreign culture. One passage in Wilkie's writing particularly defines his visual material in terms of black and white; it comes from his visit to Prince Hallicoo Mirza on 27 October, 1840, when he drew a little girl:

> She was a white, but had a little colour, full eye and lip, very long hair, and rich dress; she had no expression and was perfectly silent; it was not explained what she was; perhaps she might be a slave — a Circassian slave: there was an elderly black in the house, who looked much like an eunuch; there was a young black girl, a slave, and a white woman, a Turk, in the house: it was a singular and characteristic scene.

Even if Wilkie chose the subject of this drawing for its 'singular and characteristic' Eastern quality, there is a notable lack of condescension in his characterisation. More attention is given to the nurse than to the child. Her feet almost stand up out of her slippers as she raises her knees to draw her charge closer. Her arms interlock round the baby, her head is lowered in a gentle tangent, and her lips lightly rest on the child's left forehead, where Wilkie has put a strong touch of white, as if to emphasize that emotional contact. Her reflective gaze goes not outward but inward, and with her pose suggests that not just her body but her whole inner being is bound up with this child. Although the white baby's features are summary, they still cleverly convey the self-absorbed contentment of a much-loved infant. Sketchily indicated on the floor is a less cared-for canine, whose prominent ribs articulate his insignificance alongside the well-fed child.

William Wyld

1806, London — 1889, Paris

Just as Tissot (*q.v.*) is sometimes mistakenly considered English, so Wyld has often been added to the French school. Posthumously his long career in France has worked to his disadvantage, resulting in neglect by art historians of both schools.

Wyld's father and grandfather were eminent London merchants, and he was not allowed lessons to develop his gift for drawing, lest he might foolishly pursue it as a career. According to the artist himself:

> In those days, the choice of art as a profession might have turned a gentleman out of all (so-called) respectable society.[1]

The premature death of Wyld's uncle, a talented amateur artist, provided the young William with a precious paint box and works to copy. After boarding school, Wyld became Secretary to the English Consulate at Calais, a significant spot, since all important dispatches and visitors from England passed through there. In Calais he became friends with the painter Louis Francia, one of the early members of the Old Watercolour Society and the teacher of Bonington (*q.v.*), whom Wyld thought owed much to his master. In addition to personal contact with the artist, Wyld was lent Francia drawings to copy by no less a personage than Beau Brummell. Wyld's family was close to Canning; when the Prime Minister died, there seemed little future for Wyld in the consular service, so another uncle found him a job in the wine trade. On holiday before taking up his post, Wyld shared a coach with Horace Vernet, a fortuitous meeting which would prove fateful in his career. Wyld worked at his job for six years in Epernay, frequently visiting the Louvre and the Luxembourg on his trips to Paris.

In 1833 his younger brother succeeded him at his job, and Wyld went off with Baron de Vialar on a visit to Algeria. The Baron was so taken with the country that he bought property there and even ended up becoming President, while Wyld stayed for six months. During that time, Horace Vernet passed through Algiers; Wyld went to renew their acquaintance and was delighted when Vernet judged from his drawings that he indeed possessed the necessary *feu sacre*[2] to become an artist. As Director of the French Academy, Vernet had a personal Man-of-War at his disposal, on which he insisted Wyld sail with him to Rome. There Wyld met Thorwaldsen, the famous Danish sculptor, who commissioned three or four watercolours. From Rome, Wyld moved to Venice in the autumn of 1833, doing sketches which he later drew onto lithographic stones to be filled in by Emile Lessore. After a perilous crossing of the Alps, Wyld went straight to Paris and began a belated artistic career that flourished for fifty years. He became celebrated not as a pastoral landscapist but as a painter of continental cities. He collaborated with Lessore in the publication of fifty Algerian views which were published in 1835 and dedicated to Horace Vernet.

Wyld had little difficulty establishing himself in the Paris art world, the polish and friends (names still famous like Moet and Perier) acquired during his days in the wine trade standing him in good stead. Wyld became friends with Paul Delaroche and Ary Scheffer, and much admired Decamps (*q.v.*). He exhibited regularly in the Salon from 1833, winning a Third Class Medal in 1839 and a Second Class Medal in 1841. The 1848 Revolution temporarily slowed picture sales, and Wyld sought patrons in his native country, sending two watercolours to the New Watercolour Society, of which he was elected an Associate. When his *View of Oran* in the 1849 Salon remained unsold, he sent it to England; with increased success there, he decided to take a flat in London. In 1852 he was honoured with an invitation from Queen Victoria to sketch the environs of Balmoral, but when the International Exhibition was held in 1855 at the Palais de l'Industrie, Wyld acceded to the request of the Comte de Nieuwerkerke that he show as a member of the French School. Wyld's six paintings, which included a six-foot view of a sixteenth century regatta at Venice, won him the Legion of Honour, presented directly by the Emperor. For the rest of his life Wyld was able to repeat and vary the same subjects, appealing to the sort of clientele he had established in the first half of his career.

1. Quoted in Philip Hamerton, 'W. Wyld's Sketches in Italy', *Portfolio*, VII (1987), p. 64.
2. *Ibid*, p. 6.

Bibliography:
Philip Hamerton, 'W. Wyld's Sketches in Italy', *Portfolio*, VII (1987), pp. 64-66, 126-9, 140-4, 161-4, 178-80, 193-6.
Marcia Pointon, *Bonington, Francia and Wyld*, London, Victoria and Albert Museum, 1985.

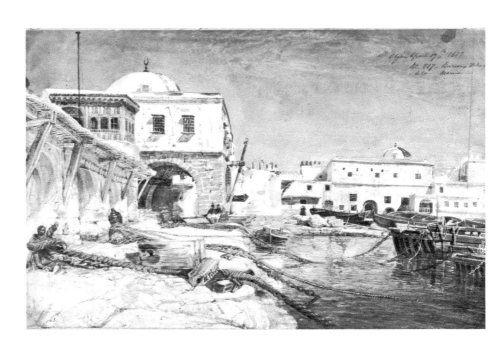

70 Bureaux des Magasins de la Marine, Algiers

Watercolour and gouache on paper,
26.8 x 41 cm.

SIGNED: left centre, on a woodblock, in
watercolour.

INSCRIBED: upper left, in ink, *Algiers April 19th
1833 — no 217 Bureaux de (sic) Maga/de la
Marine--.*

NUMBERED: lower left, in ink, *62.*

PROVENANCE: James Connell & Sons, from
whom purchased, 1920.

LITERATURE: Marcia Pointon, *Bonington,
Francia and Wyld* (London 1985), pp. 69, 75,
illus. fig. 32.

**The Whitworth Art Gallery, University of
Manchester**

In a recent catalogue including this work, Marcia Pointon has argued:

> Wyld's Algerian views exemplify the disjuncture between topographical
> reportage and the process of myth-making. In the transformation from on-
> the-spot images to popular lithographs or grand salon paintings we can discern
> important shifts and modifications. There is a process of distancing and
> generalization on the one hand and a deliberate adjustment of content and
> detail on the other, both going on simultaneously. Wyld's gouache study
> of the *Bureau et (sic) Magasins de la Marine, Algiers*, in the Whitworth Art
> Gallery, University of Manchester, features some of those tell-tale absences
> identified by Linda Nochlin as characteristic of Imperialist imagery of the
> Orient: the absence of scenes of work and industry, the apparent absence
> of art strategy, of that which reminds the viewer of the 'bringing into being
> of the work', the absence of history suggesting a world without change. There
> exist independent sketches of Arab figures by Wyld which he used at later
> stages, but the initial view is virtually uninhabited; the only sign of life is
> two distant figures inert upon a bench.[1]

There are a few problems here. Not that absences tell no tales; omissions can
be significant. But strong Eastern sun does send most people other than crazy artists
into the shade, where Pointon might glimpse an extra figure or two. Wyld clearly
did this work on-the-spot (we know exactly when), so perhaps her myth-making
criticisms are not meant to apply. But anyone who has ever tried a watercolour —
quite a few people — can follow the 'bringing into being' of this picture all over
its surface (the sky, for example). As for the absence of history, it is tempting to take
the easy way out and say Wyld was not a history painter. But if what she wants is
a French flag or two, I wonder if the uniform those two seated men wear may not
have something to do with colonial administration. Colonialism is not only a more
important historical 'fact' and artistic subject than a set of offices and warehouses
used by the French navy on an empty quay on a sunny day in Algiers, 19 April,
1833, it is also a *different* artistic subject. Too much dwelling on absences does lose
sight of the rather pleasant presence of the topographical skill that Wyld aimed here
to demonstrate he had developed as an amateur artist and was soon to turn into a
profitable professional career. At this stage in his evolution Wyld certainly seemed
part of the intimate and, yes, sensitive English watercolour school. Compared to the
dramatic orchestration of David Roberts (*q.v.*), Wyld's distortions' are fairly minor.
On the whole this is a fairly unfiltered example of the East experienced, certainly
an inappropriately slight image on which to hang Linda Nochlin's weighty
arguments.[2] A smaller watercolour of this scene, comparatively full of figures and
curious architectural differences, was sold by Spink & Son in the spring of 1978.

1. Marcia Pointon, *op. cit.* (1985), p. 75.
2. Linda Nochlin, 'The Imaginary
Orient', *Art in America*, vol. 71 (May
1983), pp. 118-31, 187-91.

Irish Orientalists[1]

JAMES THOMPSON

Some past and present writers would scoff at the term 'Irish Orientalists' since, according to their theory, the Irish *are* 'Orientals', descendants of North Africans or races further East, who were the first to colonize this country and possibly Britain as well. At the end of the eighteenth century Charles Vallancey, an English engineer, argued for an Eastern origin of the Irish, engaging in heated scholarly debate with Edward Ledwich, Irish vicar and antiquarian. Vallancey published his proposed pedigrees in two books, *The Ancient History of Ireland Proved from the Sanskrit Books of the Brahmins of India* (Dublin 1797) and *An Essay on the Primitive Inhabitants of Great Britain and Ireland, Proving that They Were Persians or Indoscythes* (Dublin 1807). Somewhat later the physician James Cowles Prichard employed complex linguistic parallels in his book *The Eastern Origin of the Celtic Nations Proved by a Comparison of their Dialects with Sanskrit, Greek, Latin and Teutonic Languages* (Oxford 1831). In our own century the historian Budgett Meakim suggested in *The Moors* (London 1902) that the Berbers were connected to 'the little black Celts' and were ancestors to part of the population of Cornwall, Wales, Scotland, and Ireland. Wyndham Lewis, in the memorable account of his 1931 Algerian Travels, *Journey into Barbary* (republished Penguin Travel Library 1987), quoted Meakin approvingly and elaborated on his conclusions. Most recently of all in his *Atlantean* (London 1986) Bob Quinn has more extensively argued a controversial line that associates the *sean-nos* singing of Connemara and the music of North Africa, the Book of Kells and a famous Arab manuscript called the *Ibn Al Bawwab*, a tumulus near Tangier and Newgrange, and several other similar aspects of North African and Irish traditions.

Yet leaving aside the issue of a deeper ethnic link, there were certainly many men of Irish descent or residence who, like countless other Europeans, went to the East to be astonished by the difference and distance that separated them from the Arab peoples.

Probably the most significant 'Irish' traveller to the East in the eighteenth century was Richard Pococke. Born and educated in England, Pococke was appointed at age twenty-one Precentor of Lismore Cathedral by his maternal uncle, the Bishop of Waterford and Lismore. In 1734 his uncle made him Vicar-General of his diocese, but Pococke had already begun a remarkable series of travels that took him, first all over Europe, then to Egypt, where he arrived in Alexandria on 20 September, 1737. He met Cosmas the Greek patriarch in Rosetta, and went up the Nile as far as Philae. By February, 1738, he was in Cairo, whence he proceeded to the Holy Land. There he visited Jerusalem and bathed in the Dead Sea, to test the accuracy of Pliny's pronouncements. He went into Palestine, explored the ruins of Baalbek (see Roberts, no. 59) visited Cyprus, climbed Mt. Ida in Candia, and saw something of Asia Minor and Greece. His account of his journeys, *A Description of the East, and Some other Countries*, came out in two volumes, the first (1743) concerned with his observations of Egypt, the second (1745) with Palestine, Syria, Mesopotamia, Cyprus, Candia, Asia Minor, Greece, and parts of Europe. The latter volume was dedicated to the Earl of Chesterfield, Lord Lieutenant of Ireland, whom Pococke served as domestic chaplain. In 1744 Pococke was made Precentor of Waterford, the following year Archdeacon of Dublin, in 1756 Bishop of Ossory, and in 1765 Bishop of Meath. In the demesne of Ardbraccan he planted the seeds of Cedars of Lebanon which are still standing. Pococke was portrayed in a splendid portrait (Musée d'Art et d'Histoire, Geneva) by the Swiss painter Jean-Etienne Liotard,[2] to whom he was probably introduced by the Irish landowner Richard Ponsonby, an extensive Eastern traveller himself, who had taken Liotar into his entourage and was also depicted by the painter in Oriental dress (coll. Earl of Bessborough). Other Irish aristocrats painted by Liotard include the wild Simon Luttrell of Luttrellstown *en Turc* (Kunstmuseum, Bern), though most recent scholarship indicates Luttrell never visited the East.

In 1811 Sir Francis Beaufort of Navan, county Meath, surveyed part of the coast

1. This brief survey can be but superficial; I only hope that it may suggest areas of possible future study. Contemporary with this exhibition Professor George Huxley has mounted at the Gennadius Library of The American School of Classical studies in Athens an important show on *Ireland and the Hellenic Tradition*, which will cover in considerable detail the long history in Ireland of Greek studies, Irish scholars of Greek in Europe, Irish travellers in Greece, and many other aspects of the connection. A similar exhibition on *Ireland and the East* might someday make a fine display at the Chester Beatty Library.
2. The Pococke portrait appeared on the cover of *The Irish Arts Review* (Summer 1987), which contained the interesting article by Brian de Breffny on 'Liotard's Irish Patron', accompanied also by handsome reproductions of the portraits of Ponsonby and Luttrell.

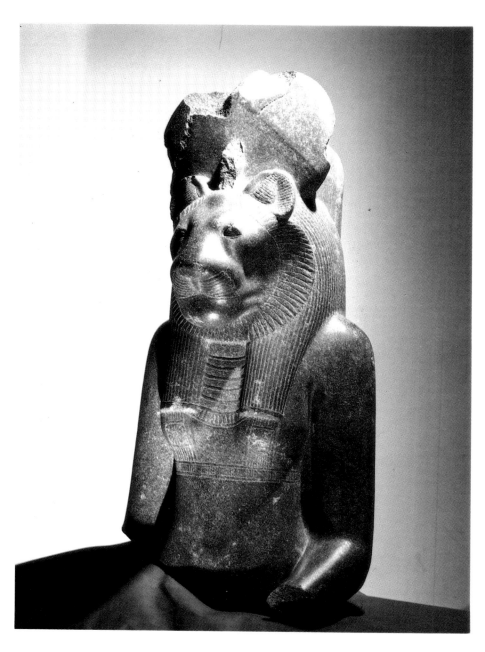

Fig. 40 *The Goddess Sekmet,* Thebes, 18th Dynasty, reign of Amenhotep III, 1403-1365 B.C., diorite sculpture. Formerly in the collection of the first Marquess of Dufferin and Ava (Sir Frederick Temple), Clandeboye, Co. Down (photograph courtesy of Sotheby's, New York).

of Syria, as outlined in his book *Karamania, or a Brief Description of the South Coast of Asia Minor* (London 1817). General Francis Rawden Chesney, of Annalong, county Down, in 1829 set out too late to fight for the Turkish Army during their War with Russia. But Sir Robert Gordon, British Ambassador to Constantinople, then commissioned Chesney to tour Egypt and Syria. Chesney's favourable reports on the feasibility of a canal linking the Mediterranean with the Red Sea overturned the adverse conclusions of Napoleon's engineers, and no less a personage than de Lesseps himself called Chesney the 'father of the Suez Canal'. Under Chesney's supervision in 1835 a large expedition was mounted to explore a route to the East via the Tigris and Euphrates rivers. During the exploration one ship sank with a loss of twenty lives; Chesney returned home in 1837, leaving a Mayo man, Lieutenant Henry Blosse Lynch, to navigate successfully from Armenia to Bagdad. Chesney published two accounts of his adventures, *The Expedition for the Survey of the Rivers Euphrates and Tigris* (London 1850) and *Narrative of the Euphrates Expedition* (London 1868).

Father of the famous writer, George Henry Moore of Moore Hall, county Mayo, journeyed to the Holy Land in 1836. His travel manuscript is today in the National Library in Dublin, and his Dead Sea Diary and Syrian Diary include sketches of buildings and costumes. His detailed description of the Dead Sea was used in the Encyclopedia Britannica until 1876. Might his Eastern trip have partly inspired his son's later interest in the Life of Saint Paul and the death of Jesus, as portrayed in books such as The Brook Kerith (1916)?

Edward Hincks, the rector of Killyleagh, county Down did important work in deciphering cuneiform, and his bust is today in the Cairo Museum. He also collected a mummy for the Ulster Museum in Belfast. Among other interesting Egyptian objects secured by Irishmen was a majestic diorite figure of the lion-headed goddess Sekmet, from Thebes, which belonged to Sir Frederick Temple of Clandeboye, county Down (Fig. 40), and which was just sold at auction in New York for almost half a million dollars.[3]

Two exceptional Irish writers dabbled in literary Orientalism. Oliver Goldsmith in his book The Citizen of the World (London 1762), followed the tradition of Montesquieu's celebrated Persian Letters (Paris 1761), whereby an ethnic outsider (in this case Chinese, or Far-Eastern) cast a naïve, honest and perceptive glance at Western society.[4] Thomas Moore's long poem 'Lalla Rookh' (London 1816) occupied perhaps greater prominence in England than Hugo's celebrated cycle Les Orientales more than a decade later in France, though neither poet ever got near the East. Longmans, Moore's publisher, offered him the largest advance — £3,000 — ever given for a poem, before he had even chosen a subject. Moore's decision to situate the work in the East was probably inspired by the vogue for such themes initiated by his friend Byron. Although it appeared in a commercially disastrous year, Moore's poem enjoyed a success that rivalled Byron and Scott not only in England but all over Europe. An interesting aspect of Moore's grandiloquent exposition of the Imaginary Orient was the way in which he managed to sneak in some patriotic Irish feelings in a poem set so far away. Moore wrote other verse with Eastern subjects, but nothing nearly so popular.

In 1838 Henry Torrens, an Irish army officer, began to publish at the same time as Edward Lane, a translation of The Book of the Thousand Nights and One Night, but his commendable effort (later remarked favourably by the acidic Burton) ceased after the first volume.

Some of the most significant writers on the East had close Irish connections. Both parents of Edward Fitzgerald (whose family took his mother's name in order to receive an enormous inheritance), letter writer extraordinaire and author of possibly the English-speaking world's most famous 'translation', The Rubaiyat of Omar Khayyam, were Irish. The paternal grandfather of the dashing Sir Richard Burton was rector of Tuam and owner of an estate in county Galway, while Thomas Robert Chapman, father of the illegitimate T. E. Lawrence, came from an Anglo-Irish landowning family.[5] Of the following Irish Orientalist painters who are discussed at greater length, further exploration is needed: Alfred Elmore's Eastern subjects, could they all be found, might comprise the most attractive group of pictures by a fairly anodyne Royal Academy artist; Richard Fox's interest in the Orient is as undefined as the rest of his life; Norman Garstin's Tangier works would be well worth reassembling alongside his eloquent article; Hone's Eastern views will undoubtedly comprise an interesting subsection of his future retrospective in the National Gallery of Ireland; Lavery's quite extensive Moroccan output over the years could make a nice show on its own; and finally O'Kelly's little-known Eastern oeuvre promises to expand with several new discoveries, now that such pictures are in vogue.

3. Sir Frederick Temple, the First Marquess of Dufferin and Ava, probably got the statue in the mid-nineteenth century. It was sold by the Fourth Marquess at Christie's in 1937, and, most recently, at Sotheby's in New York, 24 November 1987, lot 43.

4. Goldsmith's novel is one of the few works to gain a grudging admiration from Rana Kabbani in her angry, perceptive attack on Western views of the East, Europe's Myths of Orient: Devise and Rule (London 1986).

5. Such an amazing pair inspires a strong temptation to essay some dangerous generalization about an Irish background spawning extremes of sexual expression and repression.

Alfred Elmore

1815, Clonakilty, County Cork — 1881, Kensington, London

Elmore's father was a surgeon in the 5th Dragoons, who retired from the service, and took his family to London when Alfred was twelve years old. Alfred began his artistic career drawing sculpture in the British Museum, then enrolled at the Royal Academy Schools in 1832. At age nineteen he exhibited his first picture *A Subject from an Old Play* at the Royal Academy, and shortly after visited Paris. In 1838 he exhibited a *Crucifixion* at the British Institution and in 1839 *The Martyrdom of St. Thomas Beckett*, which he painted for Daniel O'Connell; both works are now in St. Andrew's Church, Westland Row, Dublin.

In 1840 Elmore left London for a long period abroad that began with an extended stay in Munich, as well as visits to Venice, Bologna, Florence, and Rome, where he remained two years. He returned to England in 1844 and that year exhibited his *Rienzi in the Forum*. The following year he was made an Associate of the Royal Academy for his *Origin of the Guelph and Ghibelline Quarrel*. His *Invention of the Stocking Loom* in 1847 was extremely popular and he painted a companion work *The Origin of the Combing Machine* (*Royal Academy*, 1862, no. 135) fifteen years later. He was elected an Academician in 1857 and painted a scene from *Two Gentlemen of Verona* as his diploma work (*Royal Academy*, 1858, no. 120).

Elmore's painting of *The Tuileries, 20th June, 1789*, where Marie Antoinette and her children are being insulted by the Revolutionary mob, was, according to Ralph James, the picture by which Elmore's name 'will be handed down to posterity' and for Strickland Elmore's 'best picture', though a contemporary Frenchman offered a strongly dissenting opinion about Elmore's depiction of his country's history.[1]

The first glimmer of Elmore's Orientalism appeared as early as 1847, when he sent to the Royal Academy a picture whose complete title read *Laura by the side of her adorer, when lo! the Mussulman was there before her* (no. 317). But his Eastern interests were not to be pursued seriously for another two decades, when he exhibited in 1868 the Biblical *Two women shall be grinding at the mill* (no. 205) at the Royal Academy, along with *Ishmael* (no. 235). The following year he showed *Home Life in Algiers* (no. 229) and *Algerian Jewesses* (no. 462), as well as a *Judith* (no. 395), introducing a subject he developed two years later (see following entry). In 1870 he showed *An Arab Toilet* (no. 986) and in 1871 exhibited, with his *Judith and Holofernes* (no. 1120), *After the Siesta — Algiers* (no. 526). In 1876 he sent *A M'Zabi. 'A hewer of wood and drawer of water'* (no. 482) to the Royal Academy, and in 1880, *An Eastern Bath* (no. 169). Thus a significant part of Elmore's work touched upon Oriental subjects, though no writer has yet suggested that he might have visited the East.

Today Elmore is generally overlooked, a competent but undistinguished Victorian history painter of a wide range of subjects, working on a grander scale but with little more distinction that Westall *(q.v.)* earlier in the century. Elmore was made an Honorary Member of the Royal Hibernian Academy in 1878.

1. The first quote is from Ralph N. James, *Painters and Their Works*, vol. I (London 1896), p. 347, the second from Walter Strickland, *A Dictionary of Irish Artists*, vol. I (Dublin 1913), p. 323. See also Ernest Chesneau, *La Peinture anglaise* (Paris n.d.), pp. 279-80: 'M.A. Elmore (1815-1880) qui fut aussi de l'Académie royale, mais dont le tableau des *Tuileries, le 20 juin 1792*, a reculé les bornes de la mauvaise peinture et du faux melodrame. On ne peut se faire une idée de cette facture insensée, de ce dessin monstrueux, de cette couleur criarde, de ces lumières éparpillées et jetées au travers de la toile.'

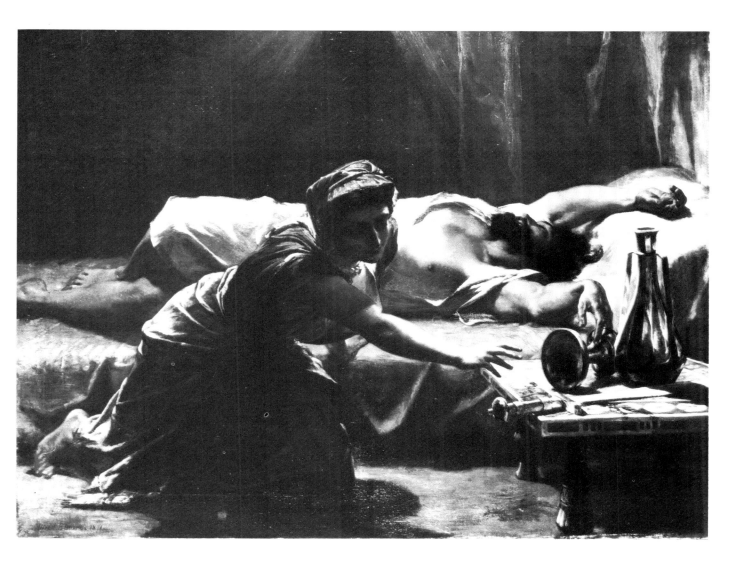

71 Judith and Holofernes

Oil on canvas, 71 x 94 cm.

SIGNED AND DATED: lower right, *Alfred Elmore, 1871*.

EXHIBITED: 1871, Royal Academy, no. 1120; 1987, Gorry Gallery, Dublin, no. 20.

Private collection, courtesy of the Gorry Gallery, Dublin.

In 1869 Elmore exhibited a *Judith* (no. 395) at the Royal Academy; two years later he showed this picture. Although not mentioned in the surveys of his work, it is one of his most impressive and successfully dramatic compositions. Having silently risen from the still-warm spot on the bed where her left hand rests, Judith stretches the fingers of her right hand toward the hilt of the sword with which she will decapitate the sleeping, drunken Holofernes, chief of the army that is about to invade her country. Extending his muscular limbs in his stupor, Holofernes has tipped over his large chalice, and the streams and stains of the spilt wine effectively anticipate his blood about to be shed. Judith is attired in red, alternating with white on her skirt like strips of flesh and blood. The sword is gold and silver, its blade visually broken by the cast shadow of the silver carafe, alongside the gold chalice. Elmore suggests the shine of valuable metal and dots the highlights on Judith's pearl necklace. His anatomy can be faulty, particularly in the foreshortened shoulder join of arm to torso, and there is little Eastern authenticity in either objects or decor. Yet it is a work of authentic and understated, power, certainly one of the best 'Irish' history paintings of the second half of the century.

Robert Fox

1810, Dublin — 1883, Dublin

Fox was born the son of a shoemaker in Bishop Street. He enrolled in the school of the Royal Dublin Society in 1835 and stayed until 1839, winning prizes every year he was a student there. He began exhibiting in the Royal Hibernian Society in 1841, where he ultimately showed forty-seven works, the British Institute of Artists in 1846, (thirty-four works) and the Royal Academy in 1853 (thirty-five works). From 1850 until his return to Dublin in 1868 he lived and painted in London. The pictures he showed in London were mainly genre and history subjects, while in Ireland he exhibited more landscapes and scenes featuring peasants and fisherfolk. One unusual religious painting, *The Daughter of Jephthah* he displayed first in the Royal Academy in 1857 (no. 140), in the British Institution the following year (no. 230), in the Royal Hibernian Society in 1860 (no. 112), and again in the Royal Academy in 1862 (no. 592). Exotic subjects appeared with some frequency in Fox's work: *A Greek Girl* (no. 1318) in the Royal Academy in 1854, and *Head of a Hindoo* the same year (no. 406); *The Chief of his Tribe* (no. 1364) in the 1855 Royal Academy show, some Spanish subjects in the early 1860s, *An East Indian* in 1864 (Royal Academy, no. 438) and *Head of an Arab* in 1866 (Royal Academy, no. 76). Fox last exhibited at the Royal Hibernian Academy in 1882; he resided the final years of his life at 4 Victoria Terrace in Rathgar.

Bibliography:
Algernon Graves, *The Royal Academy Exhibitors, 1769-1904*, vol. III (London 1905), p. 153.
Walter Strickland, *A Dictionary of Irish Artists*, vol. I (Dublin 1913), p. 381.
Anne Stewart, *Royal Hibernian Academy of Arts: Index of Exhibitors and their works 1826-1979*, vol. I (Dublin 1985), p. 274.

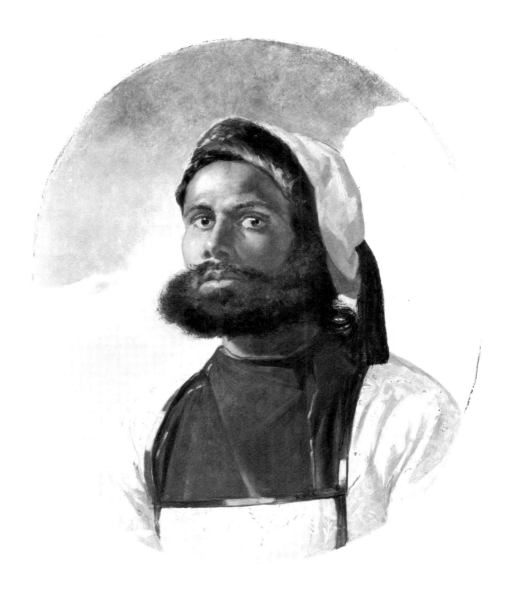

72 Head of an Oriental

Oil on canvas, 60 x 49 cm.

SIGNED: *R. Fox*

PROVENANCE: Cynthia O'Connor and Co. Ltd., where purchased, 1976.

LITERATURE: *National Gallery of Ireland, Illustrated Summary Catalogue of Paintings* (Dublin 1981), no. 4187, p. 206.

National Gallery of Ireland (cat. no. 4187).

When this picture first came to the National Gallery, it bore the false signature of 'William Müller' (*q.v.*), possibly inspired by the *Head of a Cingari, Xanthus* he exhibited at the Royal Academy in 1845 (no. 203). Fox himself showed a *Head of a Hindoo* at the Royal Academy in 1854 (no. 406) and a *Head of an Arab* there in 1866 (no. 76). Of the two this is more likely the latter, although he is not anyone's idea of a typical Arab. His costume and appearance suggest the Balkans or Albania,[1] while his dark complexion might situate him further South in Arab lands, rather than far enough East for him to be a *Hindoo*.

Fox clearly took pleasure in the colours and textures of his subject's exotic dress and appearance, the fur trim and black tassel of his bright red hat, his bushy beard, his olive tunic and his outer blouse of patterned satin or silk, reddish gold decorated with blue dots and trimmed in blue ribbon. Perhaps the artist himself attired a London ethnic type in a bright composite costume, making current difficulties in specific identification quite understandable.

1. I am grateful to Briony Llewellyn for her help in trying to place the costume, race or country of this figure.

Norman Garstin

1847, Cahirconlish, County Limerick — 1926

Garstin was the only child of an Anglo-Irish regular soldier, Colonel William Garstin, and an Irishwoman, Mary Hastings Moore, who was related to George Moore. Tragedy dogged the young Norman: his mother was afflicted with a form of muscular paralysis that left her unable to speak, and his father subsequently committed suicide. Garstin was raised by a succession of relations and guardians; his health was delicate, and his belated decision to become a painter was, ironically, precipitated by the loss of his right eye.

Before that accident Garstin had studied engineering and architecture, and dug for diamonds in South Africa, where he was friends with Cecil Rhodes and for a short space of time a successful journalist, a skill he later practised intermittently in his occasional writings on art. Back in Ireland, he lost his eye when he was struck by a thornbush while riding. His aspirations as a painter led him to Antwerp, where Walter Osborne and Joseph Malachy Kavanagh were also working. There Garstin studied first with Charles Verlat and then with Theodore Verstraete. After Antwerp Garstin moved to the studio of Carolus Duran in Paris, where he may have overlapped Helen Mabel Trevor. In Paris, Garstin met Degas and admired the work of Manet. While concluding, in an *Art Journal* article of 1884,[1] that it was 'hardly possible that posterity will accept him as a great painter', Garstin was eloquently sensitive to Manet's qualities and his pivotal importance in Western art:

> ...there is delicious brightness and happiness in his work - it is a world of *sans-souci*. He lets in air and light. Pictures like his later ones amongst the brown bitumen canvases of the average exhibition seem like patches of sunlight on a prison wall. It is hardly possible to overestimate the value of Manet's work upon modern painting. He had no receipt; he sat down before nature with the pleasure and simplicity of a child, and gave to us the light and air and joy of outdoor life.[2]

Garstin sent his first picture to the Royal Academy in 1883, listing an Irish address, but that same year was in the South of France. In 1885 he was in Venice and in Tangier. There he stayed with Ion Perdicaris, a wealthy Greek-American friend from Paris who had served as Garibaldi's emissary to London. Perdicaris later memorialized their North African adventures in his novel *Mohammed Benani*, where the hero, Frank Weston, was based on Garstin. Garstin himself described Morocco as 'an Arabian Nights existence, where anything could happen'.[3]

After his return, Garstin married an Englishwoman, but was travelling again in 1886 on the first of two visits to Canada, the second coming in 1892. In 1889 Garstin exhibited what has been called his most important painting[4], *The Rain it Raineth Every Day*, a work in which the ambitions of his Academy submissions met the spontaneity of his outdoor sketches. The title of the picture comes from *King Lear*, its subject was the Promenade of Penzance, the Cornish town in which Garstin had settled and to whose Corporation he donated the painting. Penzance was near Newlyn, where several artists such as Stanhope Forbes had gathered; Garstin was regarded, partly on account of his writing, as the intellectual of the group, known today as the 'Newlyn School'. Due to his guardians' mismanagement of his money, Garstin became bankrupt and had to supplement his sporadic painting sales in his later years with teaching. His two sons extended his literary gifts as writers, while his daughter Alethea became an accomplished painter whom some critics rate higher than her father; she also visited North Africa, going twice to Morocco in her red Morris Eight tourer with her eighty-year old mother.

1. The article is signed 'N. Garstein' (sic) but has been attributed to Garstin, who wrote several more articles for the *Art Journal*.
2. 'Edouard Manet', *Art Journal* (1884), p. 110.
3. Quoted in *Norman and Alethea Garstin, Two Impressionists — Father and Daughter* (Penwith-Bristol-Dublin-London 1978), p. 19.
4. *Ibid*, p. 20.

Bibliography:
Julian Campbell, *The Irish Impressionists*, (Dublin 1984), pp. 85-6, 130, 193-7.
Norman and Alethea Garstin, Two Impressionists — Father and Daughter, Penwith-Bristol-Dublin-London, 1978.
Artists of the Newlyn School (1880-1900), Newlyn-Penzance, Bristol, 1979.

73 Seated Arab, Tangier

Oil on canvas, 32 x 50 cm.

SIGNED, INSCRIBED AND DATED: lower left,
NORMAN GARSTIN/TANGIER/1886.

PROVENANCE: Gorry Gallery, Dublin, sale
1984, lot 41, where purchased.

EXHIBITED: 1984, Gorry Gallery, Dublin,
no. 41.

**Private collection, courtesy of the Gorry
Gallery, Dublin.**

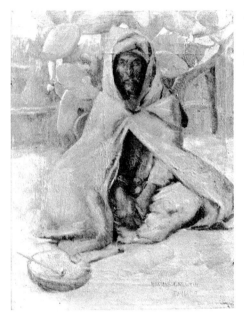

Fig. 41 Norman Garstin, *A Tangerine
Beggar,* oil on canvas (Private
collection).

In his article 'Tangier as a Sketching Ground' Garstin mentioned the difficulties in obtaining models due to a Koranic ban on figure representation.[1] But by dint of persuasion or pay, Garstin did manage in at least two small pictures to paint Arabs comfortably seated. In the other work, *A Tangerine Beggar* (Fig. 41), Garstin approached an older man head-on, his ascetic face shadowed by his hood, his legs crossed and knees flattened to create a strong compositional triangle before the prickly pads of the nopal cactus behind.

The younger Arab in this work does not engage the spectator directly but instead seems lost in his own sad thoughts. Juxtaposed with the corner rubble of a destroyed structure, his disconsolate introversion could be read as a concetto on vanished Muslim might, fallen in the face of Western colonial conquest, and set before the recurring, infinite blue horizon of the Mediterranean. Garstin's picture is, however, much more about painting than it is about colonialism. In his article on Tangier, he referred to 'the illimitable gradations of white':

> the white of eggs, the white of milk, the white of cream, the white of teeth, the white of pearls, the white of opals, yes, and even the immaculate white of fair women...[2]

For apart from the distant blue of the sea, the olive shades of the vegetation and the tawny tones of the Arab's skin, this is a picture that concerns itself with many and varied whites, from the warm pink white of the wall behind the man to the pale green white of his robe, from the cool blue white of the sky to the immaculate white of his turban. It is also a picture about the bravura of the artist's brush, what the painter Patrick Heron described with reference to one of the Tangier landscapes as Garstin's

> wonderfully sensitive mastery of this stroking and stabbing and smudging technique of the tiny, sharp and blunt brushes.[3]

Certainly one of the delights the picture provides is to follow the lively way the artist has created structure and texture with his square-headed brush. One of the factors in Garstin's ability to produce inventive, vivid images out of what had become fairly banal subject matter was his awareness, as Fromentin (*q.v.*) had argued much earlier, that exoticism of subject was not itself sufficient to make distinctive work. As he declared in his article on Tangier, written in the form of a letter to a friend:

> I more than sympathise with your lack of interest in the banalities of Eastern pictures. The art of painting consists of new and personal visions of old and familiar scenes, whereas the commonplace painter, whether of the East or West, is forever presenting you with impersonal and wearisomely familiar visions of scenes that are sometimes new and sometimes old. Furthermore, when he goes to the East he is apt to mistake the freshness of his surroundings for something fresh and striking in itself, forgetting that it is only fresh to him, and that the original treatment of a rag-fair in the East end of London would be more interesting than the commonplace rendering of harems and bazaars in the gorgeous East of the world.[4]

1. Norman Garstin, 'Tangier as a Sketching Ground', *The Studio*, vol. II, no. 53 (August 16 1897), p. 182. The Koranic prohibition on figurative images is mostly a Western myth.
2. *Ibid*, p. 178.
3. Patrick Heron, 'Introduction', *Norman and Alethea Garstin, Two Impressionists — Father and Daughter*, exhibition catalogue, Penwith-Bristol-Dublin-London, 1978, p. 14.
4. Norman Garstin, *op. cit.*, p. 177.

Nathaniel Hone

1831, Dublin — 1917, St. Doulough's Park, Raheny, Dublin

Hone was the namesake and great-grandnephew of the famous Irish eighteenth-century artist. He studied Practical Engineering and Chemistry and Geology at Trinity College, graduating with honours at age nineteen. After starting a career as an engineer on the Midland Great Western Railway, he decided to become an artist and went to Paris in 1853 to study painting with Adolphe Yvon, a French painter of genre and battle scenes. In about 1854 Hone entered the studio of Thomas Couture, where he met Manet,[1] who was about the same age, and Fantin-Latour. Starting around 1855 Hone began to visit Barbizon, and he settled there in about 1857 for over a decade, possessing independent means. In Barbizon, Hone knew Millet, Jacques, and Corot. In 1865 he moved across the Fontainebleau Forest to Bourron-Marlotte, a smaller artistic colony, where he met Gustave Courbet, Théodore Rousseau, and Henri Harpignies (who became his best friend in France), as well as the young painters who were developing Impressionism: Monet, Renoir, and Sisley. Starting in 1865 Hone began to show in the Salon, listing as his teacher in addition to Yvon and Couture, Brandon, a close Paris friend whose portrait of Hone is in the National Gallery of Ireland. Hone also exhibited in the Salons of 1867, 1868 and 1869, but left for Italy around the time of the Franco-Prussian War.

Hone returned to Ireland in 1872 and married. After a Mediterranean honeymoon, he settled in the family estate at Malahide, later moving to Raheny in a property inherited from his uncle. According to Julian Campbell,[2] Hone painted in Constantinople and may have visited Palestine. In 1892 he travelled with his wife to Egypt, which he described as 'a pleasant place to paint in':

> The little Mussulman boys are much better behaved towards painters than is the average little Christian boy. One of them used to take charge of me and keep strangers and flies away with a horse-hair whisk whenever I set up my easel out of doors.[3]

After his death in 1917, Hone was described by one writer as the last survivor of the Barbizon School of painters; certainly he was Ireland's most vital link with the great innovations of French landscape in the nineteenth century.

1. Hone described Manet thus to Thomas Bodkin: 'He was a regular dandy in appearance, always well got up and elegant. He looked much more like a mere man of fashion than an artist' (unpublished notes on Hone, Trinity College, Dublin, quoted in Julian Campbell, *The Irish Impressionists*, (Dublin 1984), n. 11, p. 119).
2. Julian Campbell, *op. cit.*, p. 28.
3. *Ibid.*

Bibliography:
Julian Campbell, *Irish Artists in France and Belgium, 1850-1914*, Ph.D. thesis, Trinity College, Dublin (1980), pp. 24-29, 142-155.
Anne Crookshank and Desmond Fitzgerald, *The Painters of Ireland* (London 1978), pp. 251-2.

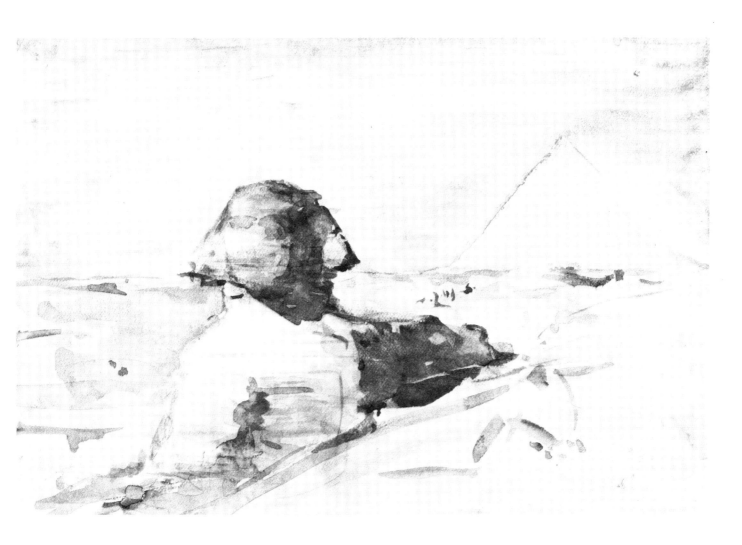

74 The Sphinx

Watercolour on paper, 12.5 x 17.4 cm.

PROVENANCE: Mrs. Magdalen Hone, by whom
bequeathed, 1919.

LITERATURE: *Catalogue of a Portion of the
Bequest made by the Late Mrs. Hone to The
National Gallery of Ireland* (Dublin 1921),
no. 4 (588), p. 6; *National Gallery of Ireland,
Illustrated Summary Catalogue of Drawings,
Watercolours and Miniatures* (Dublin 1983),
no. 3473, p. 321.

National Gallery of Ireland (cat. no. 3473).

The National Gallery of Ireland owns two watercolours of the Sphinx by Hone. The
other one views the monument from the opposite side: the time is set closer to midday
as evidenced by the shorter shadows and the sky, drained of intense colour, actually
suggesting greater heat, to which Hone was not receptive. He wrote back to Ireland
from Egypt:

> I am beginning to thirst for rain and grey skies.[1]

This drawing was done in blues and pale browns, with the two intermingling
in the Sphinx's dark shadows, which indicate late afternoon, or possibly early morning.
The paper has a rough surface, almost like the texture of canvas. The front body
and forepaws of the colossal statue have been freed from the sand, not by Mariette-
Bey (see Seddon, no 63), but by another Frenchman Gaston Maspero, excavating only
six years before Hone's arrival. The Great Pyramid in the right middle distance has
had its height slightly exaggerated, while in the oil it has been severely diminished.

1. Letter from Cairo, 6 March 1892,
Sarah Purser Papers, National Gallery of
Ireland, quoted in Julian Campbell, *The
Irish Impressionists, op. cit.*, p. 28.

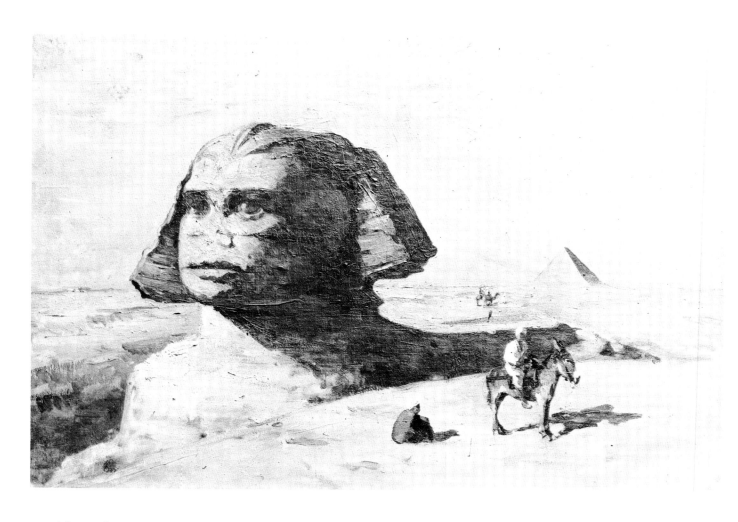

75 The Sphinx

Oil on canvas, 63 x 92 cm.

PROVENANCE: Mrs. Magdalen Hone, by whom bequeathed, 1919.

LITERATURE: *Catalogue of a Portion of the Bequest made by the Late Mrs. Hone to the National Gallery of Ireland* (Dublin 1921), no. 51 (16), p.4.

National Gallery of Ireland (cat. no. 1434).

1. Letter from Cairo, 6 March 1892, Sarah Purser papers, National Gallery of Ireland, quoted in Julian Campbell, *The Irish Impressionists, op. cit.*, p. 28. In *Cornhill to Grand Cairo*, Thackeray denied that there was anything sublime in the Pyramids, saying that he preferred Shelley's sonnets on them to the real thing. Much more recently Jonathan Raban (*Arabia through the Looking Glass* (London 1980), p. 285) suggested that seeing the Pharoahs' tombs would 'warm the cockles of the heart of any thorough going gangster':

> It is easy to imagine Al Capone or Ronnie Kray being moved to tears by the sight of the Great Pyramid. Every single enormous block of it tells you that Mister Big was here.

The National Gallery of Ireland Illustrated Summary Catalogue of Drawings (1983) lists the previous entry as a study for this oil sketch, but even though they share a similar viewpoint, it is hard to insist on any direct connection. Here the scene is set closer to the Sphinx, so that the exposed paws are hidden by the edge of the unexcavated ground. Hone felt no special affection for Egypt's massive monuments; in a letter he damned the Pyramids as emphatically as any tourist since Thackeray:

> The worst thing about this place is the pyramids. I hate the sight of these hideous piles of stones, momentoes (sic) of a grinding oppression.[1]

Hone took none of the pleasure of artists like Seddon (see no. 63) or Goodall in delineating the crisp sculptural lines and outlines of the solid sculptural mass, such as the finely carved upper lip. The strong shadows he painted in the Sphinx's dark eye sockets endow it with a curious life-like presence, though Hone has added more detail than in the watercolour, in the ridges of the *nemes* headcloth on the sides and top, where once a cobra *uraeus* would have projected. One only has, however, to glance at the brilliantly sketched donkey and its sunlit rider, set against the Sphinx's shadow, to realise where Hone's true enthusiasm went in this composition.

Sir John Lavery

1856,[1] Belfast — 1941, Rossenarra House, Kilkenny

The fluid facility and extensive productivity of Lavery's evolved style, particularly in his grander portraits, might suggest an artist who started life as society's darling, a silver spoon stuffed in his mouth. In fact the opposite was the case, and Lavery's final fairy-tale success came only after a beginning of Brothers Grimm horrors.

Lavery's father was a publican who drowned on an emigrant ship to America in search of a more profitable profession; Lavery's mother died of grief soon after. Orphaned at age three, Lavery was harshly but unsuccessfully disciplined by a stern aunt in county Down. At age eleven he was sent to another relative who owned a pawnshop in Scotland. After a return to Ireland, he worked in Glasgow for three years as an apprentice to a painter-photographer, managing to pay his own fees at the school of art there. His initial efforts to set out as an independent artist were aided by a felicitous fire in his studio, from which he collected £300 in insurance that got him to London, and on to the Academie Julian in Paris, where he was taught by Bouguereau (q.v.). Later moving to the artist's colony at Grez-sur-Loing, where Hone (q.v.) also worked, Lavery spent what Walter Shaw-Sparow called his 'happiest days in France'.[2] From 1883 Lavery began exhibiting in the French Salon, but he returned to Scotland to become a member of the Glasgow School of Painters, who helped spread the influence of French art in the British Isles. Lavery's *The Tennis Match* was a success first at the Royal Academy in 1886 and then at the Paris Salon of 1888, where it won him a Third Class Medal. Bought first by the Neue Pinakothek in Munich, it is today in the Aberdeen Art Gallery. In Paris it was admired by fellow Irishman George Moore, who wrote:

> I do not know Mr. Lavery, I never heard anyone speak of him but it is my duty to find talent and proclaim it.[3]

In London Lavery met Whistler, a major influence on his early work, in 1887, and a decade later he served as Vice President under Whistler's Presidency of the newly-formed International Society of Sculptors, Painters and Gravers. Lavery also became good friends with the great French sculptor Rodin, whose portrait he painted.

Lavery won bronze medals at successive Paris International Exhibitions in 1889 and 1900. In the latter year he showed in the Salon his handsome self-portrait *Father and Daughter*, which was bought by the Musée National d'Art Moderne in Paris (now Musée d'Orsay). He was elected to the Royal Hibernian Academy in 1907, knighted in 1918, became a Royal Academician in 1921, and received honorary doctorates from both Queen's University, Belfast (1935), and Trinity College, Dublin (1936). At age eighty-four he wrote 'with astonishing verve and frankness'[4] his autobiography, *The Life of a Painter*.

Lavery first visited Morocco with his friend R.B. Cunninghame Graham in the autumn of 1890 and was so charmed by the place that he purchased property in Tangier and returned almost annually. He showed at least fifteen Moroccan subjects at the Goupil Gallery in his exhibition of June, 1891, ten or more at the Leicester Galleries show of November 1904, while over a third of his sixty-six works on display in the Goupil Gallery in August 1908, were Eastern scenes.[5]

1. The date of Lavery's birth has not been definitely established. The artist himself wrote *(The Life of a Painter* (London 1940), p. 15): 'to save explanations when asked, I chose Saint Patrick's Day as being, for an Irishman, easy to remember'. Lavery was baptised in the Catholic church of St. Patrick, Donegal Street, Belfast, on 26 March 1856.
2. Walter Shaw-Sparow, *John Lavery and his Work* (London 1911), p. 46.
3. Quoted in Julian Campbell, *The Irish Impressionists* (Dublin 1984), p. 71.
4. Thomas Bodkin, 'Sir John Lavery', *The Dictionary of National Biography, 1941-1950* (Oxford 1959), p. 489.
5. Shaw-Sparow, *op. cit.*, pp. 174-5, 185, 189.

Bibliography:
Thomas Bodkin, 'Sir John Lavery', *The Dictionary of National Biography, 1941-1950* (Oxford 1959), pp. 487-89.
Julian Campbell, *The Irish Impressionists* (Dublin 1984), pp. 64-72, 126-9, 191-2.
John Lavery, *The Life of a Painter* (London 1940).
Kenneth McConkey, *Lavery*, Edinburgh-London-Belfast-Dublin, 1984-5.
Walter Shaw-Sparow, *John Lavery and his Work* (London 1911).

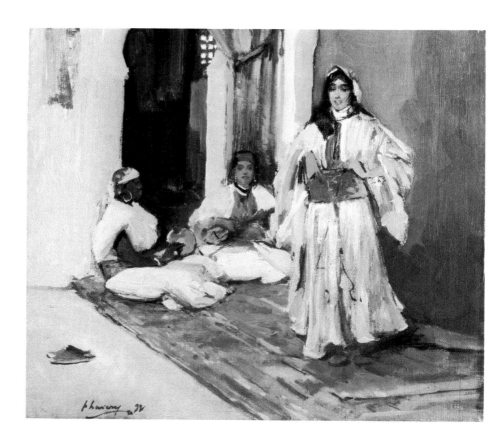

76 Habiba

Oil on canvas, 24 x 27 cm.

SIGNED AND DATED: lower left, *J. Lavery 92.*

PROVENANCE: The Fine Art Society; sale, Christies', London, where purchased, April 1984.

EXHIBITED: 1986, *The AIB Collection*, Douglas Hyde Gallery, Trinity College, Dublin, p. 22 (illus.)

The Allied Irish Bank Collection, Dublin

A Moroccan woman stands straight, just about to break into her dance. Her eyes are lowered modestly, her mouth open in concentration. She is accompanied by two female musicians: a negress seated in profile facing to the right provides percussion, while a woman seated full face, like a diminished version of the dancer, plays the 'oud. On the uncarpeted floor to the left can be seen the dancer's red *babouches*, their colour picked up in the rope that restrains the curtain in the back to let in a little illuminaton through the latticed window. Somewhat surprisingly for an artist so enamoured of light, the picture seems to have been worked up from overall dark tonalities.

Lavery recounted in *The Life of a Painter* his difficulties in finding Eastern women to paint. Once he spent a week in a severely cramped secret spot in order to portray a harem from fifty feet away.[1] On two other occasions he arranged to have Moorish women sent to model. The first time he rejected both candidates when they unveiled to reveal:

> two of the most hideous beldams I have ever seen out of a brothel — where they had really come from. What an opportunity for a sur-realist![2]

The second time Lavery was similarly disappointed when he regarded a female, who had been described as the most beautiful in all Tunisia, as 'a fat, hideous woman dressed with fantastic splendour'.[2] Later he astutely acknowledged that his dismissal of these models was wrong, and based on his false preconceptions:

> Years afterwards, when I recalled that scene, I saw what I had missed — a real Oriental instead of the artificial thing I was searching for. Blinded by what I wanted, I could not see how wonderful a picture I might have painted...[4]

Thus did the artist acknowledge that his vision of the East, despite his wide experience, owed much to what he *wished* to see, so that this graceful work compounds deft observation with willed imaginings.

Is it just possible that his sketch might be *A Moorish Dance*, the first Oriental picture Lavery exhibited at the Royal Academy in 1893 (no. 5)?

1. John Lavery, *The Life of a Painter* (London 1940), pp. 103-4.
2. *Ibid*, p. 103.
3. *Ibid*, p. 104.
4. *Ibid*.

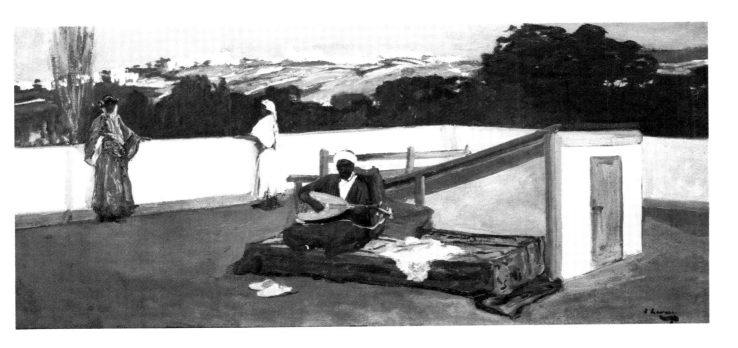

77 The Housetop, Evening

Oil on canvas, 56 x 120 cm.

SIGNED: lower right, *J. Lavery*.

PROVENANCE: the artist's family.

EXHIBITED: ?1908, Goupil Gallery, Paris, no. 51.

Mr. Patrick O'Driscoll

Apart from the enclosed and guarded harem, the rooftop and the bath were about the only places in which Eastern women could disport themselves with any measure of freedom, presumably perched above the prying eyes of strange men. Although far less common than harem scenes, rooftop subjects did appear in the work of a number of artists, such as Benjamin Constant's *The Scarf Dance* (Vassar College Art Gallery, Poughkeepsie, New York), which is about the same size as this painting. Lavery did several rooftop scenes; a roughly similar composition, with two Arab men and a musician, entitled *Tangier: Moonlight* was sold by Spink & Son in 197_.

Here Lavery has taken advantage of the strong horizontal stability of the canvas' long rectangular shape to construct his composition out of gentle diagonals, the slight upward rise of the pink roof wall and the buildings of the town in the distance, the more abrupt descent of the dormer over the stairway that leads to the main house below. The picture's focus and anchor is the musician seated on an old carpet covering a long box, and behind him Lavery has skilfully set a green bench, the same colour as much of the paint trim on the house, as one of the composition's rare horizontals. The central musician wears a slate blue/purple tunic over a white shirt and a white turban with a red top; there are blue shadows on his face, and his 'oud has a sky-blue strap and a touch of bright red on the bottom. The woman on the left, her back to the wall, is the most complex and carefully worked piece of the painting. Her garment is pale blue, almost indigo, echoing the colour of the sea, and gold, and she has a red sash and red slippers. The other woman facing away also wears red *babouches* and a red sash over her white tunic. The top of a dried-out poplar tree next to her contrasts with the lush greens of the distant sunlit slopes. The simple shapes of the bright buildings have been represented with heavy impastoed white, interrupted by narrow exposed areas of the dark grain of the canvas, which stands for shadows. This painting is titled, signed and dated '1914' on the back of the canvas, which makes the suggestion that it might have been no. 51 of Lavery's 1908 Goupil Exhibiton, *The Housetops, Night* seem unlikely.

Aloysius O'Kelly

1851,[1] Dublin — 1926, Brooklyn, New York

O'Kelly's early history is unclear, but he went to Paris only a few years after Edwin Lord Weeks (*q.v.*), also studying with Léon Bonnat[2] and Gérôme (*q.v.*), in whose studio O'Kelly enrolled on 7 October, 1874.[3] He was painting in Brittany around 1876, and exhibited Breton scenes in Dublin and London in the late 1870s and mid-1880s. In 1884 he sent to the Paris Salon his only picture, entitled, *Mass in a Thatched Cottage in Connemara*, a work he had exhibited the previous year in London at the Royal Academy (no. 765).

Sometime in the mid-1880s, perhaps inspired by the example of Gérôme, O'Kelly travelled to Egypt, painting in and around Cairo. He exhibited scenes of bazaars, mosques, city streets and deserts at both the Royal Hibernian Academy and the Royal Academy for several years, into the 1890s.

Sometime before 1909 he moved to New York. In 1912 he had exhibitions in New York, Chicago, and Milwaukee, spending five months of the summer and autumn painting in Maine. He became a member of the New York watercolour club, but his move to America has resulted in his later years being scarcely better known than his early ones. O'Kelly's brother James J. O'Kelly was a member of Parliament for county Roscommon and a good friend of Charles Stewart Parnell, during and after the Kitty O'Shea debacle.

1. This birthdate is taken from the roster of Gérôme's American pupils, listed in H. Barbara Weinberg, *The American Pupils of Jean-Léon Gérôme*, (Fort Worth 1984), n. 383, p. 103. Julian Campbell, *The Irish Impressionists, op. cit.*, p.124, suggested 1850, which was mentioned in O'Kelly's letters to William Macbeth 1909-12; Thieme-Becker gives 1853.
2. O'Kelly was listed as a pupil of Bonnat in the catalogue of the 1884 Salon, n. 1828, p. 163.
3. H. Barbara Weinberg, *op. cit.*, p. 103.

Bibliography:
Julian Campbell, *The Irish Impressionists*, (Dublin 1984), pp. 56, 124, 163-70.

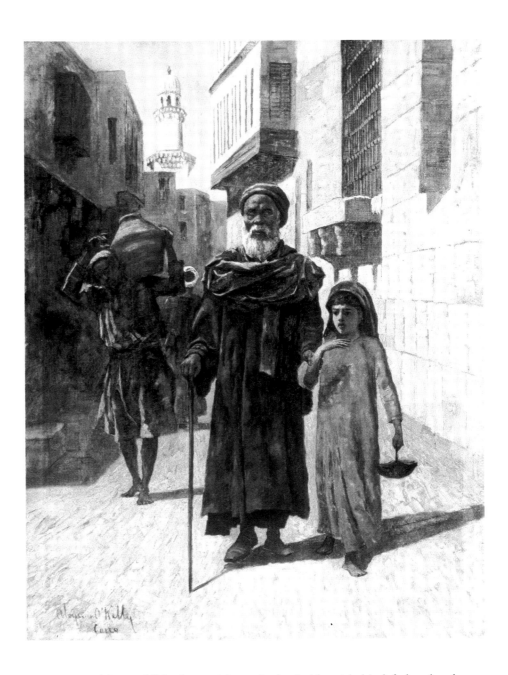

78 A Blind Beggar, Cairo

Oil on canvas, 42.5 x 30.5 cm.

SIGNED AND INSCRIBED: lower left, *Aloysius O'Kelly/Cairo*; also signed and inscribed on reverse.

PROVENANCE: Gorry Gallery, Dublin, where purchased, 1986.

EXHIBITED: 1891, Royal Hibernian Academy, no. 310.

Mr. and Mrs. L. Quinn

Accompanied by a child whose right wrist he holds with his left hand, a beggar descends the street, lifting his right foot, which follows the cane he extends with his left hand. Although obviously blind, he seems to know his way. Following behind them on the left is a man who carries a water jug on his right shoulder, his fingers flickering in the sunlight. Between the watercarrier and the old man can be seen an Arab going in the opposite direction; his overlapped body skilfully sutures theirs, and the red centre of his turban serves almost as a central target that focuses the perspective recession and structure of the composition. In the building on the left traces of underdrawing can be seen, as well as the ghost of a figure seated on the blocks in front. O'Kelly used the direction of his brushstrokes to reinforce the recession of the street and also to define the orientation of blocks on the sides of the buildings. Echoes of colour help hold the picture together: the blue of the old man's cape is the same as the young water carrier's tunic, the yellow of his slippers the same as the robe of the accompanying child, who, on account of her headdress, is probably a girl, since Arab females do not adopt the veil until puberty. On the rising street can be seen a projecting window with *mashribiyya* and the tower of a mosque penetrating the patch of bright blue sky. O'Kelly used a similar composition for a more crowded street scene, with three veiled women, a man on a donkey and a busy shop, sold at Sotheby's, London, 16 June 1982 (lot 455).

179

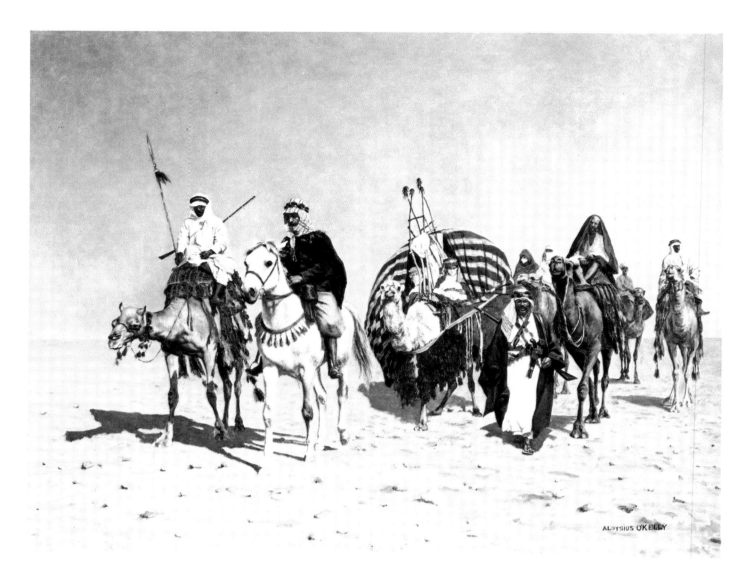

79 The Hareem Guard

Oil on canvas, 71 x 91.5 cm.

SIGNED: lower right, *ALOYSIUS O'KELLY.*

PROVENANCE: James O'Kelly, M.P. for county Roscommon, and brother of the artist, by whom given to the present owner.

EXHIBITED: 1894, Royal Hibernian Academy, no. 140 (priced £50)

Private collection, courtesy of the Gorry Gallery, Dublin

1. The illustration on page 168 of Lynne Thornton, *La Femme dans la Peinture Orientaliste* (Paris 1984), also from 1880, must relate to Guillaumet's Salon painting. It shows a similar contraption on the back of a camel to the one illustrated in the O'Kelly picture.

As a title *The Hareem Guard* would normally conjure up an image of a muscular Nubian, armed to the teeth and barring a door that led to such miraculous feminine beauties as lesser men were left only to imagine. A picture like this exhibited work could easily be associated with such exhibited O'Kelly paintings as *On the Arabian Desert* (Royal Academy, 1890, no. 61) or *On the Desert* (1891, no. 1370). Yet the identity between the picture's traditional name and that of a painting shown in the Royal Hibernian Academy in 1894, suggests that its principal subject is the escort of the two veiled women in the *palanquin* or *bassour* in the right centre of the composition. O'Kelly could have seen Guillaumet's painting *The 'Palanquins'-Laghouat* in the 1880 Salon.[1]

O'Kelly has constructed his picture as a procession seen from a three-quarter view, so that the rich variety of his Arabs and their costumes are displayed to full advantage. Five camels with solo riders can be seen, with the mount of a sixth rider not visible. A white camel, strapped with a fringed livery of long red tassels, bears the awkward load of the crescent frame covered with two matching striped blankets to shelter its precious cargo. Leading the procession are the impressive duo of a warrior in yellow with a lance in his right hand and a musket slung behind his back mounted on a camel, and a rider in a desert dress that is more Europeanized, atop a graceful grey horse, whose handsome head is perhaps the most sensitive and stirring in the entire picture. With a barren landscape of rocks, sand, a thin illumined line of a distant mountain range, and short cast shadows, the Irish artist effectively suggested the draining dusty heat of a desert journey in the late morning or early afternoon.

Index of artists and collections cited in Text

Index of Lenders with Catalogue Numbers